If only all women could focus more on their aspirations
and less on their bodies.

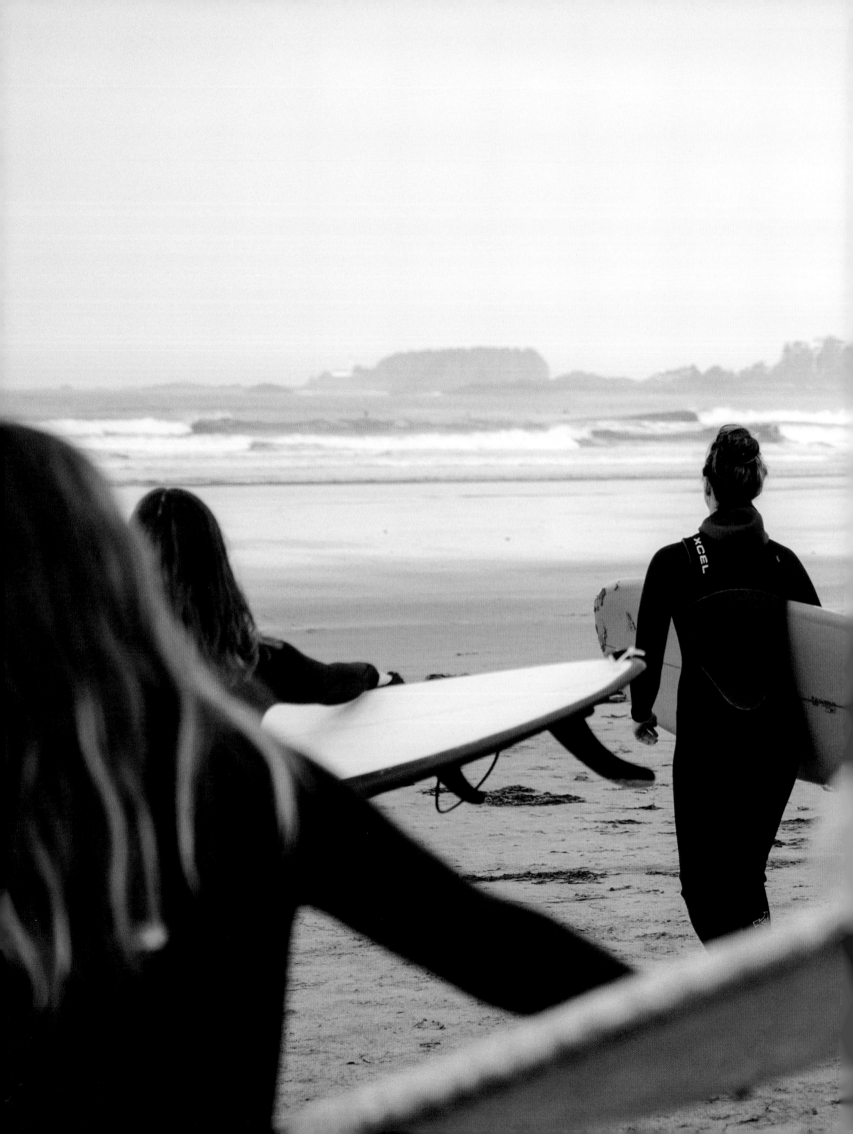

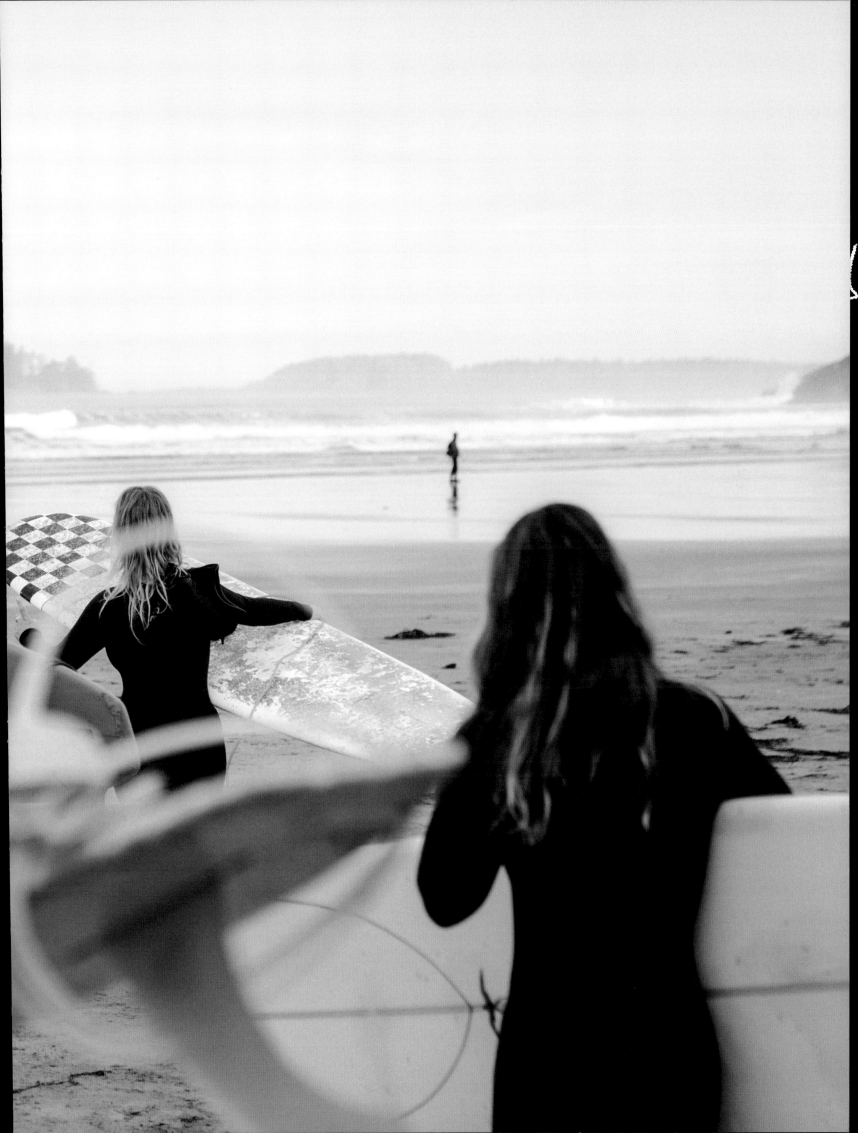

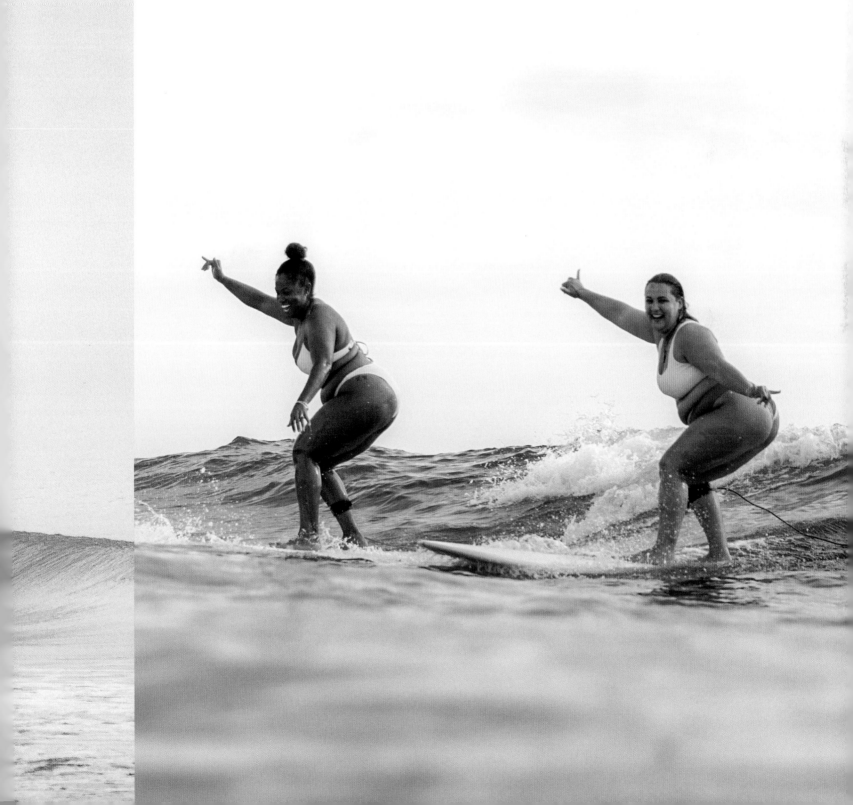

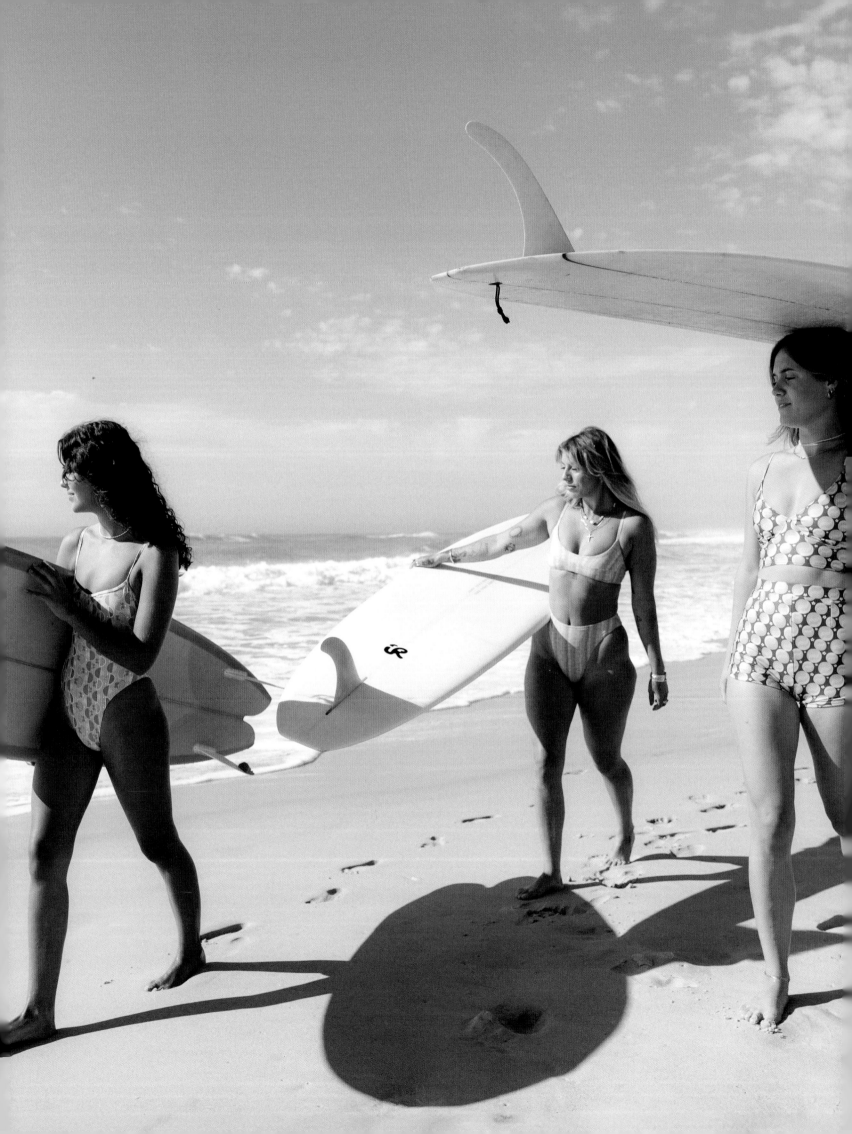

CAROLINA AMELL

EVERY BODY SURF

A Tribute to Self-Love and Sisterhood

PRESTEL

Munich · London · New York

Tara Crystal

"As I get older, I feel more comfortable with my own body."

My relationship with my body changes a lot, just as my body changes a lot. Sometimes I have a hard time accepting my body image and my self-image, and other times I feel beautiful. Sadly, I think that most women look at themselves and want to change something: sometimes I wish I was a bit thinner, or taller. Other times I'll try on clothes and feel like nothing is fitting right and that nothing looks good on me. That can get a bit frustrating.

I am 35 years old now, so it has been a rollercoaster, I would say that when I was younger, I was a lot fitter, and I surfed more. Now as I am aging and my body is going through hormonal changes, I feel different. But at the same time I am very grateful for the body I have: I am strong, physically able, and healthy. What more could I ask for?

When I feel insecure, I try to do something nice for someone else, I don't focus on my physical appearance and instead I focus on what is in my heart and in my mind. But at other times I will dress up and take a little more pride in my appearance. It feels good to reflect on the outside what is on the inside.

When I am feeling down, unmotivated, or sad, I often just want to go back to the ocean. I am very surf-motivated. When I am in the ocean and I can surf more, I know I will be happier mentally and physically. Surfing drives me.

I think the media tends to over-sexualize women and that can lead to body dysmorphia. As I get older, I feel more comfortable with my own body, but I think that this over-sexualization, together with unattainable beauty

The winter season at the North Shore, Oahu, Hawaii.

8

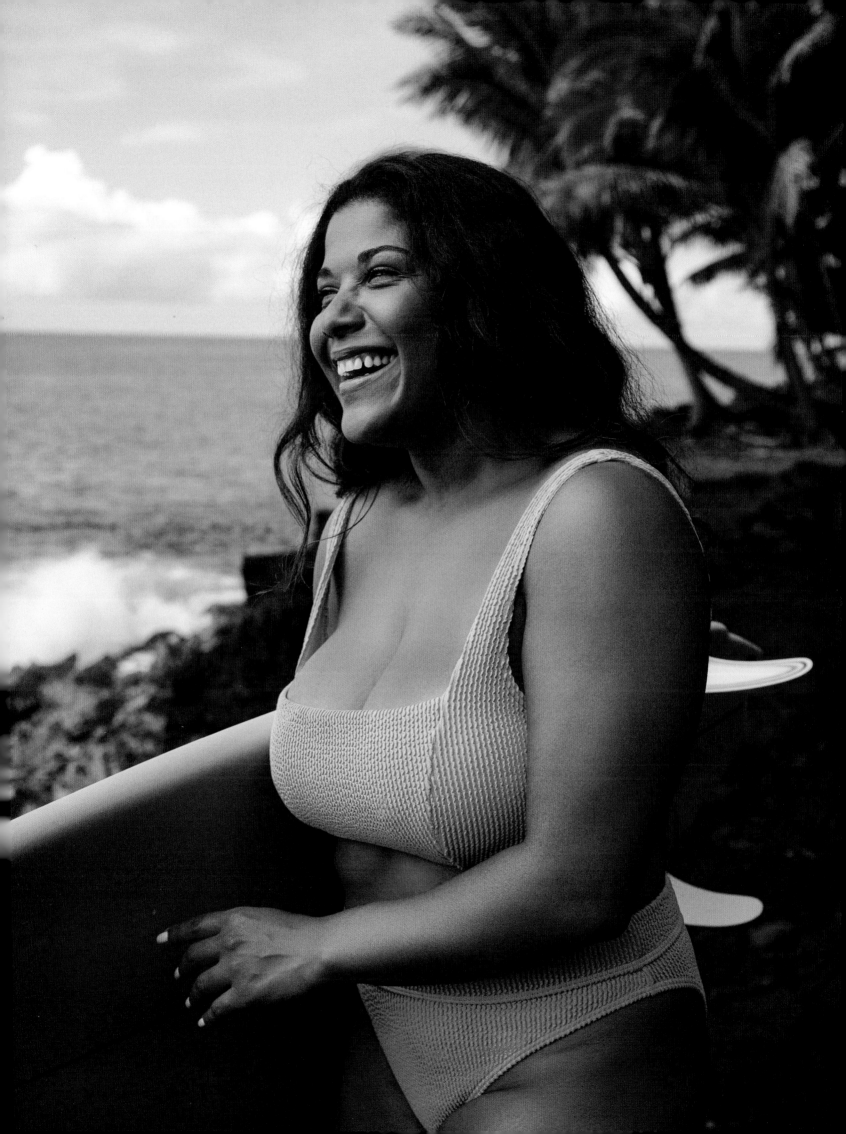

Tara Crystal

standards, can be really unhealthy for young women. I think it is sad that as a society we are in a place where we feel so uncomfortable in our bodies that we need to have cosmetic surgeries.

Surfing has always played a huge part in my mental happiness. I can't remember a time in my life when I've gone surfing and had a bad day. Surfing has always been my anchor and I love it. When I'm in the water it's just me versus my relationship with the ocean. I don't care how I look, I'm there to get waves, not to look pretty. When I'm in the ocean, my mind calms. The other surfers in the lineup are not focusing on my appearance, they are also just there to catch waves. The judgments are left on land.

My journey to finding self-love I feel is a lifelong process, rooted in kindness to others. I feel truly loved by my community, and because of that I feel whole. I know it is hard. Sometimes we are our own harshest critics, and we have awful negative thoughts and yucky voices that can be so loud that they try to hold us back, but that is the moment to remember that there are people that you know who support you and love you. I am also very aware that we are here for a limited time. I have chosen to spend that time with people who care about me for who I am instead of what I look like. That is really important.

"My journey to finding self-love I feel is a lifelong process, rooted in kindness to others. I feel truly loved by my community because of that I feel whole."

There are a lot of good people in this world, and if you gravitate toward them, you will be fine. No nice people are truly ugly, and no mean people are truly beautiful.

To quiet the negative thoughts that you might have, just keep being a good person and be kind, even to yourself. I have one funny memory: I was looking in the mirror and trying on clothes and I said, "Oh! I look so bad!" and one of my good friends told me right then and there: "Be nice to my friend!!!"

Modeling for Alohiwai.com, Red Road, Hawaii island.

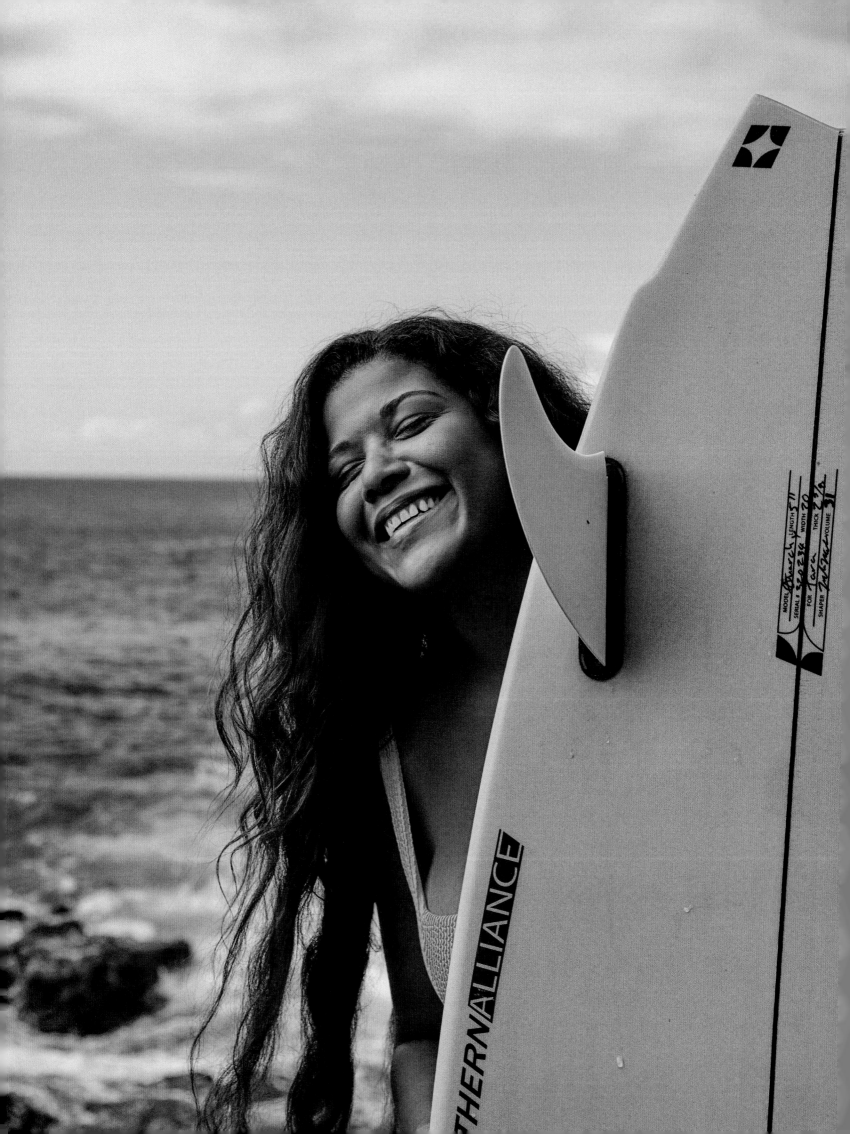

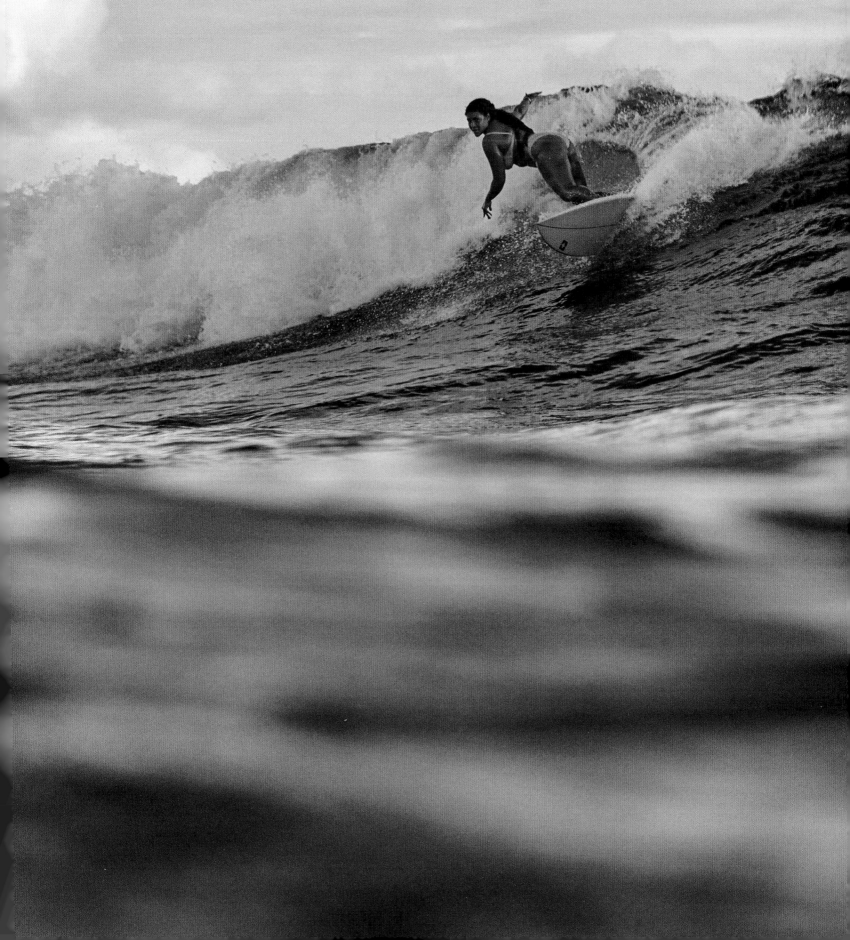

Be careful how you talk to yourself
because you are listening.

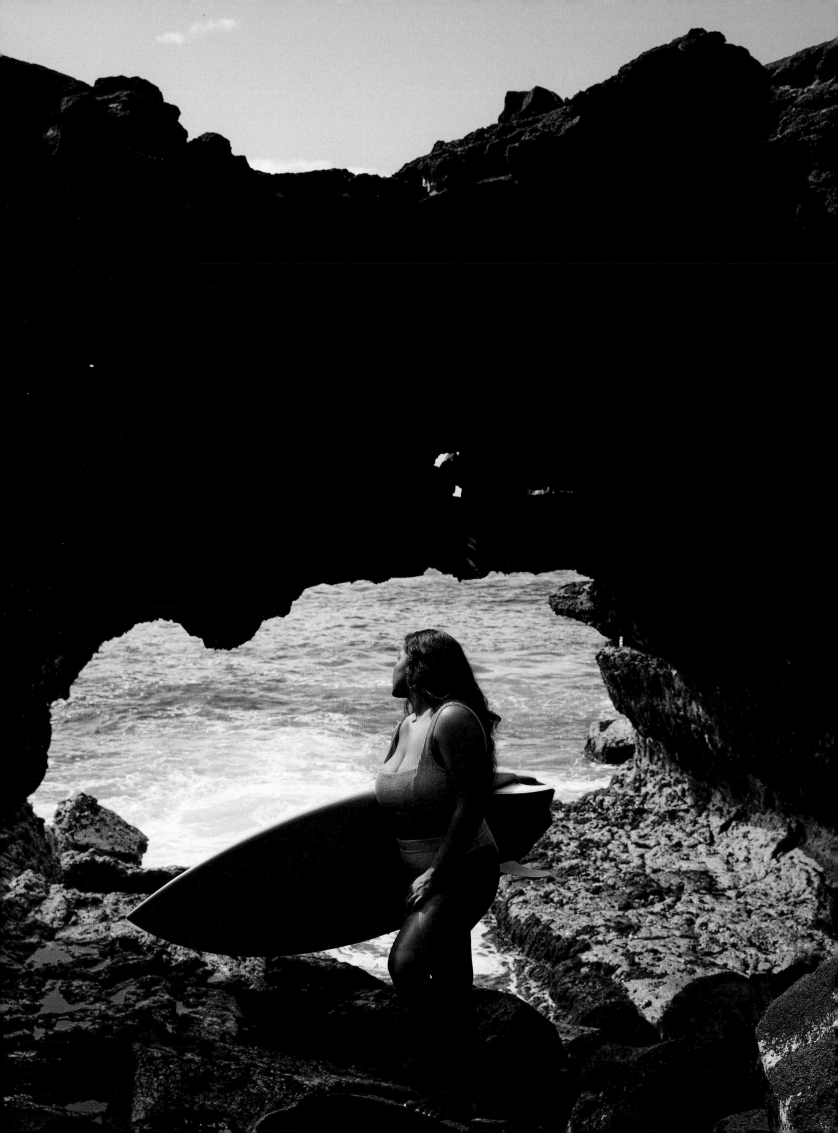

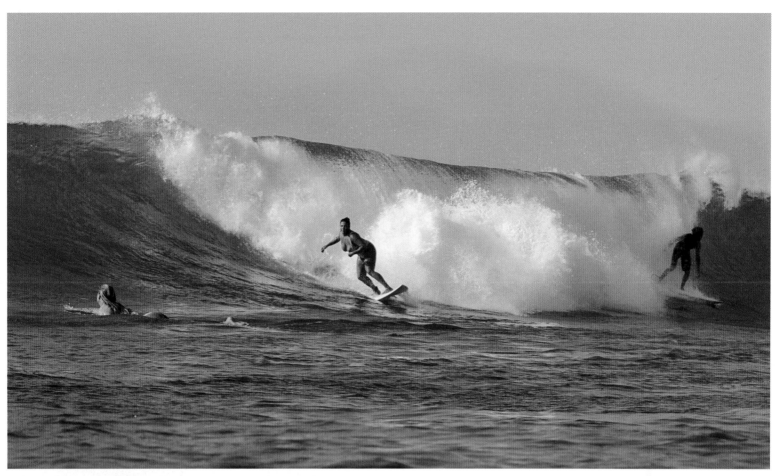

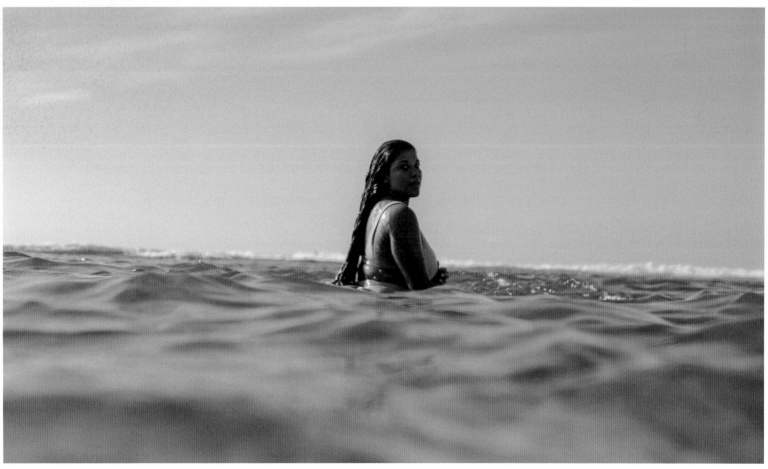

North Shore, Oahu, Hawaii.

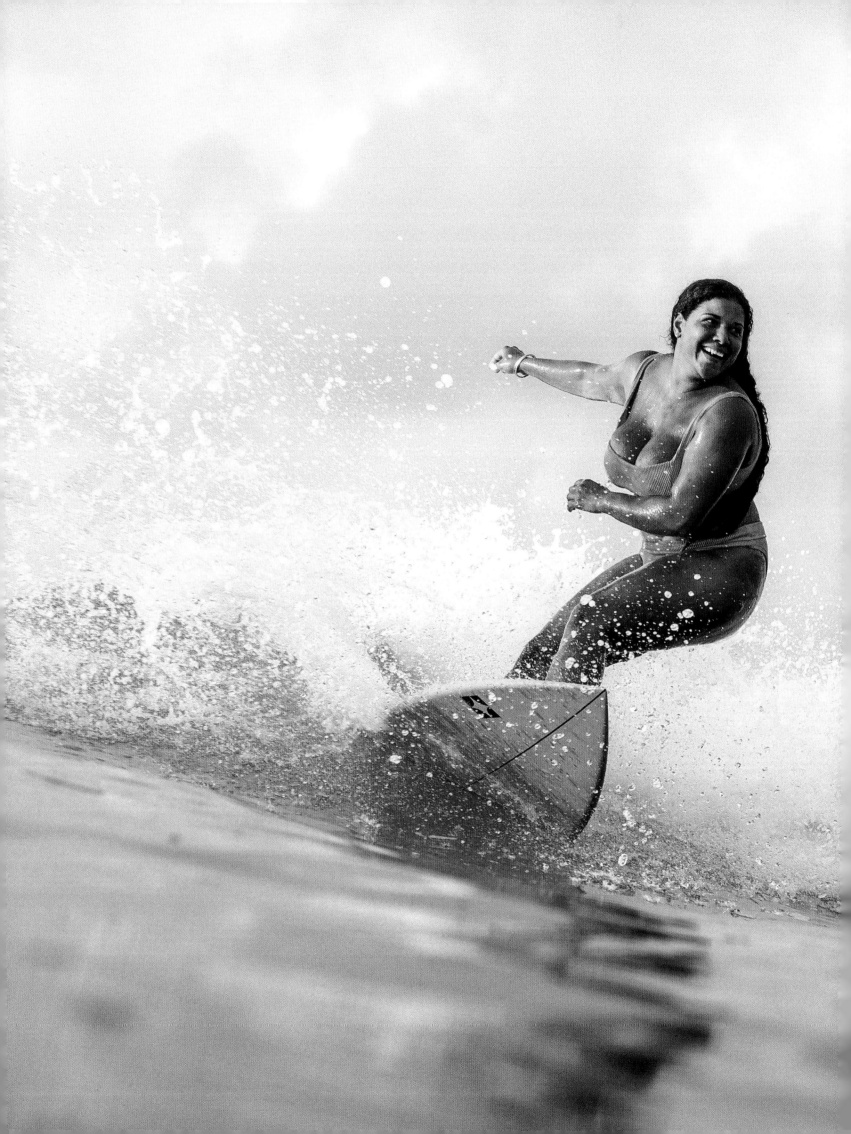

There is power in kindness.

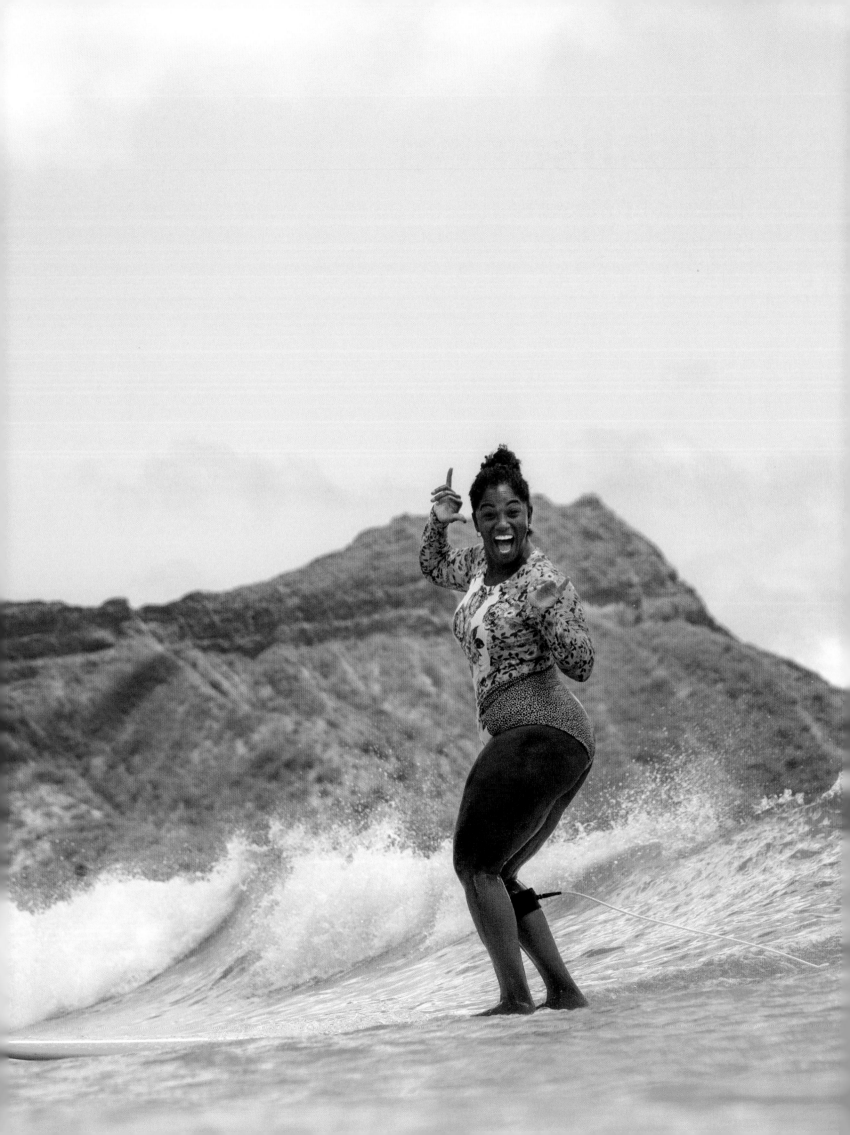

Bri Atisanoe

"There's no need to prove yourself to anyone. Live like you don't have an audience."

I was raised in Kona, where I was the only little Black mixed Hawaiian girl. There weren't many girls who looked like me, and my mom Kalei raised me in her footsteps. I was rooted in our Hawaiian culture, dancing hula and loving the ocean with my siblings. Not knowing much about afro hair, she did her best. So, it was often in a bun, and my peers were quick to share their unsolicited thoughts about it. When I moved to Oahu to live with my mom Schelle and my other siblings, the differences were still noticed but more accepted, and at last I had my sisters there, so people were more familiar with our mixed background.

As a little girl, I started doing mirror work. I would tell myself, "You're enough, you're beautiful, your skin is beautiful, your nappy hair is beautiful, your bigger thighs are beautiful, and even your stretch marks are beautiful. You are different, and this is ok." Over the years I gained confidence, held my head high, set goals that seemed out of reach, and always loved my uniqueness.

Raising our two girls with my husband Malaki, we wanted things to be different for them. Showing our girls they can pull up a seat at any table, be bold, don't let people speak words over you that aren't true, and, most importantly, love yourself. It's not just kids their age that can be mean; sometimes it's a teacher or other adults. They go through their own trials, and society hasn't changed much, but we support each other. They know my experiences and their dad's experiences, which helps them learn to advocate for themselves in spaces where they might feel they don't belong because of other people's opinions and actions.

Coping with beauty pressures can be tough. Beauty should be a standard that your create, not left in the hands and thoughts of a stranger or a magazine or some social media post. If I don't feel like I meet my own beauty standards, I check my heart. What's stopping me from being a loving, giving person to those around me? I've been asked if I'm always this happy. I have a lot to be happy about—good health, meeting career goals, and a loving and supportive family creating a space where I can be authentically me.

I've worked with companies that were more inclined to work with me for reasons that didn't align with America's typical standards of sex appeal. I'm

If happiness were a person.

19

grateful to work with each of them. If I didn't feel sexy in my own skin, I'd need to work on that myself. Shifting my mindset because of my beauty isn't defined by others but by who I am. In my eyes, beauty is a heart condition.

Embracing life and its changes has been a journey. I've gained weight and lost weight and at times my pants fit a little tighter. I've embraced it. I bought bigger pants instead. I'm comfortable with being 230 pounds and recognizing that my body goes through seasons and how fluid that can be.

I believe we need to talk about the things that make us uncomfortable. I'm not going to pretend to be smaller than I am, a different skin color or different than who I am to fit in someone's box. I represent someone out there who needs to see that it's okay to be curvy or thinner. Whether it's wearing a two-piece swimsuit, trying a new activity like surfing, or just being confident in your body, it's important to be true to yourself.

"I love being around strong, inspiring women who push me to be more direct, step out of my comfort zone, and speak up."

There's no need to prove yourself to anyone. Give yourself some grace and be who you are. You're meant to be that person.

I model self-love by prioritizing time for me, loving and learning me over and over again. My girls see that self-love isn't always perfect. They see me having moments where I think, "Gosh, I could change this or that." Then I catch myself and decide to reset. I enjoy the sun on my skin, the energy I put into paddling, and the healing that comes from being in the ocean.

As a mom and a wife, life can be busy. Balancing high career goals or just day to day tasks. Finding something fulfilling for myself is essential, and the ocean has always been that for me. When I was young, I played mermaid in the tide pools on the Big Island. As I grew older, I went on surf dates in Waikiki. To this day, the ocean remains a peaceful, healing place where I can be alone and 100 percent myself. It's like a warm hug with no expectations, just you, the ocean, and your surfboard.

Live like you don't have an audience.

I definitely feel this way. I consider myself a people person and a woman's woman. I love being around strong, inspiring women who push me to be more direct, step out of my comfort zone, and speak up. I found my voice in my thirties, and at 36, I'm still learning. Finding a group of amazing women is essential, but if you're a lone wolf, don't feel bad. That's a valuable space too. You can be the one trailblazing and leading the way.

The ocean is captivating. Gratitude and peace come even when you're waiting for a set.

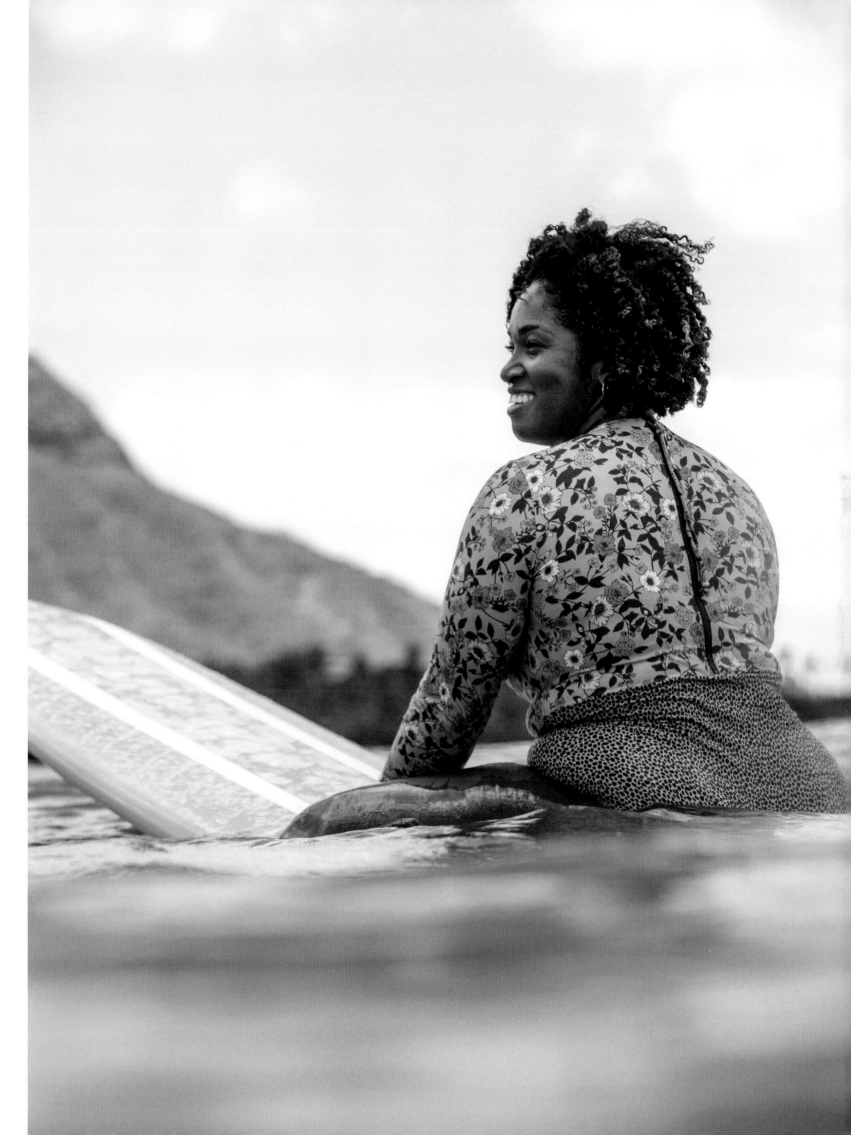

Embracing what makes you unique
is so powerful.

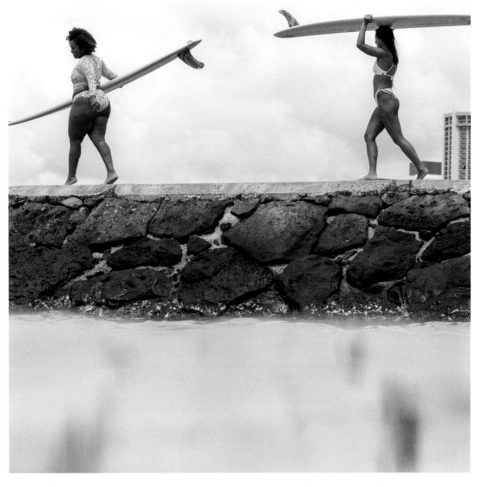

Left In a daze after wrapping up my first shoot, but so grateful to work with a brand that respected my vision and let me share my creativity. | Top Not letting a gloomy day keep me from catching some ankle biters. Every wave is a good wave!

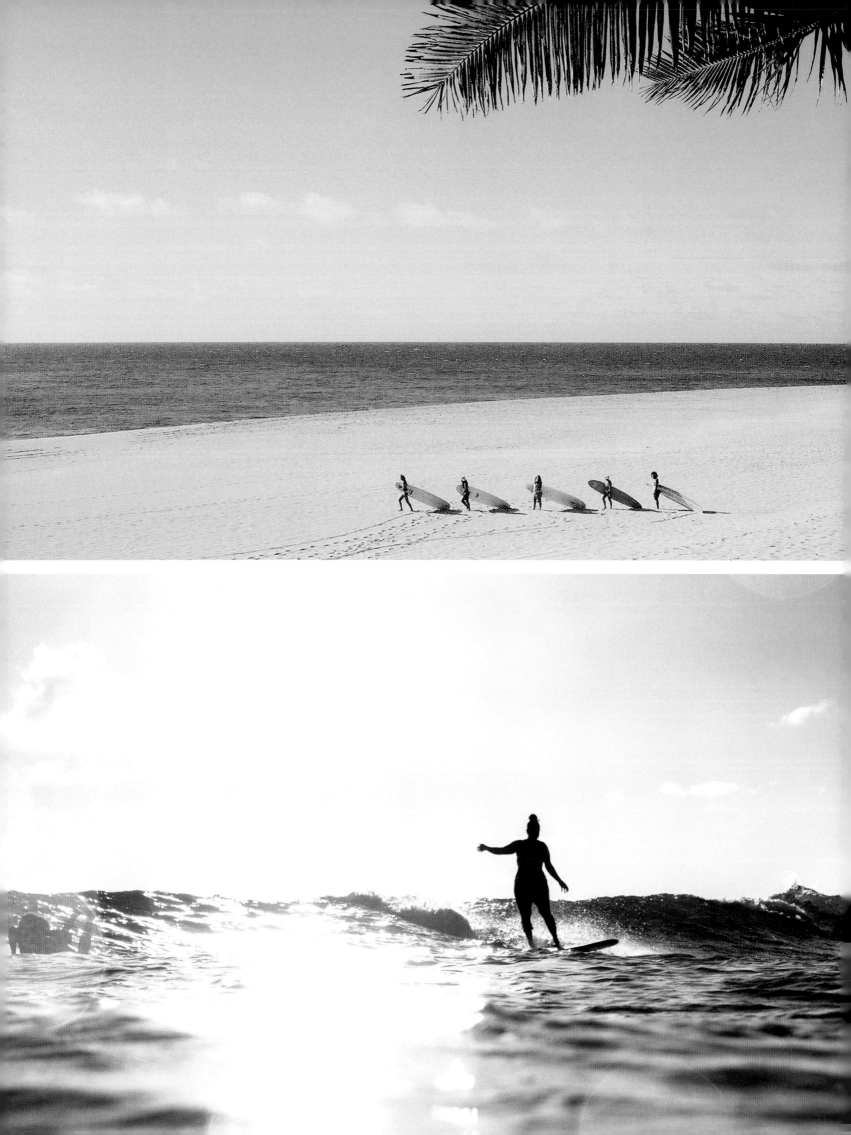

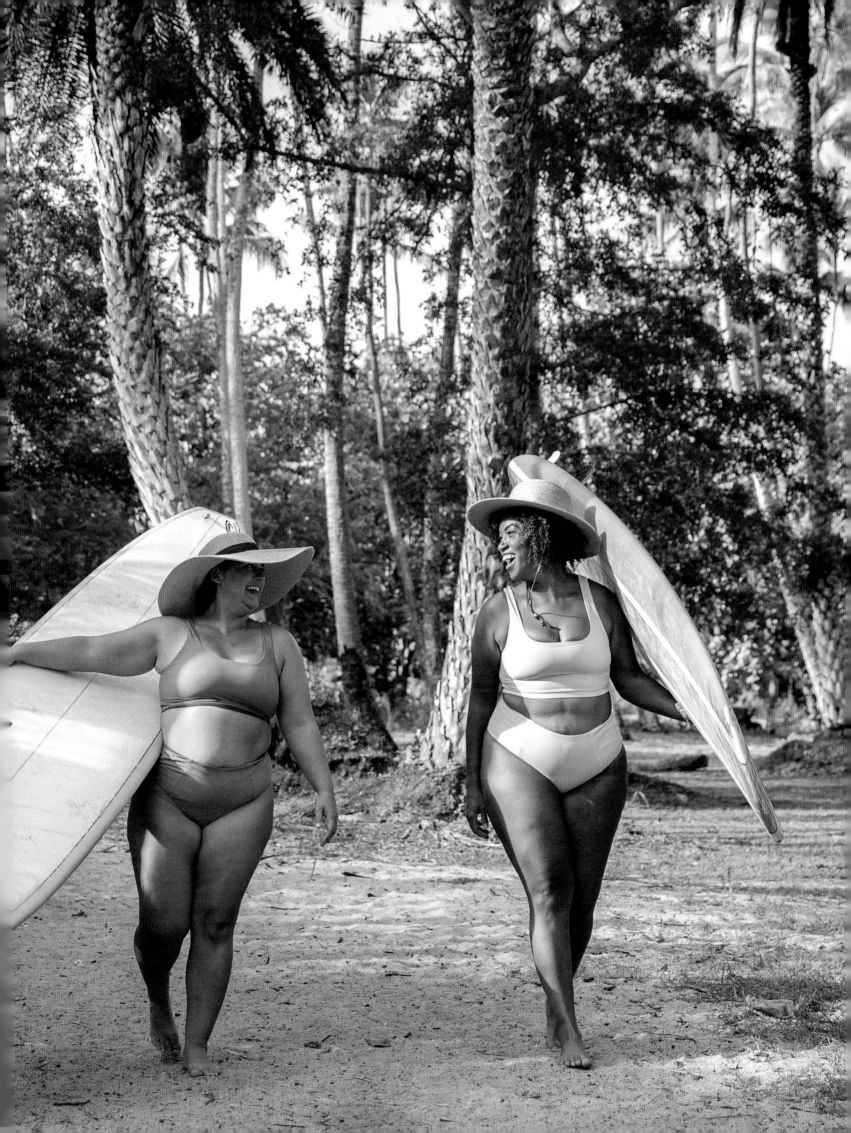

An empowered woman
empowers women.

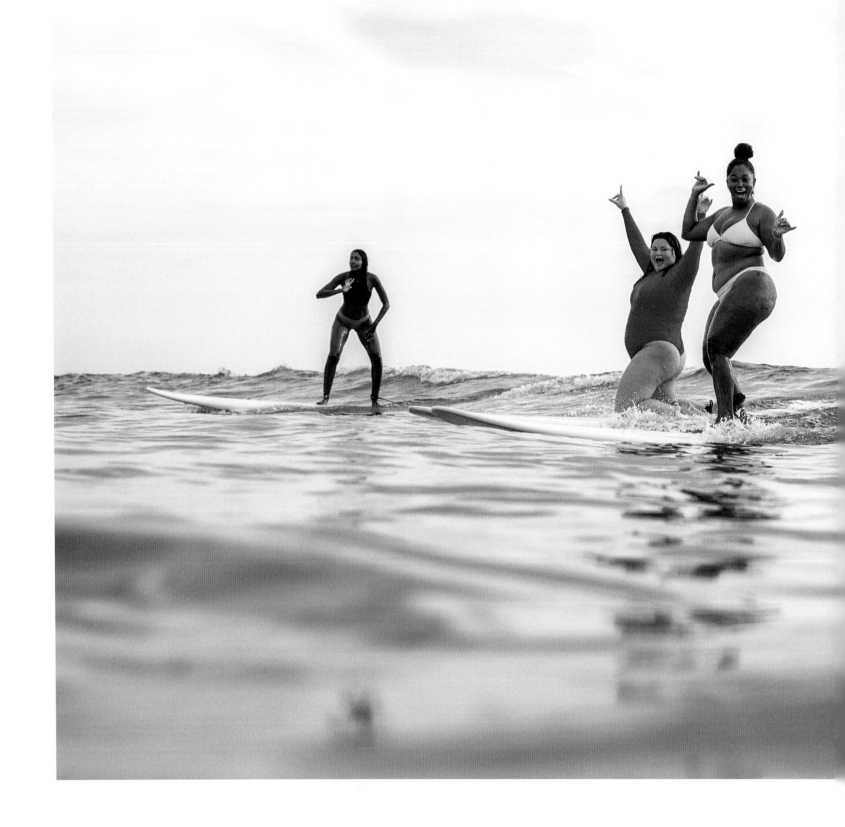

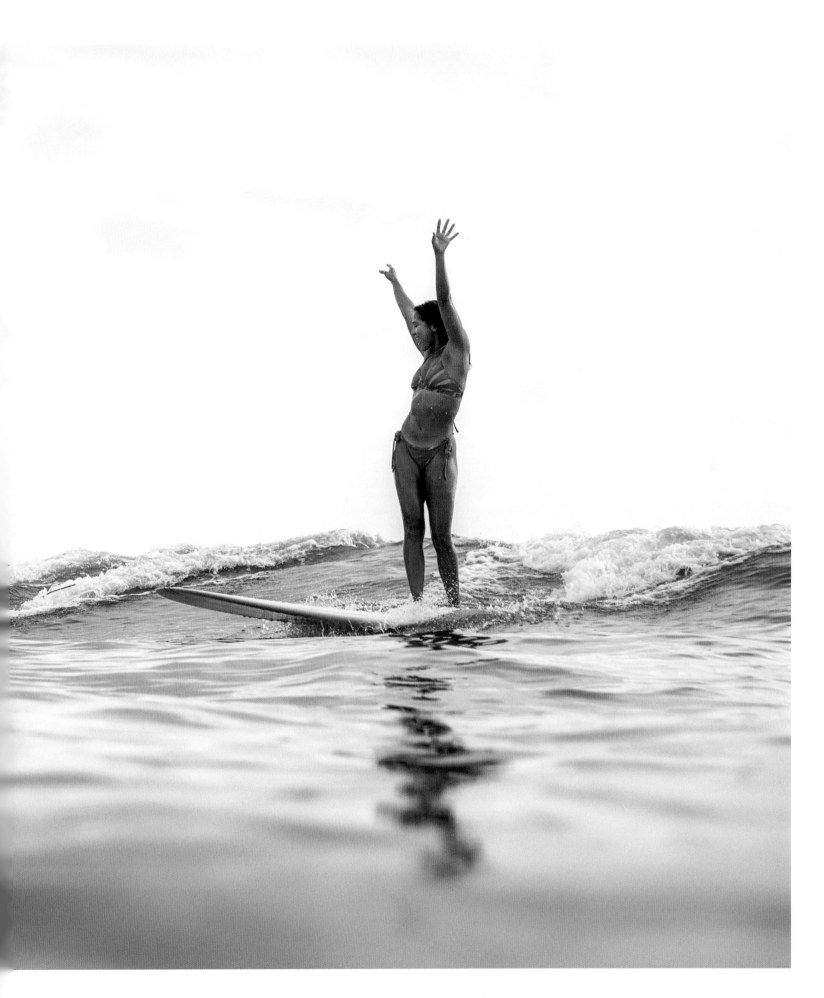

Celebrating a party wave with my girls. | Previous double page (left-top) A day of surfing with friends. (Left-bottom) A soul-fulfilling surf session with the ladies of @texturedwaves 2022 Hawaii Co-Wash retreat. (Right) Casually walking to a secret surf break.

Kirra Calleja

"Not being insecure and comparing yourself to other women is one of the hardest things ever!"

I started surfing at the age of 13. My very first surfboard was a 6'0 purple T Mack Thruster, it was like a soft-top thing. I spent my early childhood in Ocean Grove and we moved to Alexandra Headland, Sunshine Coast, Queensland, when I was about nine years old. My dad taught me how to surf and I will always be grateful to have grown up on the beach surfing before and after school. Dad would start his yellow EH Holden around 6 a.m. The loud exhaust would wake me up and I knew it was time to go surfing!

Growing up with my dad was definitely amazing, but I guess you could say I missed the feminine side of things. That warm, fuzzy feeling you get when your mom gives you a hug and brushes your hair for you. You could say I had the *Brady Bunch* family type. My dad married my stepmother, who had three children older than me, and then blessed me with my little brother. Oh dear, my childhood with this family was something out of a TV show. Think of *Shameless*, but not quite. I had a beautiful stepsister who I looked up to and two older stepbrothers who did nothing wrong in their mother's eyes but were addicted to drugs from an early age. Obviously, I was the devil's child in my stepmother's world. But I couldn't have been further from it. All I wanted was a mother who loved me.

My mom got involved with the dark side of drugs, the evil drug heroin. The homewrecking drug, if you like. It takes over your life. I was a heroin baby, born prematurely and then kept alive by a little machine for a few weeks until my body got used to living without the drug. My oldest sister, who was also a heroin baby, had a dark childhood as well. Her father died when she was a baby and our mother wasn't around. Now my sister is an inspiration to everyone, the best mother anyone could ask for to her two beautiful children.

I never really had the encouragement to be confident and happy with my body. I struggled with my weight and had braces and very hormonal skin. I hated food (I was a very picky eater) and never knew what a healthy, nutritious diet was.

In Lombok for a Xanadu surf retreat. Xanadu went above and beyond to find uncrowded waves for us to make it extra special.

28

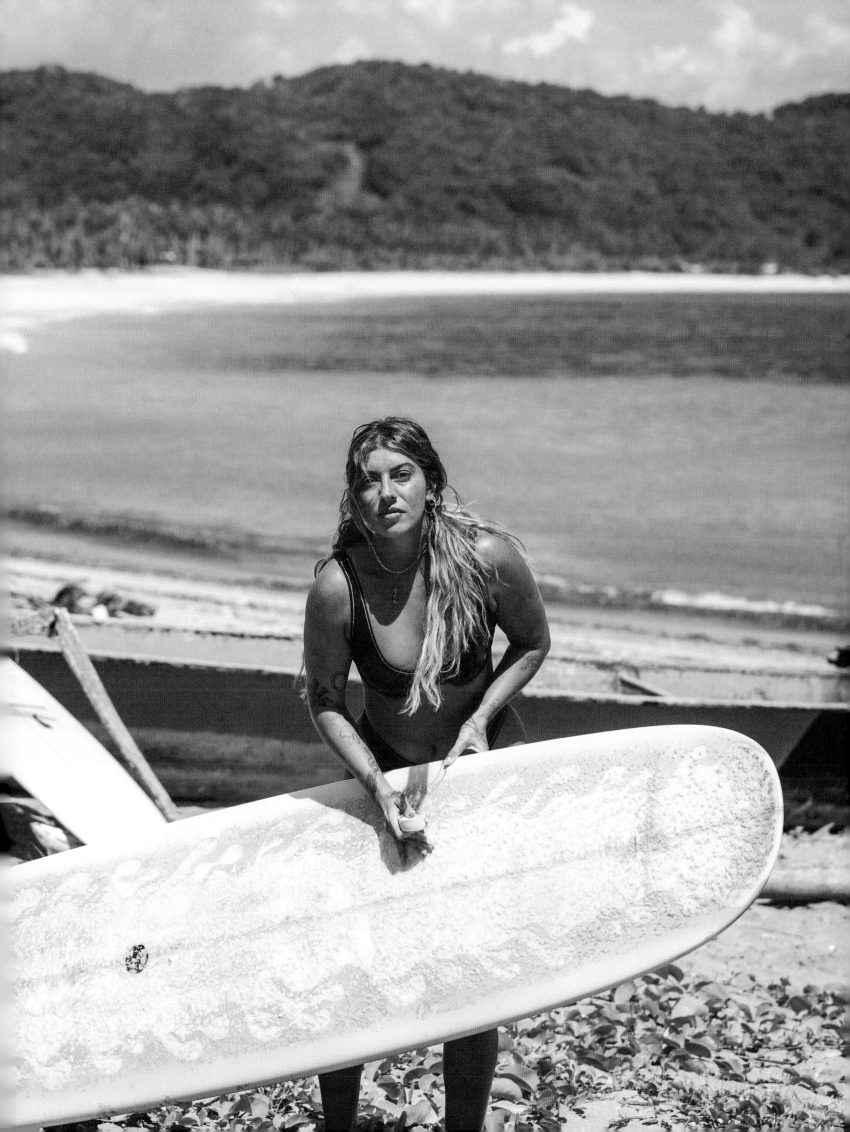

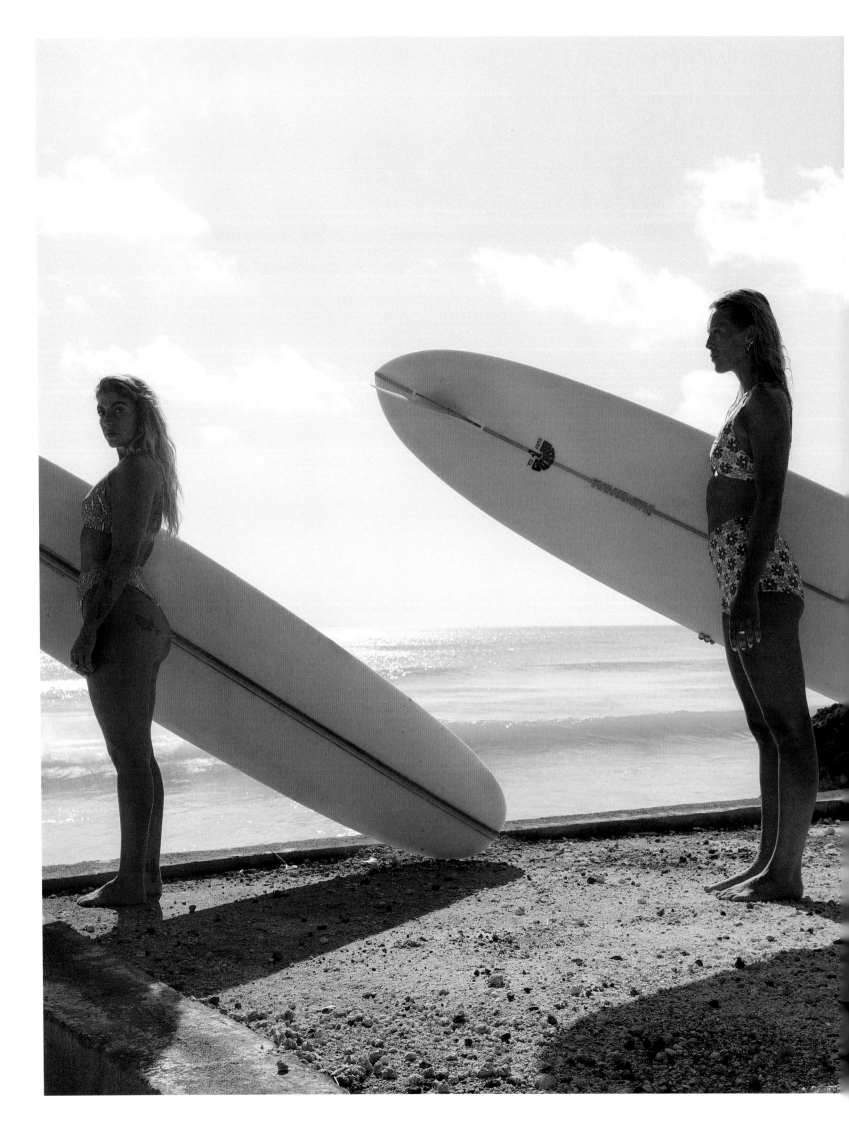

Kirra Calleja

It wasn't until I got into the world of surfing at the age of 19 that I really blossomed. It was an escape from the world. My first real boyfriend showed me the surfing lifestyle and I will always be grateful for that. The beauty of dancing over the water. The beauty of making friends for life. The beauty of freedom in the ocean. It's life-changing.

Fast forward to the age of 25 and many life lessons later, I moved to Coolangatta and met my closest friends Sam and Ramana from Inner Relm, a sustainable swimwear brand. There the sun shone so brightly that I found my confidence! I found my people. Inner Relm is a brand that made me feel like no other. It's funny how a swimsuit can make you feel so empowered. The way the colors compliment your skin and the cut compliments your curves.

Being a curvy girl and living in swimwear 24/7 can have a really big impact on your mental health. Not being insecure and comparing yourself to other women is one of the hardest things ever.

Surfing has become a fashion statement. I will be the first to say that I love it. I love that we can express ourselves in swimwear. That's where the confidence comes in. If you're comfortable with what you're wearing in the water, surfing starts to speak for itself. You feel good and you're going to get those toes on the nose.

"Don't be afraid to wear those swimsuits either, if you like them and feel comfortable. Dance on the water until you can't get up. Smile, cry, laugh, and love."

But the real game changer was finding out I had endometriosis and polycystic ovarian syndrome. Battling weight gain, irregular periods, skin problems, crippling stomach pains that prevent you from physically working or even surfing. I had the surgery to remove it about seven months ago. Well, most of it. It does grow back. Imagine mold growing on bread. Yeah, not nice.

We are still not sure what the cause of endometriosis is. I think it's a never-ending story. Different doctors tell you that there is nothing wrong with you. It's all in your head. Take some Panadol, you'll be fine. This is my cry to all girls: Do not take no for an answer! Fight for what you feel. You are not dramatic, you are not weak! Believe me, I know that spending hours and hours in hospital only to be told you are fine and sent home is soul-crushing! But please don't give up on yourself.

Shooting for Inner Relm on a beautiful day in a stunning location in Bali.

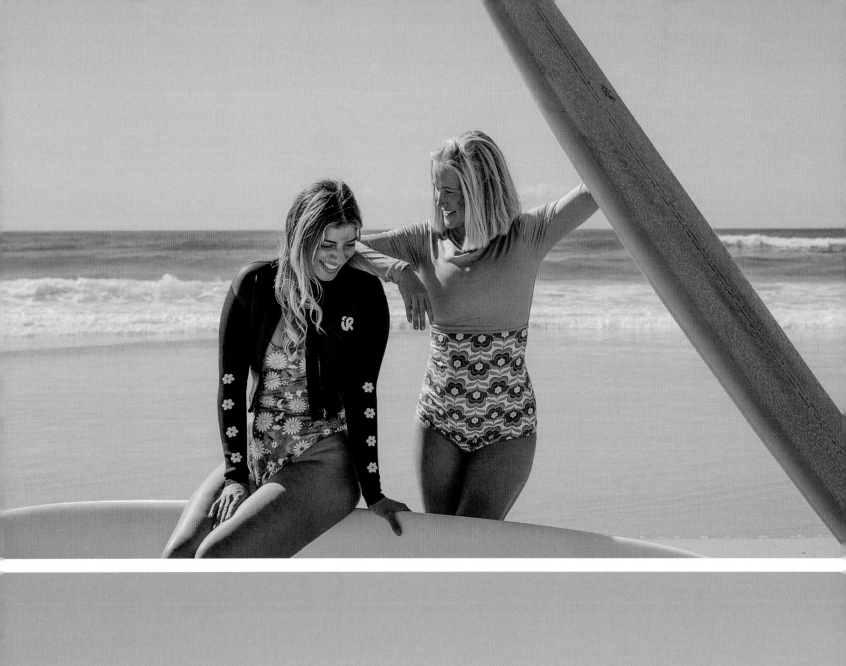
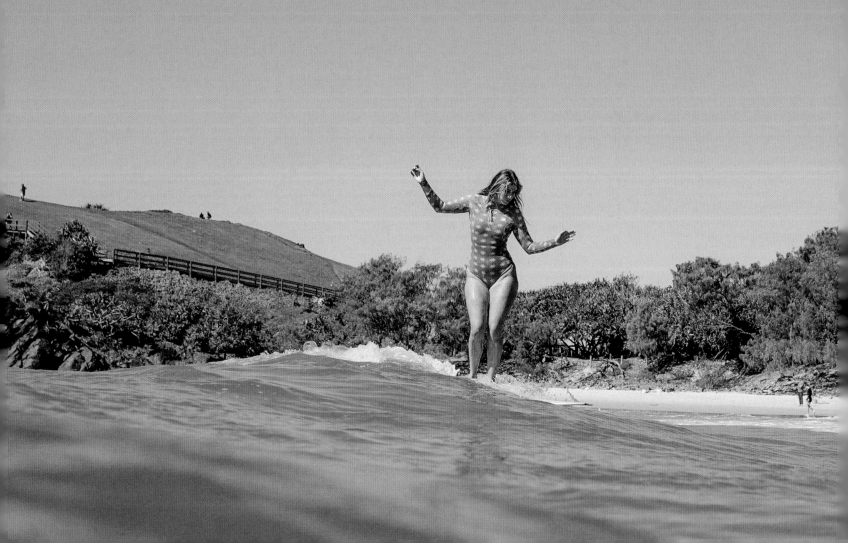

"I have my insecurities, and sometimes it's difficult to shut out that noise in our head of not feeling worthy, of thinking we are not enough."

Kirra Calleja

The only thing that has really helped me on this crazy journey has been changing my habits with food. I had to completely change the way I ate. Nothing processed, no sugar, no gluten, nothing in a packet, really. I wake up every day and train—I have to be in the ocean before the sun rises. Crazy, I know. But there is no better feeling than being in the ocean before the sun says hello. I prep all my food to make sure I'm eating clean. I eat a lot of food and try to add a lot of color. I can't say this enough, but food is medicine. If you don't feel good on the inside, you won't feel good on the outside. And sure, I will definitely eat a whole bar of chocolate and Francie's pizza from time to time.

My confidence in myself has come with eating the right way. My mind is clear and I'm truly happy with how I live. I stay motivated, knowing how I feel on the inside. But of course, I have my insecurities, and sometimes it's difficult to shut out that noise in our head of not feeling worthy, of thinking we are not enough. I have that every day! We have to sit with our deep thoughts and work on them. I know it's easier said than done and it's just noise, but I feel that journaling has helped me to block out those negative thoughts. Drawing little pictures of what makes me happy. And the big one: surround yourself with people who see your light! Your friends want the best for you. Even if sometimes you don't think you deserve it, you do!

For me to feel worthy, I have to dig deep, because I think the sense of abandonment comes from being left by my mother. Knowing your attachment style is also very crucial. Once you know this, you can navigate what triggers you and you can voice your concerns.

There is a life lesson here: never be afraid to ask a question, someone will have the answer. Don't be afraid to wear those swimsuits either, if you like them and feel comfortable. Dance on the water until you can't get up. Smile, cry, laugh, and love.

My two favorites: Marina, behind the camera, always capturing magical moments, and Anna, my ride or die surf sister, at a very special local place in the heart of Northern NSW Rivers, Australia.

The best weight to lose
is the weight of other people's opinions.

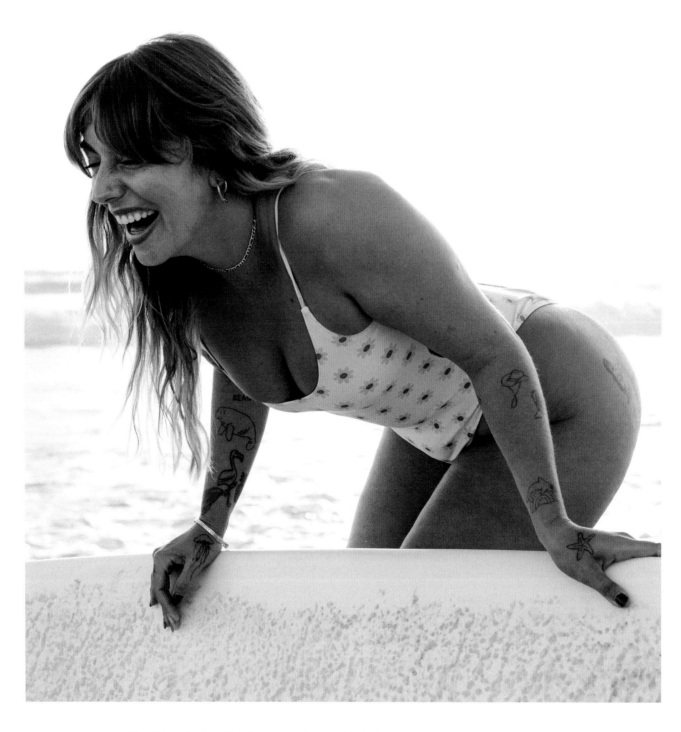

Top A shoot for Inner Relm's summer collection. | Right Another magical day in Lombok with beautiful people in and out
of the water. | Next double page Shooting for Inner Relm on a very hot day in Bali.

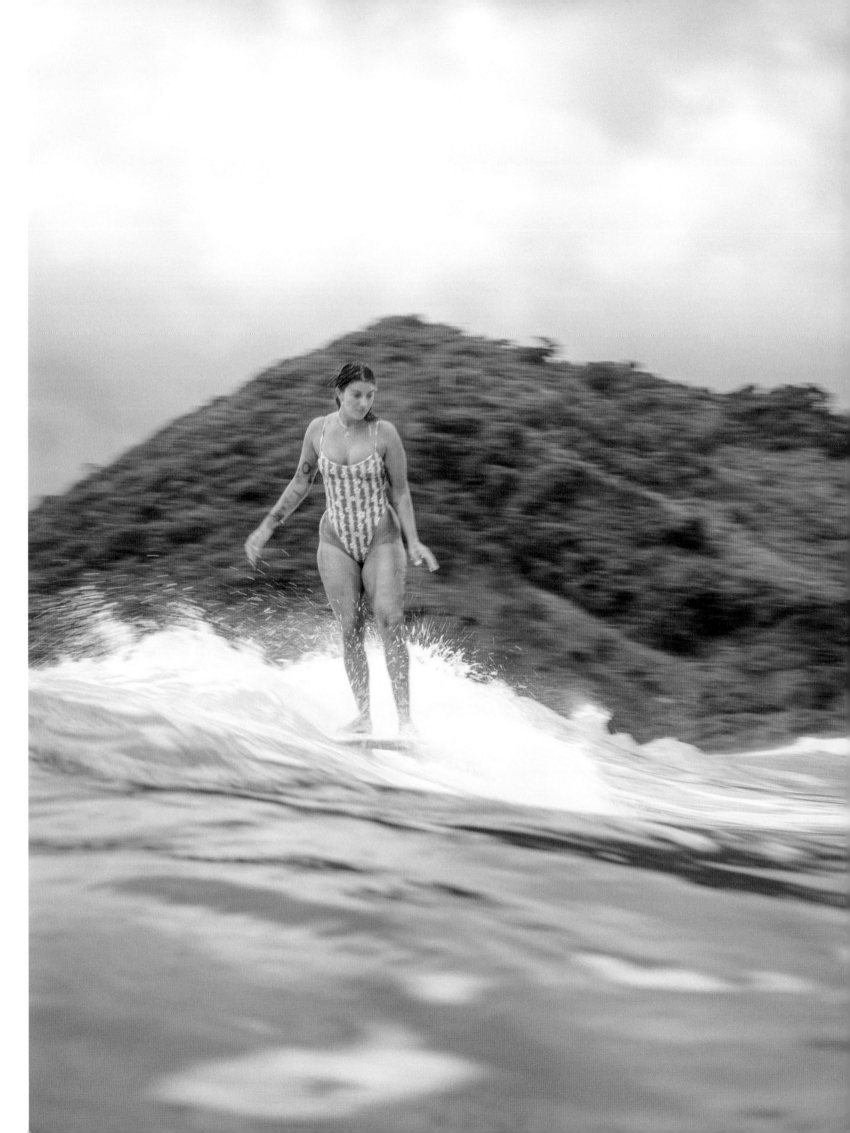

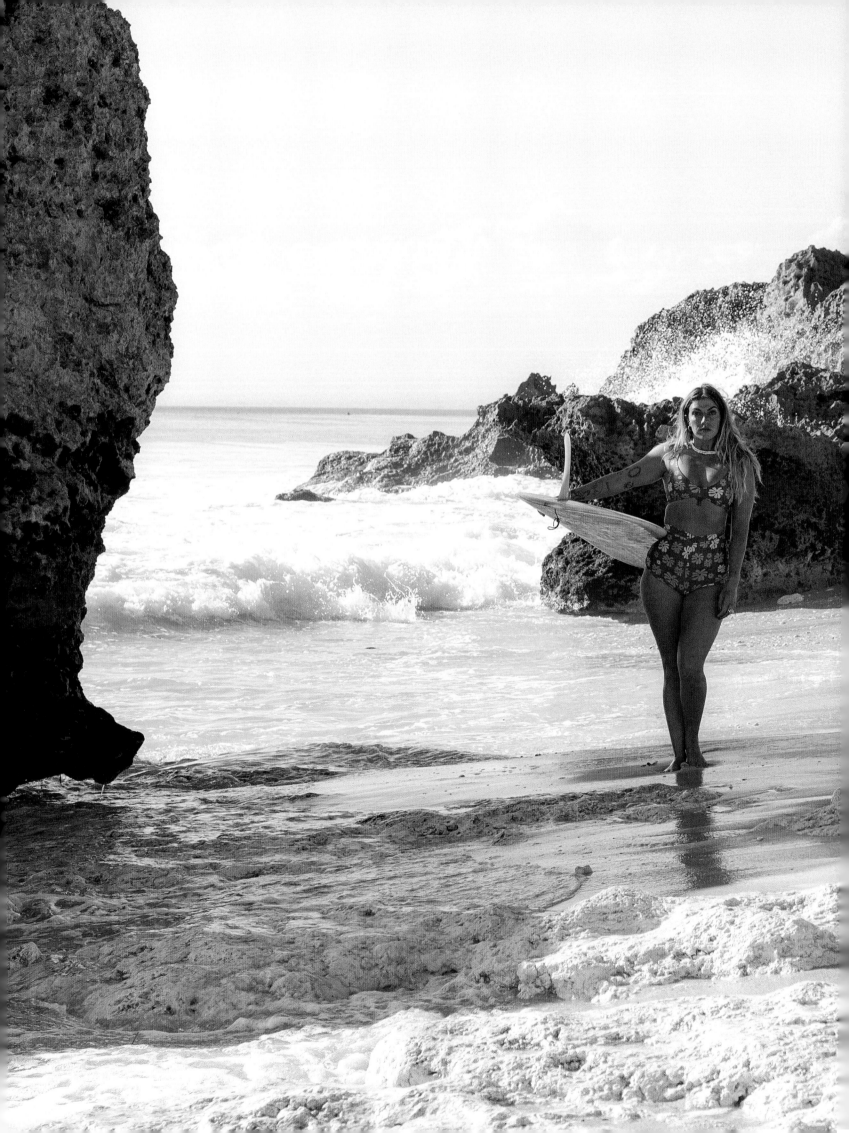

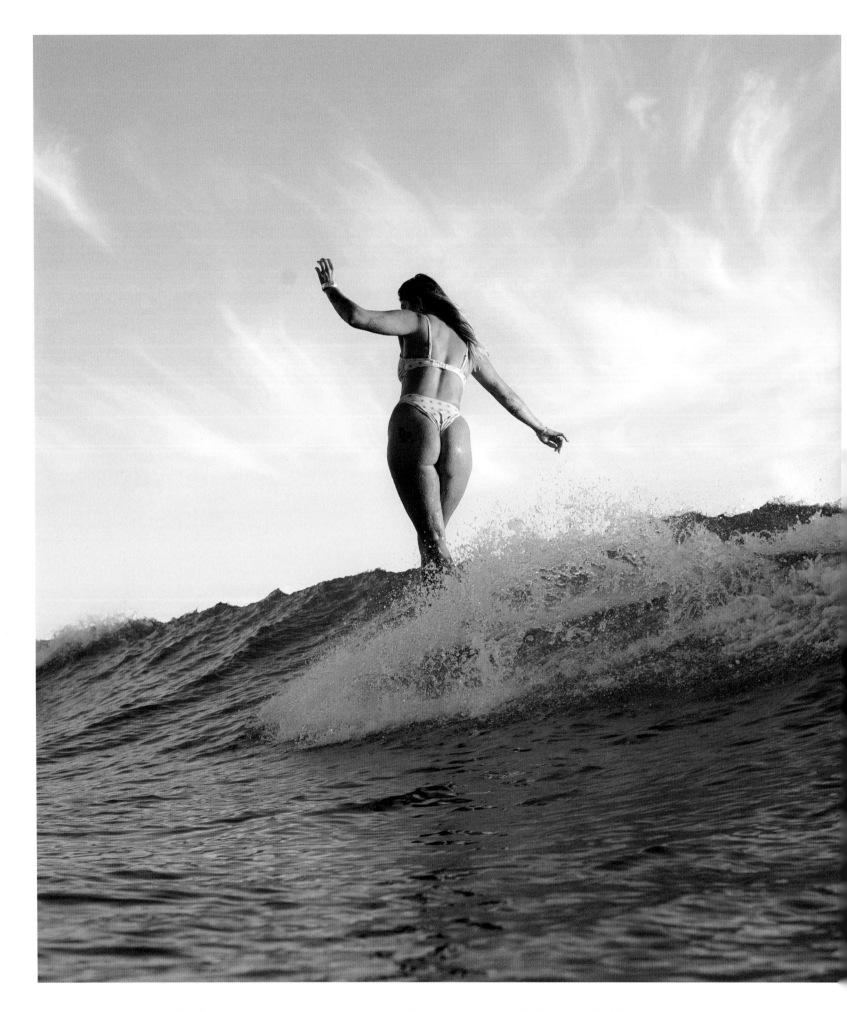

Top A crisp sunrise moment at one of my favorite surf spots at the southern Gold Coast, Australia. | Right A very special day surfing
on the Sunshine Coast with my girls, who I met surfing many years ago. I will never forget this day with the most perfect waves.

38

Other women
are not competition.

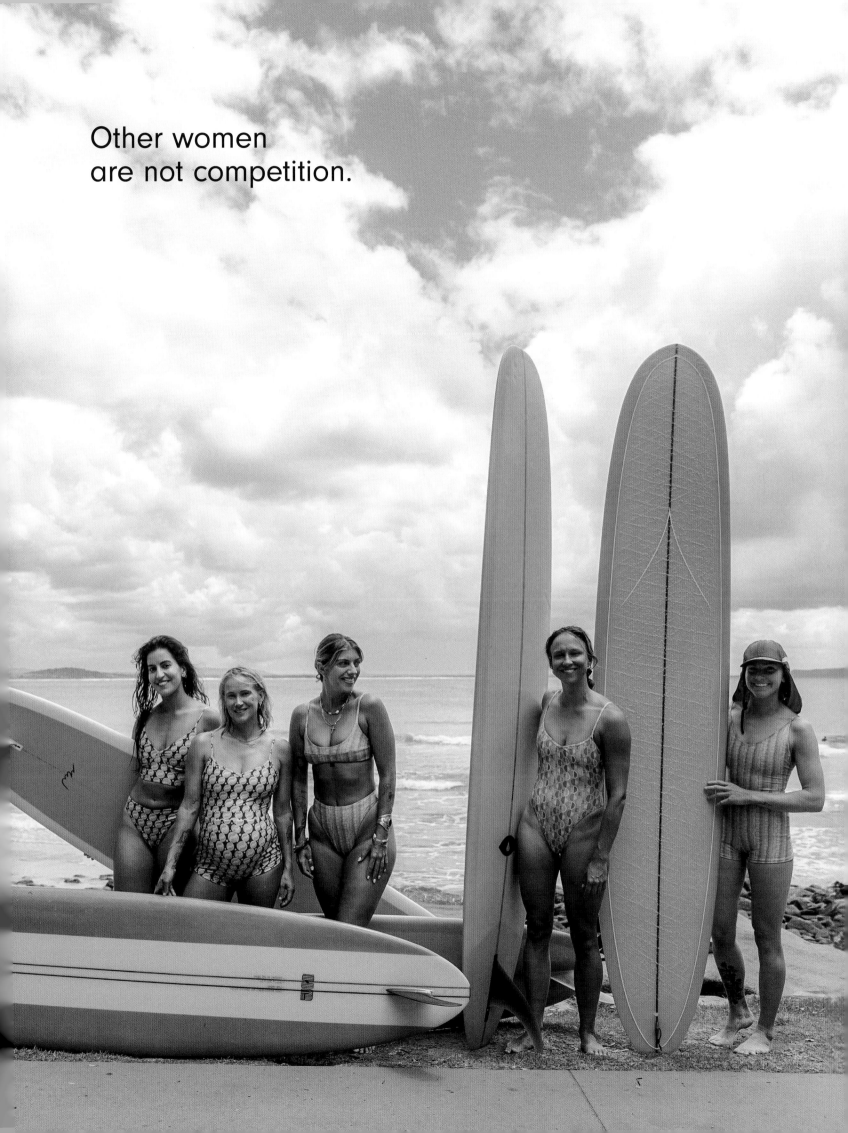

Chelsea Ross

"Surfing has played a significant role in helping me grow into a healthier relationship with myself."

Surfing has been a part of my life for as long as I can remember, and I feel incredibly fortunate to have turned my passion into my life's work as the founder of Surf Goddess Retreats in Bali. My journey to create this beautiful space where women can connect with themselves, their bodies, and each other through surfing, yoga, and wellness practices has been both deeply personal and immensely rewarding. However, my relationship with my body and my self-love journey have not always been smooth sailing. Surfing has played a significant role in helping me grow into a healthier relationship with myself.

I had always wanted to learn to surf but felt there was a barrier because I was a woman, and a woman who didn't fit the bikini-clad surfer girl image. I really had to just let go of my body image and the pressures of fitting into the commercial surf world's standards of what a surfer girl should look like. As a female surfer, I often felt the need to measure up to certain physical ideals, which took a toll on my self-esteem. But the more I immersed myself in the sport, being led by an amazingly grounded female surf mentor, the more I discovered the true essence of surfing: a space to simply have fun and not take myself or life so seriously. Through playing in the waves I got to explore my strengths, and embrace my individual relationship with the ocean.

Surfing taught me to be present, light-hearted, and mindful, which is crucial when you're on the water, working with the power of the waves. As I focused more on the experience of being in the water and less on how I looked in a swimsuit, I began to appreciate my body for its resilience and ability to navigate the ocean. This shift in perspective was liberating, and it marked the beginning of my journey towards self-acceptance and self-love.

Surf like nobody's watching! I always like to play when I surf: trimming the face while throwing up a soul arch fills me with pure joy.

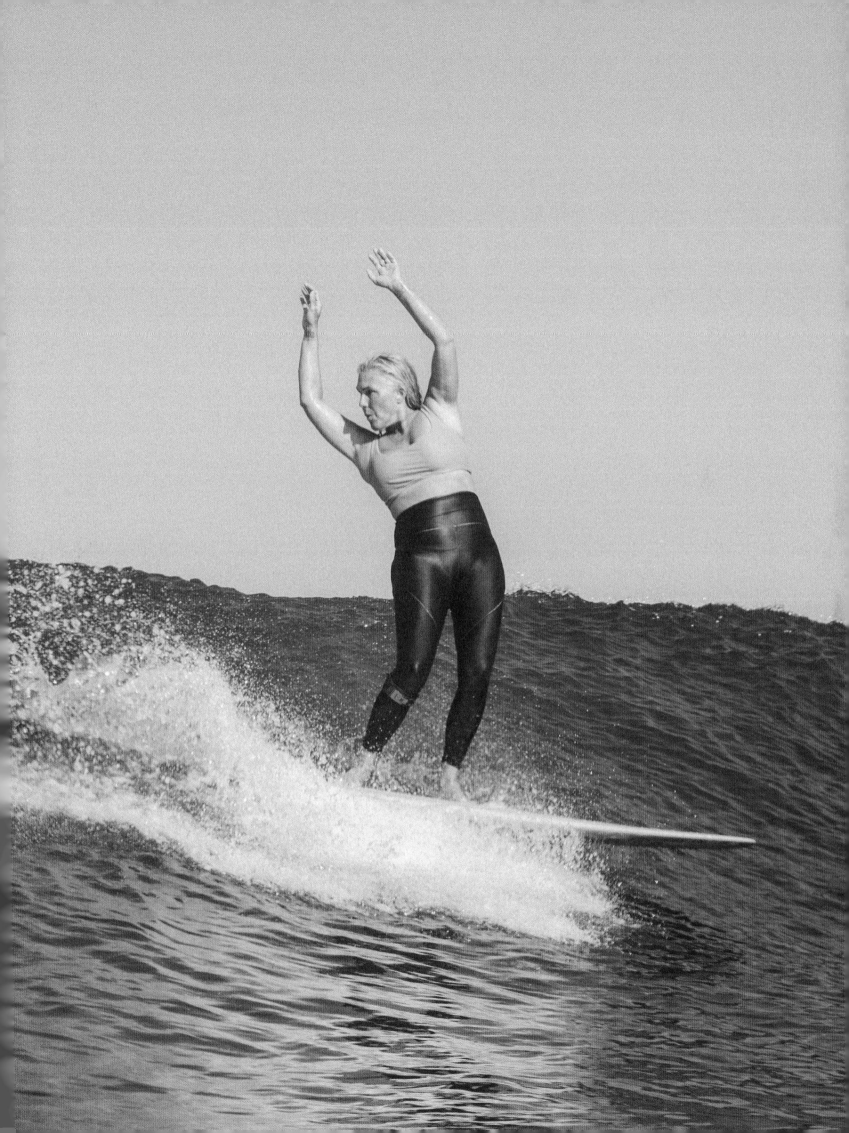

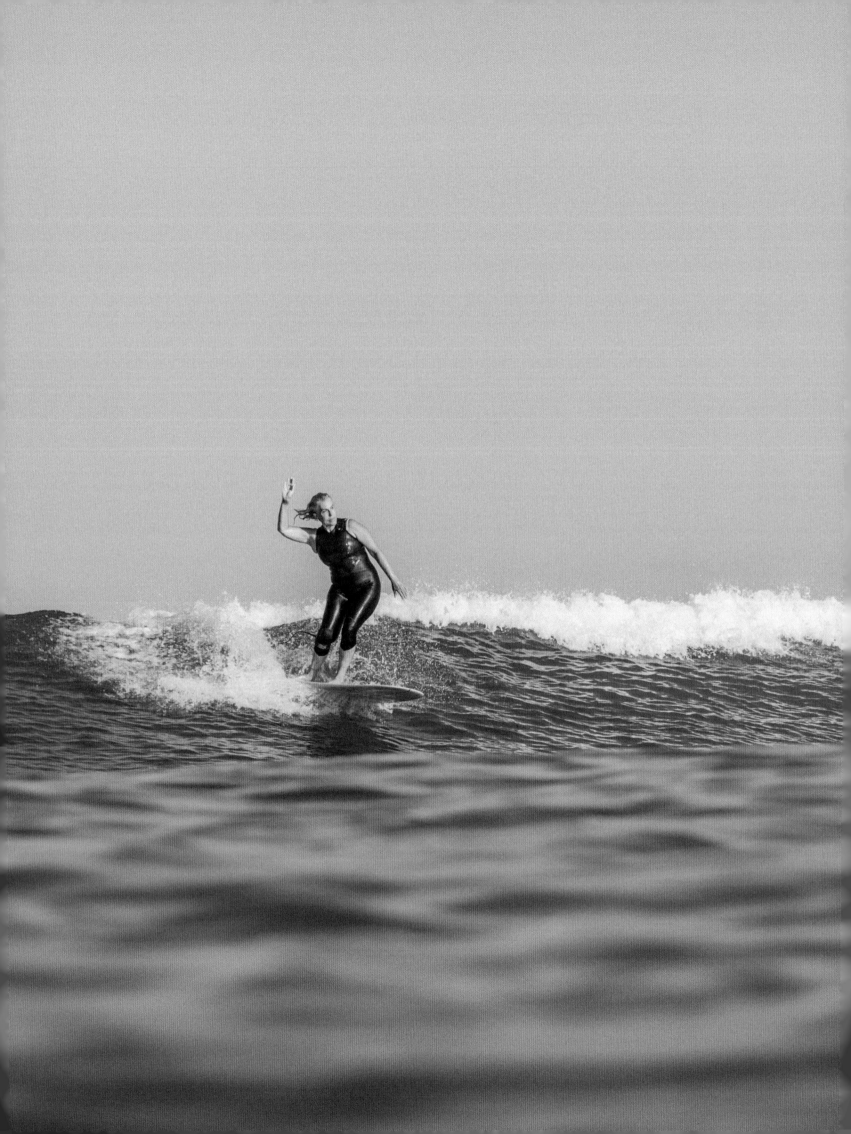

Chelsea Ross

Even though I am not a competition-level surfer and I don't look like the girls in the surf magazines, I didn't let that stop me realizing my dream of starting Surf Goddess Retreats. I just felt the deep need to share the joy of surfing with all women.

The retreats are designed to offer women a safe, nurturing space to discover their inner strength and cultivate a healthier relationship with their bodies. Through the practice of surfing, yoga, meditation, and wellness workshops, I encourage women to connect with themselves on a deeper level and become empowered. What makes surfing with other women truly special is the community we build. Women from all walks of life come together to support one another, share their experiences, and celebrate their achievements. This sense of sisterhood is at the heart of my surfing, and it's a core part of what makes my surf retreat experience so transformative. In the water, we encourage each other to take risks, face our fears, and embrace our strengths.

As I continue surfing with younger and older women, I am constantly inspired by their courage, resilience, and growth. I've seen countless transformations as women overcome their insecurities, embrace their bodies, and find joy in the journey of self-discovery. These moments of empowerment are the reason why I created Surf Goddess Retreat, and they reinforce my belief in the importance of actively creating spaces where women can thrive with each other and within themselves.

Surfing has also taught me the value of balance, both in and out of the water. As a surfer, I've learned to read the ocean, find my rhythm, and adapt to changing conditions. These lessons have translated into other areas of my life, including my approach to self-care and wellness. By learning to become a friend to my body through listening to it and honoring its needs, I've been able to cultivate a healthier relationship with myself and maintain a sense of healthy harmony.

"I've seen countless transformations as women overcome their insecurities, embrace their bodies, and find joy in the journey of self-discovery."

I see waves as my dance partner to explore what rhythm we can share. It's about exploring creative possibilities in that brief and magical moment.

"Something wonderful happens when women surf. We grow more confident in ourselves, we wash away the cares of the world, we see the bigger picture of life and our place in nature."

Chelsea Ross

Living in Bali and surfing its waves has been another key aspect of my journey toward self-love and empowerment. The island's spiritual energy and natural beauty provide a perfect backdrop for the retreats and offer a sense of serenity and inspiration. Bali has taught me to appreciate the interconnectedness of all things and the importance of living in harmony with nature.

Something wonderful happens when women surf. We grow more confident in ourselves, we wash away the cares of the world, we see the bigger picture of life and our place in nature. It gives us an immediate lesson in how to combine both power and surrender, how to go with the flow and smile.

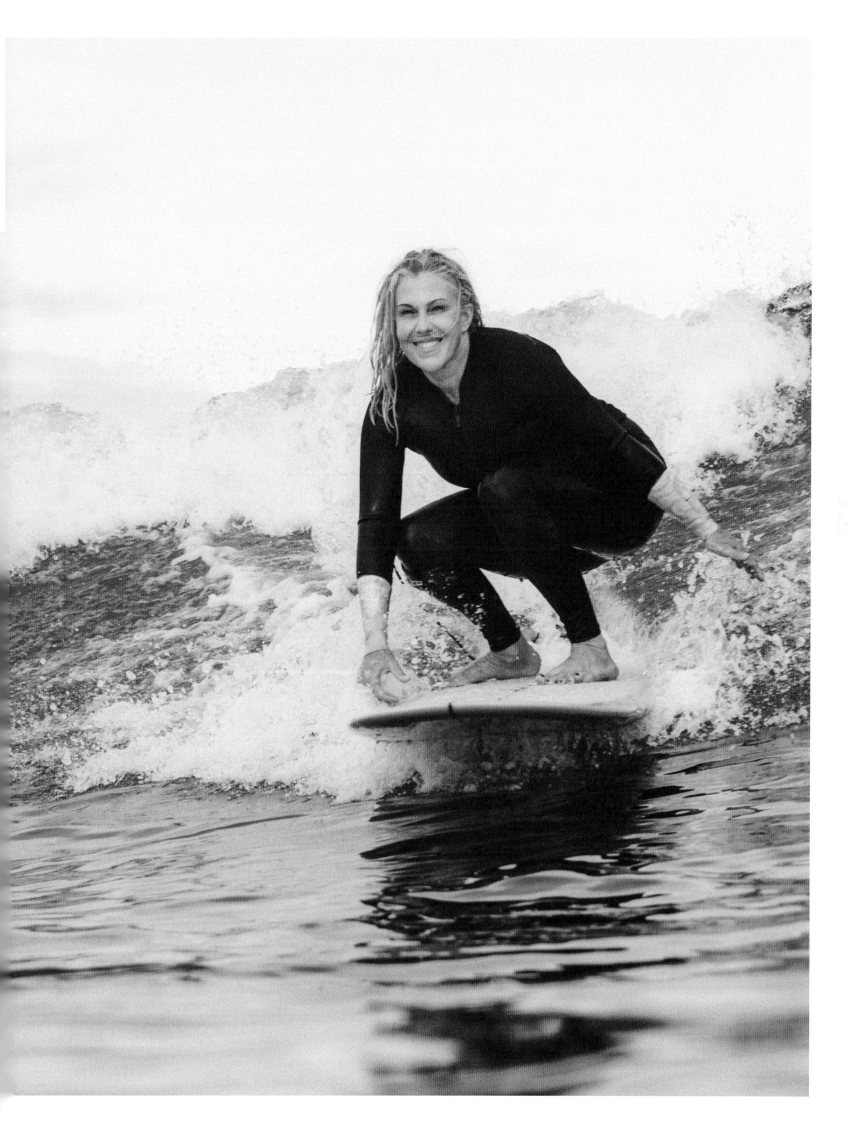

Even if we all ate the same diet
and exercised the same way,
our bodies would still be different!

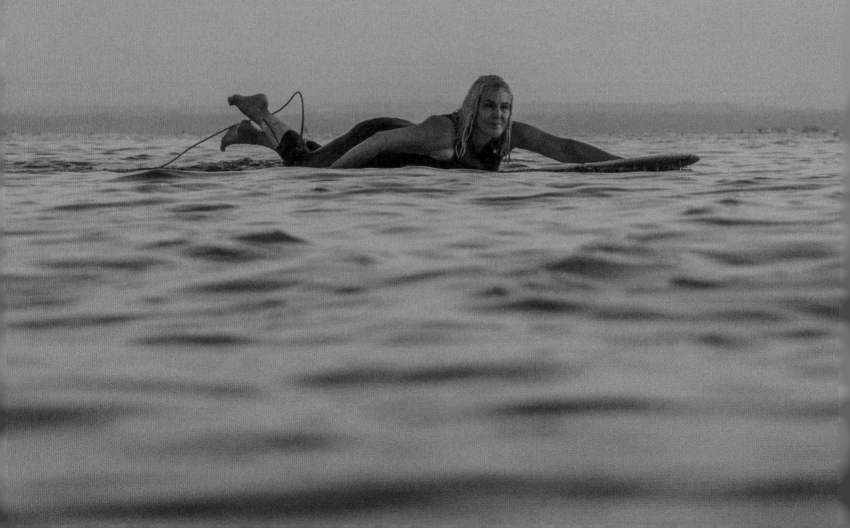

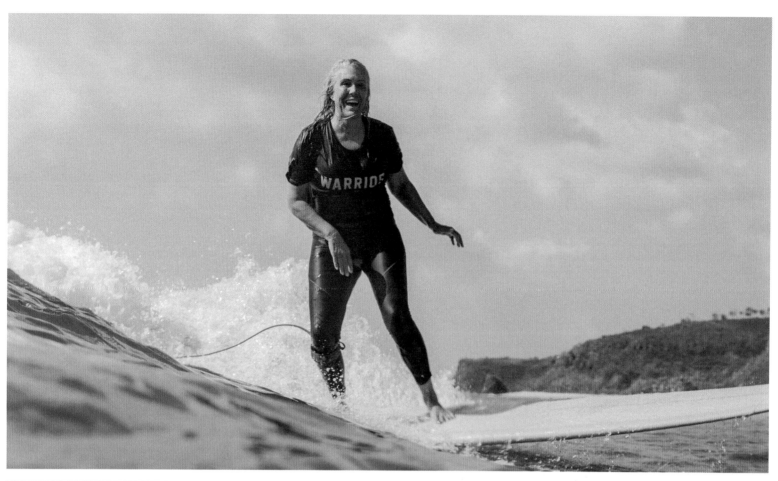

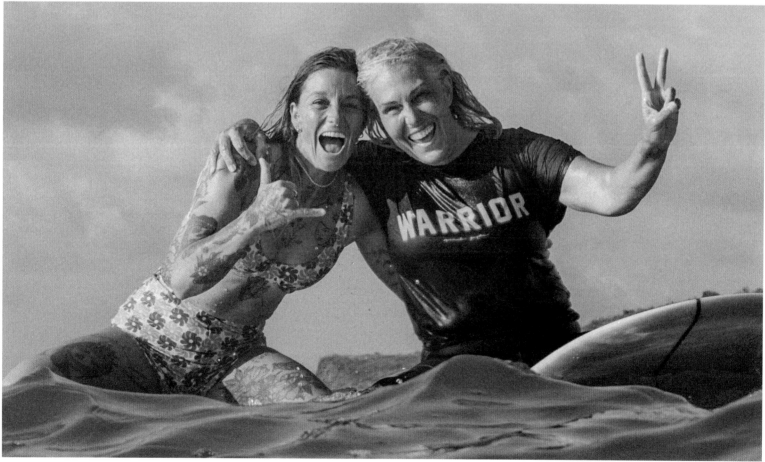

Left Dawn is my favorite time to surf, watching the colors change as the world wakes up. Paddling out, Mount Rinjani, Lombok, Indonesia. | Top Surfing is about having a good time—with the wave, with myself, and with my surf goddess seasters.

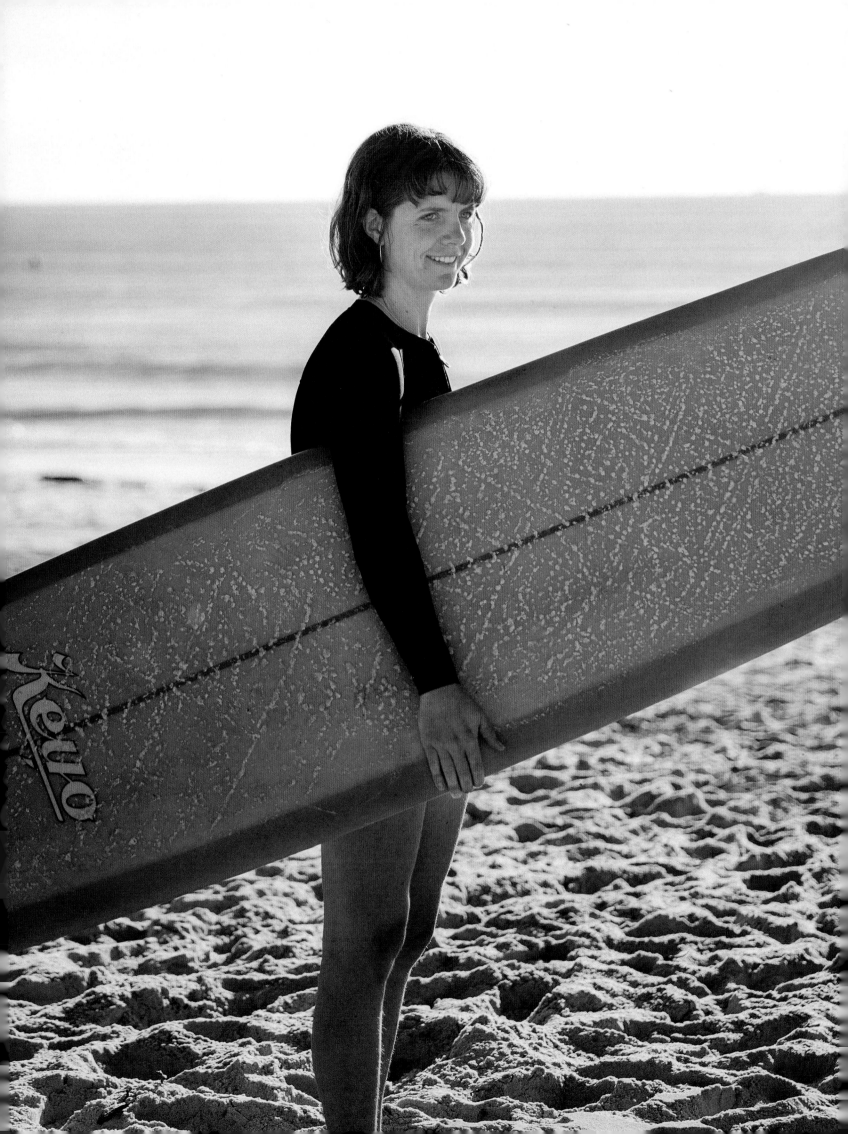

Lucy Small

"As women and girls, often it is how our bodies look and how they make others feel that is attributed value."

In surfing, as in many areas of our societies and communities, no matter how hard we as women and girls train, work, travel, and compete, often it is how our bodies look and how they make others feel that is attributed value. For too long, women surfers have been told that it's sex appeal, not surf appeal, that will allow them to have a career in the surf industry.

Across all sports women face challenges like this. Why are women athletes expected to double as models if they are to gain sponsorship support? In surfing, this has changed bit by bit over the years, thanks to the hard work and efforts of women in the industry who have pushed for their talents and skills to be valued enough to open the doors to a career as an elite athlete.

When I was a teenager I came to understand this through advertising and surf magazines, before social media, where I started to notice that only those who fit within the very narrow confines of traditional beauty standards ever made it onto these kinds of platforms. The bodies that were shown were thin, blonde, and often represented in a hypersexualized way. When I looked at my teenage body in the mirror, that wasn't what I saw. My shoulders had grown wide from hours and hours in the water, my hips were bruised, and my ribs had callouses on them. I was soft around my hips, weight that made me a powerful surfer. I had a normal body, and it could surf. Shouldn't that be enough? Meanwhile, men would get all the glory for pulling into a massive barrel, no matter their body shape.

I was hungry to watch women's surfing at the time. I was in a small town: we didn't have professionals around or an industry to speak of. So we relied on magazines and DVDs, and I got the message loud and clear: women's surfing doesn't matter. There were hardly any women's surf films and hardly

On the beach for the filming of *Below Surface*, a movie about our campaign for gender equality in surfing. Maroubra, Sydney, Australia.

49

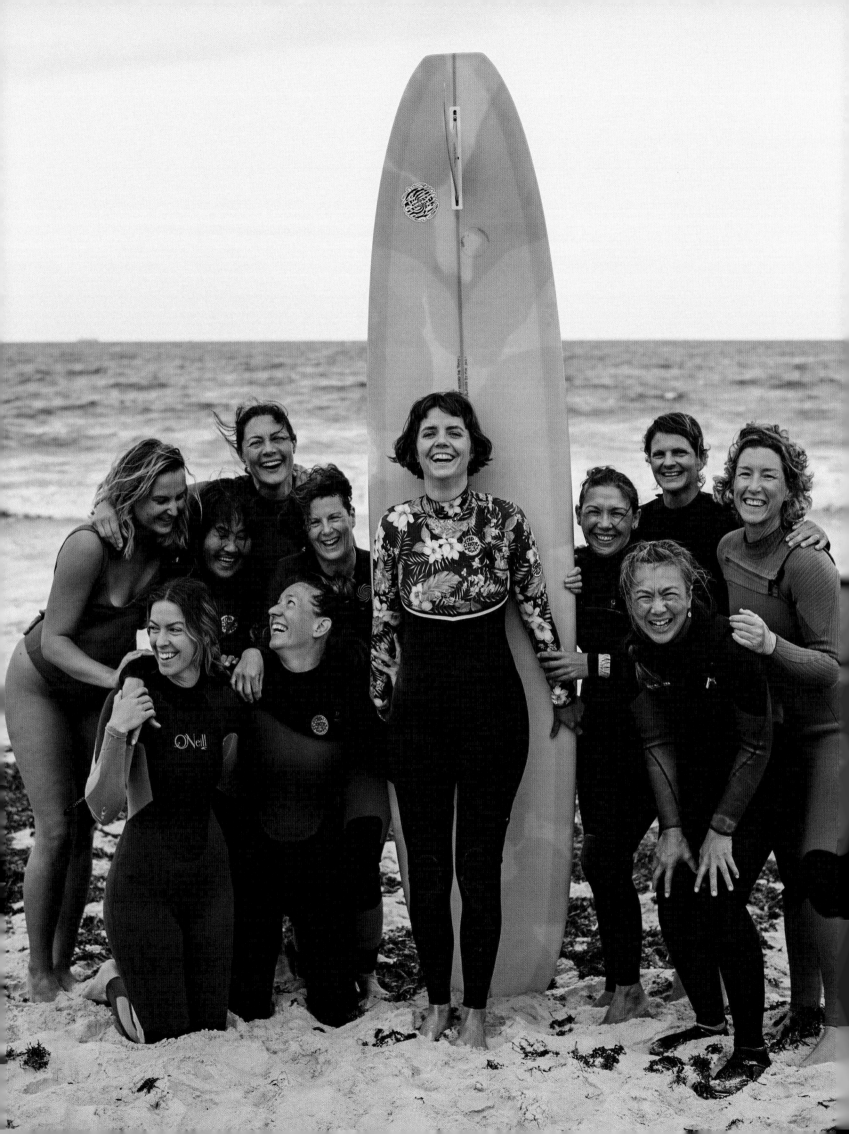

any photos or stories about women surfers in the mags. Often women were shown on the beach in bikinis while men surfed in the background (think that cliché shot of an out-of-focus woman in the foreground and a man in focus on a wave in the background).

When I left my hometown in Western Australia and moved to the surf industry capital of Torquay, Victoria, I noticed the differences even more. The turret of the Rip Curl head office overlooked the main road as you drove in and on one panel was a giant image of three-time World Champion Mick Fanning enveloped in a fan of turquoise blue water as he shot toward the exit of a barrel. When fellow team rider Tyler Wright won her first World Title they added her image to the adjacent panel: a portrait. She looked great and the image wasn't sexualized, but it wasn't surfing.

Over time, women have pushed back and broken down every barrier laid out in front of them. Women's surfing, despite the push toward equality sometimes appearing to be two steps forward and three steps back, has refused to be held back by old stereotypes and tropes. Instead, we have busted through until talent, dedication, and skill are being celebrated and valued.

"It was my body, with its bruised hips and lumpy ribs, funny-looking toes curled over the nose of my board, flying down the line."

When I was a teenager I wanted to see women with normal bodies riding waves in magazines as a sign that one day, I too could be in magazines riding waves with my normal body. When I say normal body I mean just a body, whatever shape or color it might be and with all the signs of damage from long days in the sun and in the water. Fifteen years later, I got my first magazine cover. It was an iconic Australian masthead called *Tracks* that I used to read every month as a teenager, when I wished there were more photos of women. The photographer was female, and it was the first time two women had teamed up for the cover in the magazine's 50-year history. It was my body, with its bruised hips and lumpy ribs, funny-looking toes curled over the nose of my board, flying down the line. All those years of wishing to see myself in magazines and there I was, on the cover.

Back in my home state of Western Australia with a group of dedicated Perth surfers. The waves were absolutely awful, but we got out there to play together and then had a warm coffee in the midwinter cold. This kind of community in surfing brings me so much joy. Next double page (left top) Surfing the Pacific Ocean Swells in the Galapagos Islands during the filming of Ceibo, a surf documentary about women's leadership in Ecuador. The waves were big and we were regularly joined by sea lions and other beautiful creatures in the lineup. (Left bottom) On the coast of Ghana filming our women's surf movie Yama. (Right) Locked in the nose in Noosa. I am always so grateful and impressed that my body somehow knows how to do this!

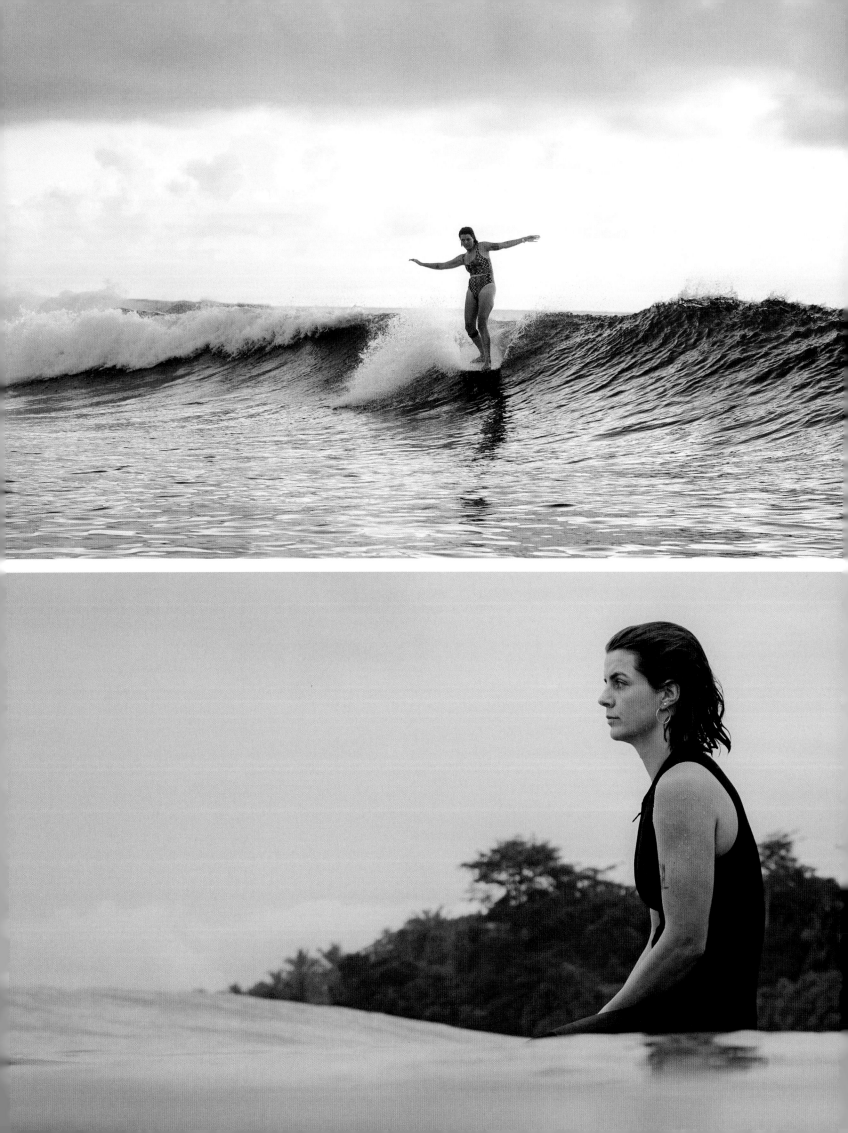

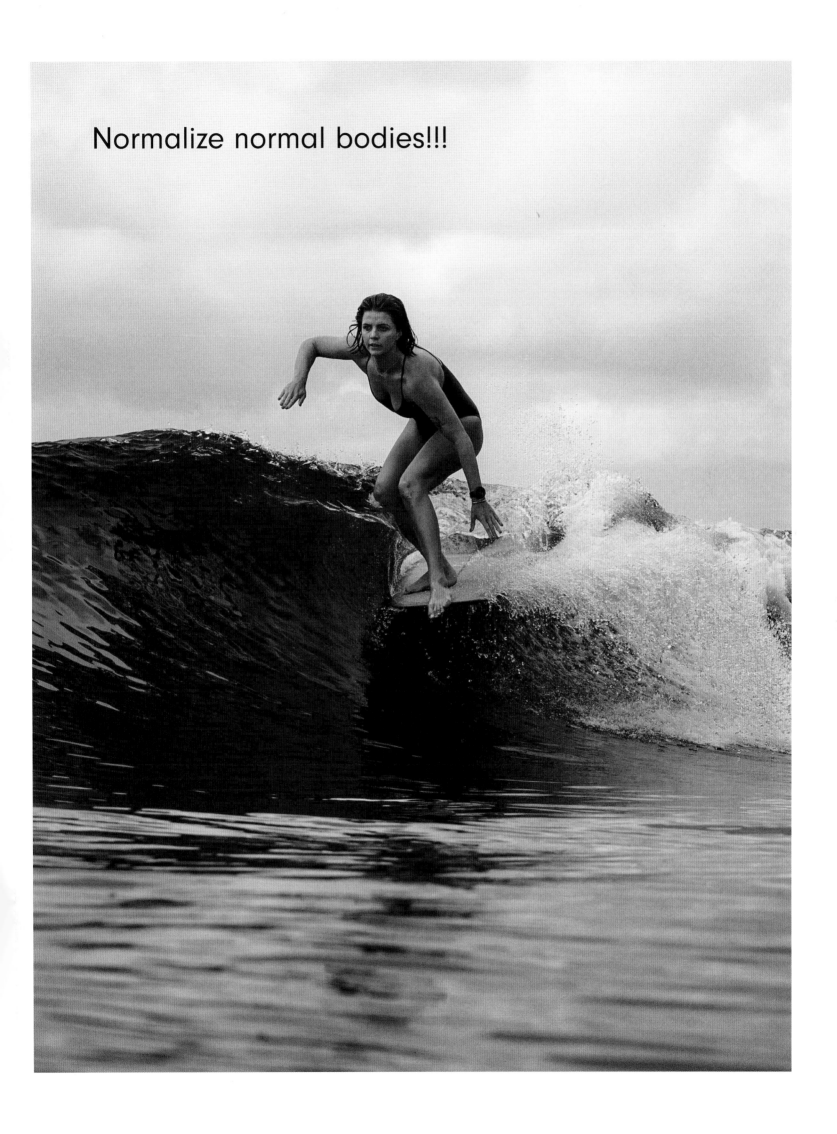

Normalize normal bodies!!!

Amy Rose Hewton

"I love my thick thighs. I love my bright eyes. I love that I am not what They want."

My body surfs, and she loves it.

Disclaimer: she loves it until I surf for days in a row, hours on end, and then I can't move my neck ... so to yoga I flow, and like the transmutable caterpillar, I transform from concrete into butter, and fly.

My body, she's dealt with many pains, some deeper and longer lasting than others. Some entangled like fishing line, netted around a turtle that flails to keep afloat. But afloat she is, and here she stands, taller than ever. A smile brimming from ear to ear. Bursting with such radiant joy that even a blind man could see the golden hues her smile emits. Because this smile embodies suffering, a comeback, and a life to be lived in unconditional LOVE.

I coined a phrase: "Conditional love is basically hate." I believe this to be a truth. There is no loving expressed in "If only I was ..." statements. Loving is in the now and in every aspect of this divine being I imbue.

Love is unconditional. I love my pinky toes that don't touch the ground. I love my double cowlick that is impossible to pin down (insert PJ Harvey's "Who The Fuck?" song here in my head, "I'm not like other girls, You can't straighten my curls ..."). I love my thick thighs. I love my bright eyes. I love that I am not what They want.

I do not meet any beauty standard. I am shorter than some and taller than others, living in the middle ground where neither the top nor the bottom shelf are in range. I'm a curly-haired wildling, speckled with freckles and scars, with tan lines and strong body. A body so strong that one day a guy I was making out with commented (don't let the question mark fool you, it was a comment disguised as a question), "Are you an arm wrestler?" To which my

I met Mark, who took this photo, at a McTavish garage sale. He loves to shoot old cars and my baby Lucille, an Austin 1800, was parked out front. Atlantic, Byron Bay.

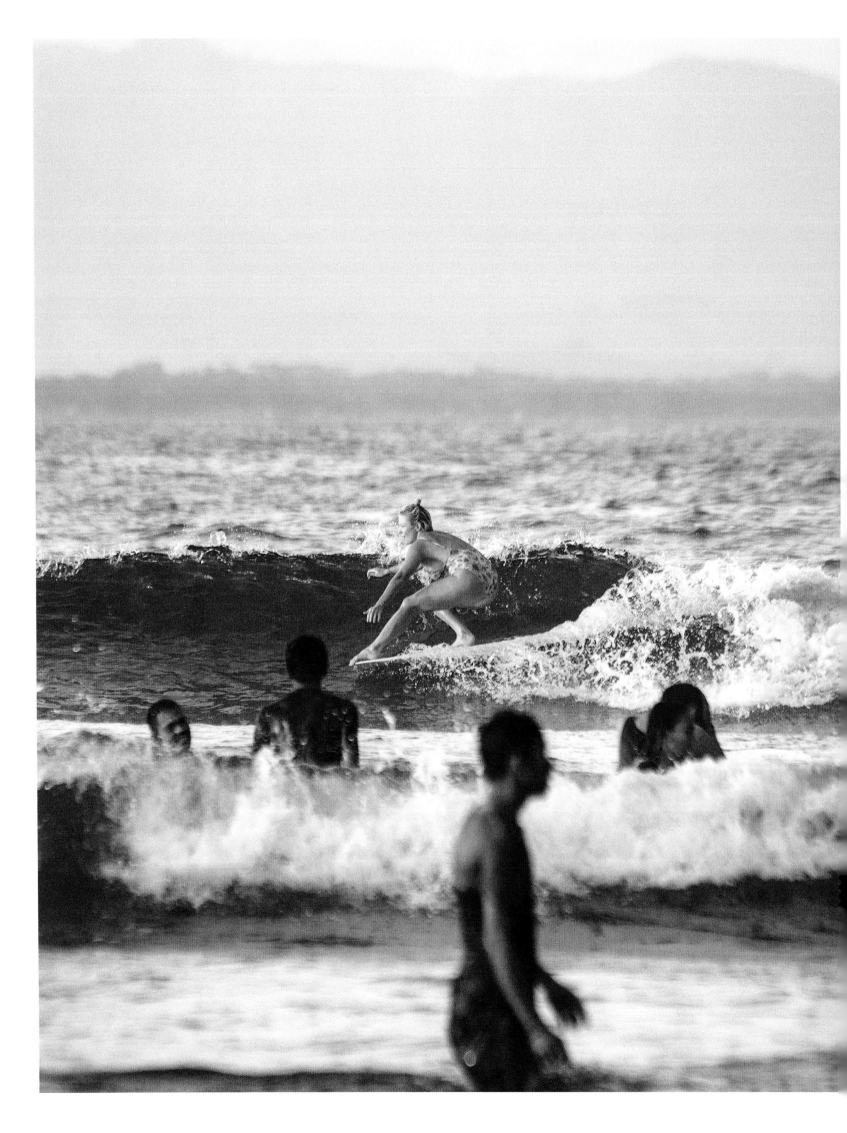

Amy Rose Hewton

response was one of utter confusion followed by a giggling fit, and then smugness, knowing that, yes, I could probably have beaten him in an arm wrestle. I love my strong body.

I have never wanted to be pigeonholed, and fitting in has never been on my agenda. I fought tooth and nail against the psychological warfare waged against me and my body by a duplicitous society that told me I could be whatever I wanted to be as long as I was beautiful. Like all wars, the fight took its toll and left me scarred. By 16 years of age I was in the grip of anorexia and bulimia, which I would both cling to and rage against for another 10 years.

Comparison is the thief of joy. Comparison drained the joy from my existence because I was not like Her. Who was She? She was someone I could never be. Someone with a completely different genetic makeup to myself.

She was placed on an impossibly high pedestal by society, and She was all I saw in magazines and on TV. She was modelling surf wear but she wasn't a surfer. Why? (Don't let the question mark fool you—this is a comment disguised as a question.) How do we learn to see love and value in ourselves when we are not represented faithfully by the communities in which we exist? How do we stop the addictive mutilation of our bodies—the sense of control we feel through torturing ourselves with eating disorders, surgeries, and plucking out eyebrows?

"I fought tooth and nail against the psychological warfare waged against me and my body by a duplicitous society that told me I could be whatever I wanted to be as long as I was beautiful."

When the focus is perpetually on how women look, it negates all the other marvelously intrinsic parts of ourselves that are divine, and we are reduced to a mere object—a still life (like that model holding a surfboard instead of surfing). I often wonder what would happen if women stopped (which we have the power to) being the pawns in this game of superficial beauty and eternal youth. What would we be able to achieve, having disentangled ourselves from the fishing line? The things we achieve even now are remarkable, but the feats we can achieve once we free ourselves from this trap are revolutionary.

Looking at today's world, where 60-year-olds aspire to look younger than 25-year-olds, I am perplexed at how we moved from the burning of our bras to the cryogenic freezing of our thighs. Yes, the burning of bras was symbolic

This was a standard day when I lived in Java. Many Jakarta locals would travel by bus to come and swim here, while we surfed out back.

Amy Rose Hewton

of a woman's right to think for herself and have agency over her own body, and to make choices that shape her own vision of the future. And I concede that I am being judgmental here to suggest that the choice to look younger is a symptom of self-hate or worthlessness. Years of therapy and other self realization avenues have helped me to see that the hate I had for myself (more pointedly, for my body) was actually the hate I had for the version of myself that society demanded of me; the version that didn't celebrate the parts of myself that I loved, like my intelligence or my surfing ability. To this day, I wear the scars of the war waged against my body.

I love being in my scarred body. She has taken me all around the world, won arm wrestles, and achieved remarkable feats.

So I dare you to love yourself: it's good for your health (and the revolution).

Top Clem wanted to take some more stylistic and art-directed photos, so I obliged, and this was the result, amazing sunrays bursting through me at Wategos Beach, Byron Bay. | Right I met Alissa, who took this photo, up in Noosa. Her passion for photography is matched by mine for surfing. The Pass, Byron Bay. | Next double page I love this photo: that walk across the sand before entering the ocean is sacred for me. Belongil Beach, Byron Bay.

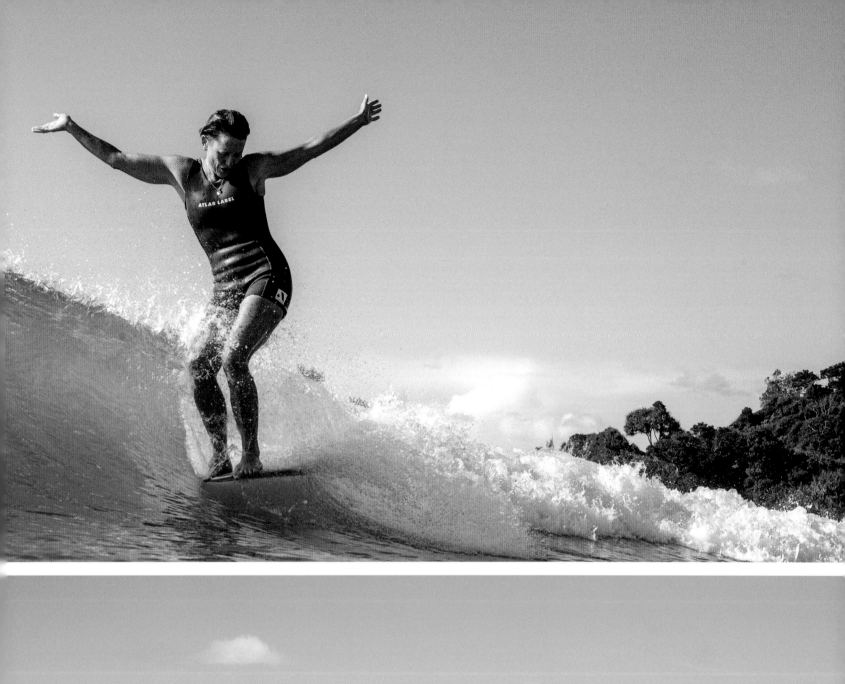
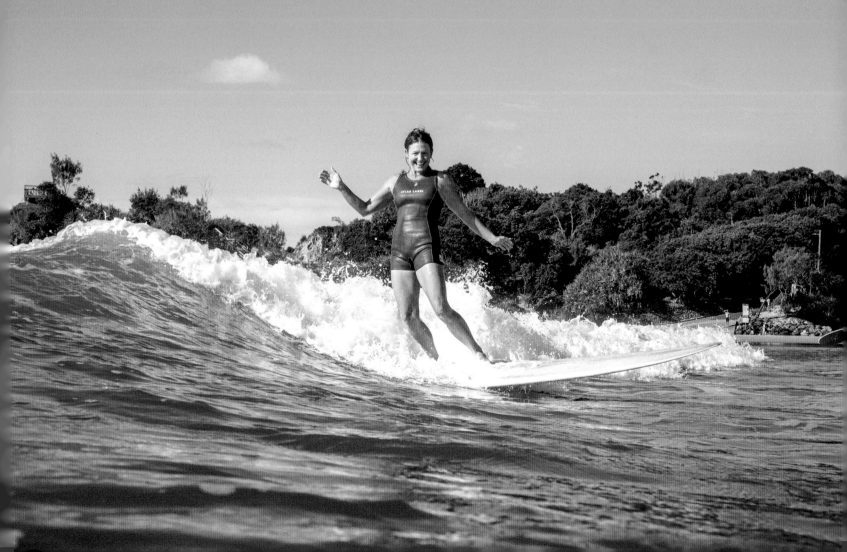

Loving yourself
is the greatest revolution.

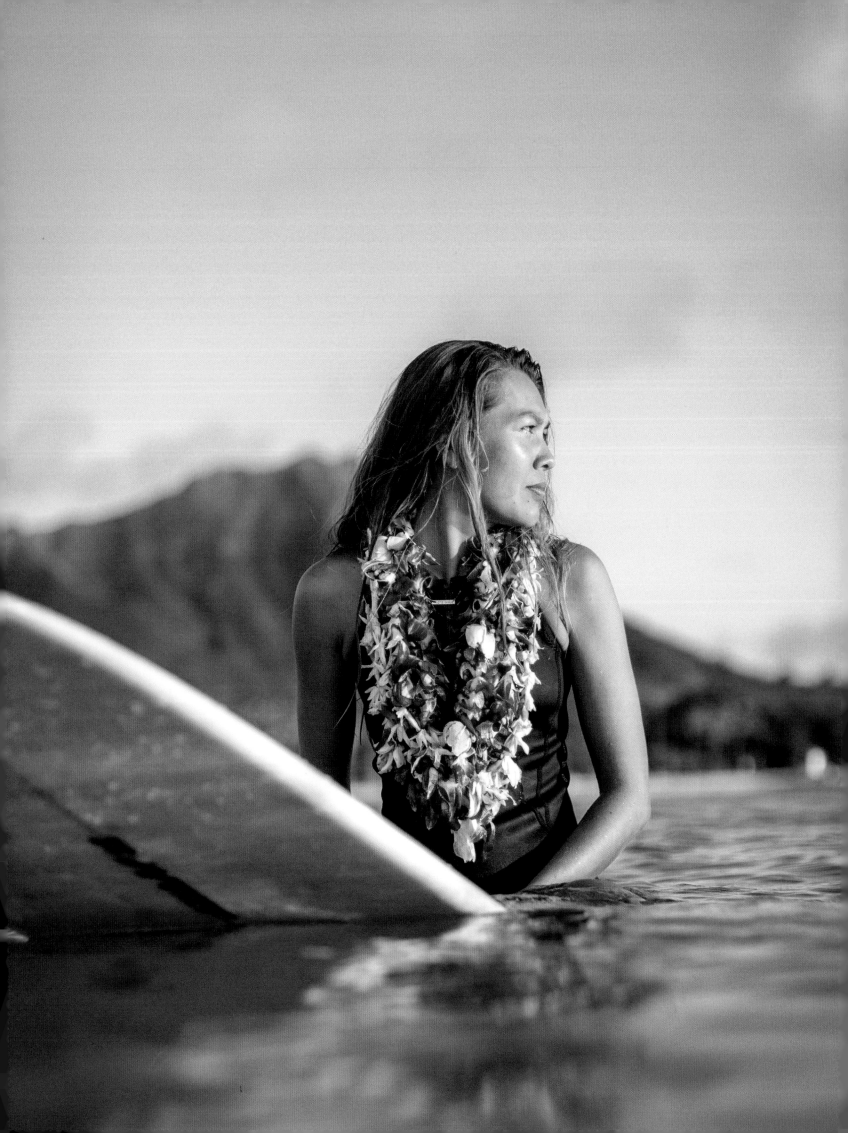

Asia Brynne

"The lineup was a place to laugh with friends and strangers alike. I've always loved the saying, 'The best surfer out there is the one having the most fun.'"

When you think of the word "surfer," what comes to mind? If you grew up like myself, looking at all the top surf magazines, the first thing that might pop into your head would be a tan guy with sun-bleached hair and a six-pack. And to be honest, if you're watching the surfers at world-famous spots, like Pipeline or Jaws, quite a few of them fit that stereotype. Those surfers train constantly to keep themselves in tip-top shape to face life-and-death situations. However, they're only a very small percentage of surfers on the planet.

Growing up longboarding in Hawaii, I've viewed the word "surfer" a little differently. The lineups I would paddle out to were made up of a variety of men and women from every background, age, and ethnicity. They included older retirees, who we lovingly call "Uncles" and "Aunties," young kids, who we call "groms," and everyone in between. Being a surfer was never a persona to fit or an identity to cling to. Surfing was just a way of life—a way of enjoying the ocean and spending time away from the cares on land. The lineup was a place to laugh with friends and strangers alike. I've always loved the saying, "The best surfer out there is the one having the most fun."

As I embarked on my journey as a water photographer, I was drawn to capturing the raw beauty of both people and the ocean, attempting to encapsulate a small part of someone's essence into a single image. Those moments usually came when I was snapping photos of friends playing in the water, rather than in a confined studio.

However, as I developed my career and began doing commercial photography, I began to look for beauty as it's defined by the common beauty standards of the fashion industry. Not only did it include shooting models that looked a certain way, but editing to make everyone look flawless— removing any stretch marks, shrinking down curves, smoothing skin, etc. This eventually leaked into my personal life. As I received photos from other photographers of myself surfing and swimming, I would notice so-called "imperfections" and would want to edit them away before sharing.

Waikiki, Hawaii.

Asia Brynne

If you asked any woman what they thought was wrong with their body, I'm sure they could come up with a list of flaws. At least, I know I could, because it's easy to self-criticize. But the fact that we each have a different shape and size showcases that we aren't clones of each other, but rather that we're each unique, with our own curves and lines. How boring would it be if we all looked the same?

In the past few years, there's been a shift in the marketing world to a celebration of the diversity of the human form, which has been delightful to witness. I've done numerous surf shoots recently for different brands that have showcased an array of beauties. These campaigns reminded me that surfing isn't just for the fit professionals that are pushing their limits, but for every person that craves gliding along that glassy wall of water.

What should matter far more than what you look like in the surf is understanding the different moods of the ocean, treating others in the lineup with respect, knowing surf etiquette, and letting yourself enjoy being present in the moment. When you let go of others' perceptions and embrace the activity itself, it's a feeling like no other. Sometimes the waves give a gentle push that soothes the soul and sometimes it's a fierce pull that makes the heart race. And that's what surfing is all about.

"When you let go of others' perceptions and embrace the activity itself, it's a feeling like no other."

When you think of the word "surfer," I hope you think of someone who plays with the ocean and appreciates nature. Someone who is addicted to that feeling of riding a wave. A person who cares more about finding that next swell than fitting a stereotype. And if this describes you, I hope that when you read the word "surfer," you think of yourself.

Shaina Bachstein, Oahu, Hawaii.

64

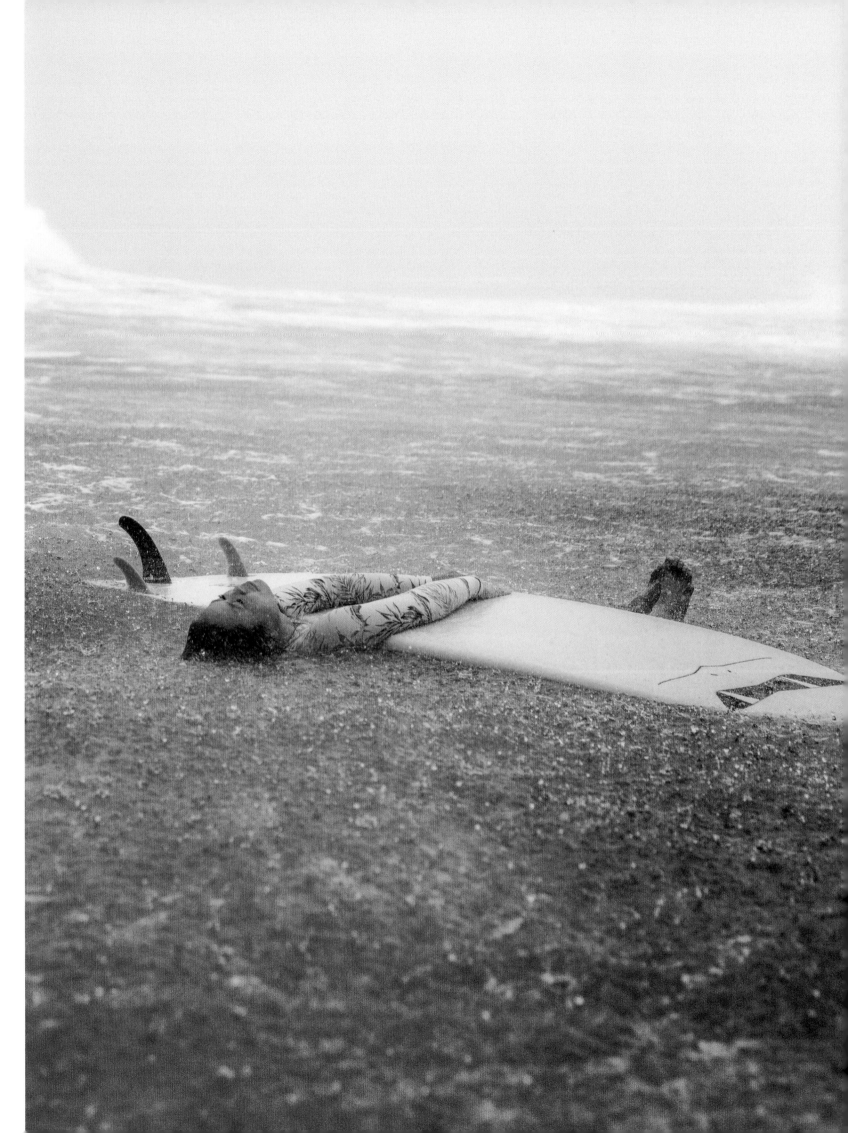

Beauty is an attitude.

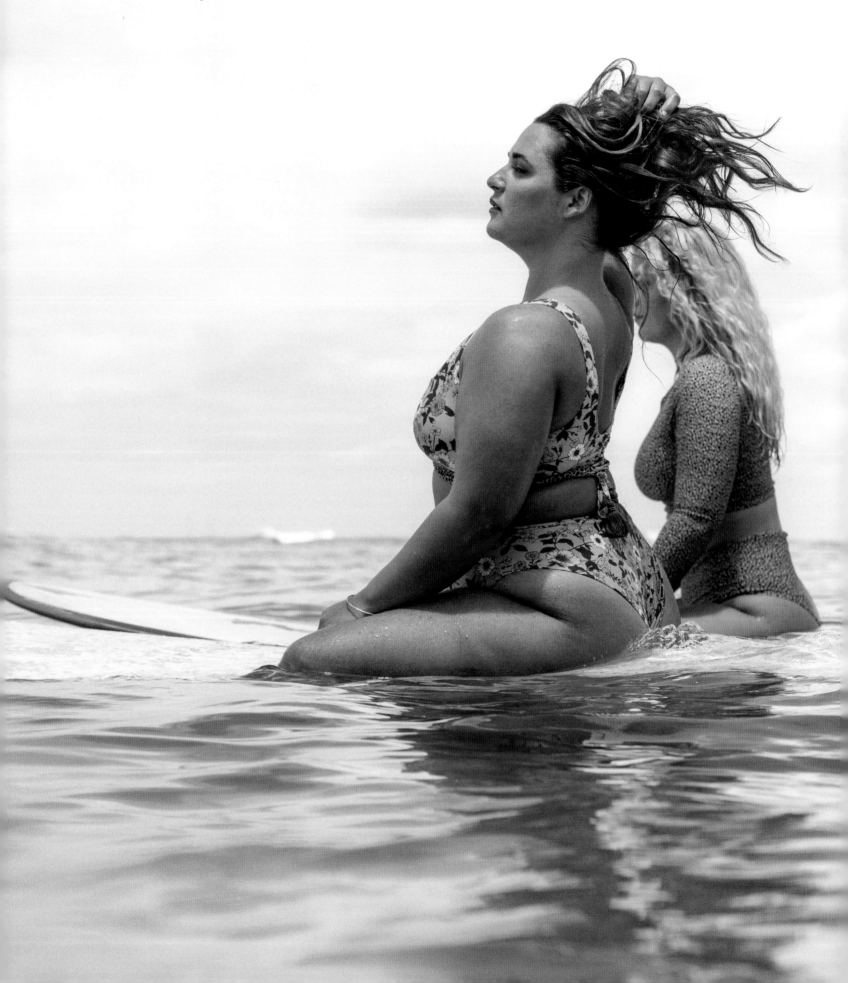

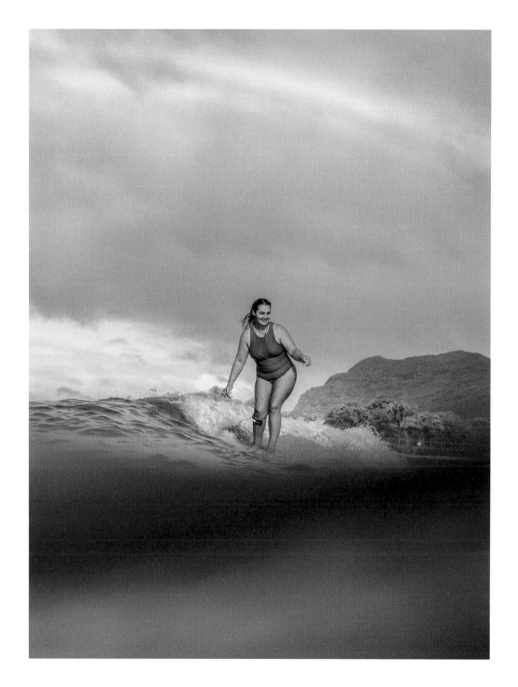

Left Elizabeth Sneed, Waikiki, Hawaii. | Top Elizabeth Sneed, Oahu, Hawaii.

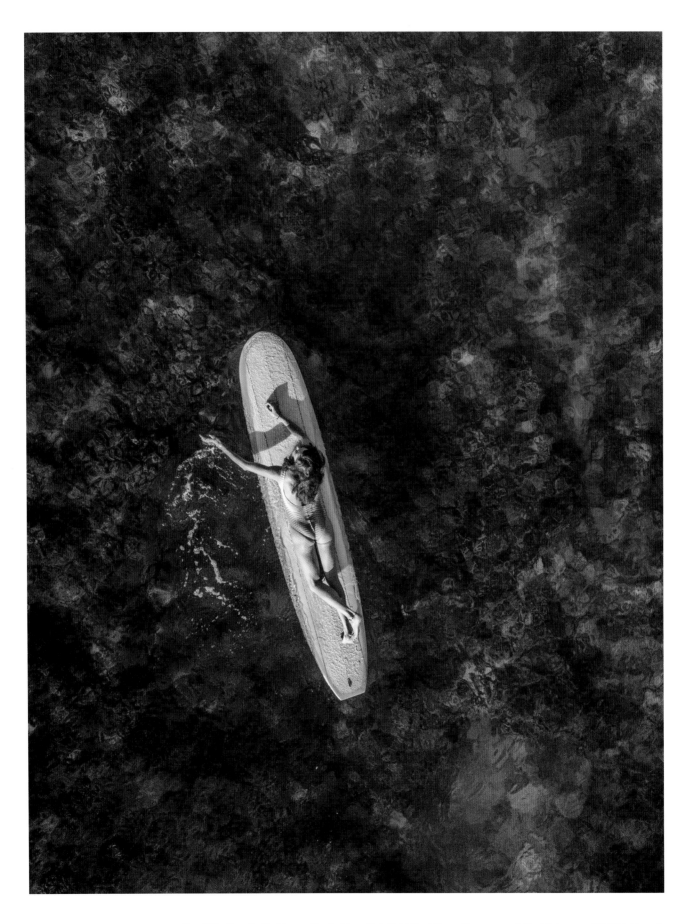

Top Billie Farrell, Ala Moana Bowls, Hawaii. | Right (top) Dana Hamann and Dani Johansen, Waikiki, Hawaii.
(Bottom) Shaina Bachstein, Dana Hamann, and friends, Oahu, Hawaii.

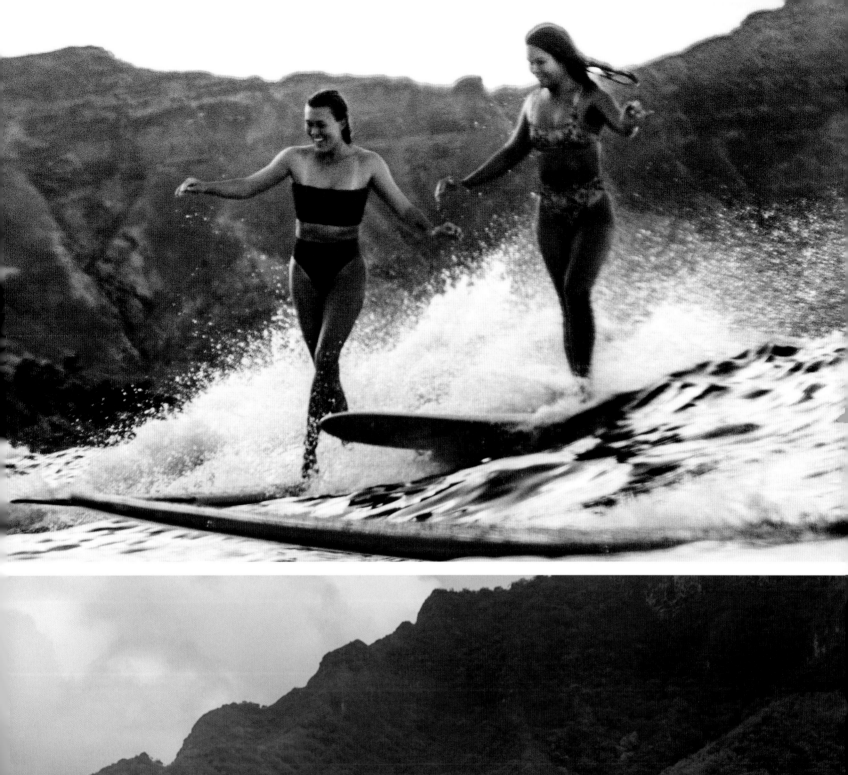
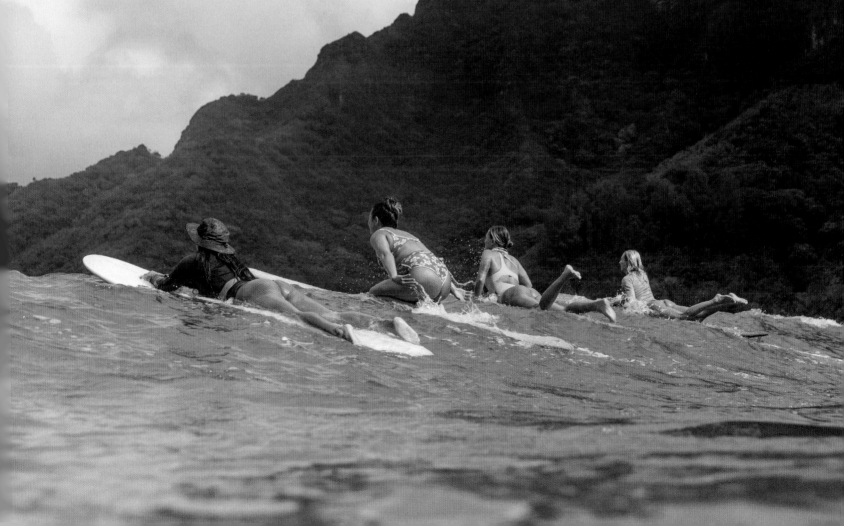

R.I.P. body shaming.

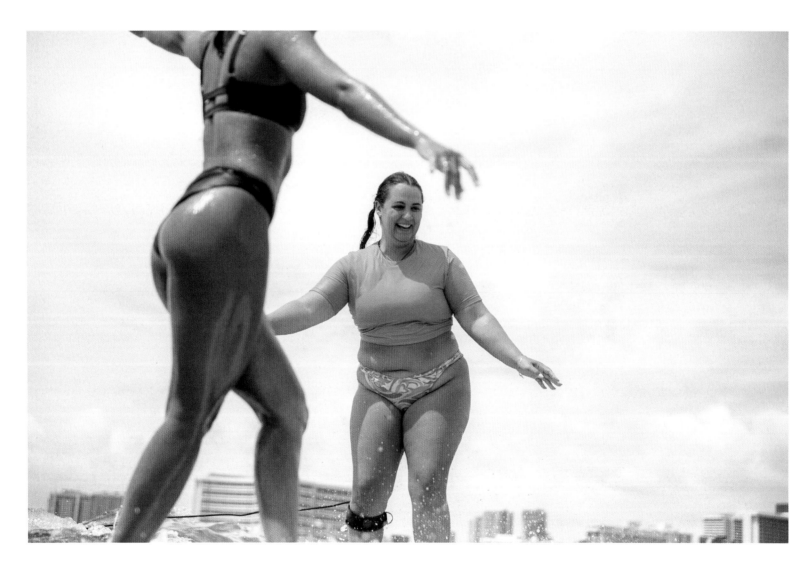

Elizabeth Sneed and friends, Waikiki, Hawaii. | Next double page Asia Brynne, Oahu, Hawaii.

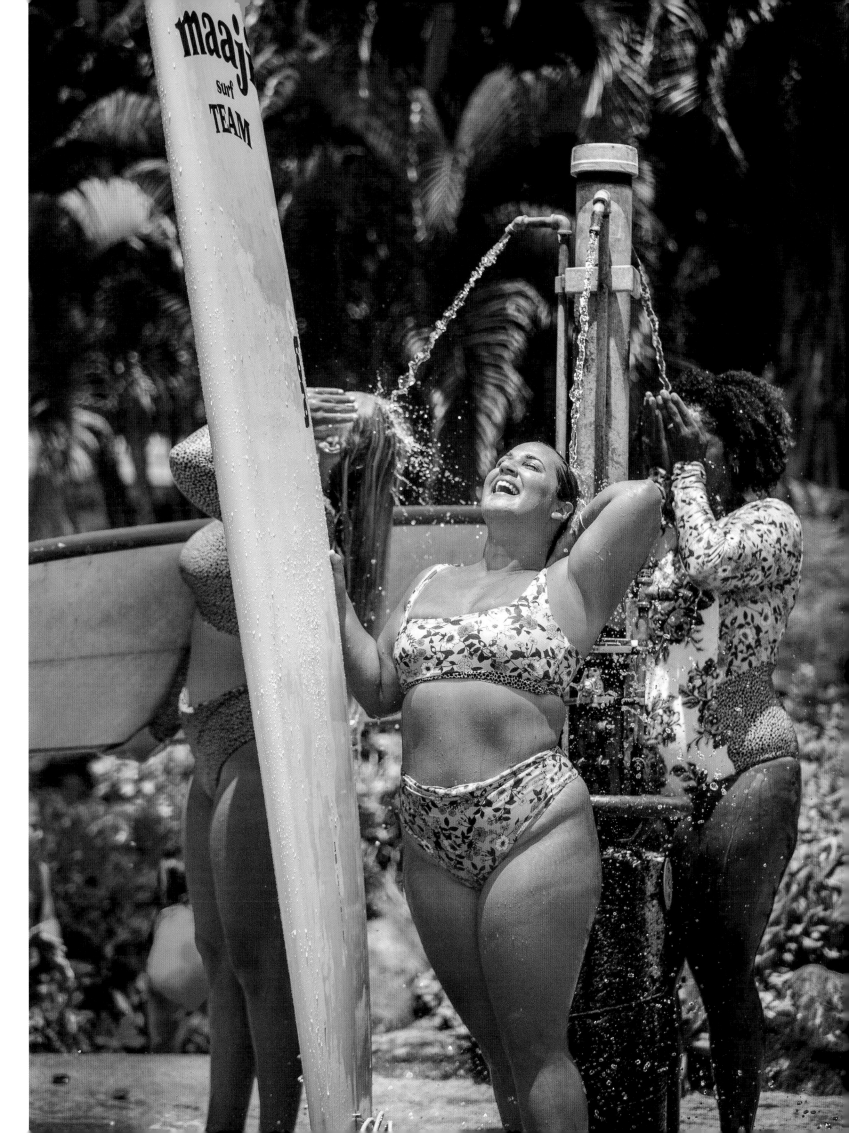

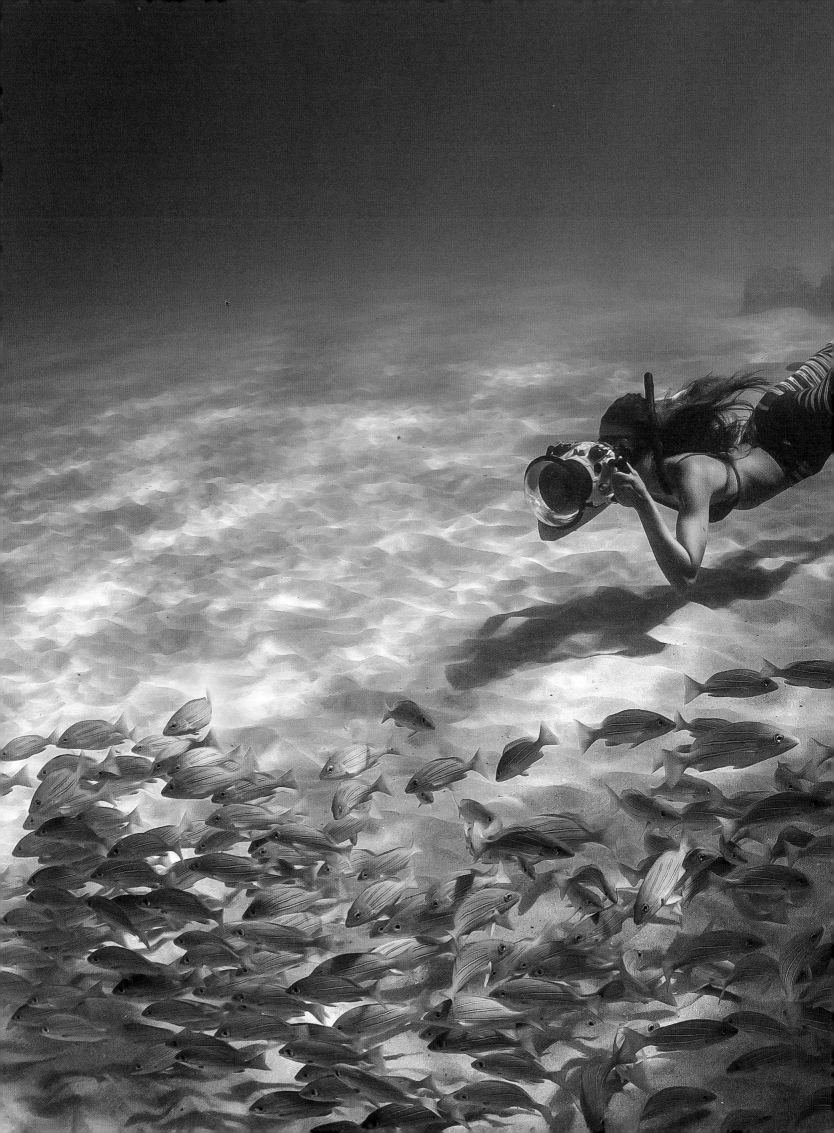

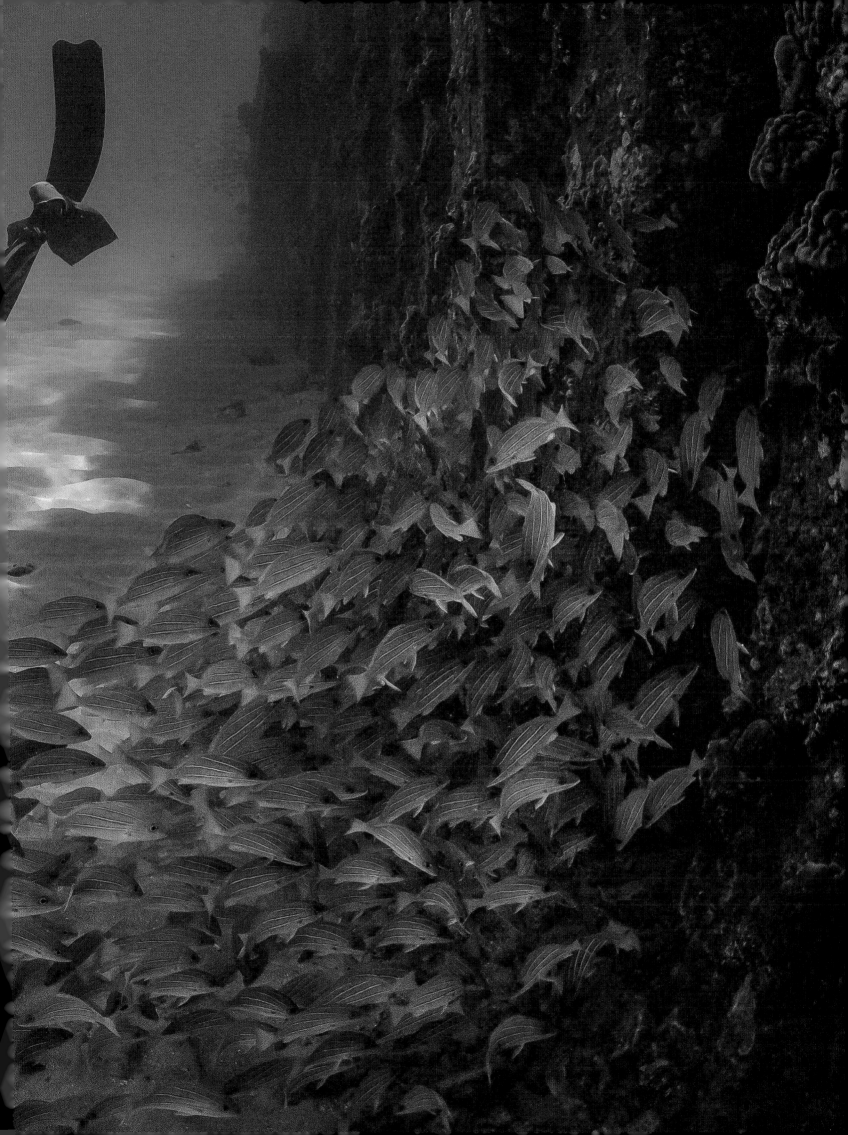

Suelen Naraísa

"My body has always been outside the norm."

I am a physical educator by training and a surfer by nature! I was born in Ubatuba, the capital of surfing, and was raised surfing on its waves since the age of eight, motivated by my older brother.

At just 10 years old, I was diagnosed with cancer and had to stay out of the water for a long time. With the support of my family, I won this painful battle and at the first opportunity, I returned to surfing. At 26 years old, I held the title of two-time Brazilian surfing champion and ranked second among Brazilian women in the world surfing rankings.

My body has always been outside the norm and surfing has shown me that no matter what people say or believe, only you know what's good for you and where you can go! The proof of this is the recognition I've received within the sport.

I think that women surfers have been leading a change for a few years now, and the stereotypes of perfect bodies have been mixed with natural ones. Even big brands have joined forces to encourage hiring women with normal bodies in the world of sports, and I believe that this initiative has helped to change the concept of body perfection.

Since I was little, I was taught to do my best, no matter what. I believe that I have contributed to a change in consciousness, too. I have always been a great athlete and completely outside the body standards that surfing showed in media.

Looking at myself in the mirror every day and affirming the woman I have become, being physically active to keep my mind and body energized (besides surfing, I love to dance), and being grateful and enjoying what life

Maldives.

74

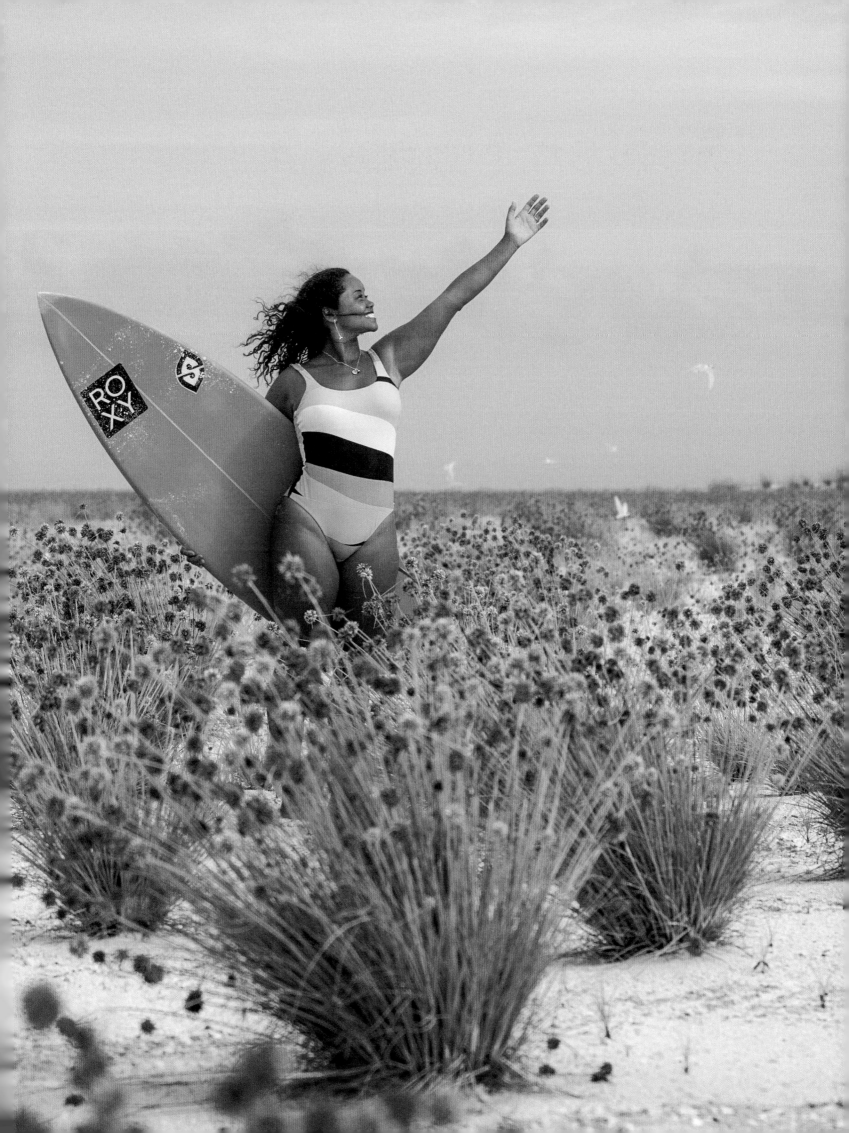

Suelen Naraísa

gives me are my ways of practicing self-love. I respect myself above all else. I have always pursued my dreams and done what makes me happy, which has resulted in me achieving great things. My conclusion is that the only person who can set my limits is me.

Sport is certainly something that motivates me to always be better physically and mentally. But photography is also something that freed me a lot. I feel fulfilled being photographed. I like the details and marks it provides, so I recognize myself and accept every detail of my body.

After becoming Brazilian surfing champion twice, I realized that I had a new mission, a great challenge: to provide as many people as possible with the inexplicable sensation of "flying over the water," of gliding on a wave. In 2005, at the age of 21, I created my own surf school in Ubatuba, on Praia de Itamambuca. It's considered the best beach for surfing in Ubatuba, with waves for all surfing levels, from beginners to professionals.

"I feel fulfilled being photographed. I like the details and marks it provides, so I recognize myself and accept every detail of my body."

In addition to surfing classes in Ubatuba, I participate in and organize several surfing events aimed at women. These provide incredible experiences, self-knowledge, increased self-esteem, integration with other women and nature, learning how to surf and much more.

Praia do Félix, Ubatuba, Brazil.

My body is perfect
just the way it is.

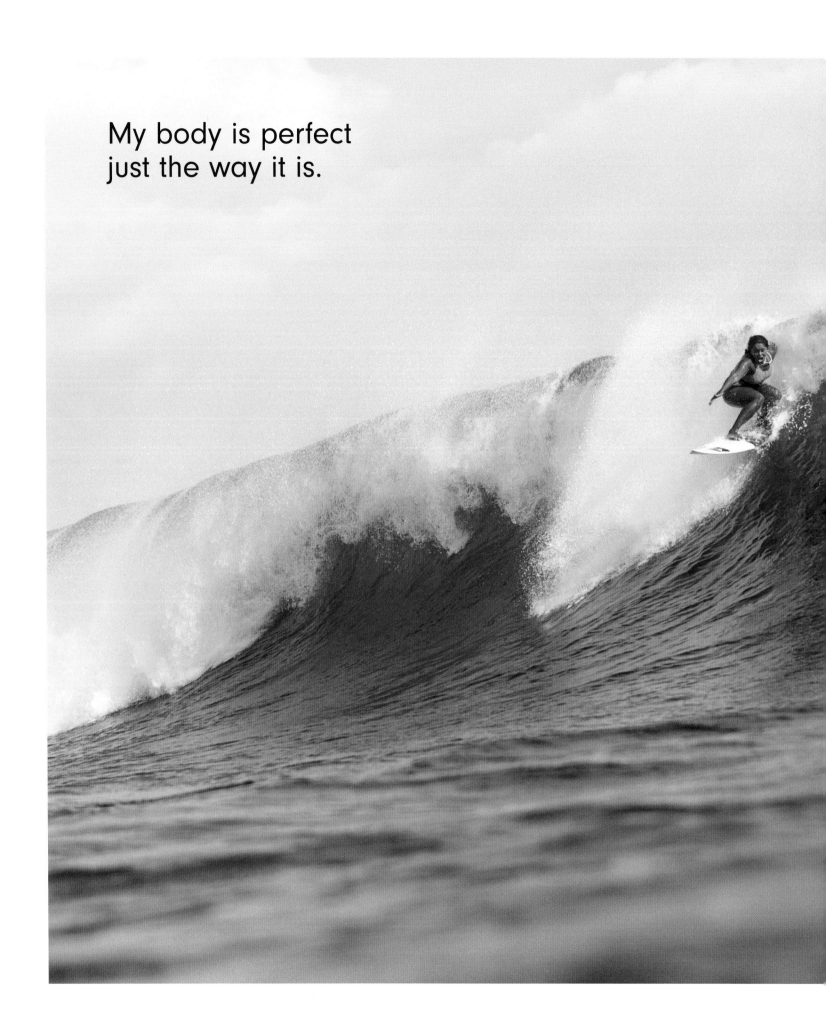

Chikens, Maldives.

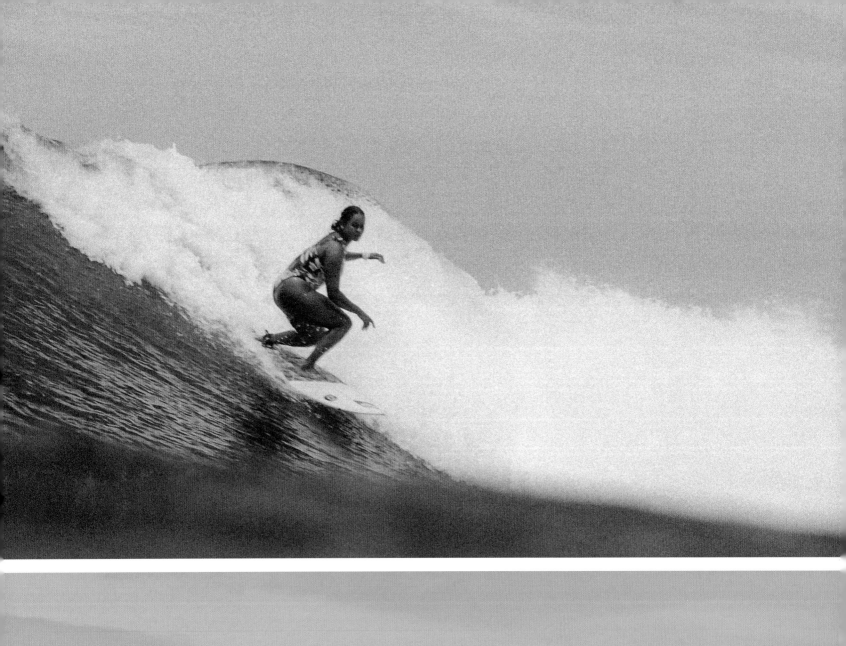

Left Sultans, Maldives. | Top Camburi, São Sebastião, Brazil.

Body size doesn't determine surfing ability.

Top Praia de Itamambuca, Ubatuba, Brazil. | Right Praia do Felix, Ubatuba, Brazil.

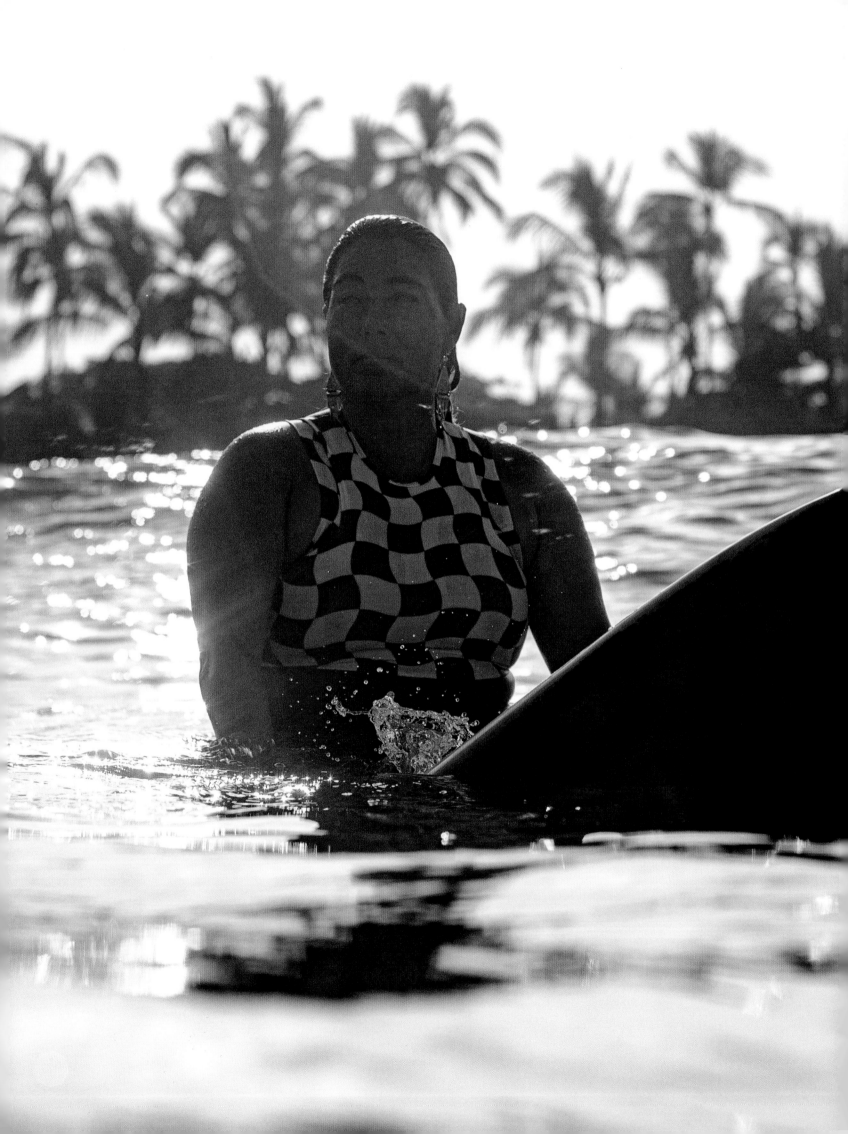

Risa Mara Machuca

"It's so important for women of all ages, shapes, and sizes to stop asking for permission."

The impact of beauty standards affects our existence in every way. From the moment you wake up and look in the mirror to the moment you close your eyes—and even when you dream. Social media has only amplified this.

Personally, I think beauty is relative, like all things in life, and we're each on our own path. Right now, at this stage of my life, I'd say I'm creating my own standard. But when I feel the beauty pressures, I remember that we are all unique and that our bodies carry our journeys.

Most of us are not sufficiently aware of unattainable standards; we don't realize that they are impossible to achieve and impossible to maintain. Like all people, I have my insecurities and I've struggled sometimes with my self-image. The best way for me to deal with them is to acknowledge them and maintain a positive attitude. Exposing myself to different cultures, traveling, and embracing different ways of life have gradually changed my perspective.

I've learned to love my body and I know I'll always have to work on it. Knee replacements are in my future due to high-school sports injuries and more, but I know that the human body needs to keep moving. It's in my nature anyway, I'm a shaker and a groover ;) I feel stronger as I age, even if my body feels the injuries. Knowing what I want and don't want is easy now and I'm grateful to have grown up when I did. I feel like the negative comments don't affect me as much anymore. They used to, a lot. It was one of the reasons I didn't surf much as a kid.

My journey to loving myself is still ongoing. It's all about believing in yourself, being thankful for every day, and moving forward, just as you are. I haven't felt pressured to fit a certain idea of femininity lately, but it used to be a challenge. Taking care of myself and being around people who lift me up are important for my well-being. Staying true to my authentic self is where I find my personal power.

Sunrise sessions at my home break in Sayulita, Nayarit, Mexico.

"Taking care of myself and being around people who lift me up are important for my well-being."

Risa Mara Machuca

I want to encourage everyone to embrace their uniqueness. We're all different, and that's what makes us stand out as individuals. Stop worrying about what you need to change to feel good about yourself and just start moving. If something scares you, it's probably worth trying.

Years and years of not giving up and staying true to what I want in life helped build up my self-esteem. Many "bottle moments" are both shared and individual experiences. And surfing absolutely has an important role. It's my happy magic time when the ocean plays its beat and I get to dance and find my own personal rhythm.

Surfing might not be changing body positivity all on its own, but it definitely celebrates being yourself. Body positivity in surfing is growing. I'm lucky to live in a community that cheers me on in the waves. It's so important for women of all ages, shapes, and sizes to stop asking for permission. I always feel at my best when I am surfing. Surfing is my happy place, where I feel free and strong.

The best way to start the day is at sea.

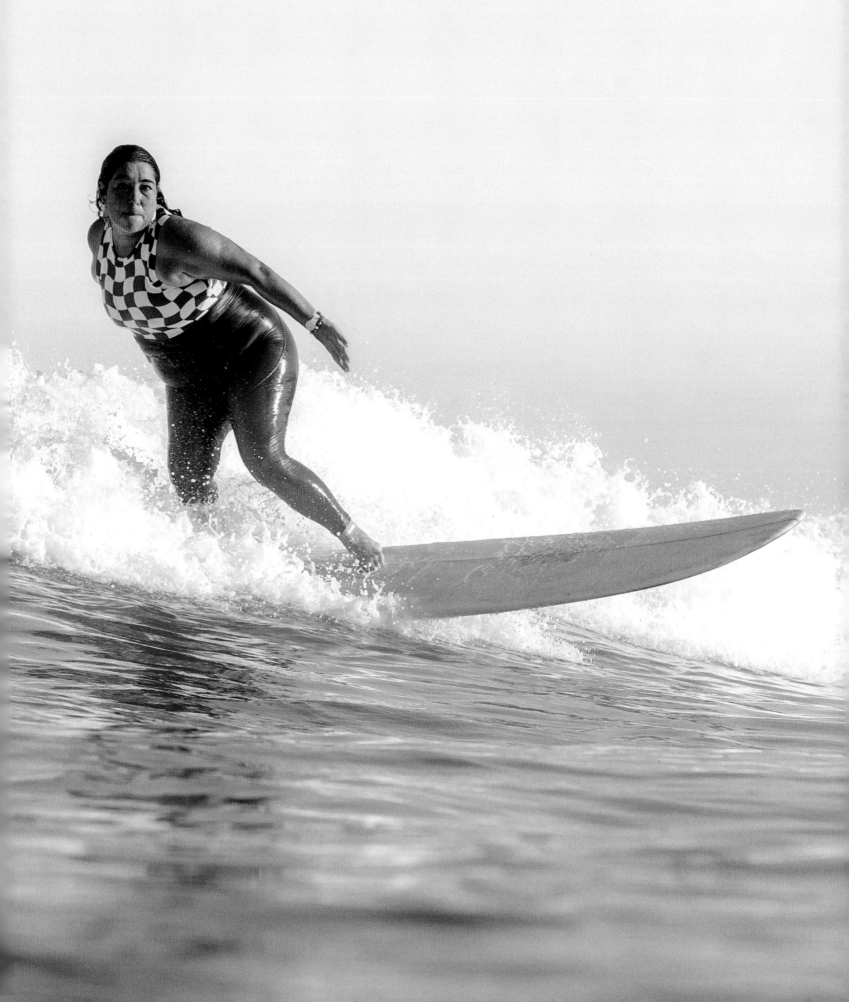

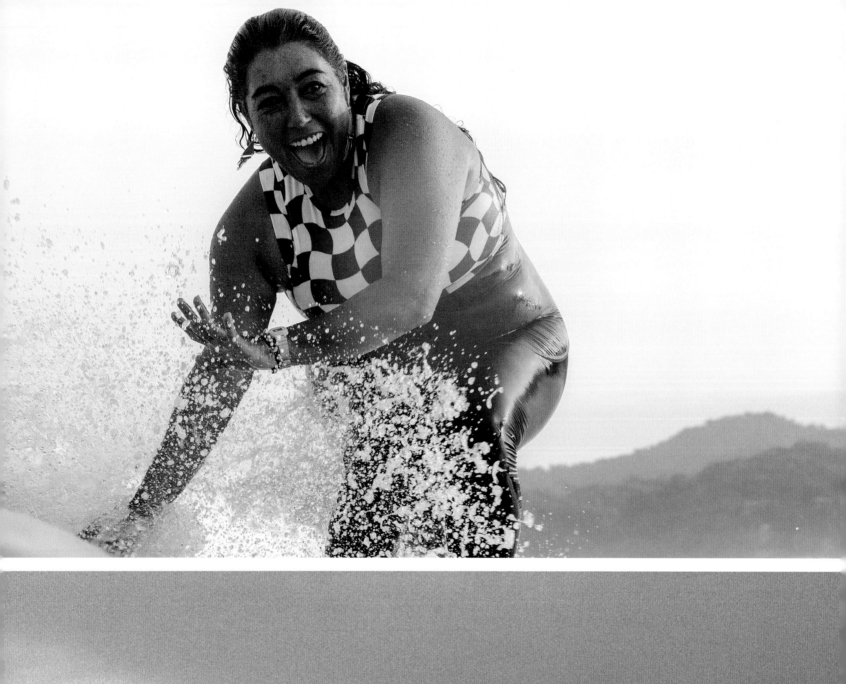
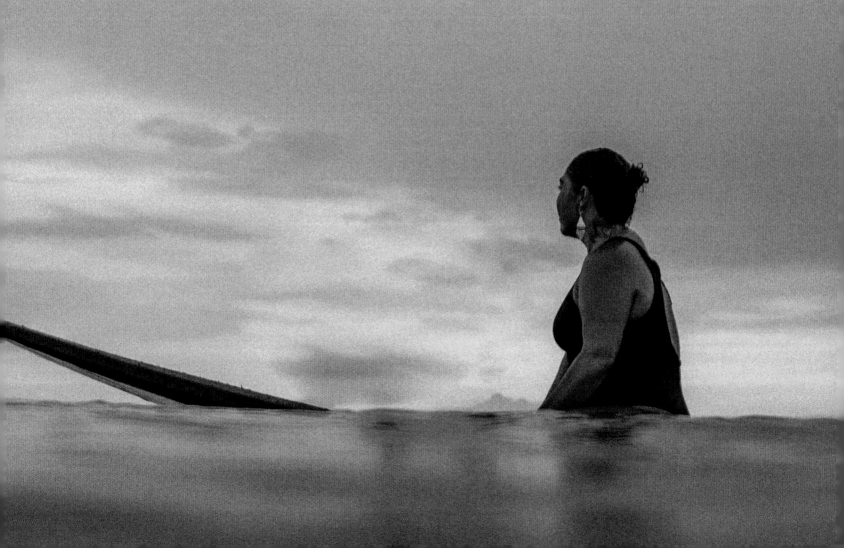

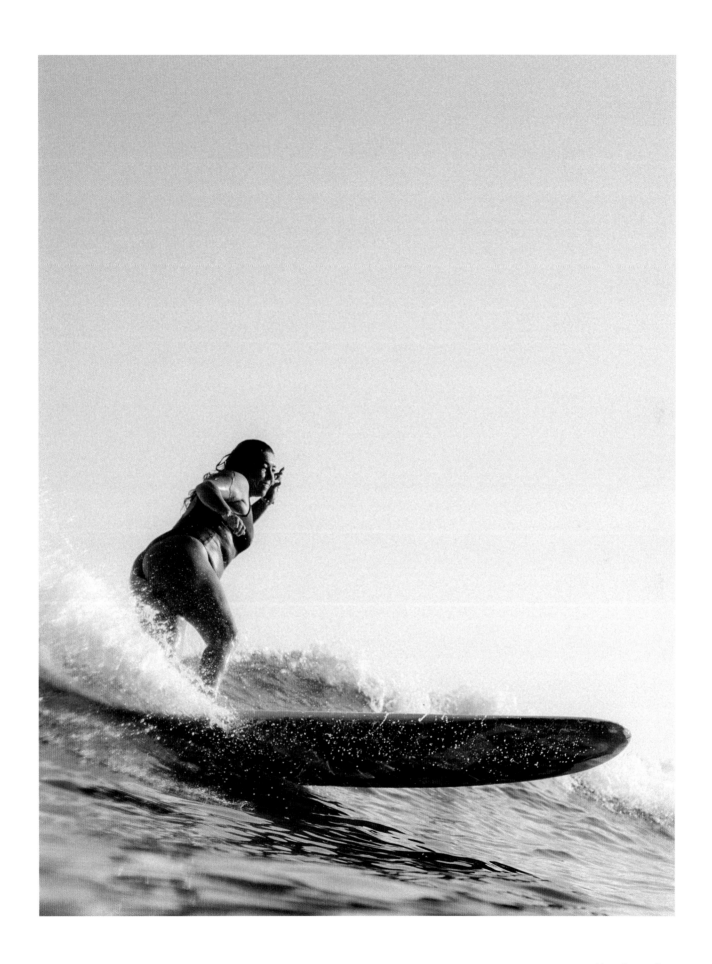

I love free surfing.

Surfing is for women of all shapes,
sizes, ethnicities, and ages.

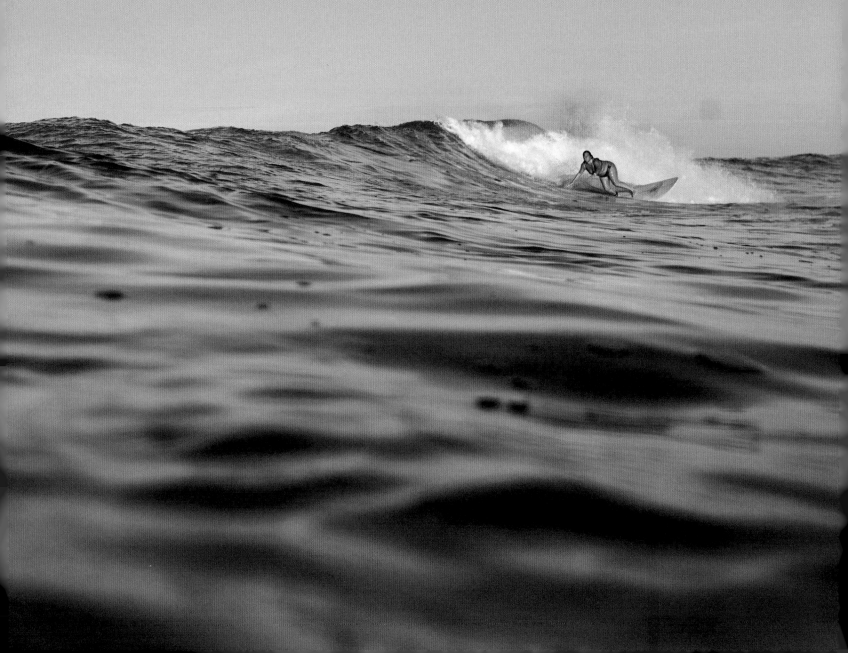

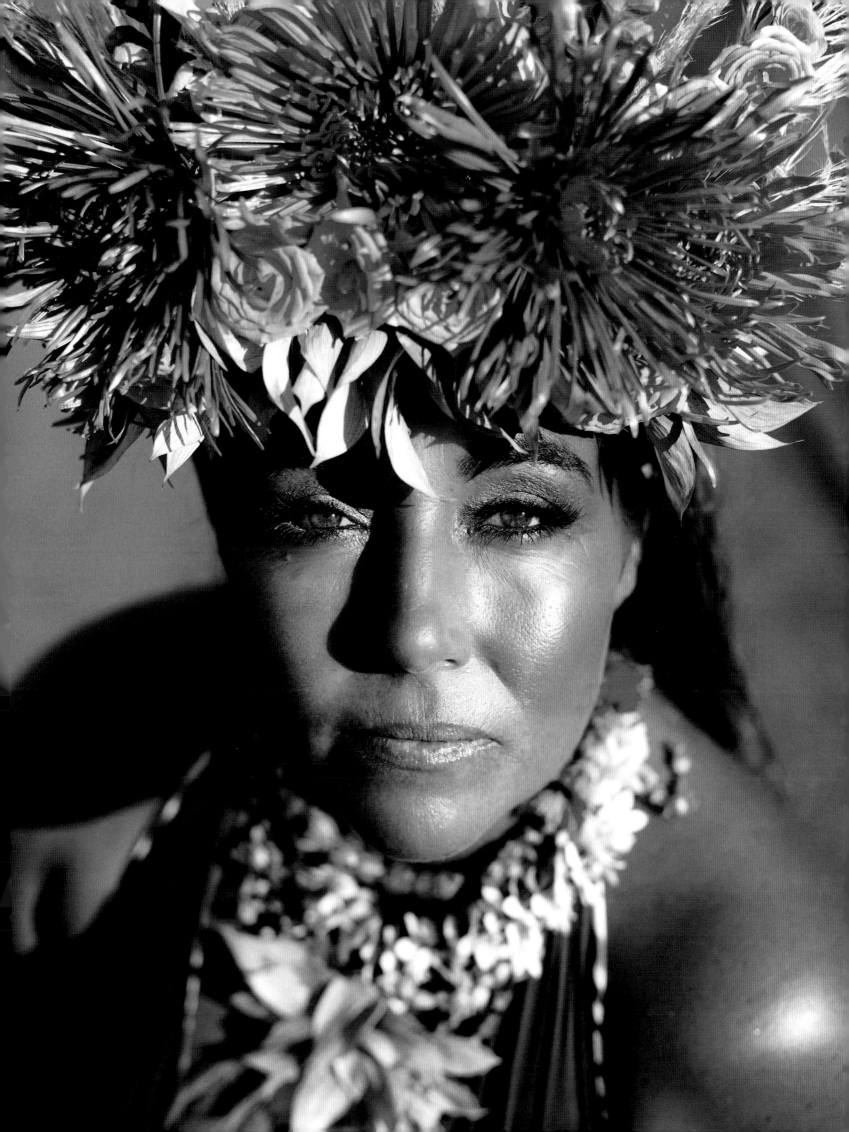

Emy Dossett

"It's empowering to be part of a chapter in time which celebrates diversity, showcasing the beauty of all body types and ethnicities in the world of surfing."

I grew up in a small coastal town on the East Coast of Australia where a significant part of my childhood revolved around the ocean. When I was growing up, there weren't many images of women surfing in the media. It was mostly men, and if there were pictures of women, they fit a very specific stereotype: white, blonde, and skinny, wearing bikinis and rarely shredding on waves.

Like most teenage girls my age, I developed a complex about my body. I thought there must be something wrong with my curvy body type, as I rarely saw muscular and curvy women represented. Then, when I was in my twenties, there was a shift in the surf industry and surf brands started showcasing women surfing. But the images still lacked ethnic representation, as most of the imagery only featured women from Australia and the USA, the dominant countries in the surf industry. Only now, in my late thirties, am I starting to see more body inclusivity and ethnic diversity in mainstream surf media.

Shortly after I started my surf and lifestyle photography career in my early thirties, I moved to Mexico. When I arrived in Sayulita, Mexico, I would swim out at sunrise and sunset with my camera, mesmerized by the local women longboarding. Mirian was the first longboarder who caught my eye. Her style was graceful and elegant enough to make anyone, surfer or not, stop to watch her. I wanted to know her story, so I invited her for a coffee and learned she was a Mexican woman with Indigenous roots, originally from the mountains of Guerrero, who had never seen the ocean and didn't know how to swim until she arrived in Sayulita. She was now hanging ten with a style that stopped anyone in their tracks.

Sayulita, Mexico.

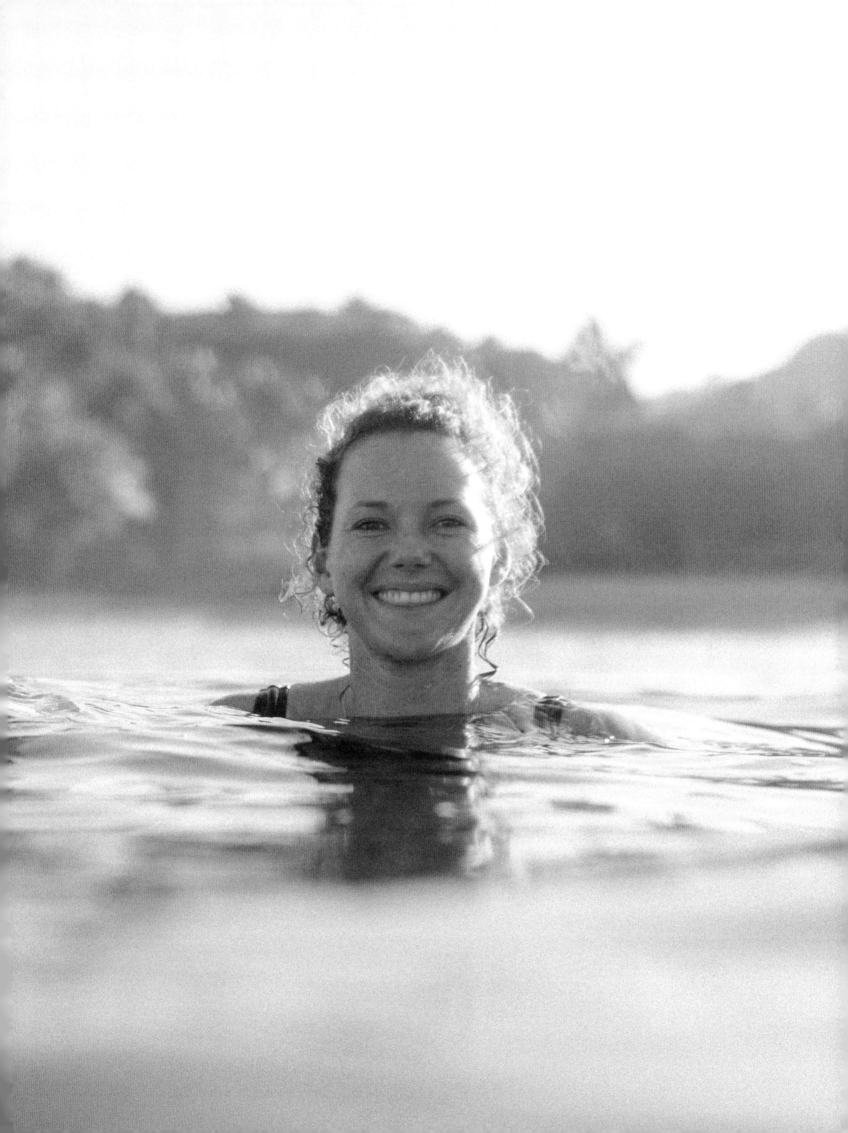

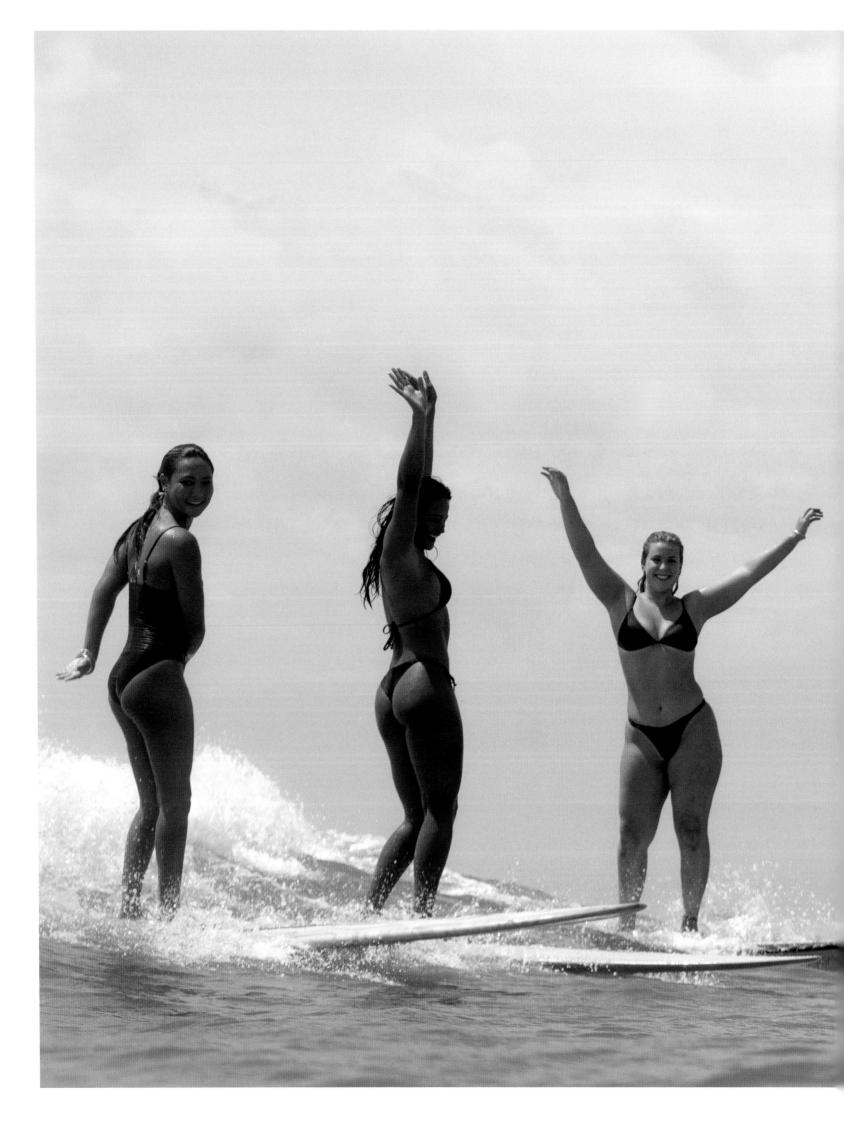

Emy Dossett

Then I met Risa, whose powerful style caught my eye from the shore. I asked her about her story and learned she was a powerhouse of a woman who had represented Mexico internationally in longboarding and had her own swimwear line for curvy women.

I was inspired by Mirian's and Risa's stories and wanted to photograph more women like them, which motivated me to pursue a career focusing on the female longboarding industry while embracing the diversity and inclusion these women represented. Their compelling narratives and their talent allowed me to collaborate with them and celebrate their stories through my artwork. This creative partnership has significantly impacted the trajectory of my career. As a female surf photographer, I'm grateful for the opportunity to create work that aligns with my beliefs and contributes to a positive shift toward greater representation in the industry. It's empowering to be part of a chapter in time which celebrates diversity, showcasing the beauty of all body types and ethnicities in the world of surfing.

"As a female surf photographer, I'm grateful for the opportunity to create work that aligns with my beliefs and contributes to a positive shift toward greater representation in the industry."

The ocean acts as a common thread for surfers, weaving us together through the elation and beauty of riding its waves. The origins of surfing date back to ancient Polynesian cultures, where it held deep spiritual significance and served as an inclusive practice that bonded communities. However, the essence of this tradition has been diluted over time by Western influences that have commodified and homogenized the surf culture. Drawing from my personal heritage, I'm intrigued by the connection between my Māori lineage and the ancestral roots of surfing in Hawaii. The legacy of my family's journey from Hawaii to New Zealand on a canoe mirrors the traditions and voyages of ancient Polynesians, and inspired my curiosity for exploring the cultural significance of surfing and its ability to connect us. By delving into the diverse histories of surfing and reclaiming its spiritual and inclusive aspects, we can rediscover the profound sense of community that surfing brings us.

Left (from left to right) Kalei Fukuda, Mahina Florence, and Gabi Turnbull.
Next double page (left) Sunrise in Sayulita, Mexico. (Right) Alyson Madrigan and friends.

Let's celebrate
body diversity!

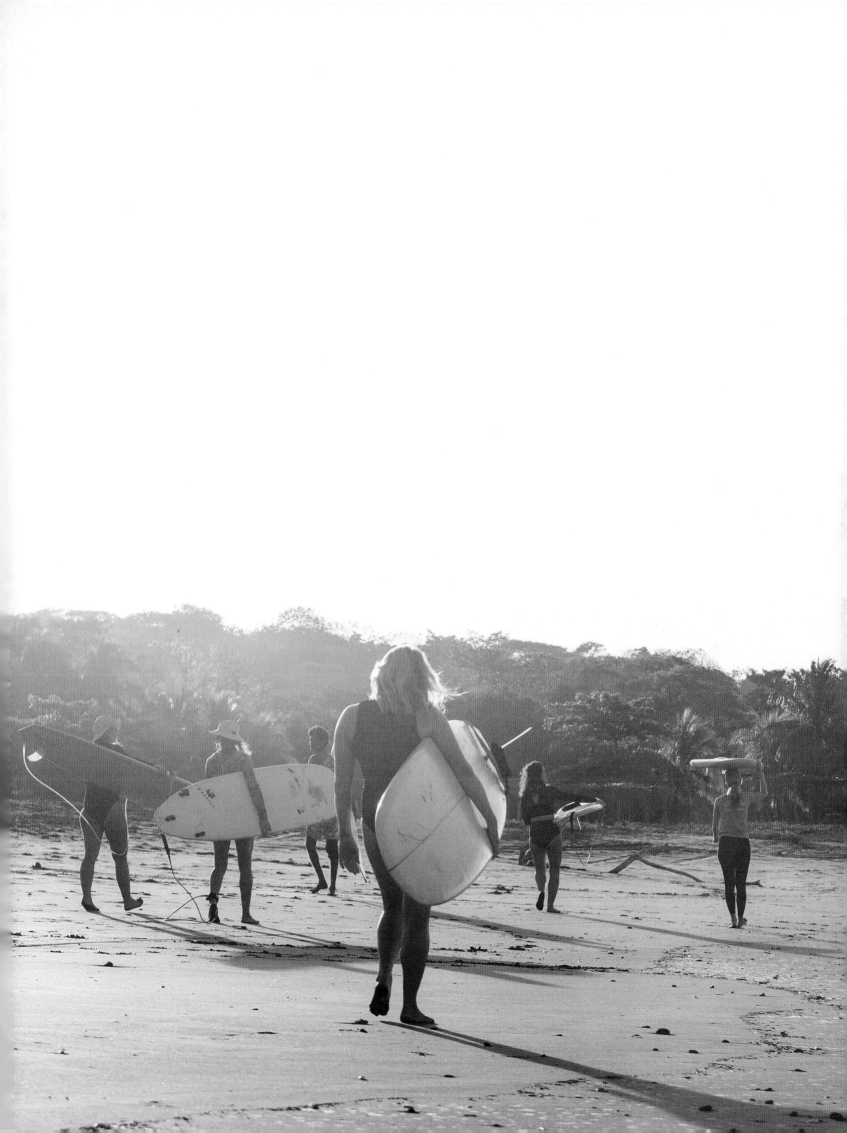

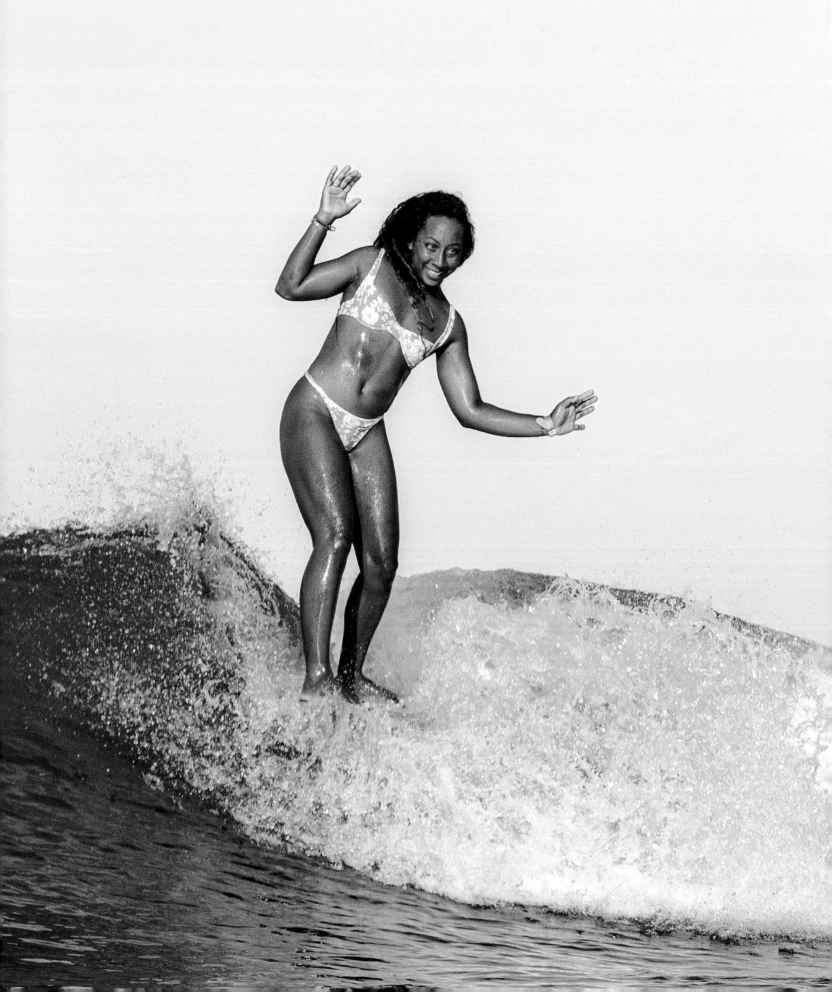

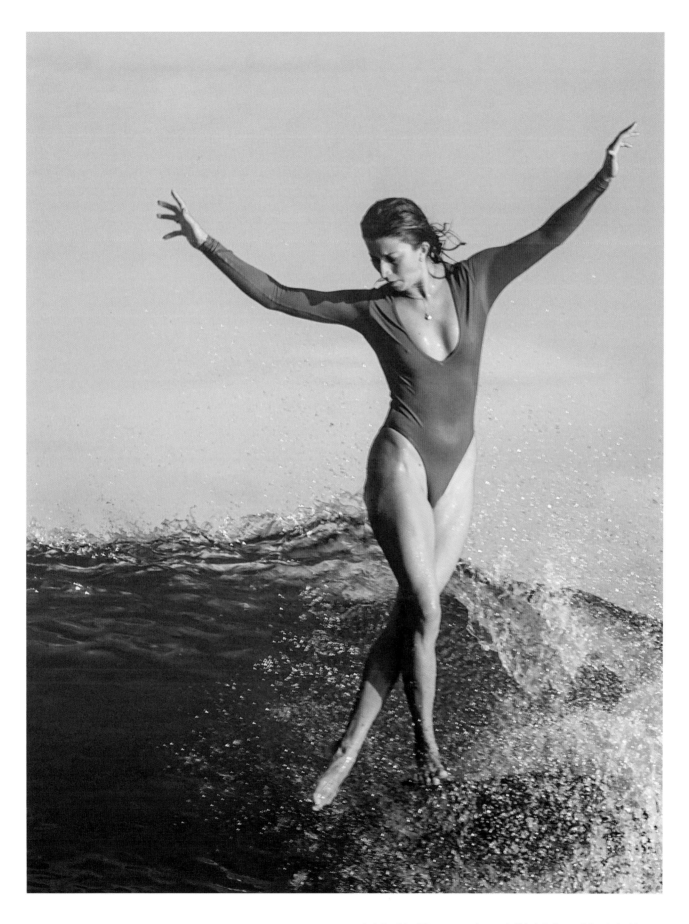

Left (top) Lexi Jorgensen, (bottom) Chloé Calmon. | Top Lola Mignot.
Previous double page (left) Nique Miller, (right top) Conie Vallese and Kassia Meador, (right bottom) Carrie Marill.

Gigi Forcadilla

"The association of fair skin with status and authority perpetuated the belief that fair skin was superior and more desirable."

The beauty standard of fair skin in the Philippines has deep historical and cultural roots.

Historically, the Philippines has been colonized by various foreign powers, including Spain, the United States, and Japan. During the Spanish colonial era, which lasted for over 300 years, fair skin became associated with the ruling class, who typically had fair complexions and held positions of power and privilege. This association of fair skin with status and authority perpetuated the belief that fair skin was superior and more desirable. *Mestizas,* which is the term that typically refers to people of mixed race, oftentimes someone with both indigenous and European ancestry, became the epitome of beauty standards. The term *mestiza* carried connotations of beauty, sophistication, and privilege, while *morena*, meaning a person of darker complexion, was subject to societal biases and discrimination.

Furthermore, coming from a predominantly agrarian society where darker skin is linked to outdoor labor and lower socioeconomic status, having fair skin became associated with wealth and leisure. In a country where my skin color could sometimes dictate how I was perceived and treated, I found myself comparing my skin tone with those around me, feeling inadequate or less attractive because I didn't fit the conventional beauty standards.

Growing up *morena* was challenging in a place where media, advertisements, and even family perceptions perpetuated the notion that fair skin equates to beauty, success, and desirability. But all that slowly changed when I began to surf.

For many residents of Siargao Island, surfing isn't merely a hobby or a sport; it's a way of life. Historically male-dominated, the sport has experienced a

On the island of Siargao, Philippines.

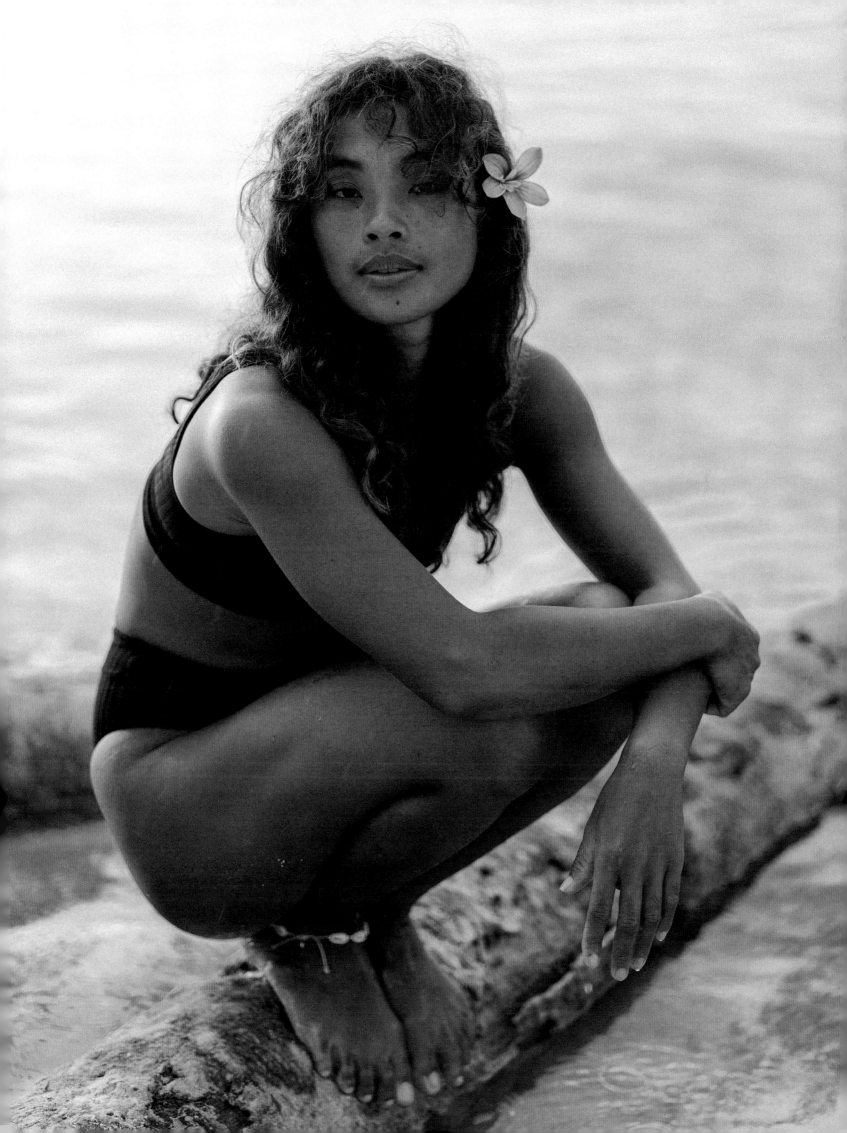

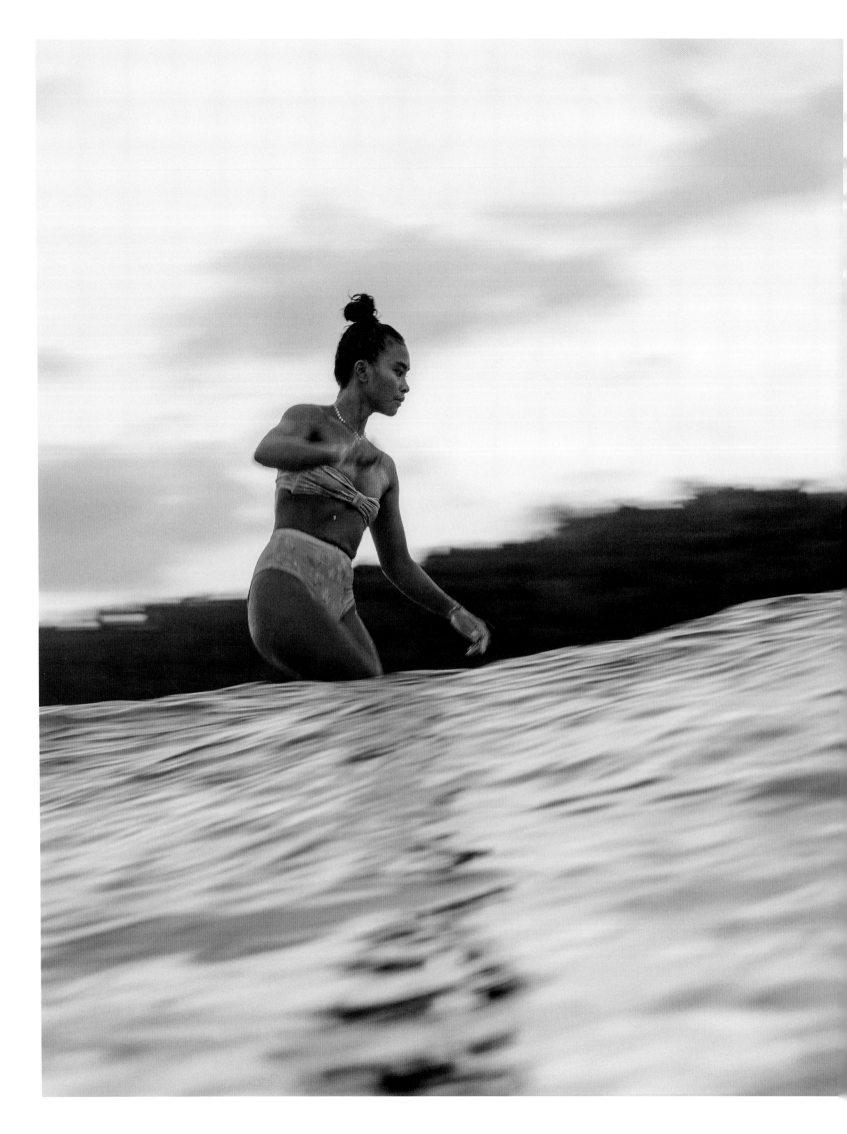

Gigi Forcadilla

noticeable shift as an increasing number of women challenge conventions and defy stereotypes while forging their own identities in the lineup.

Despite being born and raised on Siargao, I didn't embrace surfing until the onset of the pandemic. Growing up, societal norms discouraged girls from participating in extreme sports and spending extended periods in the sun. Coming from a culture so deeply entrenched in the belief that fair skin epitomized beauty and that women should tend to the home, it was difficult to entertain the thought that I could become a surfer.

However, this mindset began to evolve as local women courageously embraced the sport, competing fiercely and unequivocally proving that waves belong to everyone regardless of gender. Hailing from a family deeply embedded in the local surfing culture, I learned to surf by observing my relatives in the water. The learning curve was steep and the early stages of my surfing journey were filled with frustration and setbacks. Yet, through this process, I learned the importance of perseverance and determination. Each conquered wave served as a testament to my growing self-assurance, both in and out of the water.

"I found strength in connecting with others who shared similar experiences, forming a supportive body-positive community that challenged societal beauty standards and promoted inclusivity."

Through surfing I discovered a community that celebrated diversity and individuality where *morena* surfers like myself were accepted. Suddenly, I had strangers telling me how they wished they were born with my skin tone and body type.

I met people from all over the world, from different cultures and backgrounds, and realized that in other countries, the sun-kissed skin color that came naturally to me was actually something that others longed to achieve. Surrounded by fellow wave riders who shared my love for the ocean, I found a sense of belonging that transcended superficial beauty standards.

Surfing became more than just a sport; it became a catalyst for self-love and acceptance. I found strength in connecting with others who shared similar experiences, forming a supportive body-positive community that challenged societal beauty standards and promoted inclusivity. In the water, it didn't matter if my skin was darker than others'; what mattered was my

Single and Unattached Competition 2024, Monaliza Point, La Union.

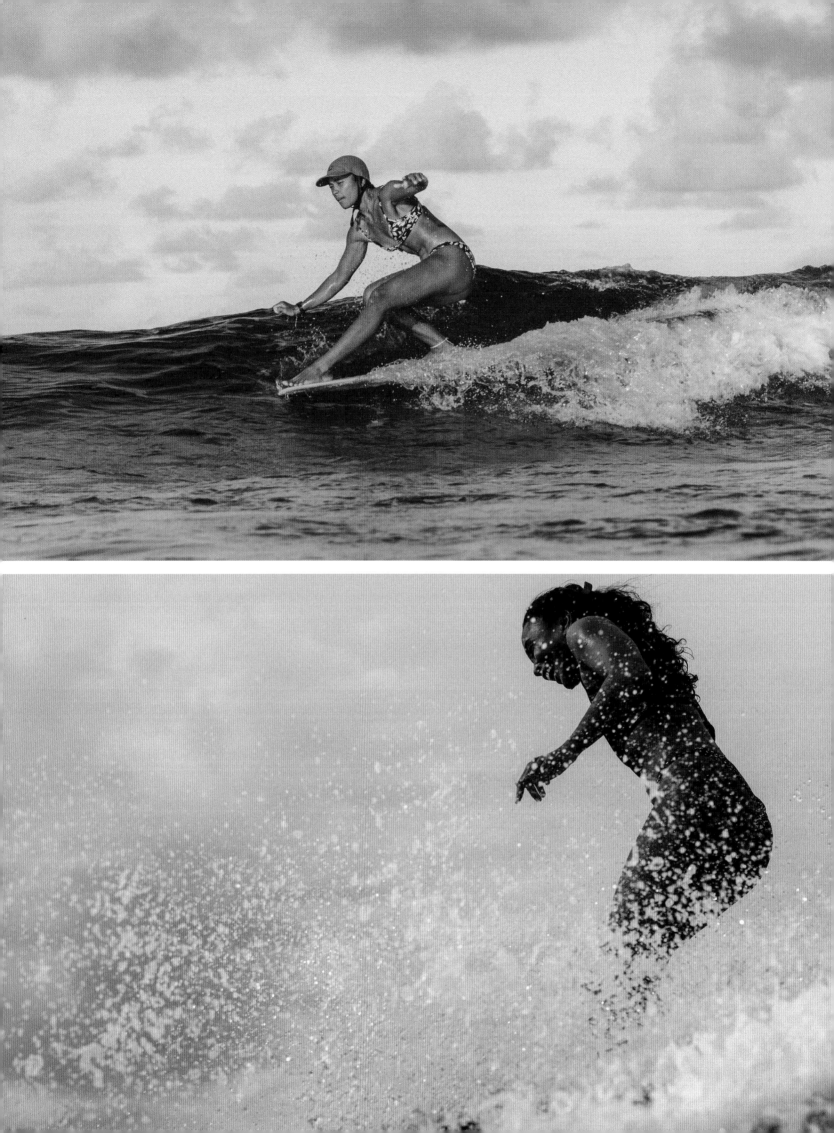

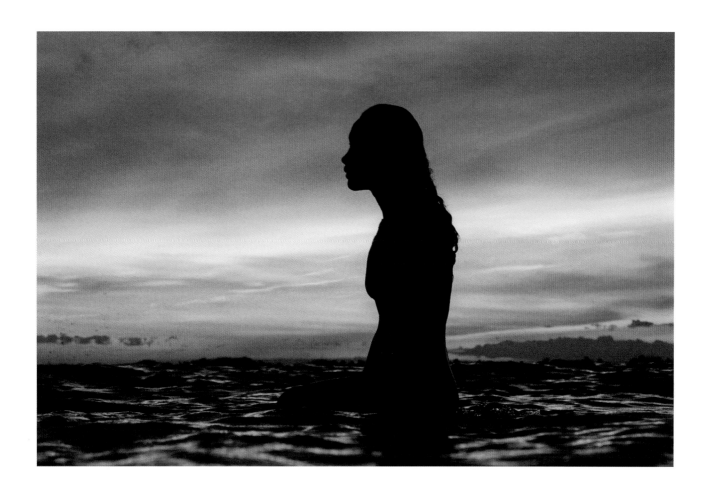

Gigi Forcadilla

connection to the waves and the freedom I found riding them. I am beyond grateful to have finally found my place in an empowering community where diversity is celebrated. And one that has helped me grow in more ways than I can imagine. The ocean has become the great equalizer, where everyone, regardless of race or background, has been united by a common passion.

My journey in the waves has profoundly shaped my self-esteem and confidence, instilling in me a profound sense of resilience and empowerment. Surfing has also opened up a whole new world for me, gifting me with experiences and adventures I wouldn't have been able to be a part of had I not joined this beautiful community. It has transformed my life in more ways than I can imagine, giving me a deep respect for nature, a sense of community with fellow surfers around the world, and awareness of the beauty of living life at its present moment.

Siargao, Philippines.

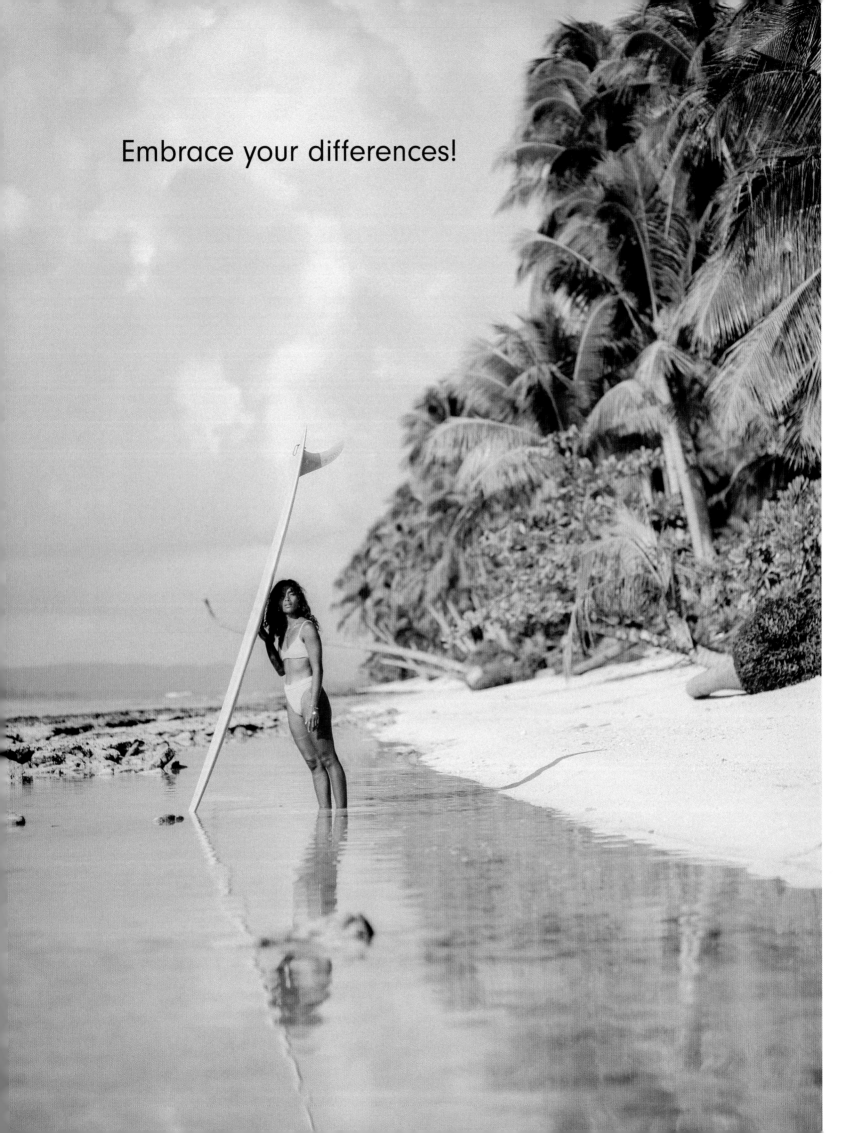

Embrace your differences!

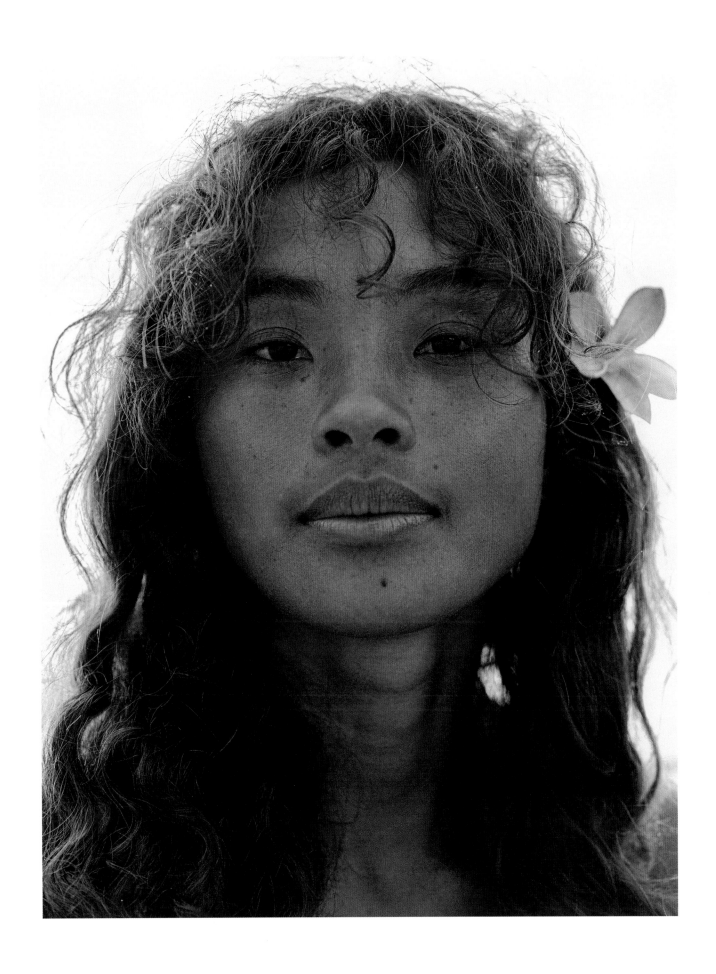

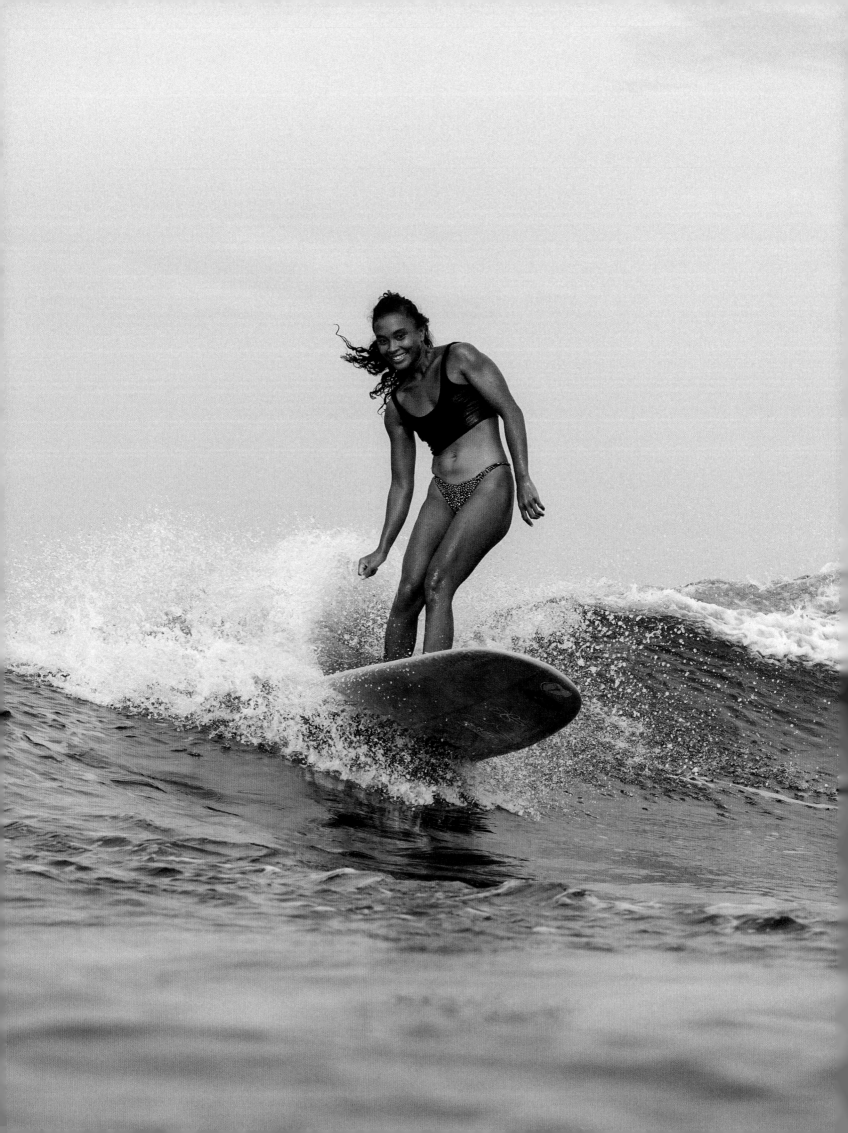

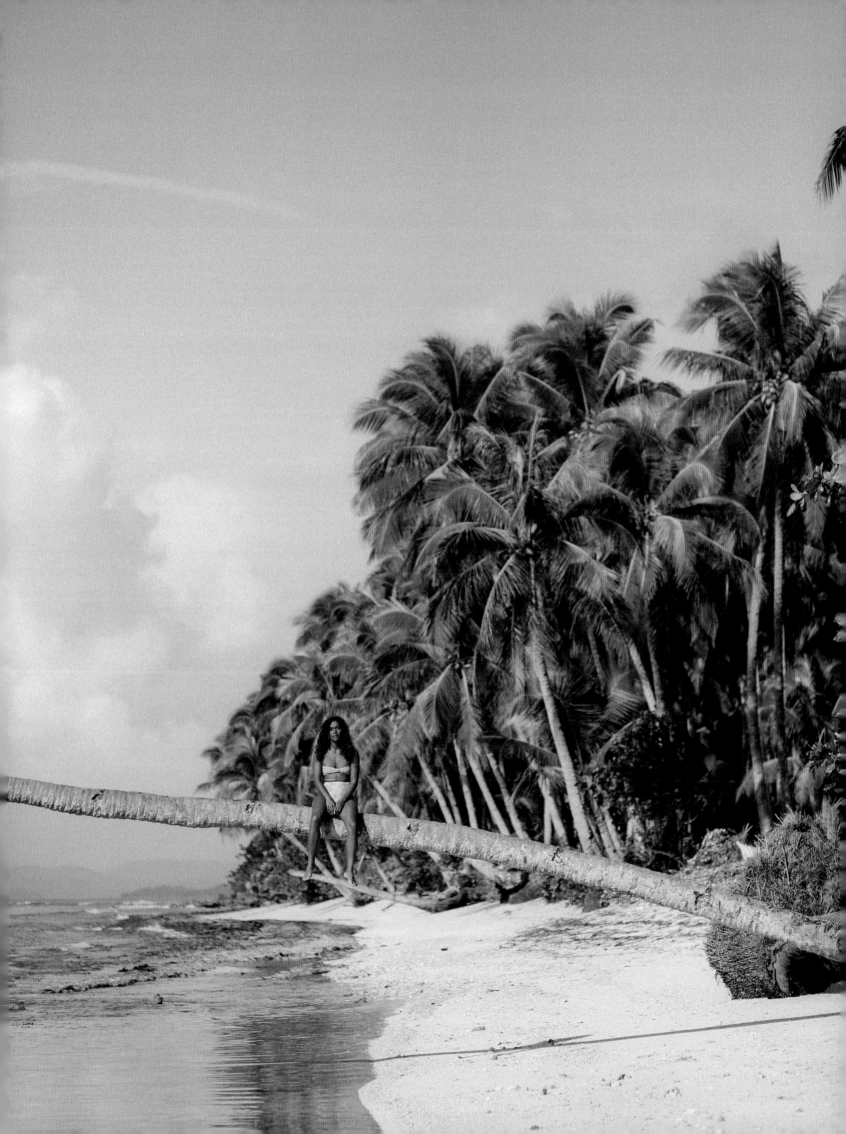

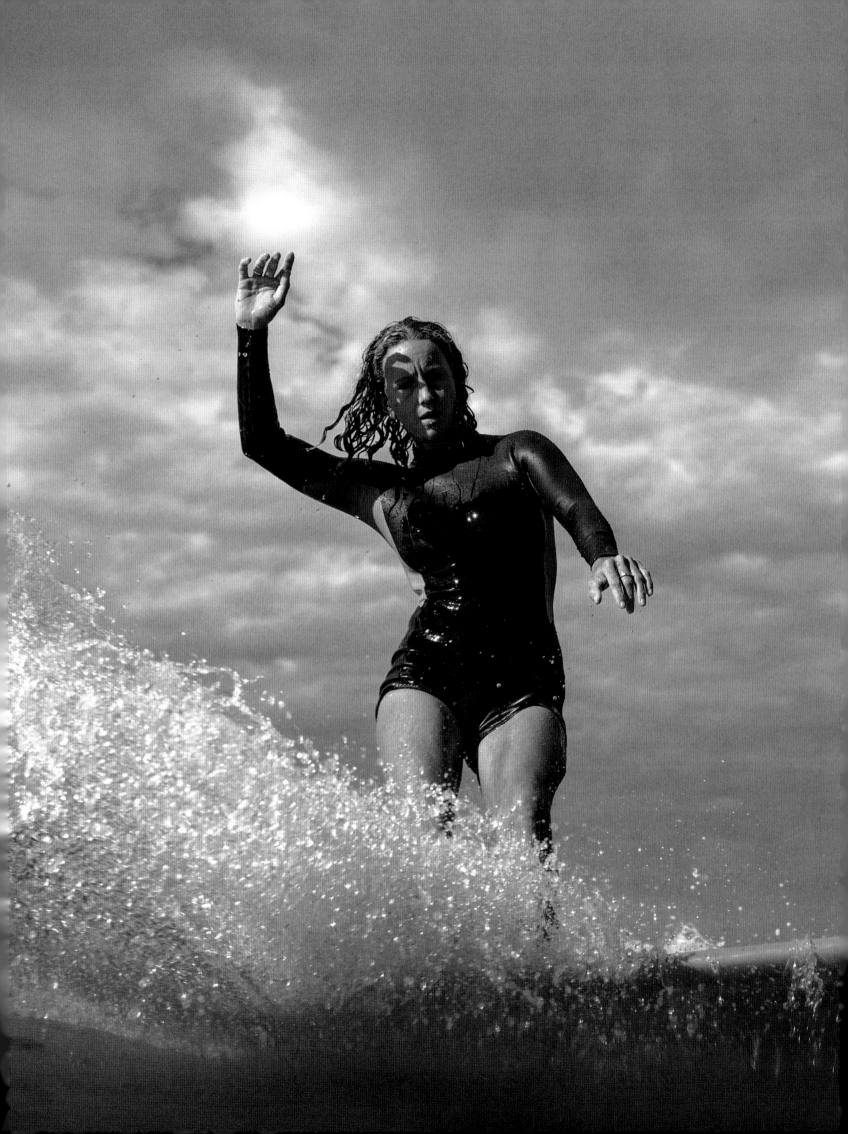

Margaux Arramon-tucoo

"A surfer has to be pretty to get a sponsor: that's a real problem."

We need to question the relationship between gender performance and sports performance in general. If you're a girl and you're a sportswoman, your body has to be at the service of your performance, so it will necessarily be more muscular and more imposing. But it's not necessarily the best sportswomen and those with athletic bodies who get the most support in sport, precisely because they don't correspond to the criteria of beauty set by the media, and that's what we're fighting for.

The fact that a surfer has to be pretty to get a sponsor is actually very specific to our sport. And we realized that's a real problem. We know great Mexican surfers who are indigenous, we know great African surfers, but we never really see them on the surf scene.

The Queen Classic Surf Festival is an inclusive platform taking the form of an event in which we give minorities the opportunity to be well represented in a safe place, a place of respect, where they can be listened to and have a loud voice. We are opening doors for women, LGBTQ+ people, poorly represented communities, and non-privileged athletes, mostly in the surfing sphere, both now and for future generations. With the festival, we do our best to try and represent a panel. We had the first transgender surfer last year: it was super important for us to show that everyone surfs.

It is proven that 9 out of 10 decisions in sports media and brand marketing are made by men. We are less likely to hear or see a woman's point of view, so we have no access to a woman's perspective. There is also a hypersexualization of women in the marketing of surfing. Surfing is a fairly naked sport, and you're often wearing a swimming costume or a tight-fitting wetsuit. But in marketing it's also often a wetsuit that's not suited to the sport: it might be very short, up to the buttocks. This sexualized imagery presents a generalized image of what a woman is capable of, and what her role is, and it objectifies women in general. It's saying that the only thing a woman's image should do is attract desire.

My home break in Biarritz, France.

Margaux Arramon-tucoo

People think it's not a real issue now, but it is, more than ever. With all the development in breaking down these images of gender differences, it is important not to shape the way women have to be. We need to look through the media and brands to change the general vision of "You're a girl anyway, you won't be able to do it like men."

It is important for future generations to have an example of what they are capable of achieving, no matter who they are, or who they want to be. It is important to show the world that it is not only privileged people, or people who fit a particular societal norm or look a particular way, that can be athletes.

We hope to shape a better understanding and a better world, to open up the conversation through our podcast, surf competition, foundation village, and music.

"We are less likely to hear or see a woman's point of view, so we have no access to a woman's perspective."

Top Lola, one of my best friends from the Vans team and one of the most stylish and talented surfers I know.
Bottom Juju, who won the first Queen Classic Surf Festival, doing a hang heal.

114

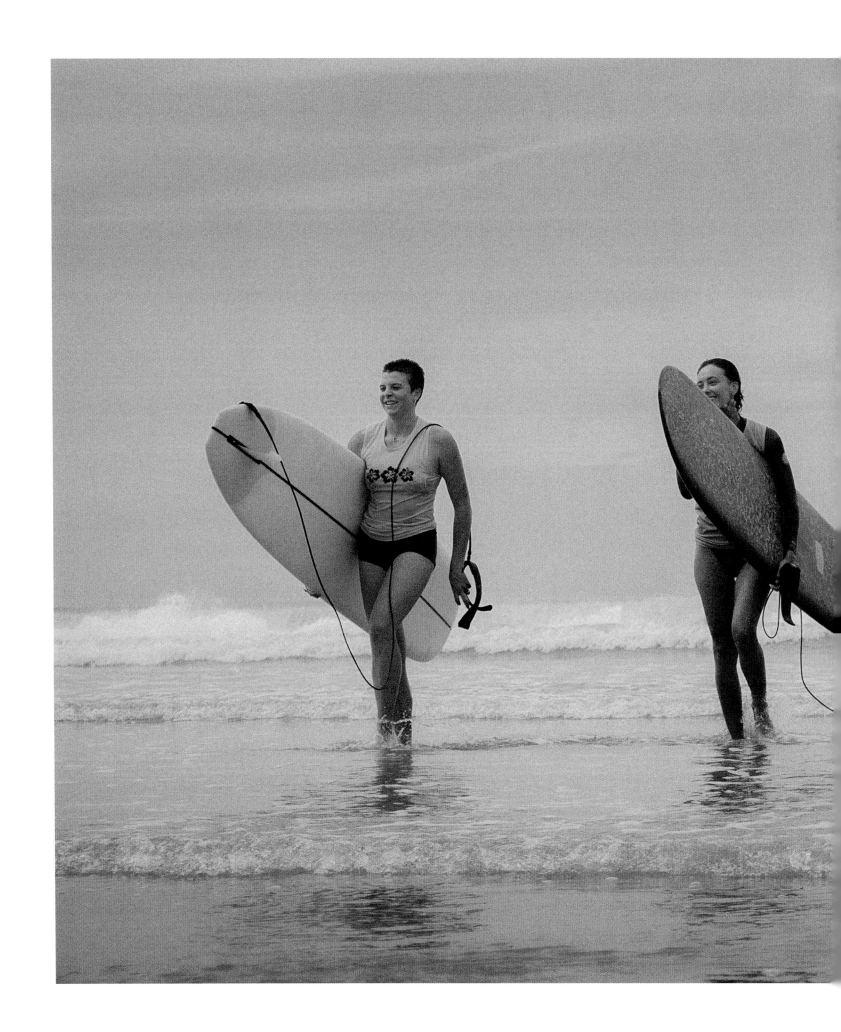

Women's obligation to be beautiful enslaves them.

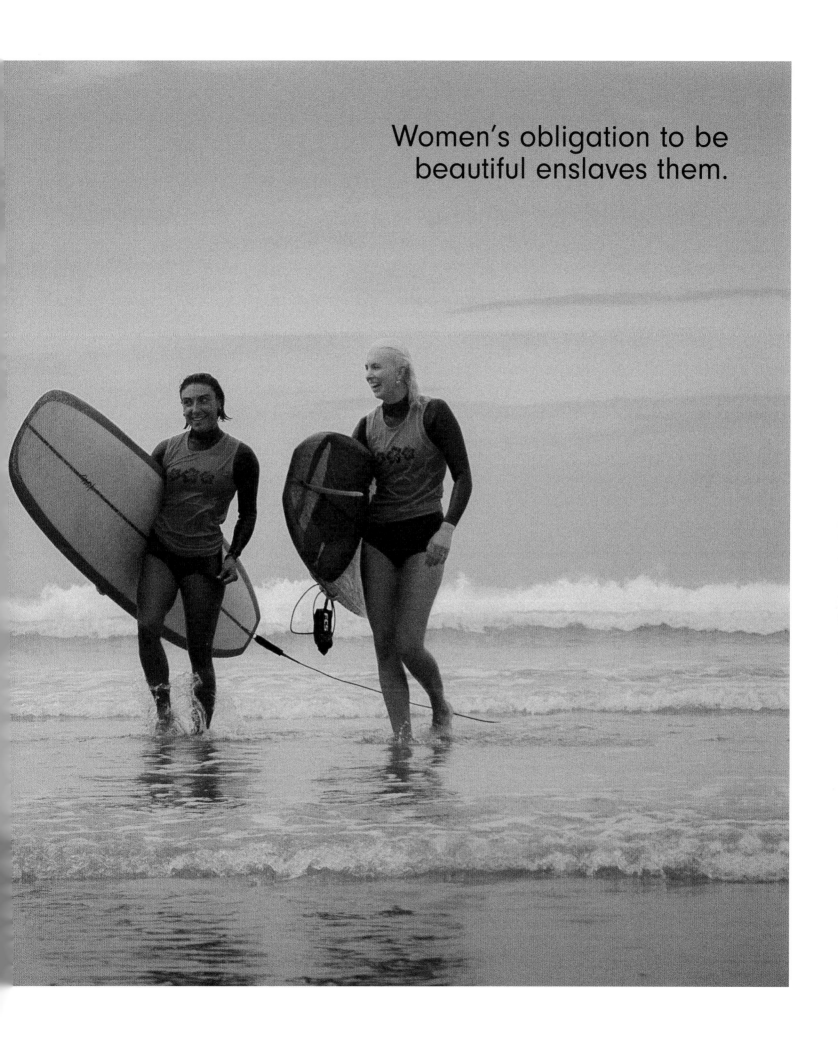

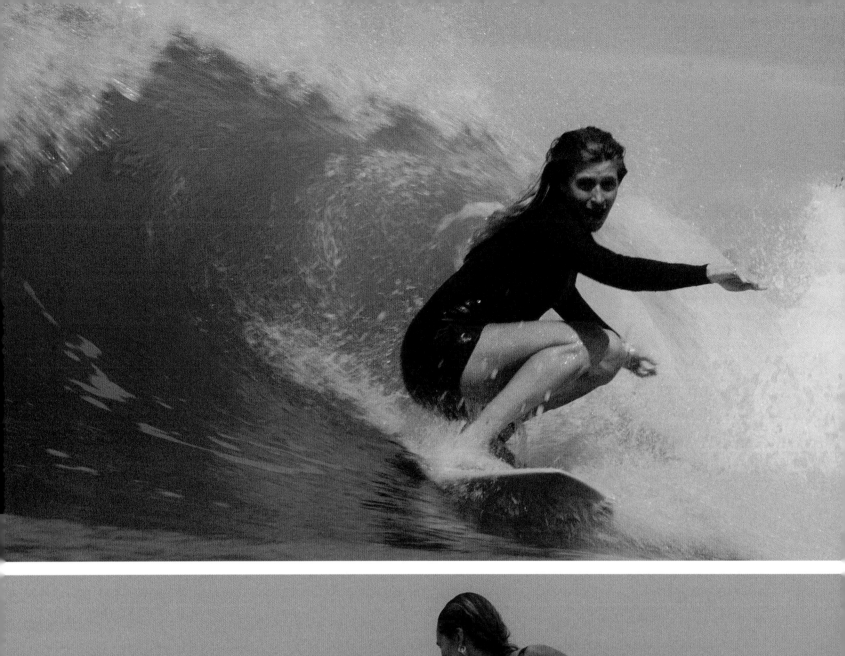
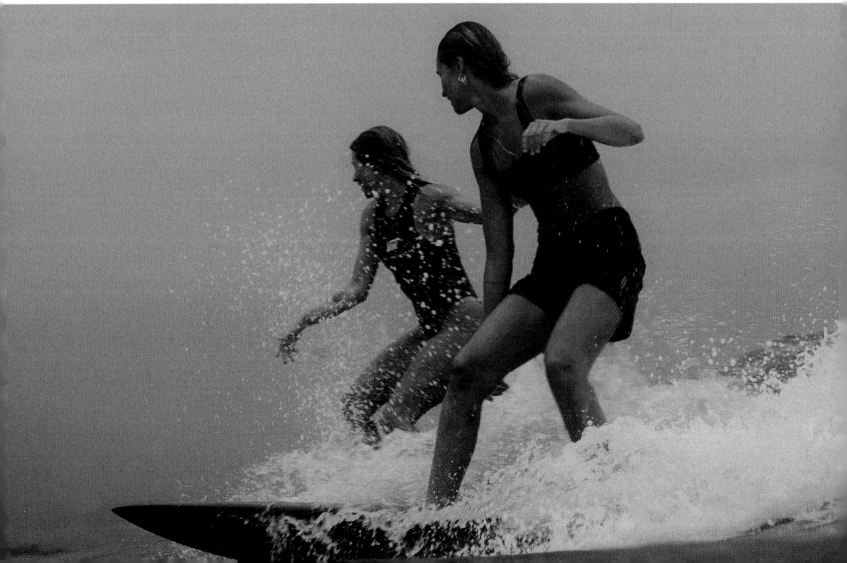

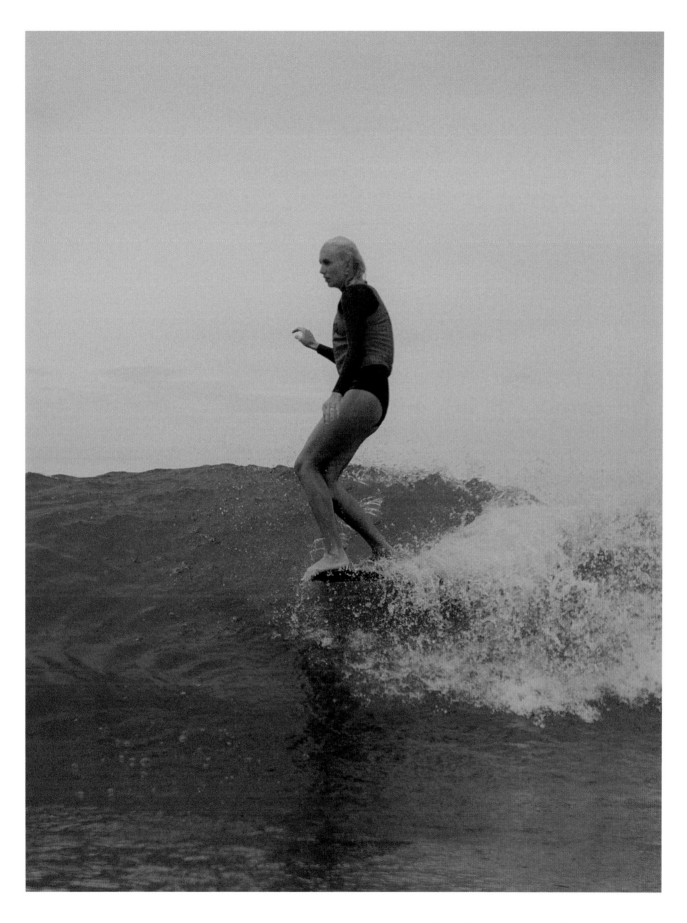

Previous double page & left Local female surfers during the expression session.
Top Mia Francis, who won the 2023 Vans Queen Classic Surf festival, during the final.

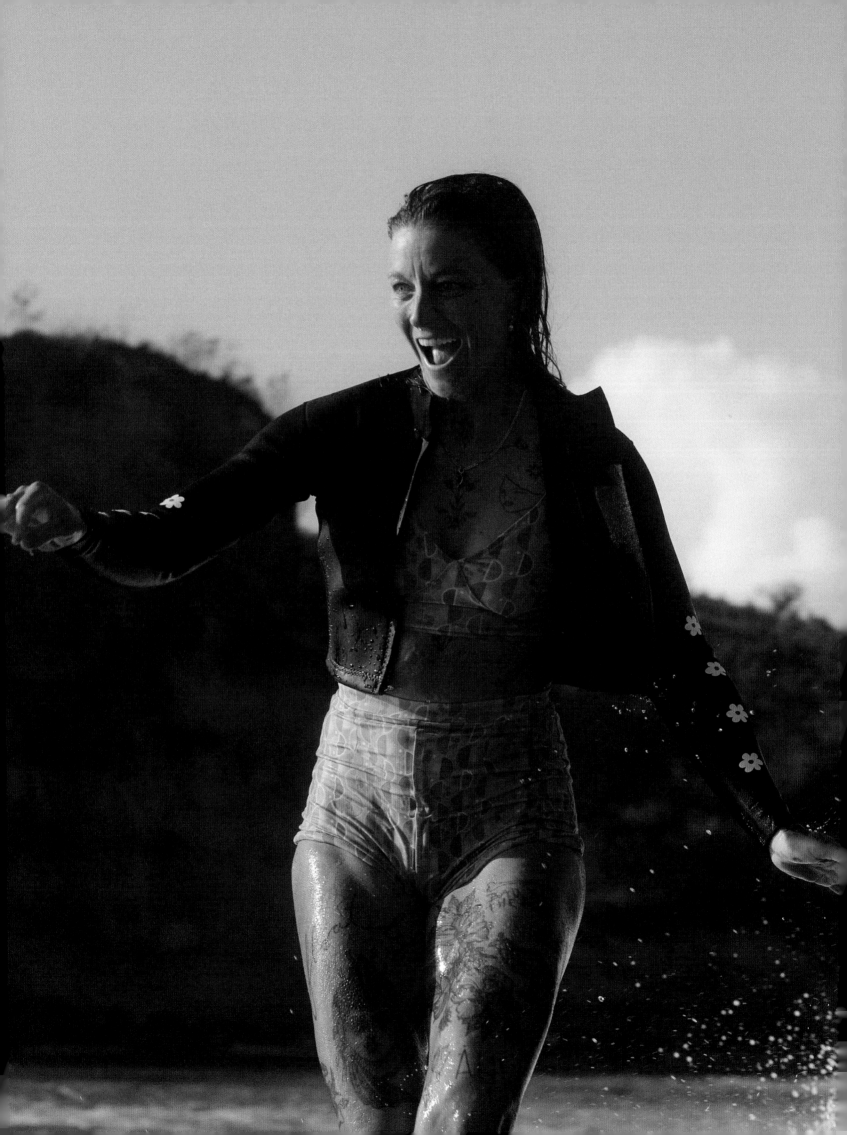

Anaïs Pierquet

"Feeling good within ourselves, peaceful, and beautiful is our birthright."

In 37 years of life, I had two big revelations about my body that awakened my spirit.

When I was 21 years old, I embarked on a journey to San Diego, California, longing to find a sense of freedom and clarity. I was so scared of life, everything was new, the city was loud and way too big for a sensitive soul like me. Cruising around Pacific Beach, Encinitas, and Little Italy, I eventually found a supportive community to grow with and embraced the relaxing vibe.

A year before my travels, I tragically lost my dad to suicide. It was time for me to heal my heart and soul. In the midst of my grief, I was drowning in a tsunami of fears, tears, and sorrows. It was challenging to leave home and my mother, but I knew I needed some distance to find myself again. My relationship with my body was destructive. As a young adult searching for myself, I struggled to understand how to navigate the human experience in this "meat suit" I was given. I felt deeply disconnected, lost. The perception I had of myself was so negative and twisted, influenced by an outside world that truly didn't understand me.

While women my age were putting on makeup, wearing high heels and dresses to look cute, I found myself seeking something different: style and comfort. Our language was different. Since I was born, I've always gravitated towards authenticity, wanting to express myself genuinely without pretense. But as I grew older, I began to realize the sad truth: in a world obsessed with appearances, authenticity often takes a backseat.

How can we remain true to ourselves and embrace our bodies when the world seems to constantly pressure us to be something we're not? At the end of my travels, I got curious about tattoos. I walked into a random shop downtown San Diego, made a bold decision and tattooed "Got to keep on

Fooling around on a fun wave in Lombok, Indonesia.

121

Anaïs Pierquet

walking" on my right foot. That was 16 years ago. Since then I have had 57 other tattoos, or, as I like to call it, one tattoo all over my body! I realized that getting ink deep under my skin wasn't merely about adorning my body with art; it was a symbolic act of reclaiming ownership over my image, an act of freedom. My tattoos are a declaration of self-love and acceptance, a step towards embracing my body, my skin, and all its imperfections. Reflecting on my tattoos stirs up so many emotions, as they have truly shifted my perception of myself. It was a powerful statement to society, my parents, and others, saying, "I no longer accept your bullying. I choose to be myself, and you don't have power over me anymore." I was becoming ME and I felt free.

A few years later, I moved to Bali and began my surfing journey. Surfing has a remarkable way of turning my negative thoughts into stardust. Every time I emerge from the waves with a clear mind, I feel joyful and grateful for my body. Over the years it has helped me feel strong instead of look strong. Being able to fine-tune my skills each day gave a significant boost to my self-esteem and confidence. When I synchronize with nature and the rhythm of life, that's when I feel in harmony with my body, with the core of my essence. I found solace in surfing, expanding my community, and sharing my new lifestyle with the world on social media. However, as my body transitioned into a woman's body over the years, I felt a sense of confusion. Negative thoughts bombarded my mind incessantly, and at times, I found myself sinking with it. I got trapped in my own self. As if I would be rejected by the world if I showed my imperfections ...

"Over the years my body has helped me feel strong instead of look strong."

We are meant to evolve, to age, to gain wisdom. Every change, every wrinkle, every gray hair makes our bodies the most magnificent vessels we could ever imagine. True beauty lies not in perfection, but in embracing our authenticity and loving ourselves unconditionally. My mind was playing tricks on me again. I paused and reflected on why I was feeling that way. Once again, the inner conflict between my values and what the world expected of me was weighing me down. We are conditioned to believe that our bodies will always remain the same. The truth is, as long as humans remain disconnected from nature and the elements that shape us, the essence of life, we will always feel uncomfortable.

Surfing saved my life a million times. Living in Bali, being in the water every single day, has helped me stay focused, cleanse negativity, and return to what truly matters—living a fulfilled life just the way I am. I don't do it for the world; I do it for myself because I am my best self when I am connected to nature, and aligned with what my body needs. Surfing makes me feel strong and empowered, and it's fun too!

Boat rides in Lombok during our Waves & Freedom surf retreat.

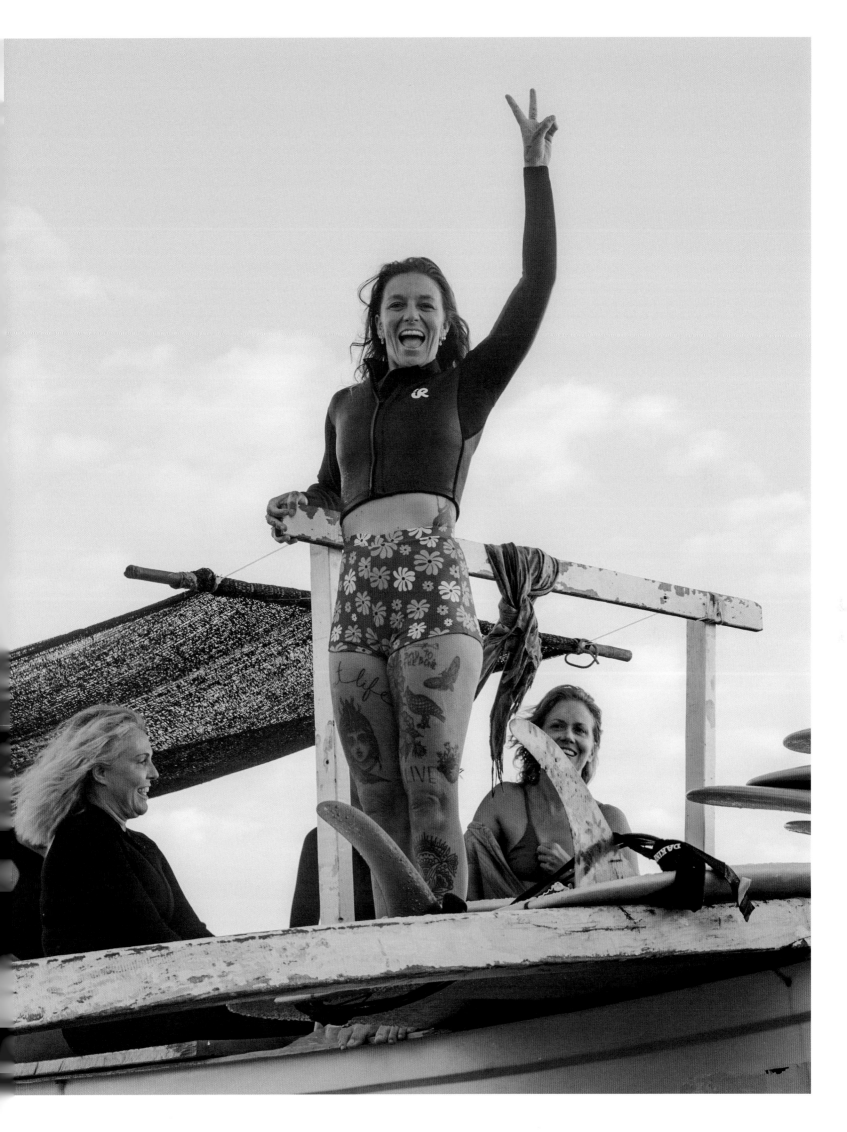

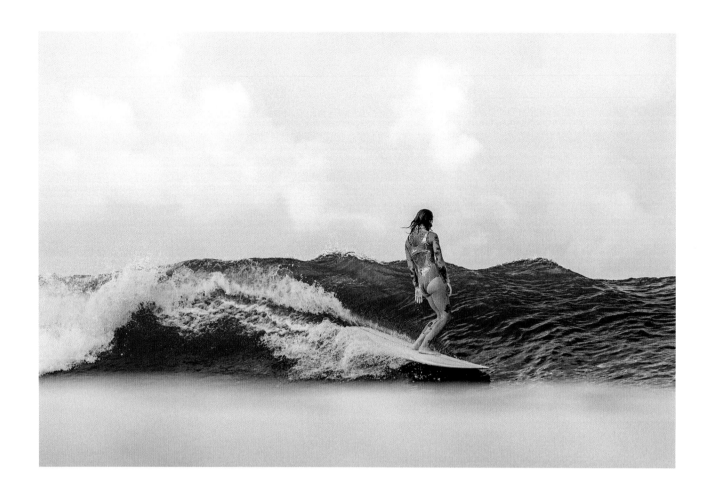

Anaïs Pierquet

When I became curious about finding inner happiness and healing my body image, I opened myself to new ways of thinking and everything started to shift. I stopped relying on society to dictate how I should look, dress, or behave. I freed myself from the depths of my soul and accepted who I am at a deeper level. From this acceptance, we grow, we bloom, we sparkle in every possible way. It's returning to the truth within us—cultivating kindness and love every single day. It's about being aware of the thoughts shaped by society, acknowledging them, and allowing them to pass, like clouds in a blue sky.

Feeling good within ourselves, peaceful, and beautiful is our birthright. No one and nothing holds power over us; we are one with Nature, and our "imperfections," as society calls them, are what make us perfect. These imperfections are the most beautiful expressions of life, and it would be cruel to strip them away from us. You are unique and beautiful. Embrace it!

Top One of my favorite waves in Indonesia, cruising with my spiritual brother Raskal, who took this photo. | Right (top) A sunset in Bali, a time that feels so far away. (Bottom) Endless rides in Bali: there was no one in the lineup that day and it was firing.

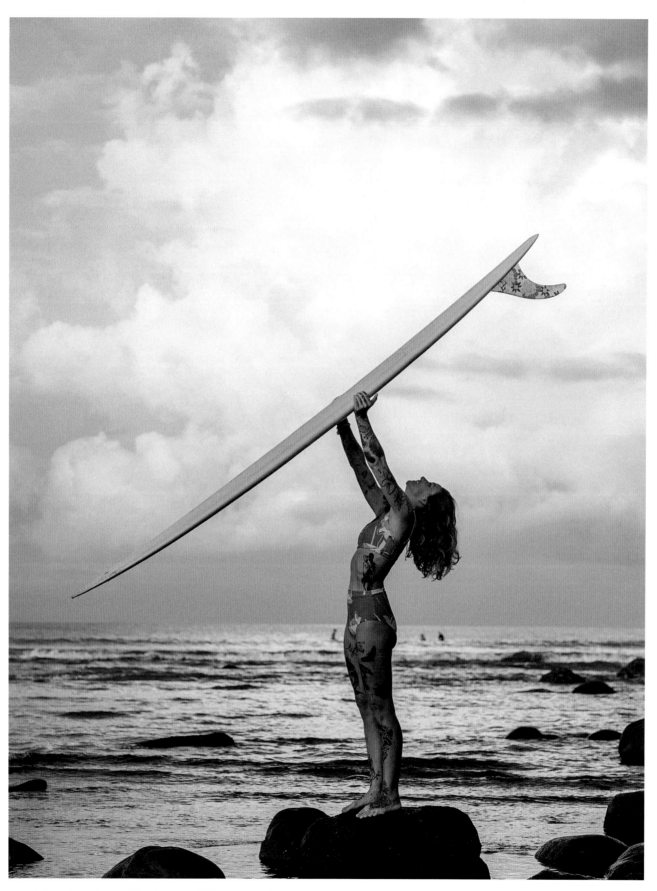

Left (top) This beautiful landscape in Bali is no more. I miss those beautiful palm trees and embracing the sunset there. (Bottom) One of my favorite turns in longboarding. | Top Sunrise up north in Bali, shooting for my new print design with Macho Fin. | Next double page (left) Sunset madness, Mentawai Islands, Indonesia. (Right) Cheat five fever because it's just too much fun, during my surf retreat in Lombok.

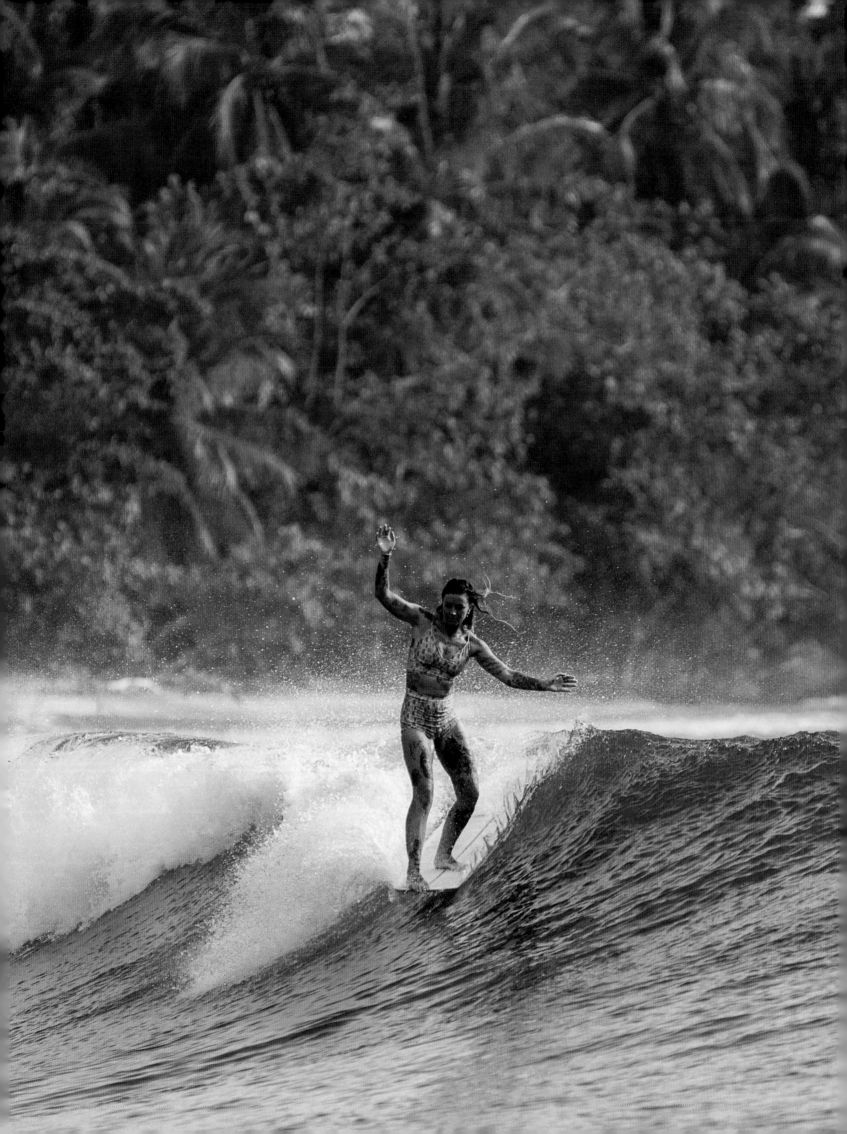

I'm tired of your beauty standards.

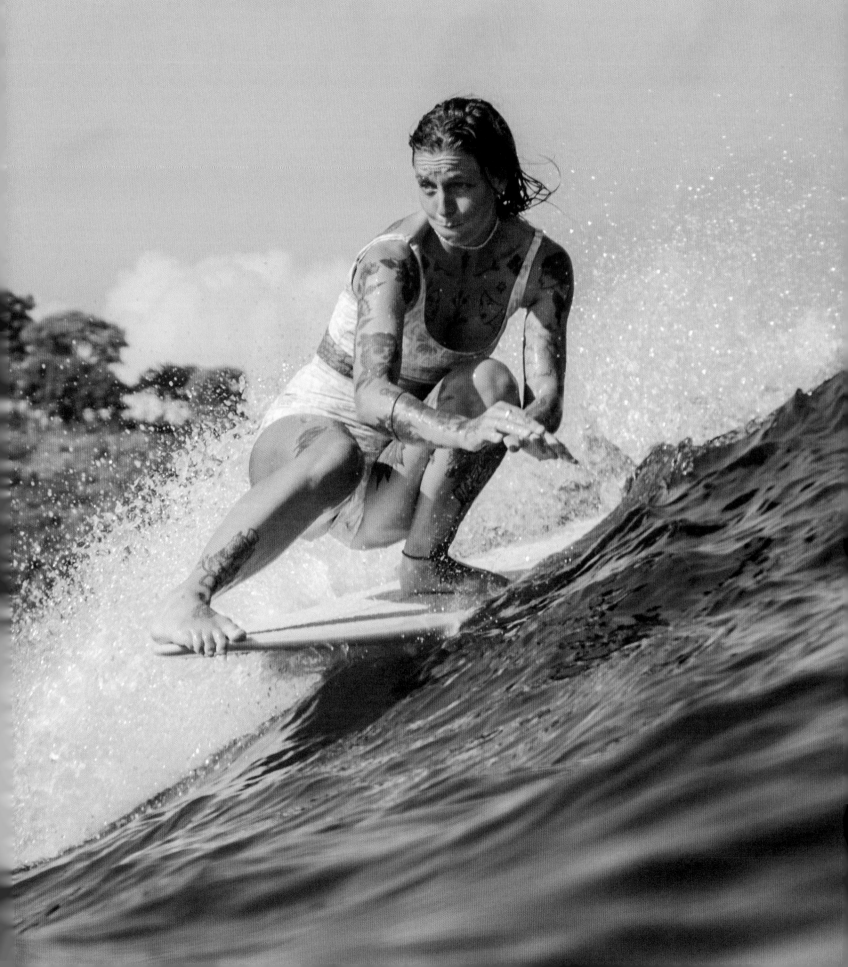

Mika Tennekoon

"For me, surfing will always be more than just a sport: it is a testament to the power of the human spirit to defy expectations, challenge norms, and ride the waves of life with grace."

In a culture where women are seldom encouraged to pursue activities deemed unconventional or risky, surfing represented exactly that—defiance of societal norms and expectations. Yet, as I stood on the shores of Arugam Bay, watching the waves crash against the sand, I felt an inexplicable pull—a calling to embrace the unknown, conquer my fears, and ride the waves of life with courage and conviction.

Surfing became more than just a hobby—it became a metaphor for life itself. With each ebb and swell of the ocean, I learned to navigate the highs and lows of my own existence, finding solace, strength, and a sense of belonging in the vast expanse of the sea. It was here, amid the roar of the waves and the caress of the salt-laden breeze, that I discovered my true essence.

My journey into the world of surfing was not without its challenges. As a woman learning to surf in her thirties in Sri Lanka, I got tanned in the sun—something considered ugly in our culture, a colonial hangup. Wearing a bikini—showing "too much skin"—was considered unnecessary or somewhat scandalous. As a mother, I faced criticism and judgment from those who questioned my priorities and choices, as well as my own self-criticism and doubt about my own emotional and physical state. But it also taught me to foster a deep appreciation of my body and its capabilities, and to be thankful for what it can do, rather than how it looks. It strengthened my connection to nature, where my perspective shifted from me to all that surrounds me. It taught me to celebrate other women who had chosen the same path as me and surfed with me in a very much male-dominated sport.

Today, reflecting on my journey, I am filled with a profound sense of gratitude: for the waves that have carried me through my little storms, for the challenges that have strengthened my resolve, and for the opportunity to inspire others to dare greatly and live boldly. For me, surfing will always be more than just a sport: it is a testament to the power of the human spirit to defy expectations, challenge norms, and ride the waves of life with grace.

The time I first fell in love with surfing. Okanda, Arugam Bay, Sri Lanka.

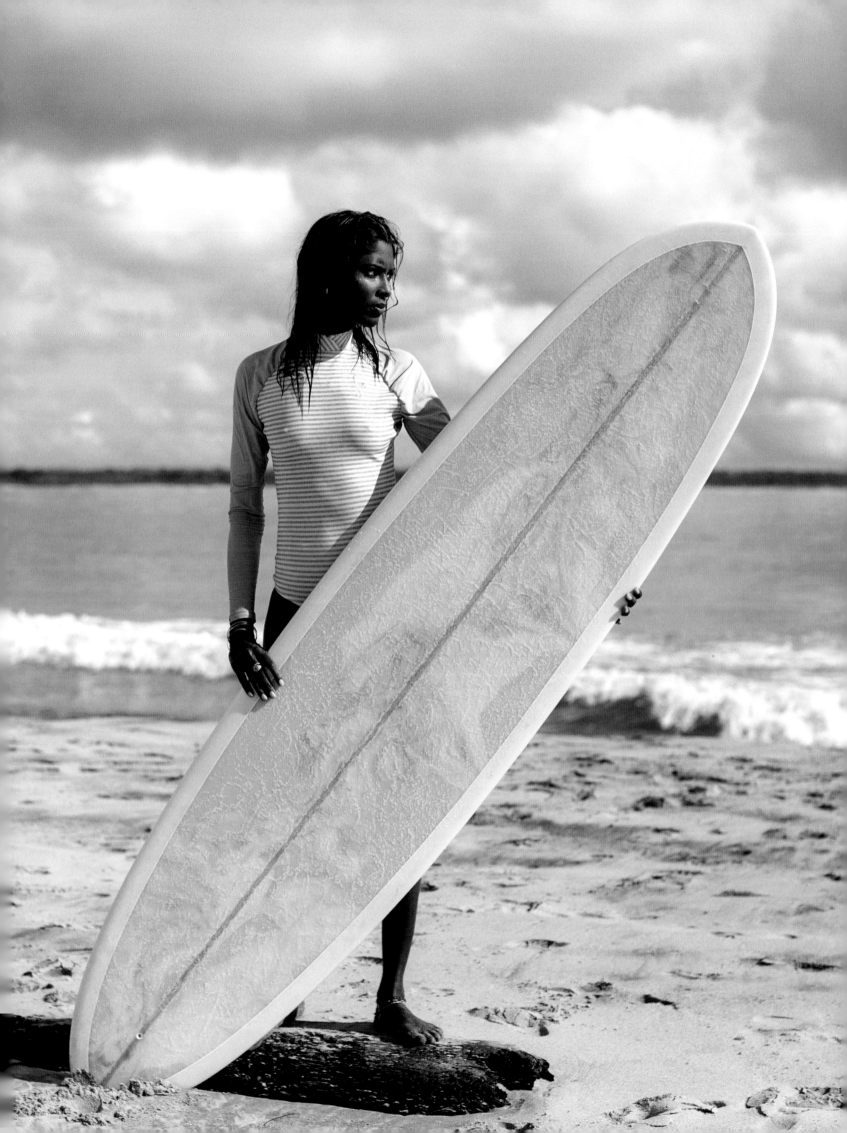

After a long day of design work, painting, and being a mom, this is my favorite way to get some space and time to myself.

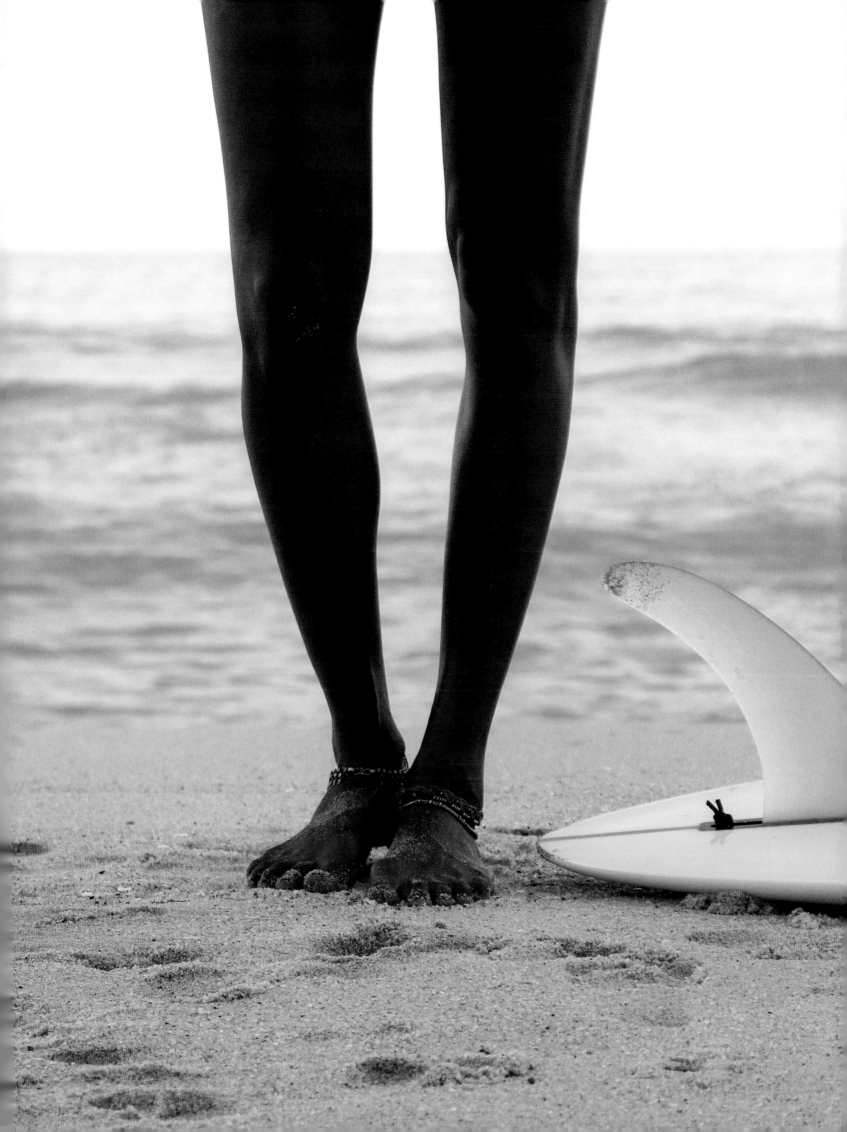

I am powerful.

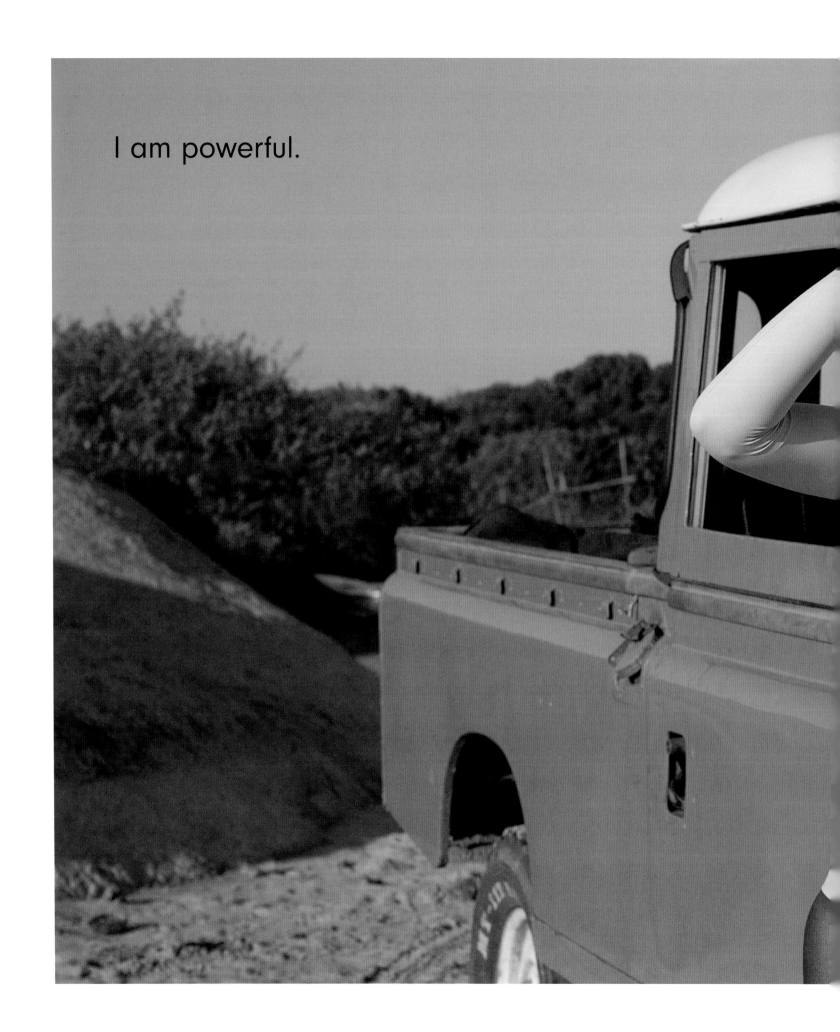

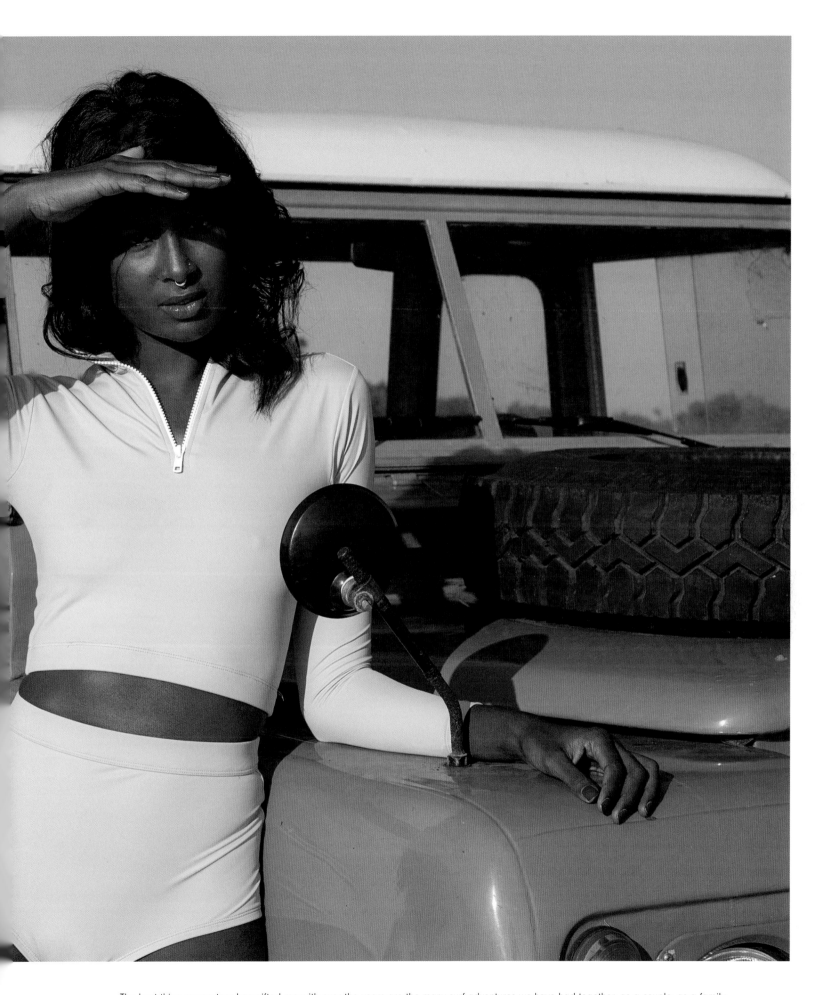

The best thing my partner has gifted me with over the years are the many surf adventures we have had together, as a couple, as a family, and as friends. Magical mornings on the coast, beautiful wildlife, and perfect point breaks.

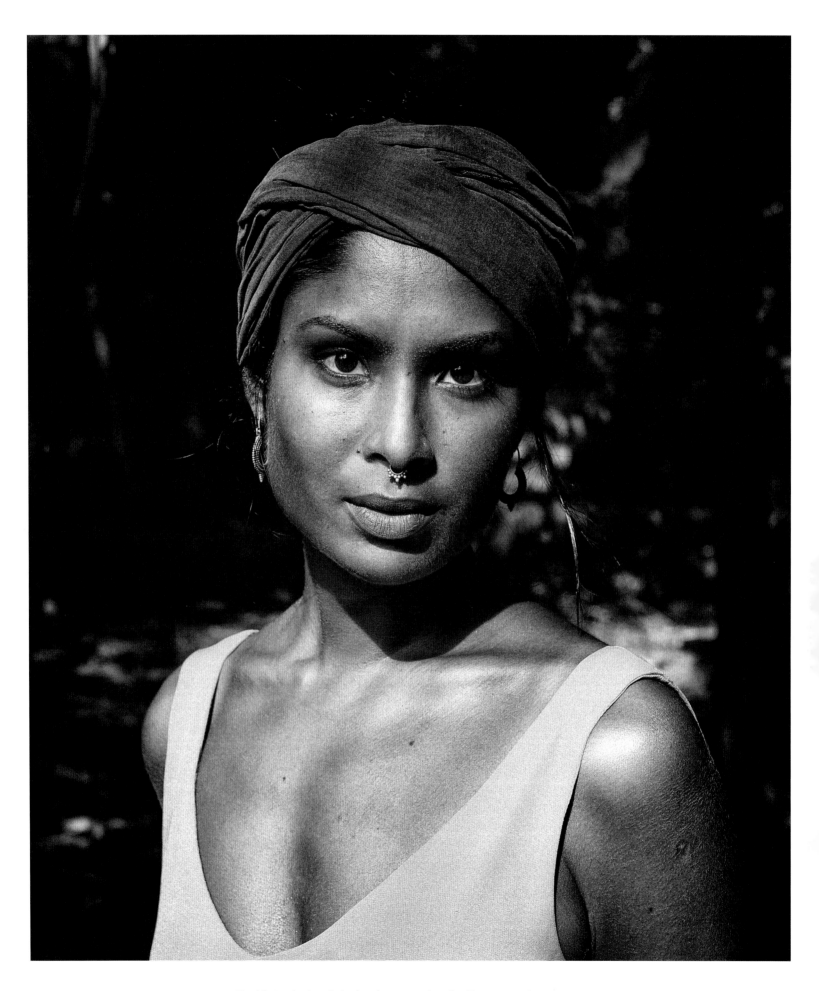

Top Moving back to Sri Lanka after over a decade of living away. I never thought I'd be here, living what I love.

Right My last surf during my pregnancy, at six months, with Sunara and Samia on the south coast of Sri Lanka, Hikkaduwa.

138

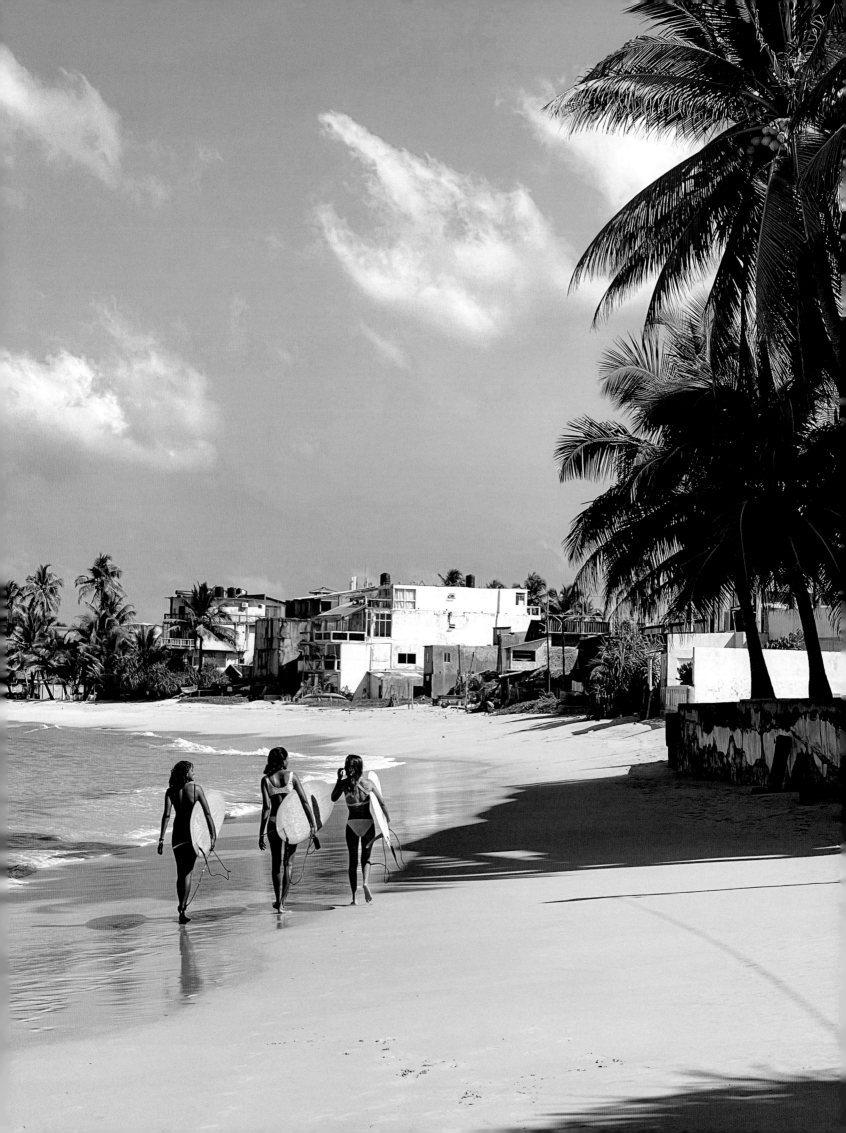

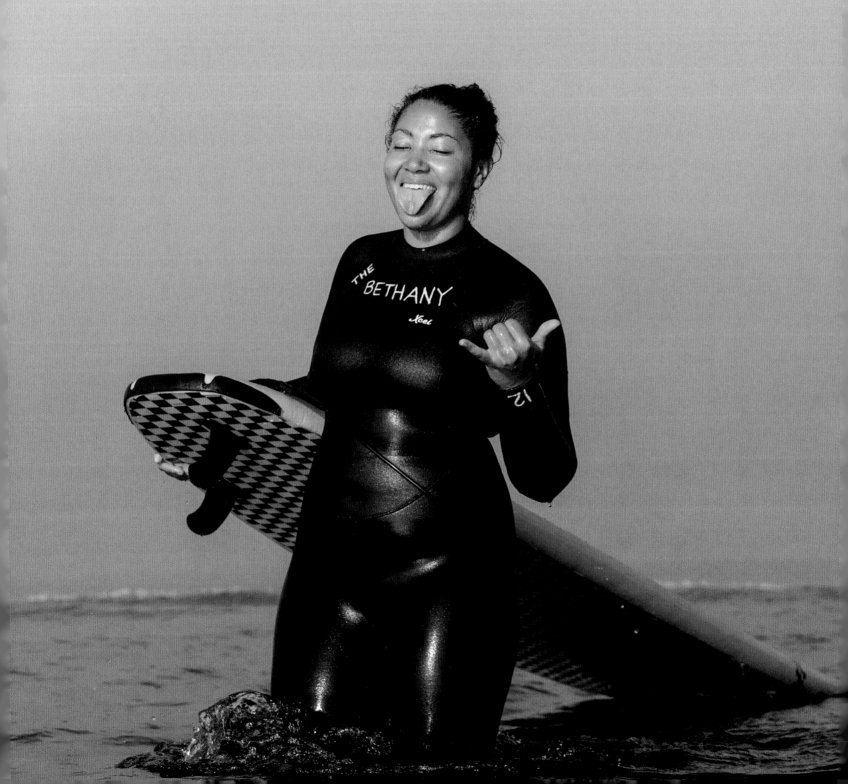

Bitches 'n Barrels

"We are dedicated to getting more women out surfing."

Based on Vancouver Island, our organization, Bitches 'n Barrels, is dedicated to getting more women out surfing. Through accessible surf trips to Tofino, our small team is committed to making surfing more diverse in our communities by creating a safe learning environment for anyone who identifies as a woman or non-binary.

We started Bitches 'n Barrels in 2017 out of a mutual desire to surf with more women. When learning to surf, it didn't take long for us to realize that a predominantly male lineup had resulted in a surf culture entrenched with machismo and exclusivity. We wanted to change that.

We planned a surf trip to Tofino with a group of girlfriends who also wanted to progress at surfing. After getting home from an unreal weekend filled with fun waves, non-stop laughter, and unwavering support in the water, we (somewhat jokingly) referred to ourselves as "Bitches 'n Barrels" in a Facebook post. Within minutes, we had countless women ask if they could join the next trip.

We identified a pattern. Our friends, who were previously intimidated in the surf lineup, felt empowered and motivated to learn alongside a group of women. As word got out, even experienced surfers got excited by the idea of progressing with a community of like-minded women.

We began running surf trips to Tofino, hosting fundraisers and community events in Victoria, and within less than a year, Bitches 'n Barrels was born.

Seven years and over fifty trips later, we remain committed to building a strong community of female surfers and adventurers throughout Vancouver Island and beyond. We want our trips to help participants build capacity and gain confidence through professional lessons and time in the water with other women.

Aliya Weibe, Tofino, BC, Canada.

The trips include a lot of laughing, encouragement, and cheering for each other's wins. Everything comes together to create a safe and inclusive space for the participants to learn and connect with each other. Surfing can have a lot of barriers to entry, and we prioritize cultivating genuine connections among participants. Our ultimate goal extends beyond developing surf skills: we want to build community, foster inclusion, and connect folks with the ocean.

There's a well-known attitude of localism in the Southern Vancouver Island surf scene. Like in many surf spots around the world, crusty locals aren't afraid of hostile confrontations with surfers who they perceive as not belonging or not deserving of the waves. This culture of exclusivity makes it an intimidating environment for people who are learning, and even more so if you don't fit the stereotypical image of a surfer (thin, white, and probably a dude). This is especially true if you're subject to discrimination and exclusion in other areas of life.

"This culture of exclusivity makes it an intimidating environment for people who are learning, and even more so if you don't fit the stereotypical image of a surfer."

Ultimately, we want women and non-binary folks to feel like they belong in the lineup. It's an incredibly vulnerable thing to put yourself out there and be seen trying something that you're maybe not great at yet. Surfing connects us with our bodies, makes us stronger, and reminds us that our value and identity as women extends far beyond what we look like on the surface. Representation matters—this is true for gender, size, and sexuality. We would like to see surf lineups be more representative of the beautiful and diverse communities of people who live on Vancouver Island.

Looking ahead, we hope that our trips play a supportive role in our participants' larger journey with surfing, sport, and adventure by boosting self-confidence and igniting a culture of belonging that extends long after the surf trips are over. We want to encourage our participants to push themselves, connect with their bodies, try hard things, and question any instinct that tells them that they don't belong somewhere.

Natsumi Williamson, Tofino, BC, Canada.

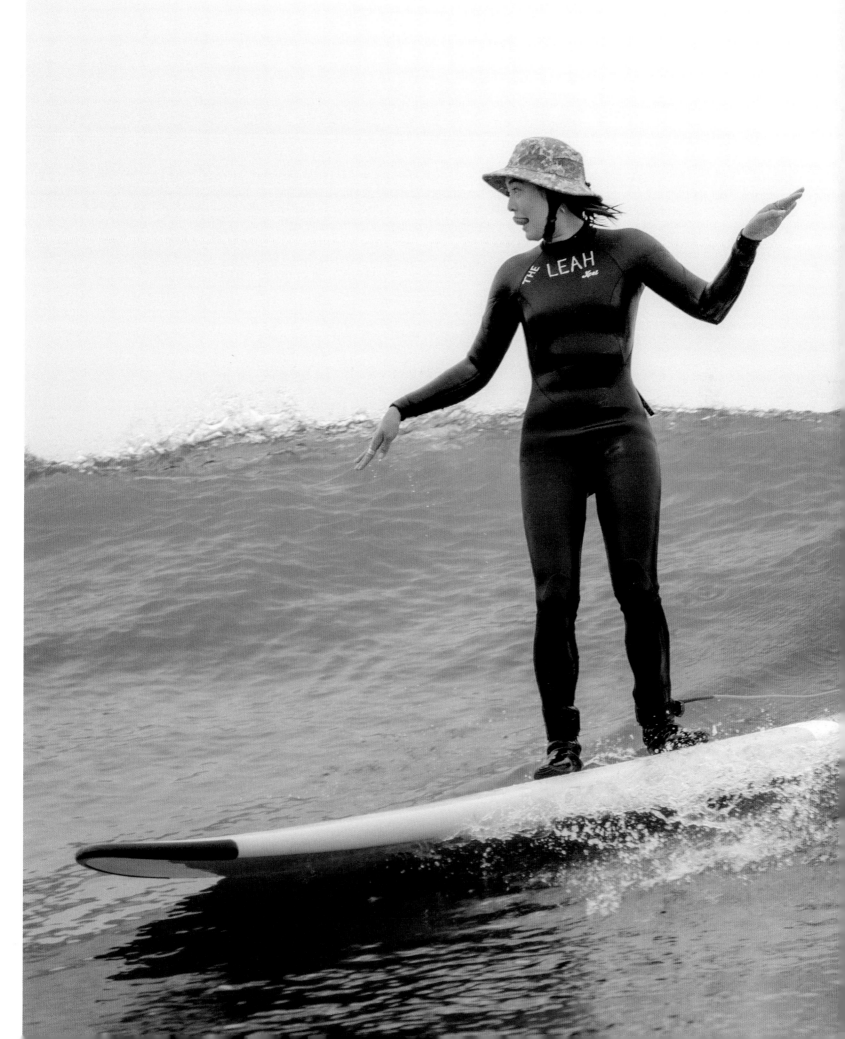

Confidence is not "They will like me,"
confidence is "I'll be fine if they don't."

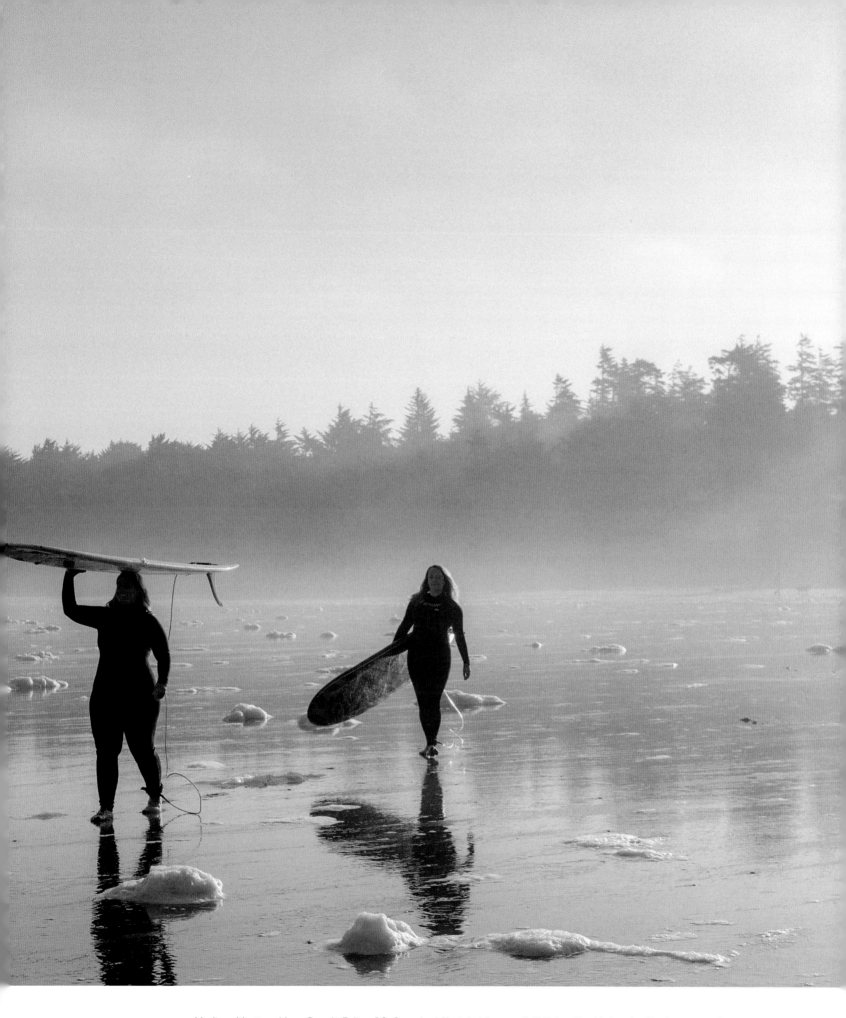

Madison Myatt and Lacy Brandt, Tofino, BC, Canada. | Next double page (left) Robyn Broekhuizen leading her group of participants, Tofino, Canada. (Right top) Tracy Murray, Tofino, BC, Canada. (Right bottom) Magda Rajkowski, Tofino, BC, Canada.

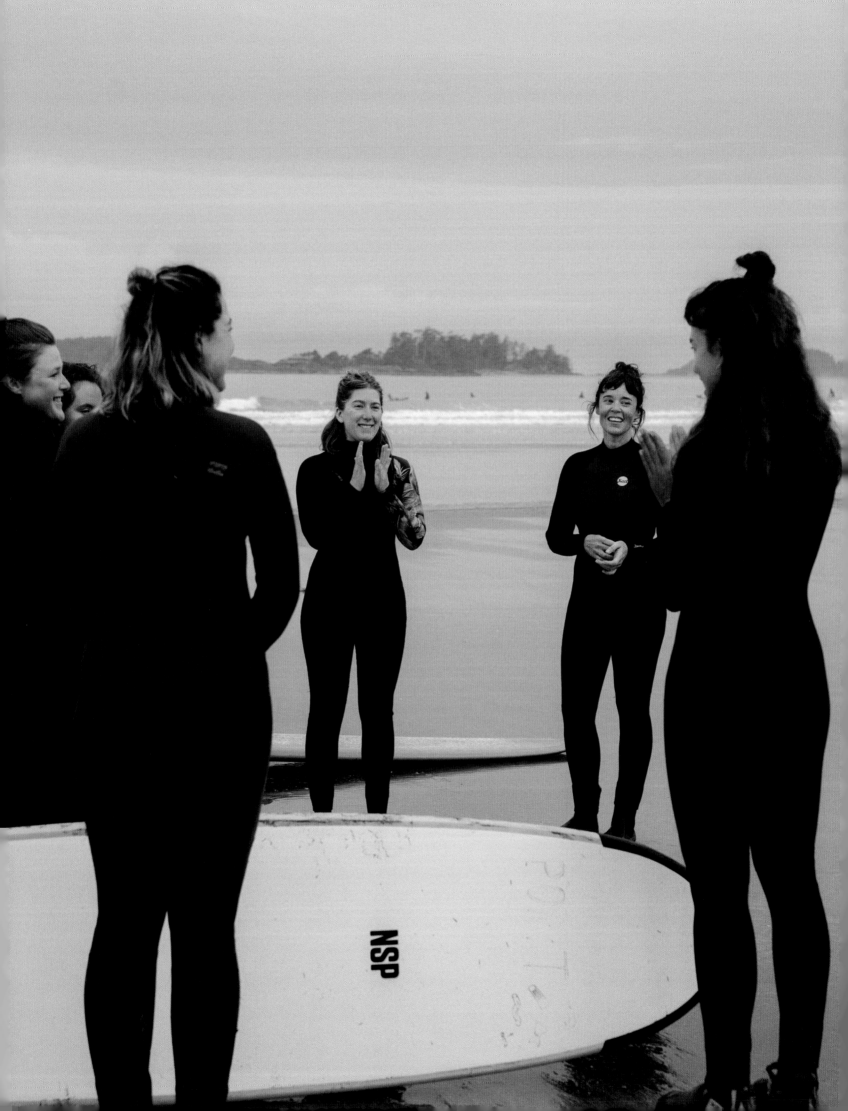

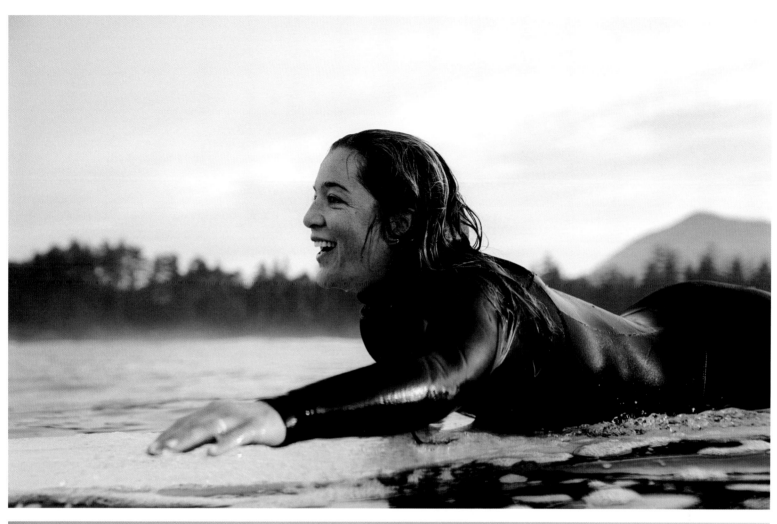
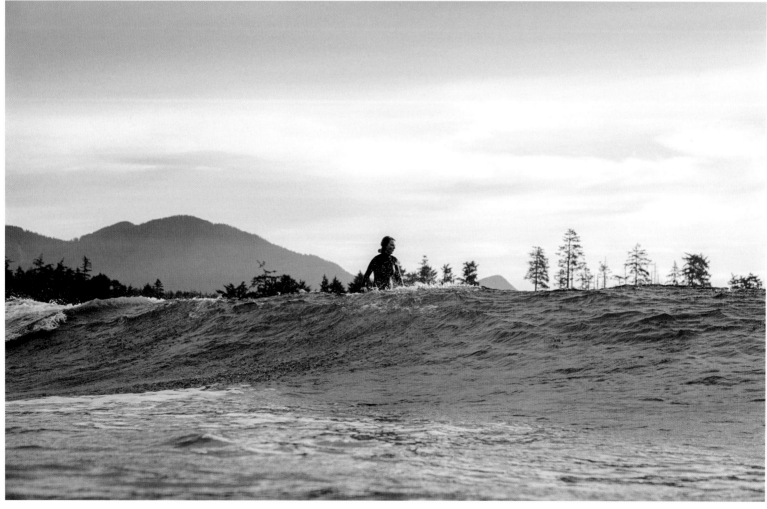

Mehana Pilago

"At my skinniest moment, when a lot of people would tell me, 'Wow, you look great,' I was actually living extremely unhealthily."

Aloha, my name is Mehana! I was born and raised on the island of Hawaii in Kailua Kona. I've been in the water since I was a baby—growing up in Hawaii, we spend the majority of our time at the beach. The ocean is our church. It is a healing place and so therapeutic. Being a mom and business owner with a very hectic and busy life, I believe it is so important to get in the ocean and take some time to yourself. Surfing is like a dance in the ocean, and in my opinion the best dopamine and serotonin rush you can get! Me and my two-year-old son regularly walk the beaches in the morning to find cool shells and ponds. His favorites to collect are opihi shells. We are so thankful for the warm clear water here and to live on such a beautiful island with so much mana.

When I'm not at the beach, I'm in my studio, Ka'eo Hawaii Tattoo and Creative Studio. I tattoo as well as running a small design agency, where I design merchandise for local brands, manage social media pages, and offer various graphic design services. I also curate a local art show where we focus on creating a fun space for local artists and entrepreneurs to share their art with the community. I am a huge believer in community and the arts and hope to keep creating a safe space for creativity.

I always had an unhealthy relationship with my weight growing up. I was never small, I was always bigger: "big-boned" or "stronger," as some would say. And at my skinniest moment, where a lot of people would tell me, "Wow, you look great," I was actually living extremely unhealthily and battling with partying too much and not eating enough. So my overall relationship with my fluctuating weight has been a rollercoaster.

Hawaii.

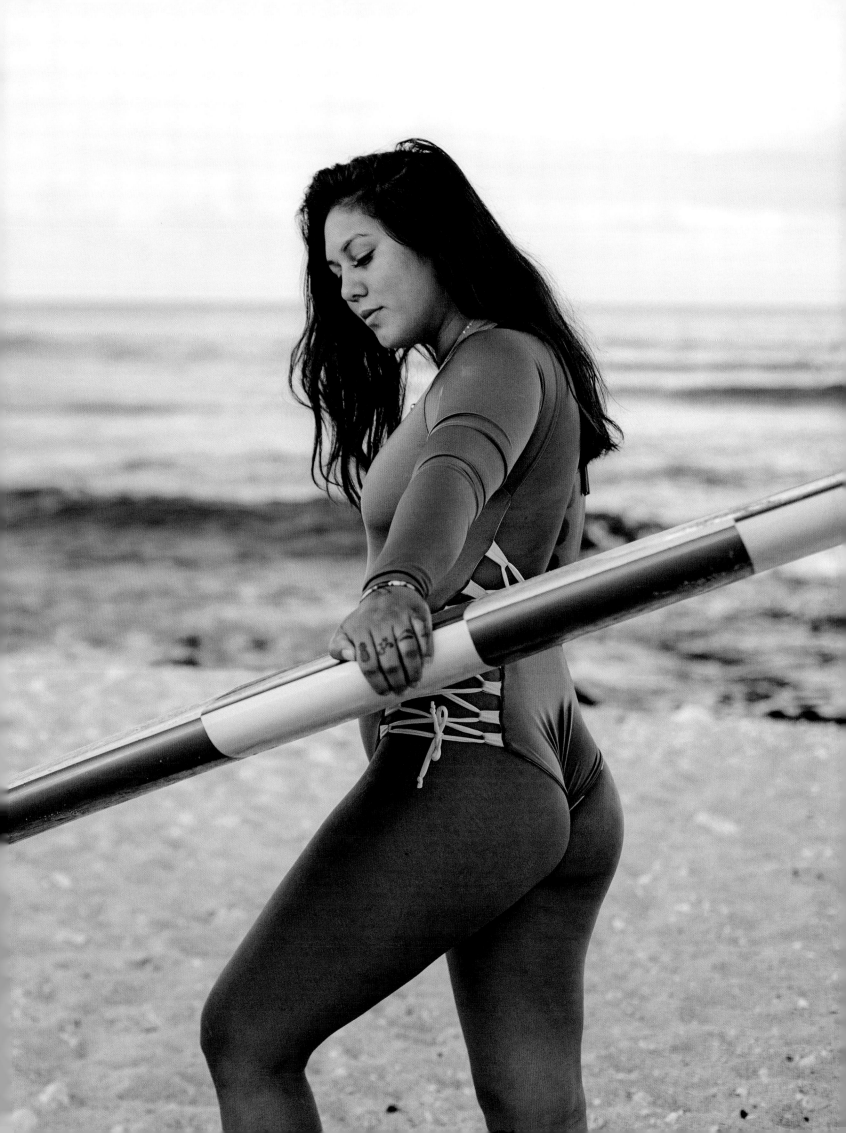

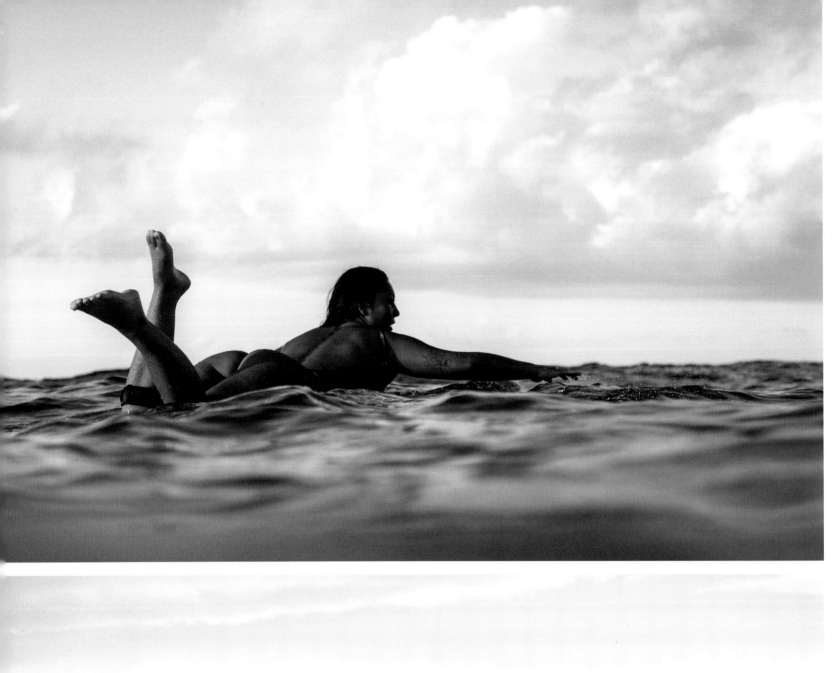
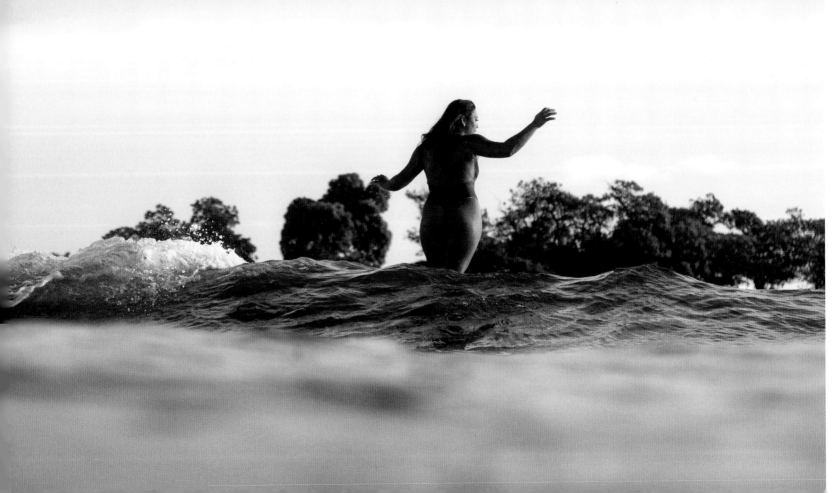

"I've always had an unhealthy relationship with my weight growing up. I was never small, I was always bigger: 'big-boned' or 'stronger,' as some would say."

Mehana Pilago

It started when I got my stretch marks almost all at once towards the end of my pregnancy. For months I thought I would be one of those lucky girls that didn't get any, but I should have known that was unlikely. I knew I would struggle with my body image after giving birth so that wasn't a huge surprise, but the first month definitely had its challenges still. I didn't fit into my regular clothes but was too small for my maternity clothes and just didn't feel like myself yet.

I am so thankful for even having the opportunity to create and grow a human inside of me. It's unbelievable our bodies are even capable of that. But still we have feelings and emotions about how we look, unfortunately, especially when we compare ourselves to what we see online. I have always admired people who have shown their real identities online and the raw realness of their lives. So, I hope to do the same on my platform. Even though it can be uncomfortable, it also feels empowering and motivating.

We are now almost one month postpartum and I am excited to get back to my strength: not a number on the scale, or a comparison to someone, but a place where I feel strong again. This is just the beginning.

Surfing at Kailua-Kona, Hawaii.

Stop promoting unhealthy beauty standards.

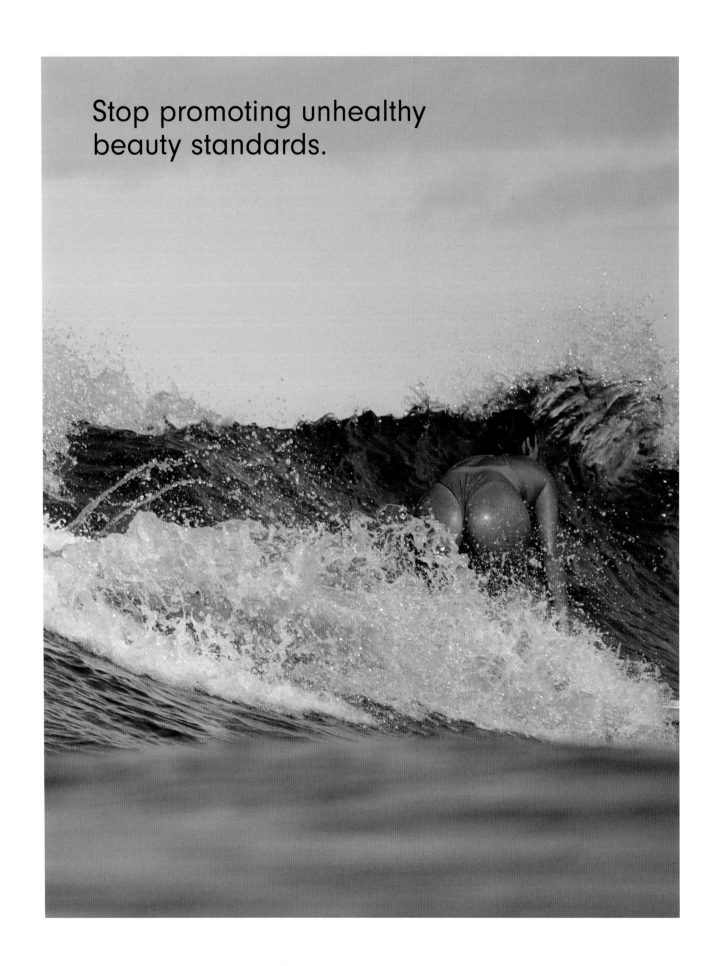

When I was pregnant, I surfed until my stomach was too big, probably around five months.

152

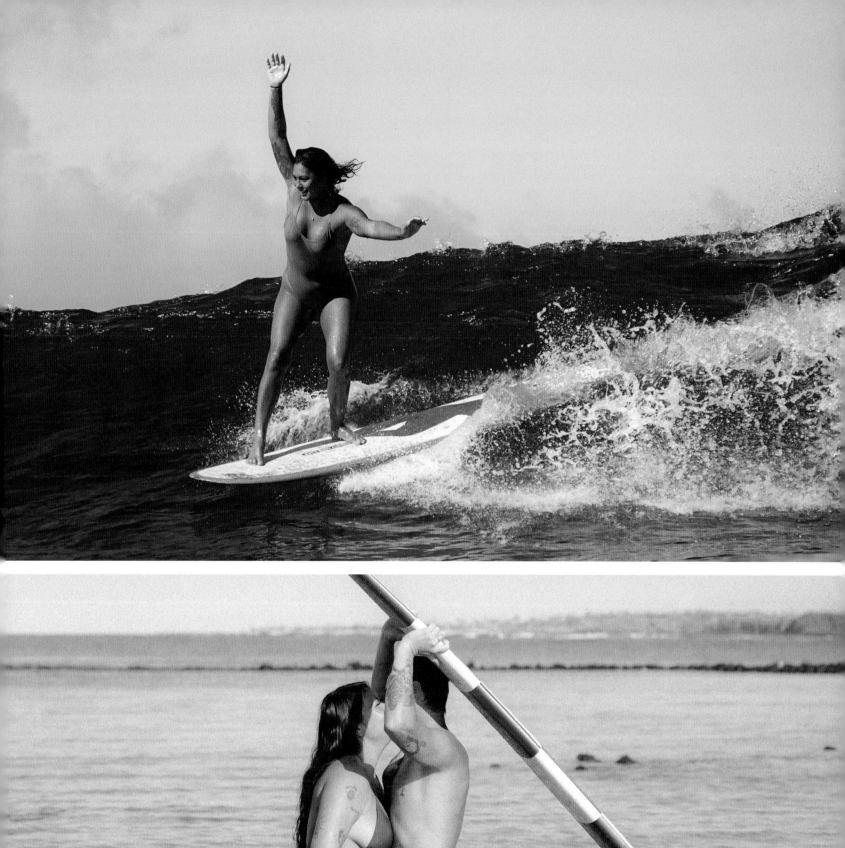
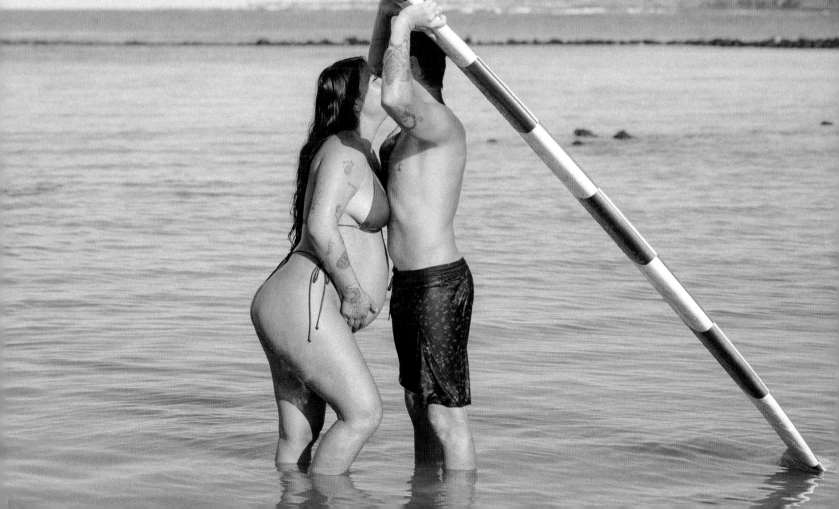

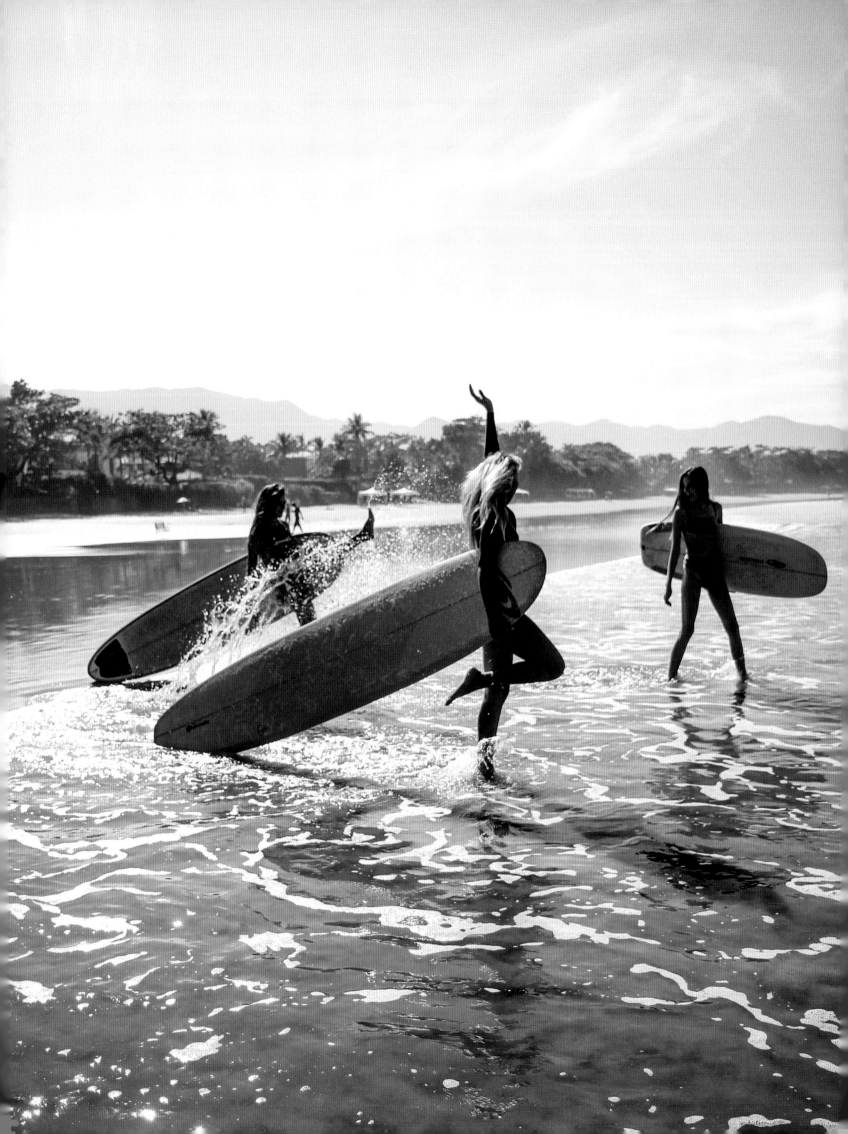

Gabriela Haydée

"Why do we try so hard to fit in a box, to look like others, struggle to follow fashion, and kill our authenticity in order to fit in?"

As often as not, I find myself thinking about the beauty of the diversity that can be found in nature: how one tree is never like another, how unique the mountains and even the shapes of clouds are, and how amazing it is to have thousands of species of birds, flowers, and insects. As a photographer, it is mesmerizing and inspiring to be part of such a beautiful and diverse world.

For this very reason, I also ask myself: why, as humans and especially as women, do we try so hard to fit in a box, to look like others, struggle to follow fashion, and kill our authenticity in order to fit in?

It is hard to find an answer.

It seems that the more we try to hold onto these standards, the more disconnected we become from our essence, from our true selves, for the sad purpose of just following the mass of society.

That's why I love surfing. I love how wild and authentic this form of human expression is. How free we can be while riding on a wave and feeling the ocean around us. You don't get too much time to think or to self-criticize while doing these things. You're just there, actively meditating and connecting yourself with your true nature.

I feel happy to see more and more women experiencing this wherever I go, embracing their authenticity, feeling freedom, and loving discovering their own identities through the waves.

That's why I believe that surfing is not just a sport. And it's even more than a lifestyle. It is an invitation to look inside and comprehend that we are not just part of nature, but we are nature itself. Our shapes are as unique as the shapes of nature, and that's why we are essentially beautiful and uniquely free.

During a photo shoot for a surf brand in Brazil with some dear friends. As a photographer, I get so happy every time I realize that this is my work, this is what I do for a living!

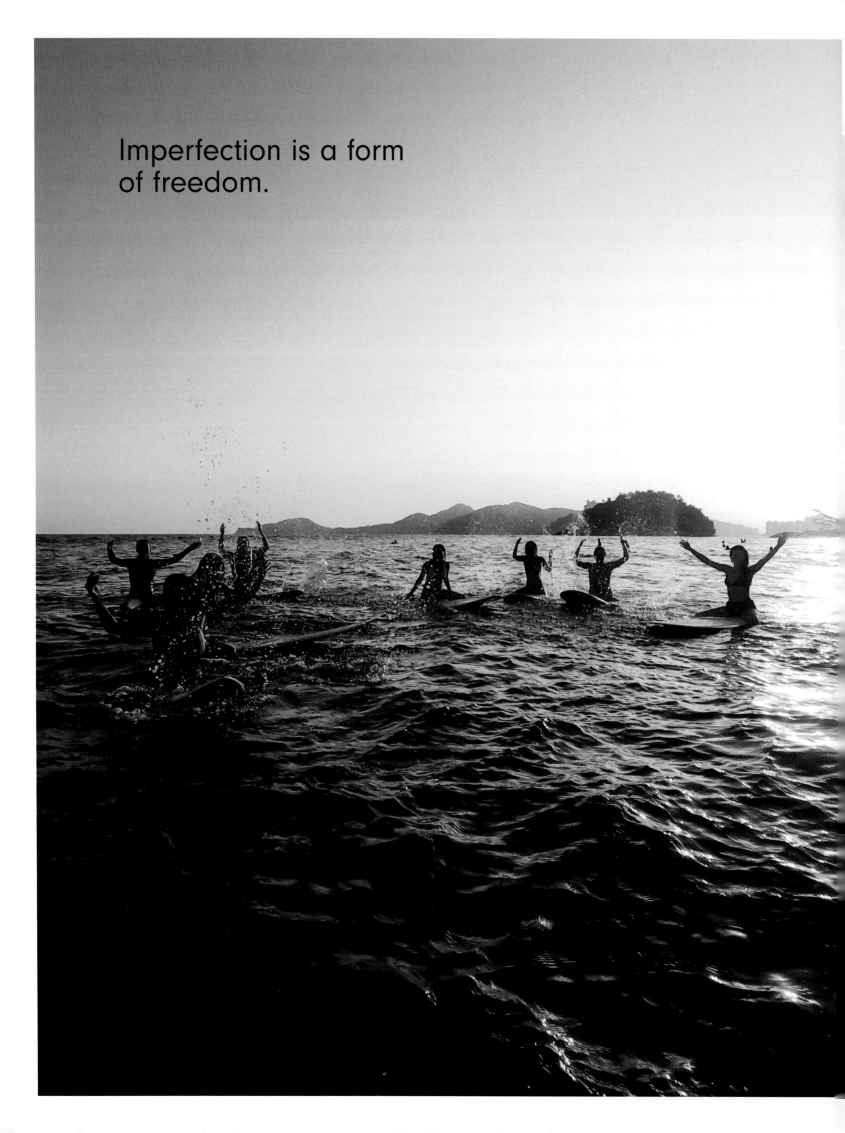

Imperfection is a form
of freedom.

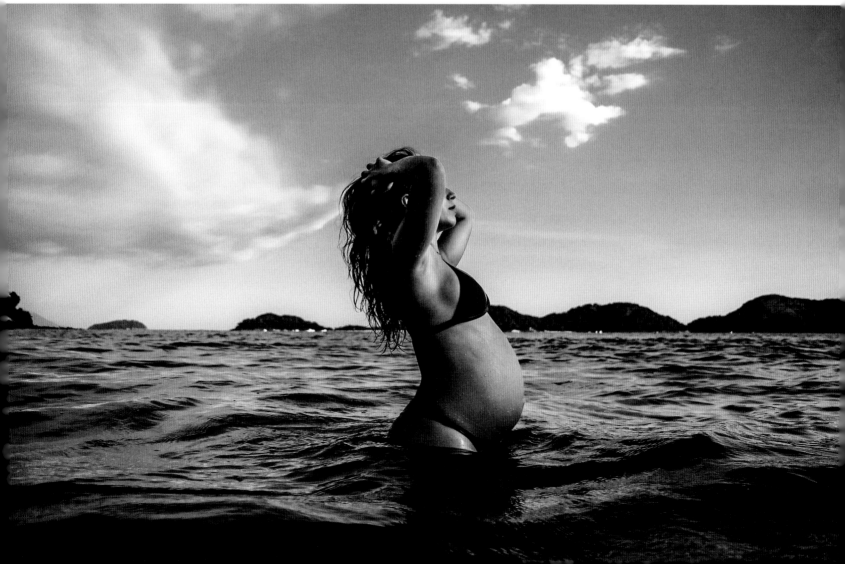

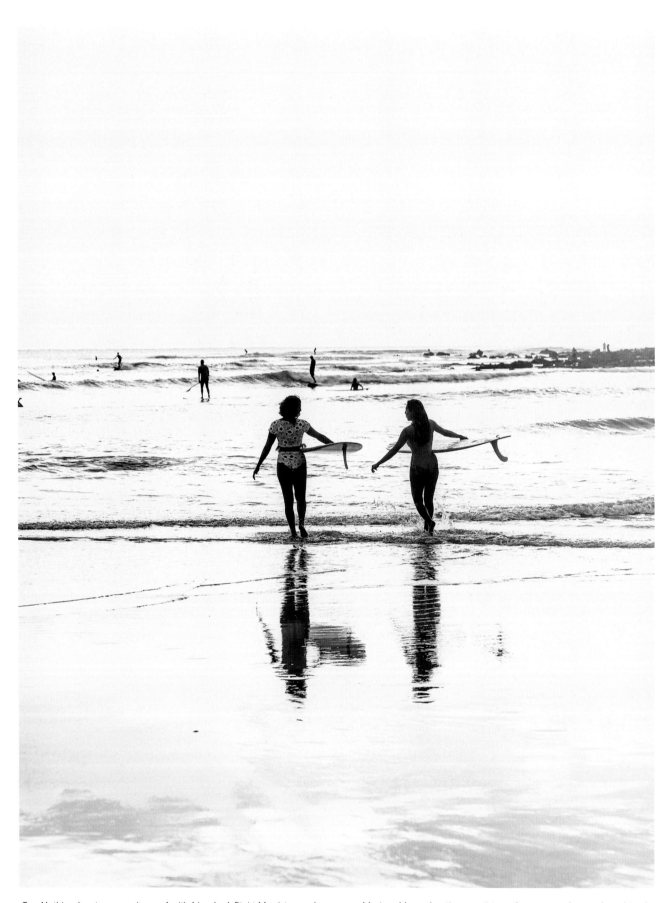

Top Nothing beats a morning surf with friends. | Right My sister and my muse, Marina. I love shooting my sisters, they are my forever best friends.
Previous double page (left) It is really special to be out there surfing with everyone, meeting your friends along the waves. (Right top) Driving around
and getting to know new places, with an adventurous and curious heart. (Right bottom) How divine, powerful, and inspiring can a woman be?

158

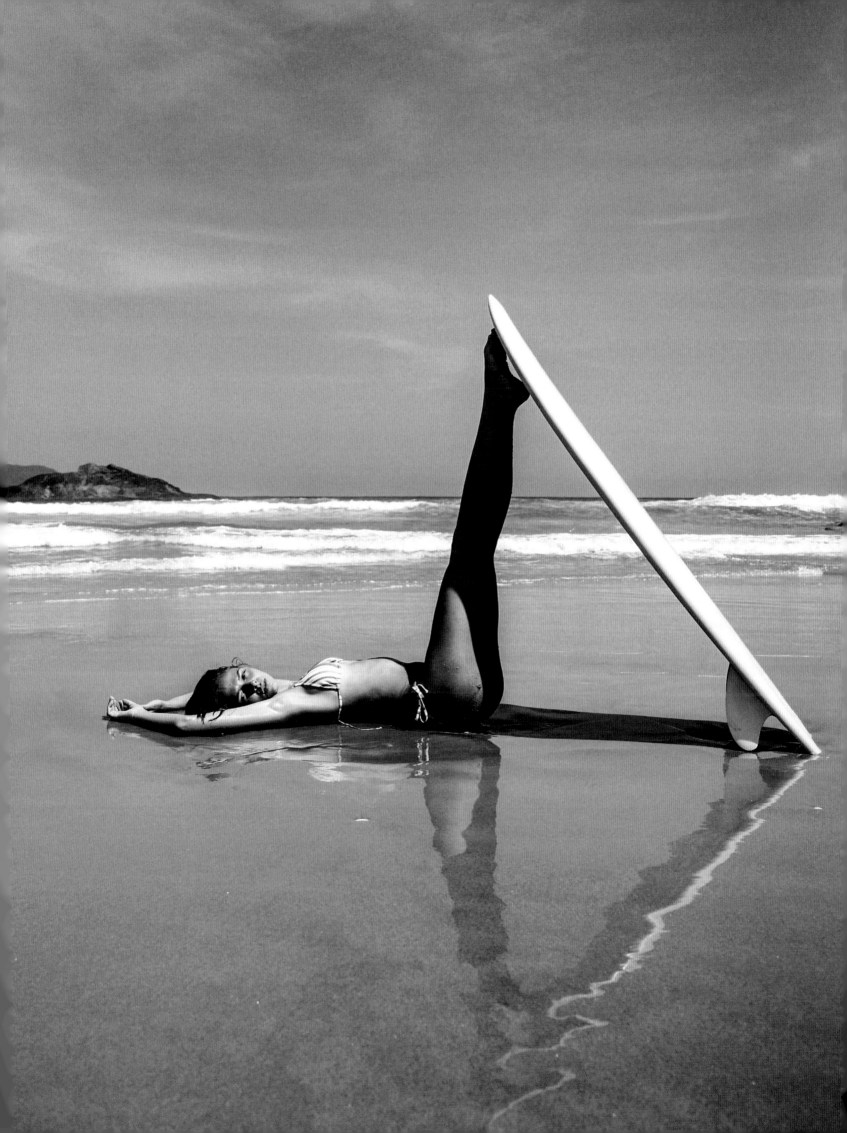

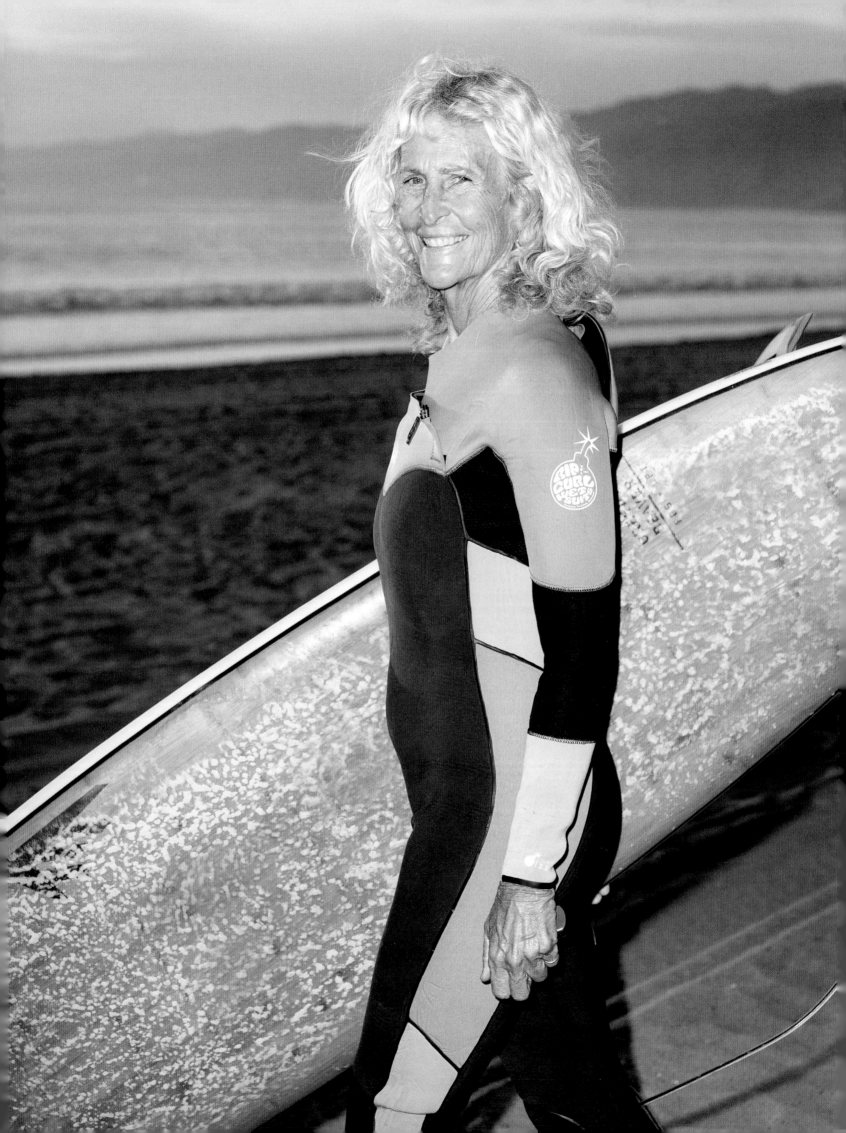

Patti Sheaff

"I can tell anyone who plans to surf well into their senior years to keep moving. Keep strengthening."

I started surfing whcn I was 14 years old. I'm 68 now and I'm still surfing. I enjoy it now more than ever!

My focus and commitment to surfing enabled me to bypass many of the body issues so many women struggle with: weight, eating disorders, dysmorphia, and obsession with appearance. This does not mean I haven't had challenges; mine have centered around injuries. I didn't discover that I had severe scoliosis until I was 28 and I had already broken a vertebra and herniated two discs at that point. Broken fingers, broken wrist, meniscus tears, knee troubles. I had to work hard to keep my body functional and able through all the injuries.

Now I struggle with a second thing called "aging." Keeping my body functioning is now my main priority, along with fighting not to succumb to the conventional idea of growing old. I have no desire to "age gracefully" in the traditional sense. I've been surfing for 54 years, longer than most people in the water these days have been alive. I know of only one other woman in the water who's older than me, and I'm the one who taught her to surf when she was 58!

When I started surfing, I lived 20 miles away from the beach and I had to take three buses to get there. When my older friends got their driver's licenses, they drove me to the beach all summer long. The Beach Boys were on the radio and I was dreaming of waves. I quit school at 17. I couldn't concentrate; I was obsessed with surfing. School could wait; surfing could not. I got a job and saved enough money to move to Hawaii, a dream that I'd always had. I was oblivious to what other people thought I should be doing with my life: going to college, getting married, having kids, things I saw most of my girlfriends doing.

The surf scene in Hawaii in 1974 was dominated by men, but women surfers like Rell Sunn and Lynne Boyer were surfing big waves and making a name for themselves. If it was a sexist atmosphere, I didn't know it, because I was so focused on getting better at surfing the powerful Hawaiian waves.

As part of this shoot for *Ageist,* an online magazine, we talked about aging and movement and how important it is to keep fit.

Patti Sheaff

I didn't pay much attention to how the guys in the water treated me at first, but I did notice that they rarely talked to me and occasionally gave me stink-eye. When I started catching waves and they could see I could surf, I got respect.

In those early days of women's competitive surfing in Hawaii, there was no prize money and barely even any trophies. I enjoyed competing and even got invited to the US Championships at Cape Hatteras in 1974, but the truth is, I've never understood how anyone could judge surfing. It's such an individual expression; it's a dance, it's an art!

After a few contests, I decided that competition was not for me. I was attracted to the free-spirited, gypsy lifestyle that traveling and surfing provided me. I loved traveling to find new surf spots; we were always trying to find uncrowded perfect waves.

"I was never really thinking about how 'old' I was; I cared only about what I needed to do stay active and keep surfing."

I loved surfing, but I wanted more: at age 29 I became a skydiver, racking up more than 1,500 jumps over the next two decades. I also started snowboarding at age 44 and for the next ten years chased mountain storms and powder with my friends in California, Utah, Colorado, Alaska and Canada. I continued to surf the whole time.

Things came pretty easily for me as an athlete, but they came with a cost: lots of pain. Eventually the physical consequences of charging hard catch up. Sometime in my fifties I noticed I needed to work harder to keep going: I started doing yoga, TRX training, lifting weights. I have always cared for my body, but after years of hard landings, crashes, broken bones, procedures, and surgeries ... my body felt broken. Conventional thinking definitely would have said—you're broken. This was the decade of pain! I was still surfing, but it was becoming more and more difficult to pick my surfboard up off the ground because of back pain.

I was never really thinking about how "old" I was; I cared only about what I needed to do stay active and keep surfing. I knew I couldn't live without it!

I had to make some changes: a hot-dog dinner from 7-Eleven wasn't going to cut it anymore. I began researching foods and supplements that would promote healing and muscle maintenance. And just when I thought I would have to give up surfing after a snowboarding fall on an ice patch that fractured my sacrum, I found a training program that changed the trajectory of

Top Nice takeoff with Santa Monica city behind me, captured by underwater photographer Bruce Olinder, my friend and diving buddy. Bottom My happy place for sure!

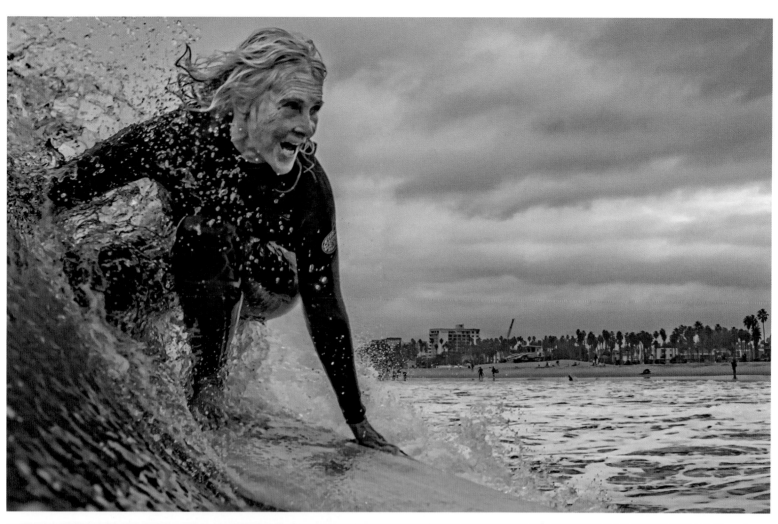
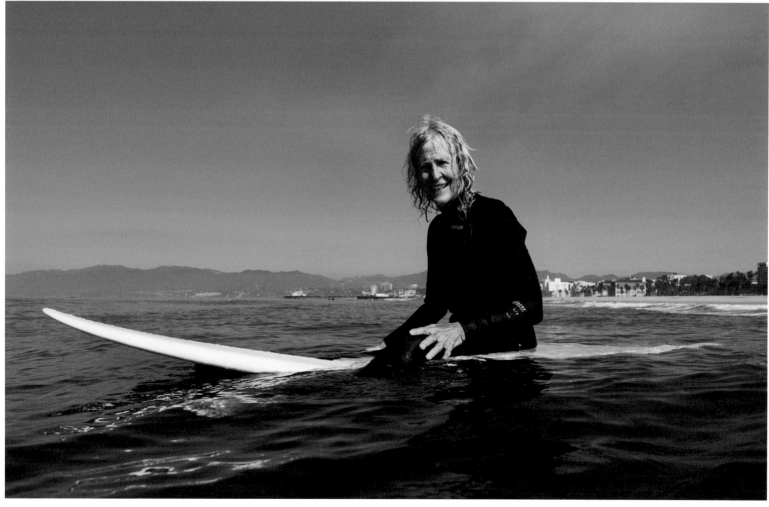

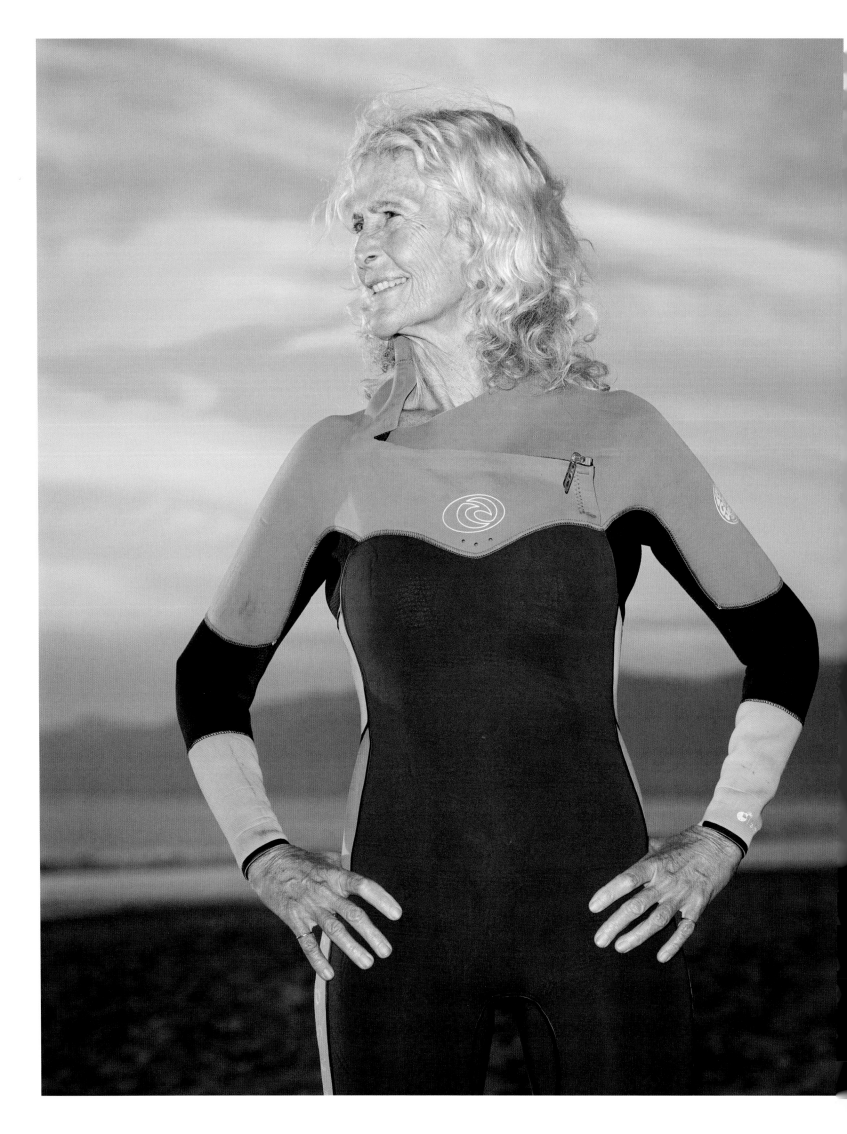

Patti Sheaff

my surfing life. It was a godsend. It delivered a miracle to me. I had been out of the water for a year when I discovered Foundation Training (FT), developed by Dr. Eric Goodman, as it was just being introduced to the public.

I began FT, which is series of corrective exercises that completely reversed the chronic severe low back pain I had been experiencing for years. To this day it's helped so many surfers of all ages. FT also has made me stronger— strong enough to want to add different types of training, such as Gyrotonics and Pilates. It has been ten years since I discovered FT; I became a certified instructor and now help other people relieve their back pain. I have a gym in my living room, an infrared sauna in the guest room, and my diet is filled with massive amounts of protein and good stuff. I am more than excited about surfing today. In fact it blows my mind.

In my mind I'm always 19 years old. I've never followed the crowd when it comes to conventional thought and my beliefs around aging are no different.

You don't stop surfing because you get old; you get old because you stop surfing!

Left Standing strong on the beach in Santa Monica. What makes me strong? Foundation training! Top The takeoff is the most critical part: set your rail and feel the glide.

Ming Hui Brown

"The ocean has many lessons to offer. Loving my strong and beautiful body is one of them."

I'm Ming Hui Brown, current International Women's Longboard Champion, from Ventura, California. My passions are sharing my love for the ocean and body positivity.

My surfing journey started during a tumultuous time of my life. When I was eight, my family moved from the exciting, cosmopolitan city of San Francisco to a quaint but very small Southern California beach town. With this huge culture shock I felt my world crumble; losing my friends and everything I knew was devastating. I became a very angry kid who felt out of place and alone. The only place that brought comfort was the beach.

I felt at home playing in the waves. That's when I discovered surfing. I convinced my father to get me a board and teach me how to surf. And just like every surfer says, I took off on my first wave and I was hooked. (Actually, screaming "Don't push me to the big—3ft—waves!!!!" But we'll leave that part out.)

Surfing was the only thing I could think about. Every school assignment somehow turned into a surfing project that featured a full-color crayon drawing of me perched at the top of an unbelievably massive wave. Literally, surfing saved my life, and when I surf, I feel peaceful and serene. I started competing in surf competitions and did very well. We would travel up and down the coast of California almost every weekend for competitions. I had a lot of success usually placing in the top three. When I started looking for sponsors to work with, I realized that I wasn't exactly what the surf brands were looking for.

Free surfing with Macy Machado before the Queen of the Point contest, La Union, Philippines.

Ming Hui Brown

From the very beginning of my surfing career, I have felt out of place, I never fit the mold of a "surfer girl." My mom is Taiwanese and I wasn't exactly blonde, blue-eyed, thin, and petite. The big surf companies weren't quite ready for the darker exotic look that I proudly sport. How times have changed :)

The only time I felt confident was when I was surfing. Out of the water, I would look at myself in the mirror and tear myself apart. "You have thunder thighs," "your shoulders are like a football player's," and "your body is not desirable," I would think. But out on the waves, my body image would morph from negative to positive. My football-player-like shoulders helped me paddle through big winter swells and into head-high waves, and my big thighs allowed me to make powerful bottom turns in critical sections of the wave. My "undesirable" body is the reason why I'm such a powerful and graceful surfer.

"My body image would morph from negative to positive. My 'undesirable' body is the reason why I'm such a powerful and graceful surfer."

The ocean has many lessons to offer. Loving my strong and beautiful body is one of them. During my 20 years of surfing and being a water woman, I have been humbled many times by the ocean. It taught me how to look at a big terrifying wave and stay calm, even though I know I'm about to get worked. I owe my self-confidence and my positive outlook on life to the ocean.

I pride myself on working with brands that resonate with my morals. Modeling for Crave designs has helped boost my confidence in my curves and surfing ability. La Jolla, California.

Top C-Street, California. | Right El Refugio State Beach, California.

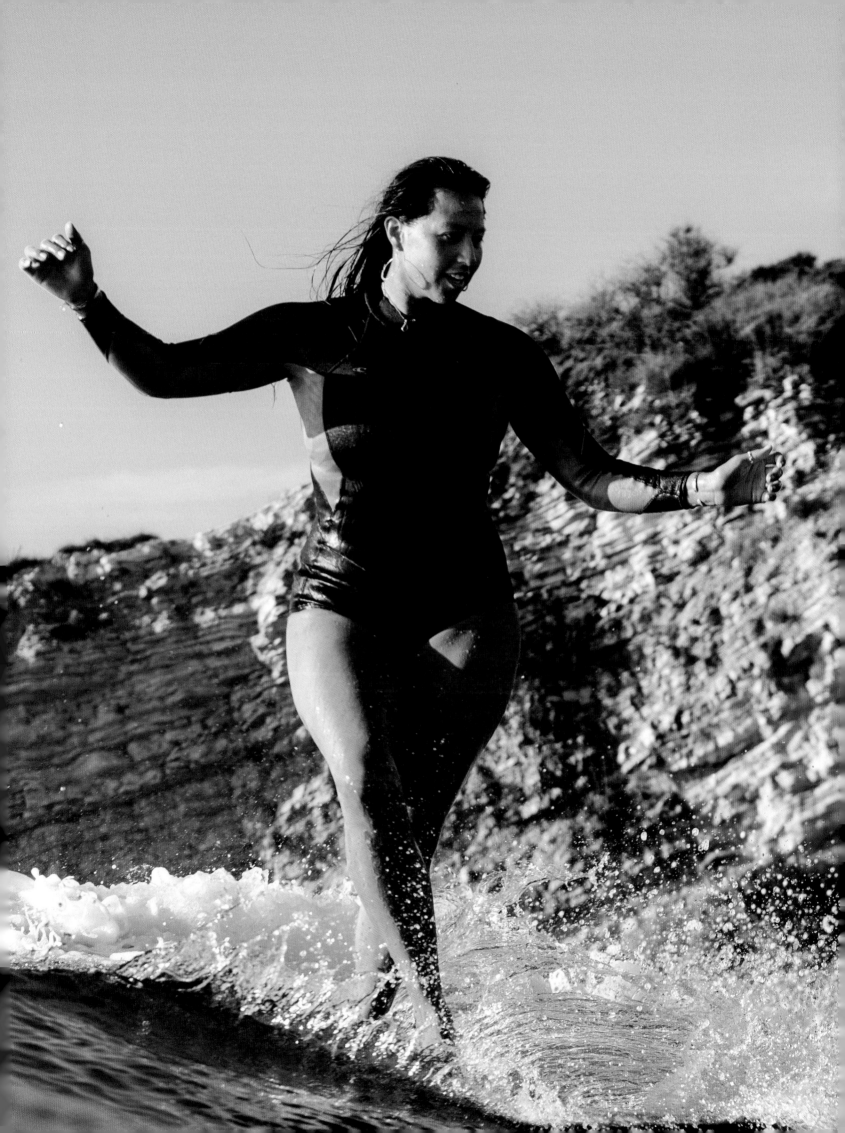

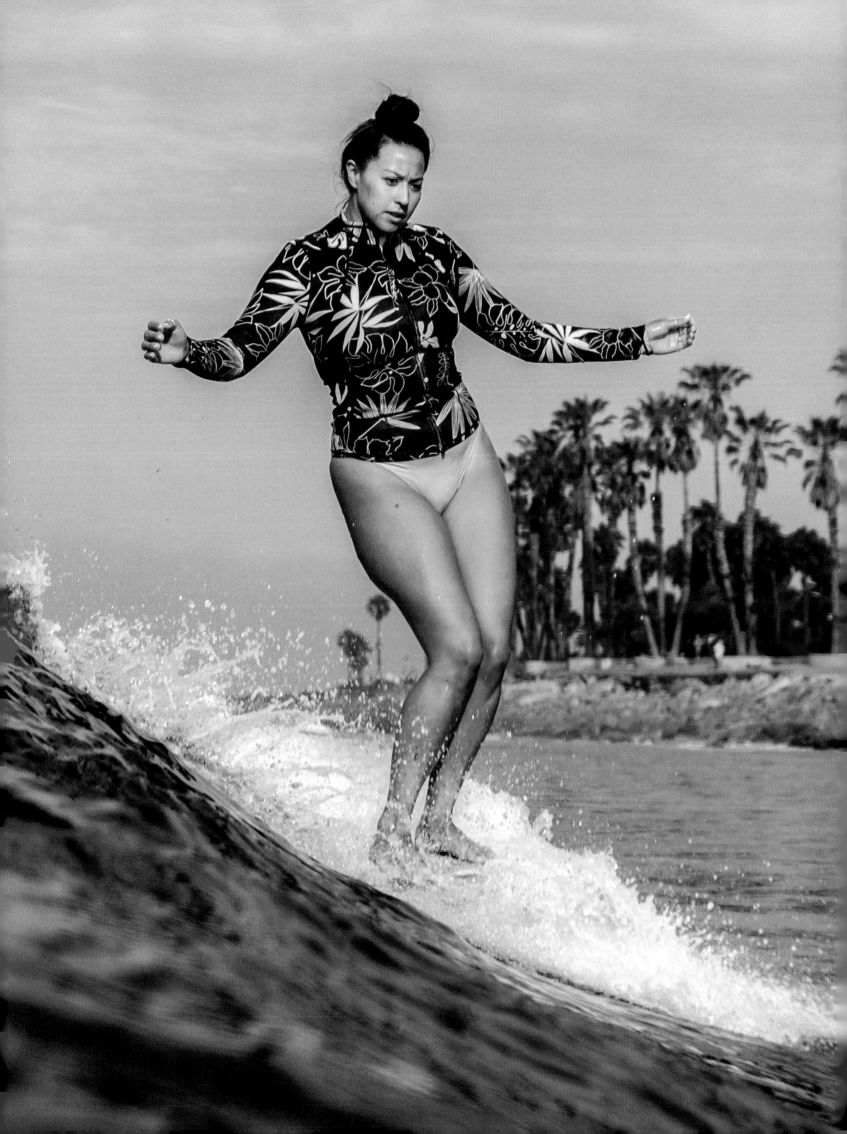

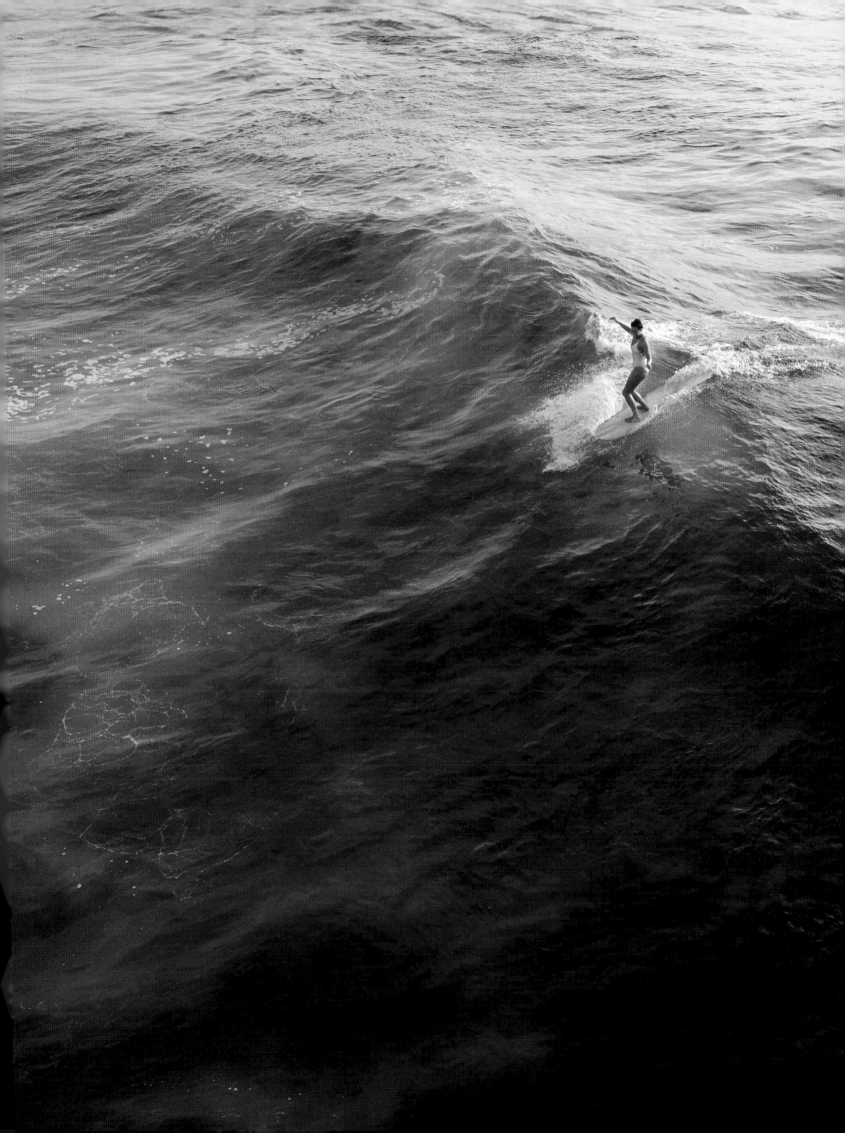

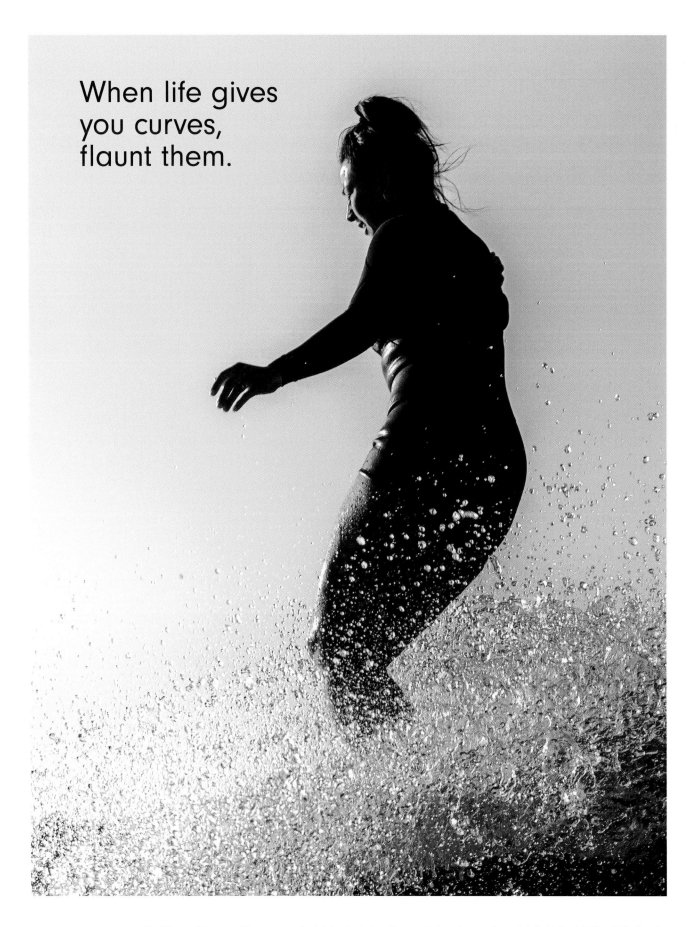

When life gives
you curves,
flaunt them.

Top When all the conditions are perfect, I don't mind waking up before the sun to surf. | Right (top) C-Street, California, (bottom) El Refugio State Beach, California. | Previous double page (left) C-Street, California, (right) La Jolla, California.

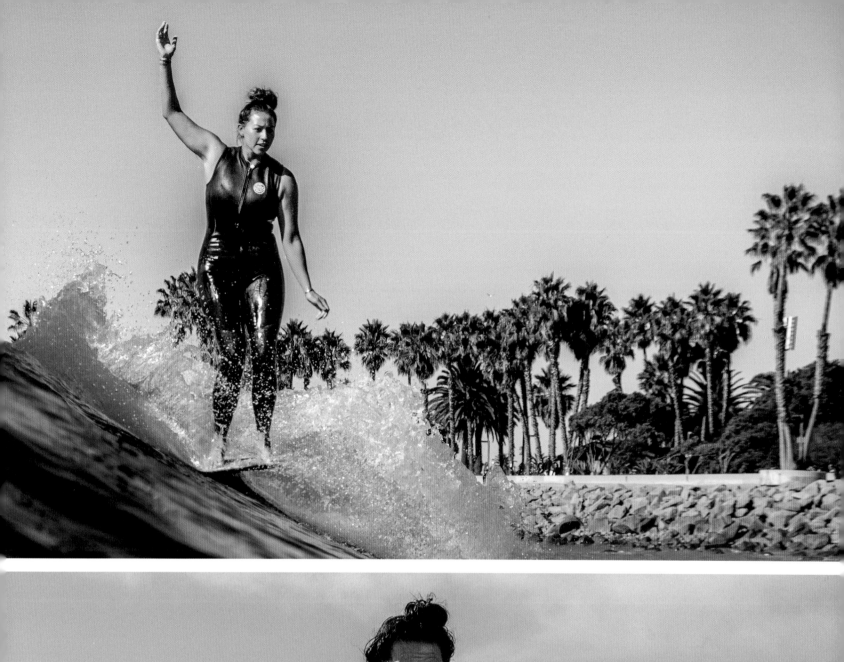
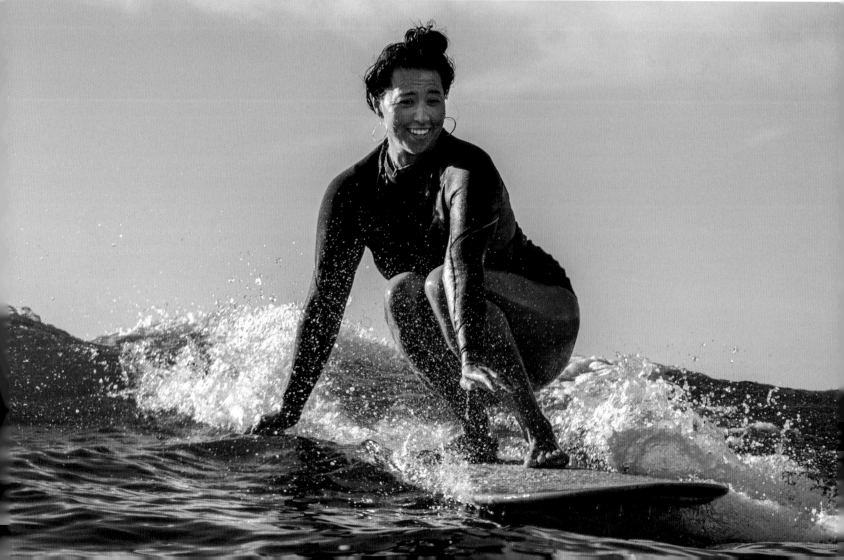

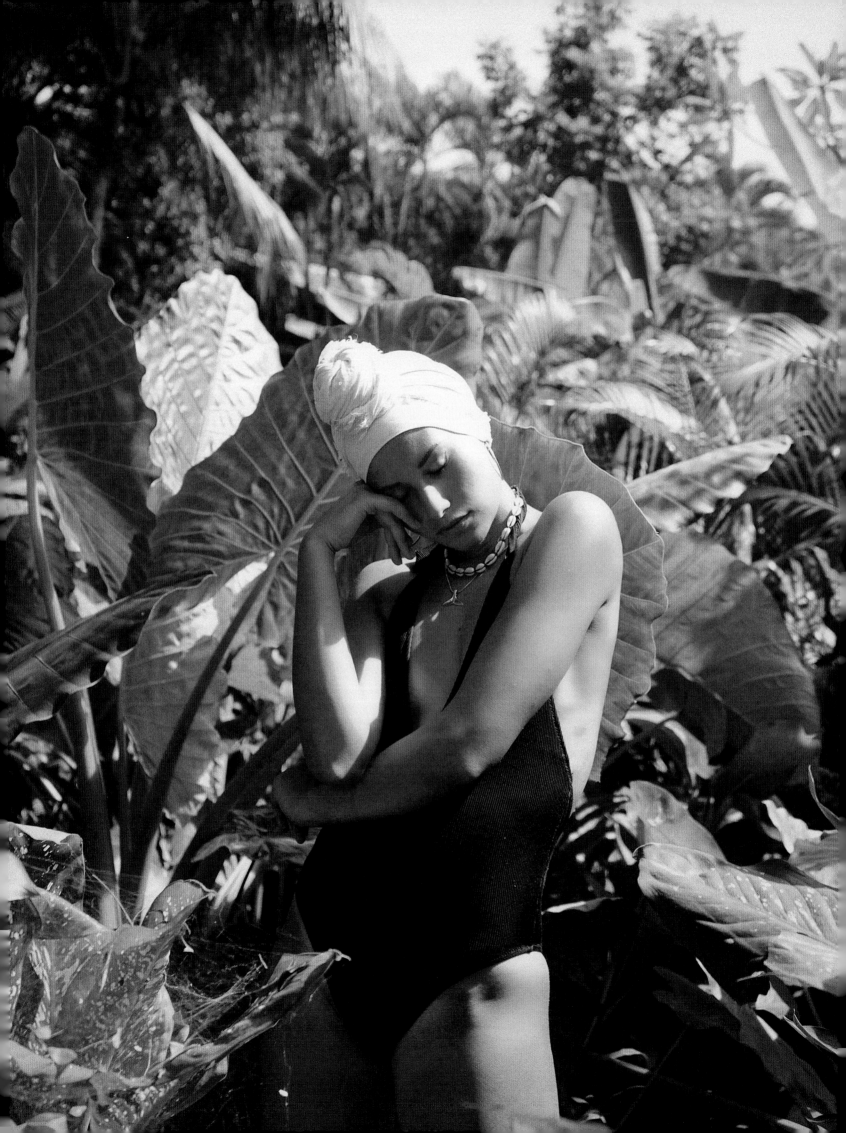

Júlia Moreno

"I took surfing as a challenge, as it would force me to show myself just as I was, without a wig to hide under."

I suppose every story must begin with a simple introduction, answering the straightforward yet tricky question: who am I? And, what made me become the person I am today? Well, my name is Júlia. I was born and raised in Barcelona in the late 1990s, but I've been tumbling around the world for a while, back and forth to different destinations. I've always told myself that there have been two different Júlias in the story of my life, and that's due to my autoimmune disease, which brought a before and after into my timeline.

When I was 19 years old, my life turned upside down unexpectedly. I remember it as if it were yesterday. It was my first year of university, and while I was in the library studying for my first exams, my hair wouldn't stop falling onto my notebook as I took notes. From then on, in just two weeks, I lost 70 percent of my hair. And I must note, I had a lot of hair back then, so it wasn't hard to notice. After hopping from one doctor's consultation to another, they finally diagnosed me with alopecia universalis. In simple terms, alopecia is an autoimmune disease in which your self-defense cells attack your hair. It was as if my body was allergic to my own hair.

I must say I had never been a super-confident girl, but somehow I did feel quite confident about my hair. So losing it was definitely a hard pill to swallow. I went from being an extrovert to hiding myself within the four walls of my home. I simply lost motivation for everything; I lost myself. I stopped taking ballet lessons, which I had been doing since I was a kid. I stopped diving into the ocean, to which I had a strong connection, and the hours I spent getting ready to go to class, trying to hide my condition, were just soul-draining.

It wasn't until I hit rock bottom that I realized things could only get better if I changed my perspective towards my situation. When I reached a point where

Santa Teresa, Costa Rica.

177

Júlia Moreno

I stopped doing the things I loved most because of fear of what people would think, my mindset shifted immediately.

The fear of never diving into the ocean again was heartbreaking. So I started by doing some research about women who were going through the same thing as I was, and who were sharing their journey on social media. Realizing that I wasn't the only one, and even reaching out to them, made me feel better. From then on, I tried to do something that would get me out of my comfort zone every other day. I started by sharing a selfie without my wig, without my scarf or anything, under the caption "not cancer, just alopecia." I remember I posted it right before going into the movies, and when I came out and checked my phone, I had thousands of likes and positive comments. I had never imagined how supportive people would actually be. I only did it to free myself, to stop having to give explanations to people. I must confess that, even though I was terrified, it was the most liberating thing I had ever done.

Right around that time in my life, I started to reconnect with surfing again. The ocean had always been my safe place, where I could stop focusing on anything but the wave that was coming towards me. For me, surfing had always been about fun, feeling independent, and connecting with nature, and nothing or nobody would change the way I felt about it. But this time, I also took it as a challenge, as it would force me to show myself just as I was. I had no wig to hide under, so it definitely was one of those things I did to start pushing myself out of my comfort zone as well.

"I only did it to free myself, to stop having to give explanations to people. I must confess that, even though I was terrified, it was the most liberating thing I had ever done."

Having rebuilt this connection with the ocean, having rebuilt myself, I realized I could never be far from one of the most beautiful things Mother Earth has ever given us. I realized I wanted salty water, sandy toes, the feeling of the sun on my skin, and the echo of the waves breaking for the rest of my life. So I decided I would keep traveling to any place that would give me those four little, yet so big, treasures. And just like that, I passed from living the big city life to building a "quality over quantity" lifestyle closer to a wilder ocean. More quality friends, more quality time with my loved ones, and more quality time for myself, trying to pursue the life I desired.

If there's something I have learned from all of this, it is that life is damned unpredictable, and we tend to take things for granted that we shouldn't. Today, I am thankful that, even though I might look different from other girls, I have

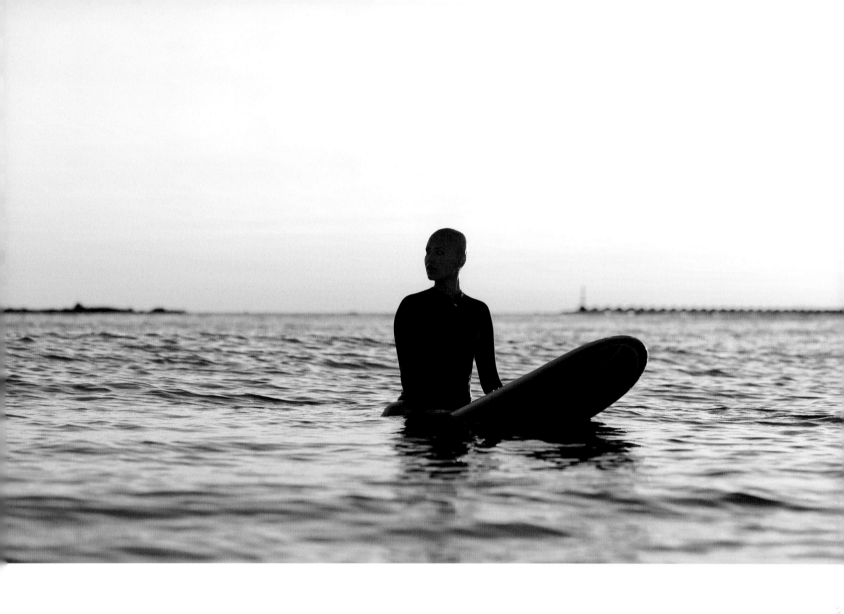

Júlia Moreno

good health, I get to move my body every chance I want, and I have the amazing opportunity to do the things I love most, with the people I want around me.

So, for those out there going through alopecia or any body insecurities, I advise: remember to look within yourself, remember those things that you loved doing that made you feel alive, and don't let anything or anyone have a say on what you should or shouldn't do. You don't want to wonder tomorrow what you could have done today because of fear, not loving yourself enough, or what people could have thought. The only light that matters is the one within you, and to make it grow, you have to feed it with positivity, good energy, self-love, and those little things that make you feel fulfilled.

Barcelona, Spain.

I complete me.

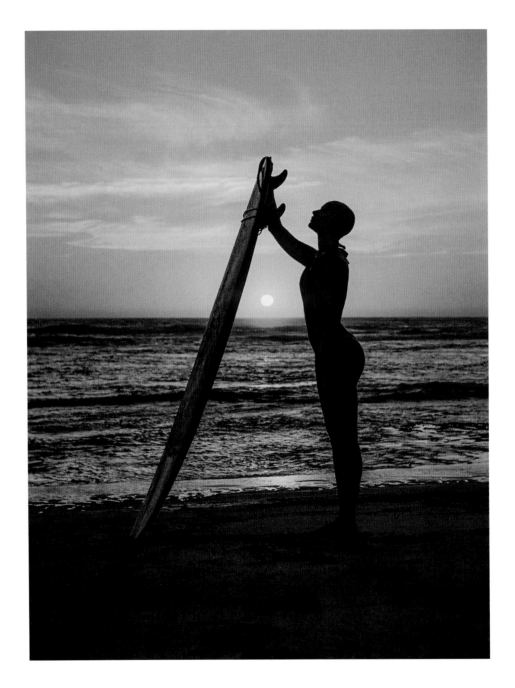

Ericeira, Portugal.

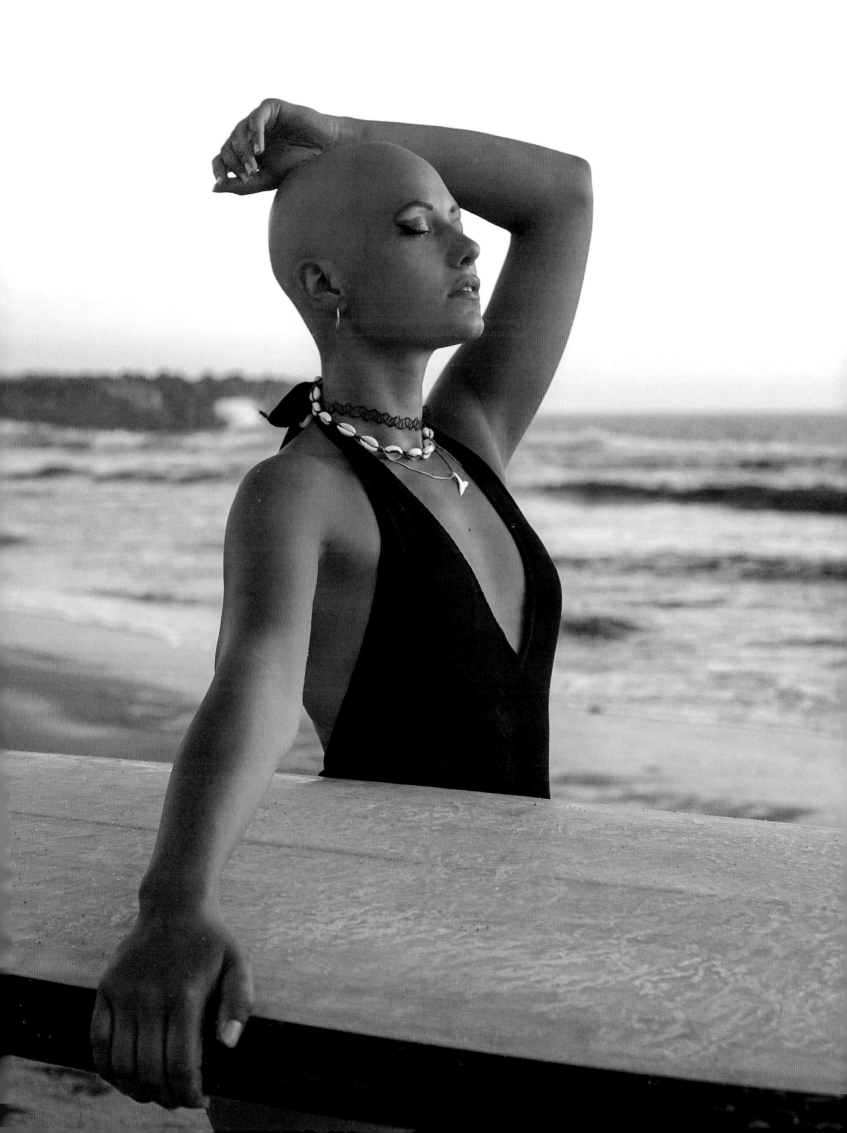

Jessa Williams

"The lack of representation in surfing can make it feel inaccessible and unwelcoming."

When I began surfing, I felt very alone and isolated—not just as an adult learner, but also as a Black woman in a space that's very white/male dominated. In my earliest days of surfing I experienced some harassment in the water, which included both racist and misogynistic slurs. I felt like many of the other women surfers didn't quite understand because they were mostly white, and the other Black or POC surfers didn't understand because they were mostly men. It became clear to me that it was the intersectionality of my identity that led to me feeling so isolated in this experience I was having of falling in love with surfing. I created Intrsxtn Surf to take this negative experience I was having and channel it into building something positive for other women like me, who may also feel, or be made to feel, that surfing isn't for them or that they are unwelcome in the water. Intrsxtn Surf exists to create a safe space for Black women and women of color to explore the outdoors through surfing. We are headed into our fourth season of programming and have helped hundreds of women catch their first waves!

Intrsxtn Surf is more than a surf collective; it is a movement that empowers Black women and WOC to reclaim their space in the world of surfing and the outdoors at large. I didn't create Intrsxtn Surf to be "inclusive." I didn't want the women joining our group to feel included in something, as if to say that it belongs to someone else but that they are "welcome" to be a part of that thing. I wanted them to know that this space was made with them in mind.

The lack of representation in surfing can make it feel inaccessible and unwelcoming, and Intrsxtn Surf was created to change that narrative. We've built a powerful community of thousands of Black women and WOC who

I'm really out here living my California dream life, and most of that is thanks to surfing. All of my efforts now are focused on helping other women experience all the joy it can bring.

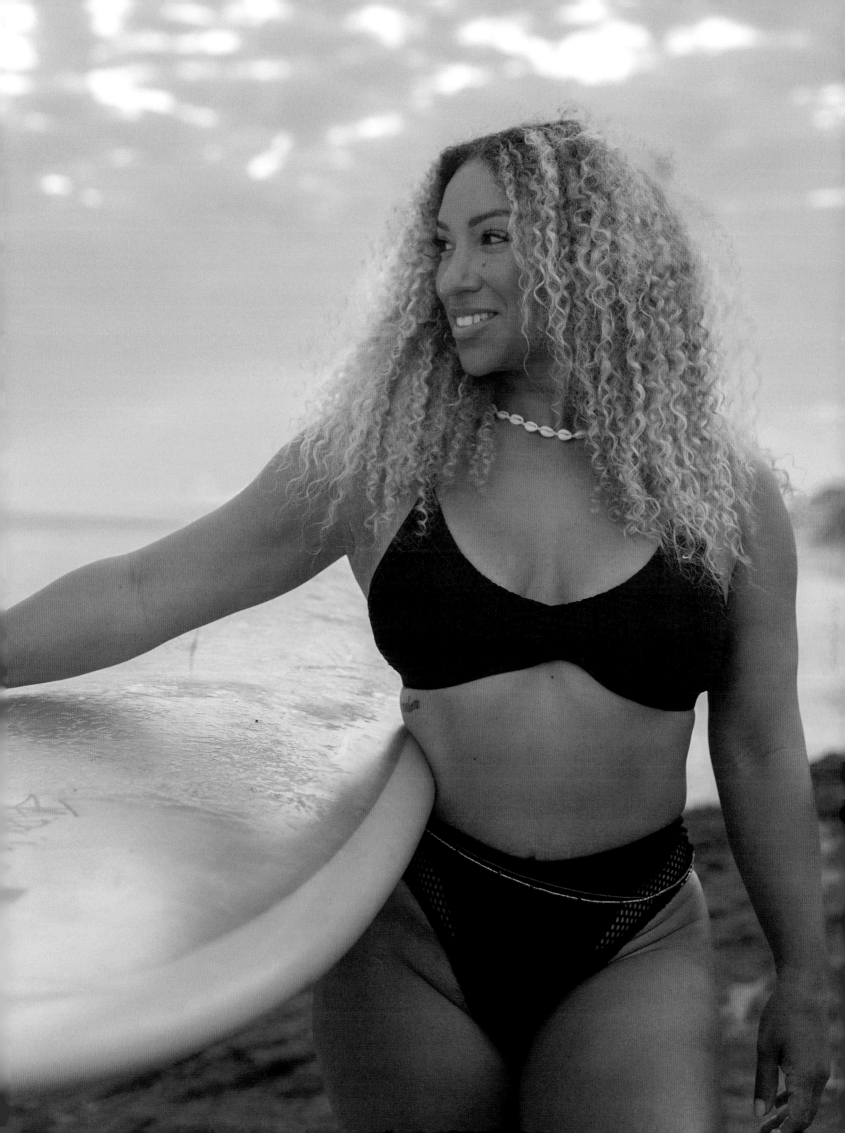

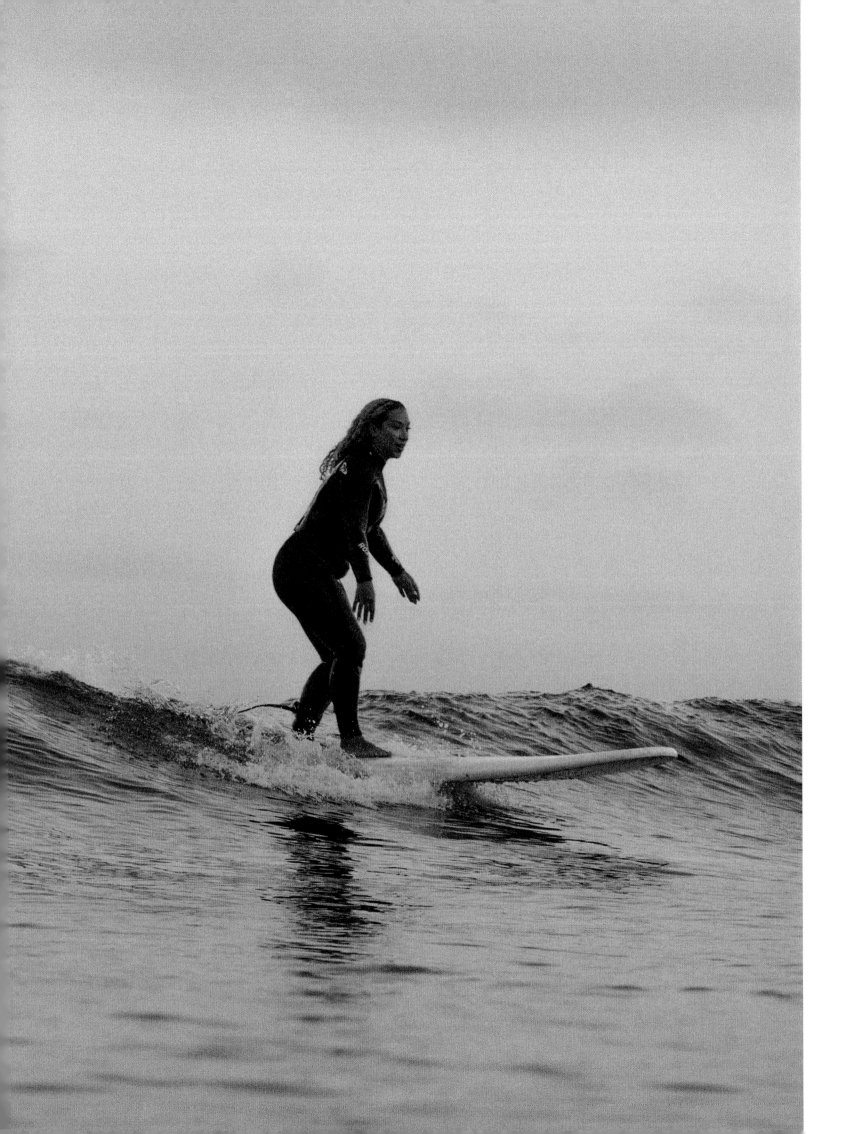

are all a part of our movement. We provide instruction, support, and a social network of adventure-seeking women who love action sports and love the outdoors. Every wave we ride is a testament to our strength, our resilience, and our right to be seen and celebrated exactly as we are.

We're best known for our community surf meetups, where we provide free beginner surf lessons. Our meetups are transformative experiences that bring Black women and WOC together to learn, support, and celebrate each other. Something that's so unique about our group is that our coaching crew is made up entirely of Black women and WOC. This is such a powerful part of the Intrsxtn Surf experience because it creates a dynamic where those who are new to surfing can see themselves reflected in their instructors. They feel safe. They feel seen. We're really creating a sense of belonging and empowerment in the water that's hard to find. We're creating and defining our own space, where our voices, stories, and bodies are at the forefront.

The impact of Intrsxtn Surf goes so far beyond the physical act of catching a wave. It's about giving ourselves permission to take up space—even where we don't see ourselves represented, welcomed, or celebrated. Any surfer knows that surfing is such a powerful metaphor for life, and as our surfers learn to navigate the waves, they also learn to navigate life's challenges with greater confidence and resilience.

"Every wave we ride is a testament to our strength, our resilience, and our right to be seen and celebrated exactly as we are."

Surfing teaches you to trust yourself. It demands that in a moment's notice, you lean into the big, scary thing coming your way and show up bigger, braver, or bolder than you might have thought you could be. I'm humbled to be a part of someone's journey as they navigate that demand out in the waves. My dream for any woman who's part of Intrsxtn Surf is that they take that version of themselves that they've found or rediscovered in the waves out into the world with them. I hope they keep giving themselves permission.

I felt in love with surfing.

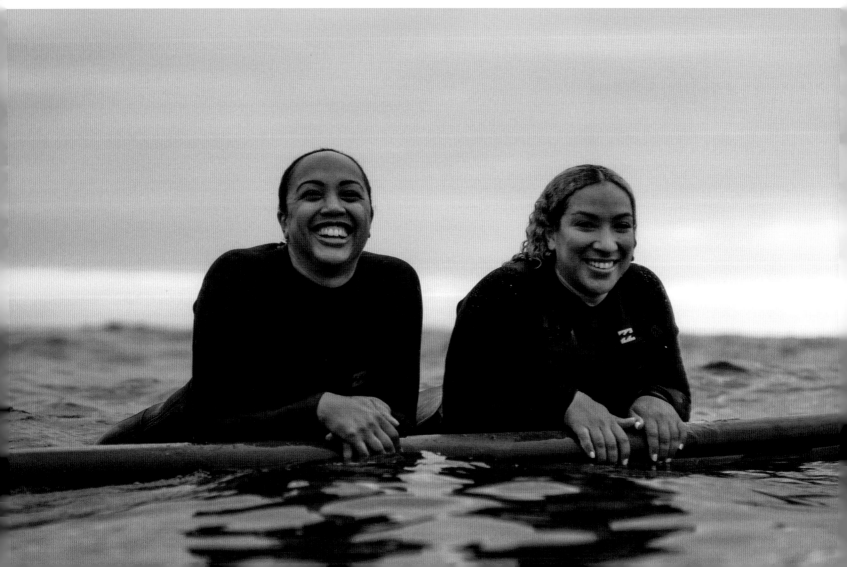

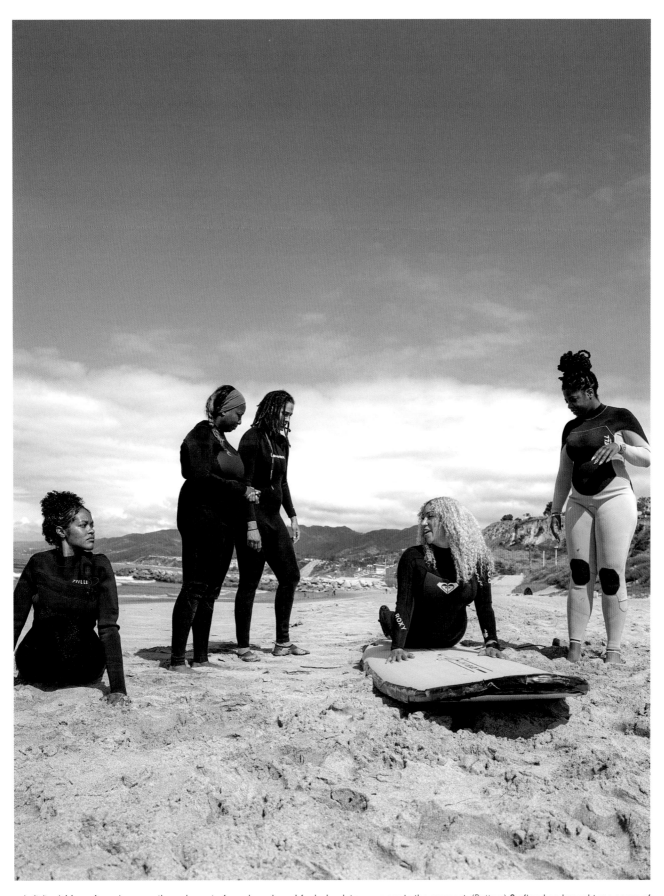

Left (top) My surf sessions are the only part of my day where I feel absolute presence in the moment. (Bottom) Surfing has brought me some of my closest friends. Erin and I met through surfing and we are like family now. | Top Our community meetups are so special because there are so many women trying surfing for the first time, together. Allowing yourself to be a beginner at something again is so empowering. It's badass!

Take up space.

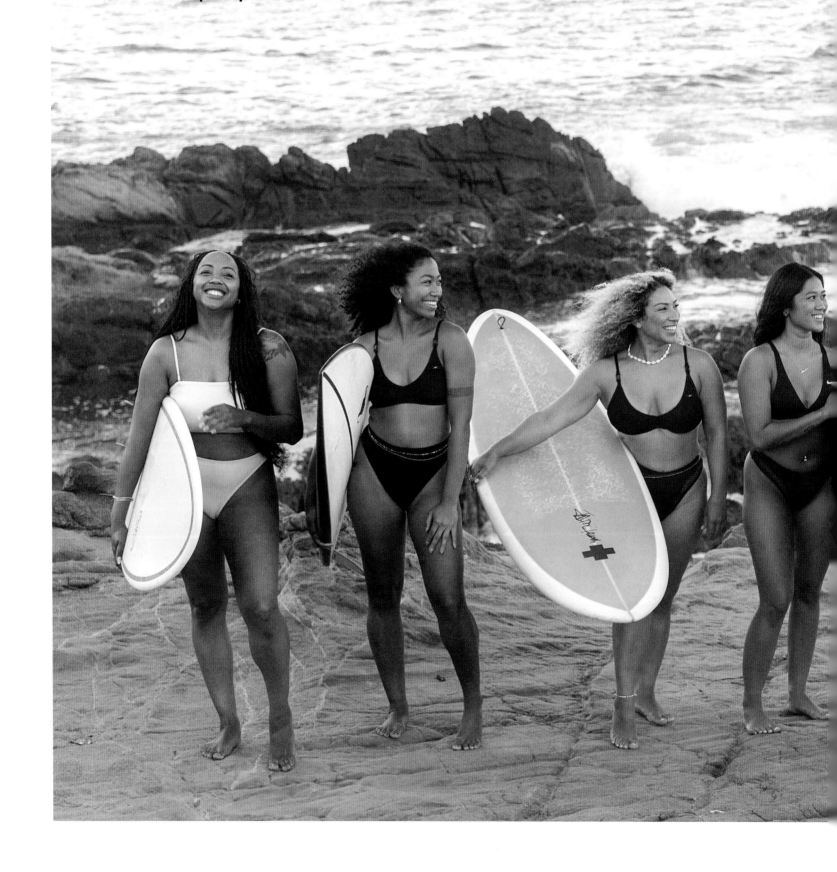

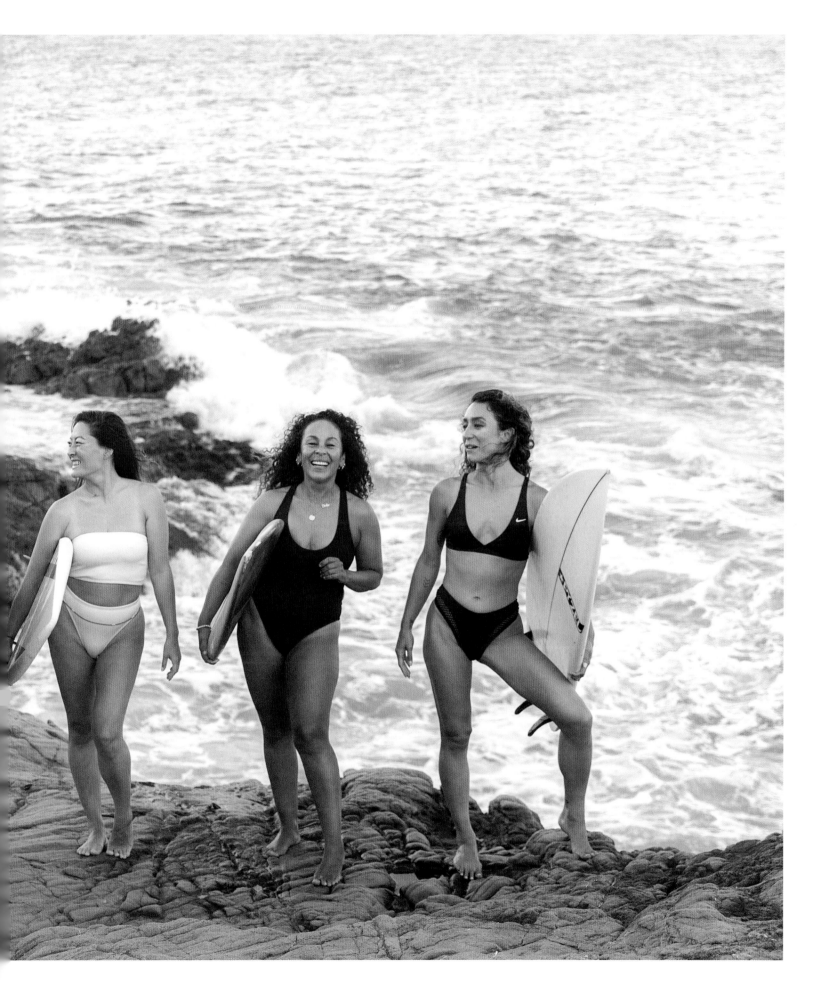

Intrsxtn Surf is the largest group of women of color surfers and the best part is that our programming is taught by an amazing group of experienced surfers who are all also women of color. There's absolutely nothing else like it.

Maddy May

"I move my body, not as punishment, or to earn food or burn off calories, but because I can."

I am so grateful for surfing; it is part of who I am. So many life lessons have been taught to me through my experiences in the ocean. It has taught me how to be brave and commit, to know my limits, to be patient and humble. Knowing what the wind, tides, and swell are doing helps me feel connected. I have tried to create a life that can revolve around and be dictated by the conditions.

Surfing is so good for my mental health. I often opt for surfs that push my comfort zone, sessions where I am slightly scared and need to focus and push myself. I think this is partly because I love the thrill and the challenge, but partly because it gives me no time to think. I find my on-land thoughts can sometimes be too much and it is the perfect way to shut them up.

My relationship with my body ebbs and flows. I have days where it consumes my thoughts entirely. I have found that focusing on what my body is capable of can help pull me out of the negative spiral. I try to focus on the positives and be grateful for my body and what it does for me. I move my body, not as punishment, or to earn food or burn off calories, but because I can. I am lucky enough to have a body that allows me to move, surf, play guitar, sing, hug the people I love, and for that, I am so grateful.

I think it's important to do the things that scare you. The things that I have most enjoyed in life have had a certain amount of fear attached. My passions

A beautiful June day at one of my favorite beaches on Phillip Island, Australia.

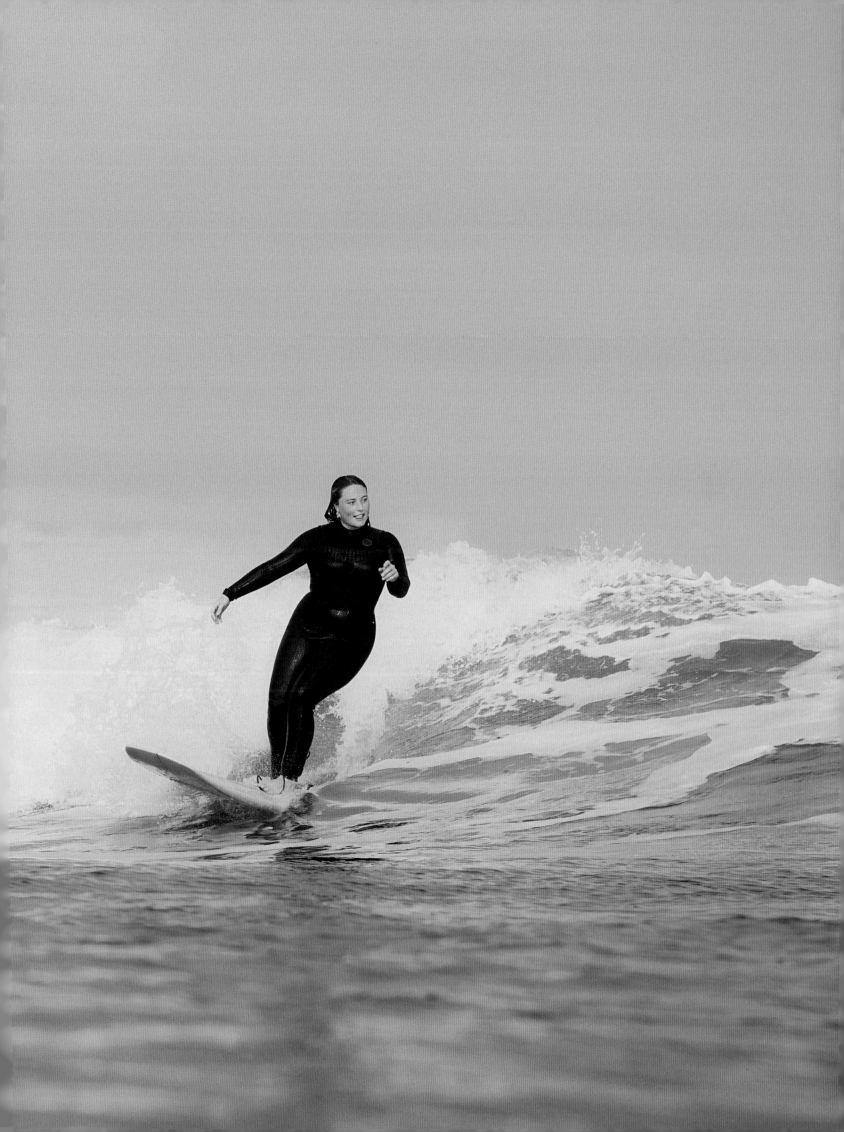

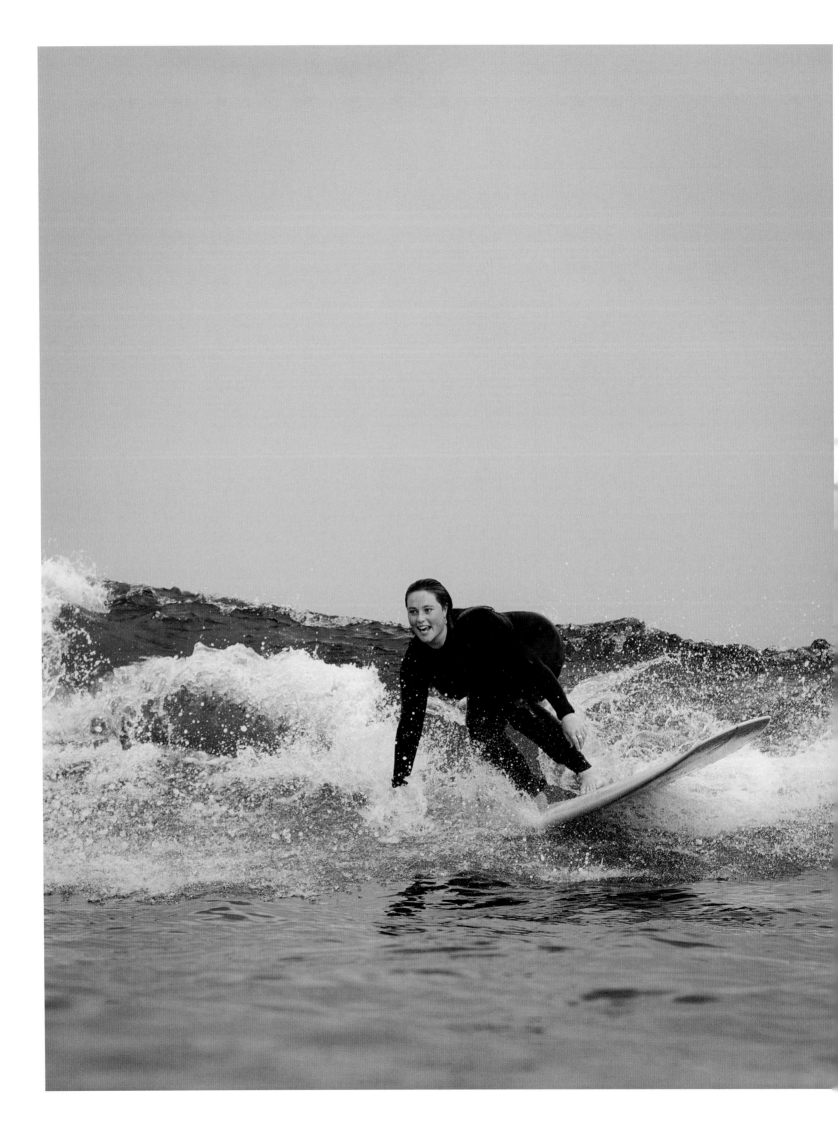

are music and surfing, and I have found ways to earn money doing what I love. Writing, recording, performing, and releasing music is daunting and makes me feel very vulnerable, but I do it anyway, because I love sharing my music, telling stories, and connecting with people. The same goes for surfing. It can be so intimidating, but I would much rather do the things that scare me and make the most of this life than let the fear stop me.

Being a full-figured surfer comes with some extra challenges. The boards are bigger and heavier and wetsuit shopping is an absolute nightmare. For every one size option for women there are three for men. They have a "short" and "tall" option for each size. Small-short, small, and small-tall. I have found that buying a men's wetsuit is cheaper and easier. It acts like a breast binder around my chest, which can be uncomfortable, but I have found that it's still a better option. For all the struggles, there are a few benefits: having more fat on my body allows me to float better, which helps with my swimming ability. If my leg rope snaps, there's a good chance that I will survive the swim back to shore.

In winter on Phillip Island, the water temperature drops to around 14 degrees Celsius (57ish Fahrenheit) As the seasons change, I have found that I can push the 3.2mm wetsuit out just a little longer before switching to a 4.3mm wetsuit like some of my friends that are lacking some natural insulation. You've got to find the positives!

"I had no role models to look up to in music or surfing that looked like me."

I work for an outdoor ed. company and we take kids surfing. I love seeing our students transition from being so obviously self-aware and self-conscious, to just completely letting that go. The cold water takes their breath away and they are focused on what they are doing. Focused on how to lay down on this big piece of floating foam, how to paddle, and how to stand up. They can't help but be in the moment. And just like magic, all of the pressures of society drift away.

Sometimes, for safety reasons, one of us instructors needs to be on a board out the back, and sometimes we have to catch a few waves and show the students how it's done. The way the kids look at us, you would think that we were pros. Even if we are just dropping into 2 foot closeouts. It feels so good! I wish the younger version of me got to see someone like me out doing what I do. Growing up, I had no role models to look up to in music or surfing that looked like me. I think if I did, it would have saved me a lot of wasted time trying to look a certain way and hating myself because I couldn't fit the mold.

You are beautiful.

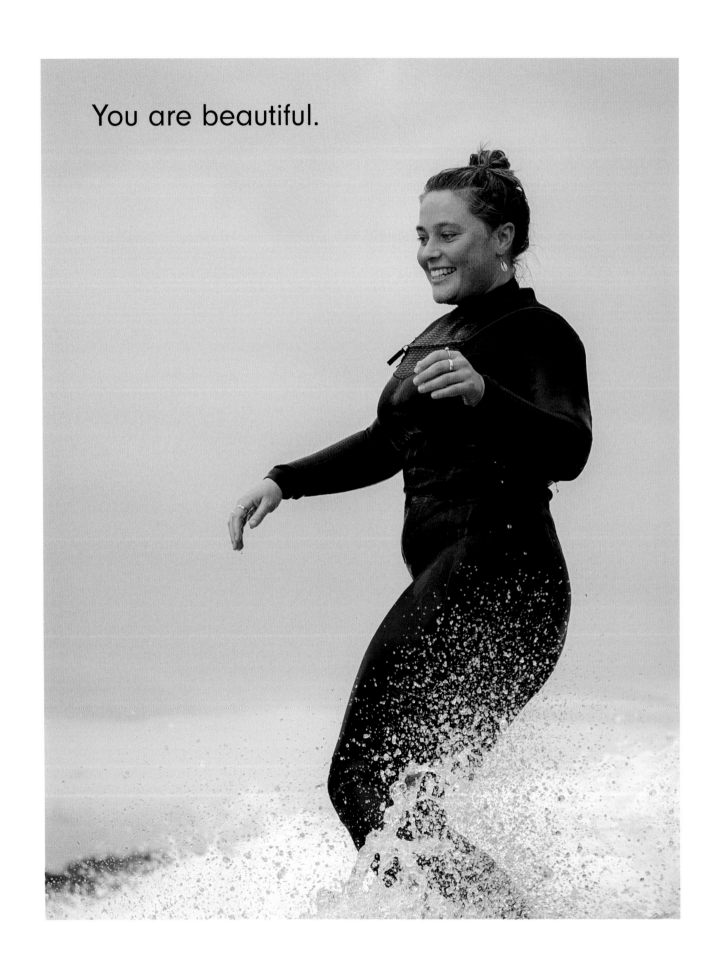

Maddy May

My love for the ocean and nature has connected me with friends all over the world. I notice these same people time and time again with that little sparkle in their eye. We are all connected in some way, whether it's an obsession for surfing or mountain bike riding, skating, snowboarding, or skiing, whatever lights you up. These hobbies, activities, obsessions, give us such a profound connection to ourselves through nature. When you are fully immersed in Mother Nature, you are most yourself. Disconnected from any of the mainstream media ideals. There is no better feeling than just being in that flow state. Time slows down, you're in the moment, con-nected. I am most in my body when I am in that flow state. I am forever chasing that feeling.

Everybody deserves a place in the ocean. As far as we know, we only get one life, so make the most of it and get out there!

Phillip Island, Australia.

195

Natsumi Taoka

"To me, every woman is beautiful and it's not for anyone to judge."

To me, every woman is beautiful and it's not for anyone to judge.

But society's idea of beauty does have an impact. Social media in particular pushes this one narrow image of beauty. It makes everyone feel like they have to look a certain way—like having light skin, being thin, and having certain features like double eyelids. It's sad to see people trying so hard to fit into that mold and trying to copy it. Even though some people say that the beauty standards set by the industry are impossible to achieve, many people still try to meet them. It's as if we don't all realize how unrealistic these standards are.

Culture plays an important role in shaping these standards, often leading people to desire characteristics they don't naturally possess. When I was in high school I saw friends dye their hair and wear colored contacts because they wanted to be like white people, changing their appearance to look more like Western ideals.

I have had to deal with my own insecurities. I'm small, don't have white skin, and am not skinny. I was bullied by my classmates when I was at school because of my skin. I've had negative comments about my appearance on Instagram and I even tried dieting because someone said I was getting fat. Those comments made me feel bad and scared.

Getting over negative comments hasn't been easy. They used to really upset me. But with time, and thanks to supportive friends, I've gotten stronger and I love myself even though I don't fit society's narrow definition of beauty. I've learned that beauty comes in all shapes and sizes. There's no one-size-fits- all

Taoka at Chiba, Japan.

definition. Once I accepted that, I started to feel better about myself and embrace my uniqueness.

As a female surfer, it's been difficult trying to balance beauty norms with what my sport is. But surfing has been my lifeline. It's not just a hobby; it's where I find peace and strength.

Surfing always makes me happy and it's also great exercise. It's the best sport for me. I love how close it brings me to nature, and being in the ocean gives me such a good feeling. The energy I get from the ocean is amazing.

Through surfing, I've learned to appreciate my body for its strength, and for what it can do. And being alone in the ocean gives me time to reflect and appreciate myself. I can even take the time to talk to myself.

I started doing yoga to get better at surfing. A lot of my friends do yoga too. They're really good at loving themselves and meditating. They tell me their stories and I learn from them. It's great to have friends who teach me new things.

"Even though some people say that the beauty standards set by the industry are impossible to achieve, many people still try to meet them. It's as if we don't all realize how unrealistic these standards are."

Surfing has also introduced me to an amazing community of women who lift each other up. Sisterhood in surfing isn't just about catching waves together; it's about supporting each other.

So my journey to self-love has been about accepting myself, finding peace in nature, and surrounding myself with positive people. And if I could say one thing to my younger self, or to anyone struggling with self-acceptance, it's this: You're beautiful just the way you are.

Surfing in the Philippines.

Top **My home break in Chiba, Japan.** | Right **Hokkaido, Japan.** | Next double page (left & right top) **At Vans Duct Tape Invitational contest, Brazil.** (Right bottom) **Chiba, Japan.**

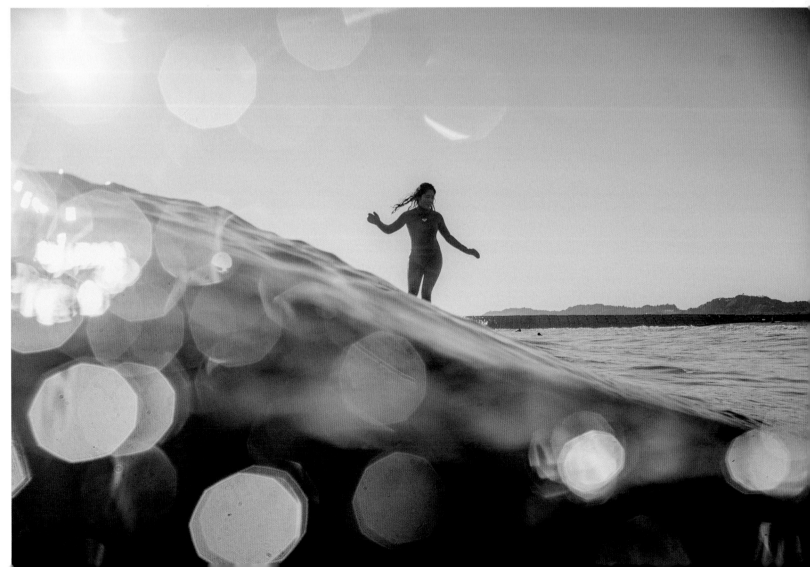

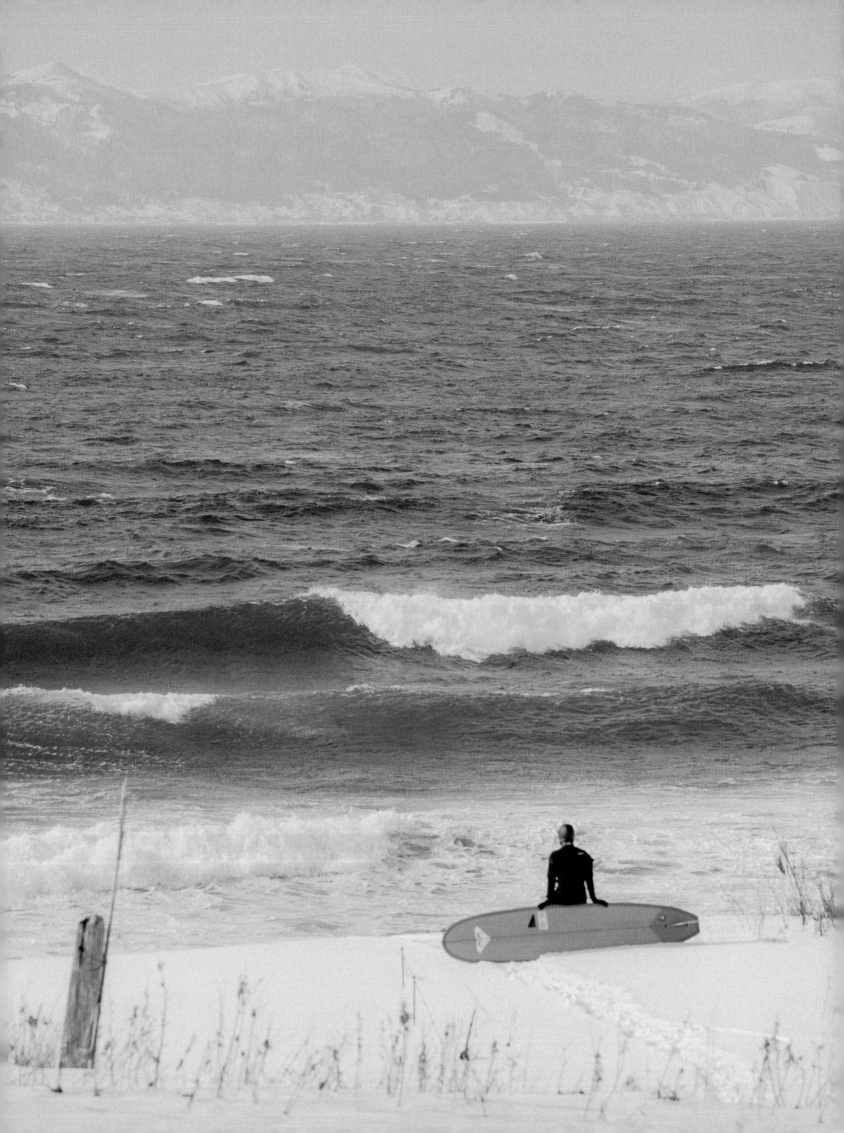

The things you say about others
say a lot about you.

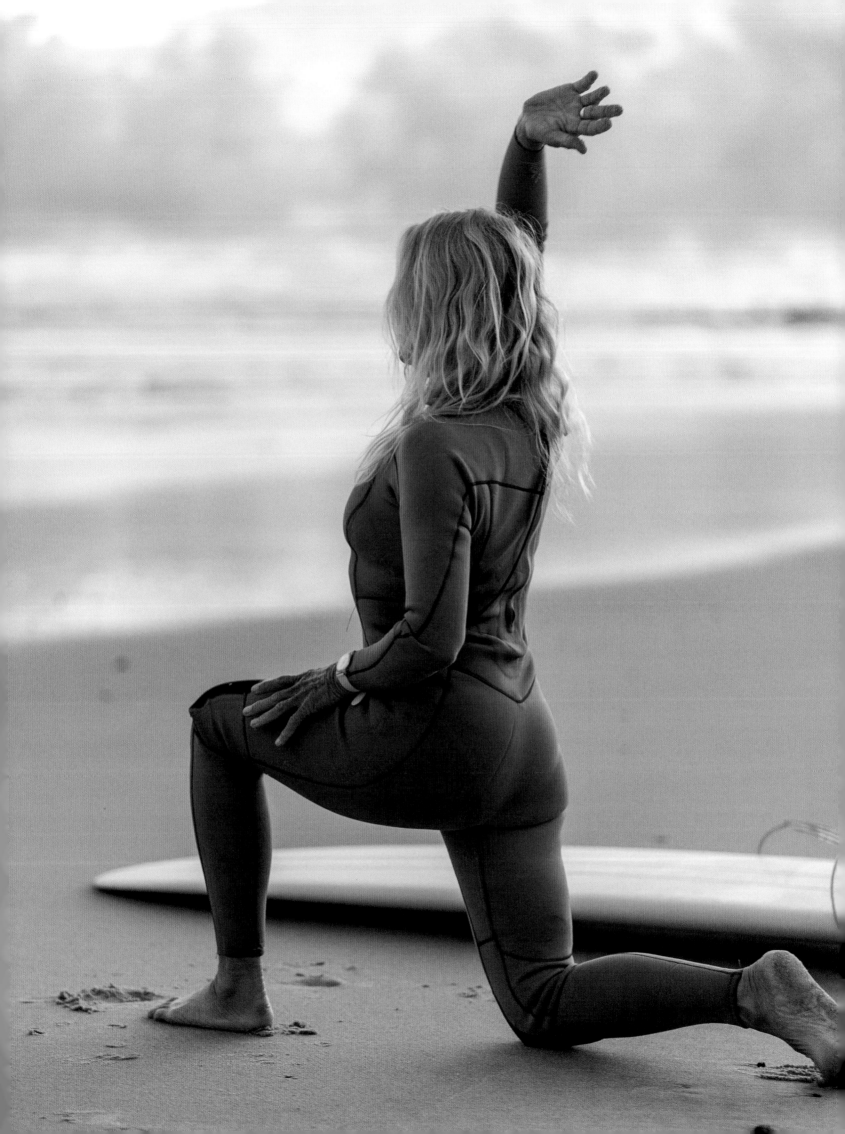

Alice MacKinnon

"I started surfing at 46 years old after a lifetime of longing. For that first year I worried I'd left it too late."

The wave approached from the horizon, inviting me to dance in a ballroom that was miraculously empty. I accepted, swinging my longboard toward Lacey's Beach, and began paddling, smoothly increasing my pace as I travelled across the water so that my speed would match the wave's when we met at its peak.

Our takeoff was serene. I exhaled and sprang to my feet, flowing into the expansive energy of the wave as it rose and reached towards the shore. There was not a single breath of wind. The water was clear aquamarine.

The rest of the world seemed to stop, standing motionless, grasping nothing, asking nothing. The incessant chatter was silent for a brilliant, precious moment.

I pivoted the board fast, pressing my back foot onto the tail, then trimming along the face of the wave. The universe expanded and contracted to a pinpoint in those moments of glide. It was just the wave, the longboard and me, dancing as one.

I started surfing at 46 years old after a lifetime of longing. For that first year I worried I'd left it too late—how would I ever learn this complex language of tides, swells, winds, board, body, mind, and breath well enough to lean into the energies of the ocean with grace?

But I persevered with endless curiosity and bloody-minded grit, a lone-wolf beginner out there in the whitewater in all weathers. I had some great mentors—experienced blokes, mainly, who had been surfing most of their lives and who saw a spark of something in my wild-eyed commitment to the local breaks. They gave me their time and their wisdom and I took in every detail and nuance they offered.

I love stretching before my surf at Rainbow Bay on the Gold Coast, Australia.

Alice MacKinnon

One of them was Gaz—Garry Palmer—owner of a Southern Gold Coast surf school. We'd meet in the water often: he'd be teaching a group of learners in the shallows and I'd be entering or leaving the water. I'd inevitably stop to chat with him and learn as much about the conditions in that moment as I possibly could. After a couple of years of this, he asked if I'd like to train as an instructor, teaching beginners with his surf school. I burst into tears of excitement about a dream come true that I'd never even begun to imagine and I got to work with gusto.

Women started to come to me asking for help with their surfing. Many were competent whitewater warriors but needed help navigating their way to the holy grail of green waves out the back. Some were terrified of the water but had a yearning to surf and were prepared to overcome their fears of sharks, drowning, and injuring themselves and others in order to play, laugh, and ride the waves the way they'd seen other women doing.

And so the "Dawn Mermaid Sessions" were born and I had the astonishing privilege of working with women in the water many mornings a week before our day jobs began.

"My life revolves around my surfing longevity, including what I eat, how I exercise, my mindfulness practices, my work in the world, and nourishing my loving connections."

For the six years that the mermaid sessions ran in the often crowded, unforgiving lineup of Currumbin Alley, I learned more than my courageous, brilliant, funny, brave students. Women were beginning to return to surfing and I felt insanely lucky to help forge our resurgence, which is now an unstoppable tsunami. At that age, in my early and mid-fifties, there were a few women older than me out there that I could watch and be inspired by.

As I write, I'm 61 and grandmother to Ellie and Tom. I'm in my 16th year of surfing and I surf most days in most conditions, year-round. My life revolves around my surfing longevity, including what I eat (vegetarian wholefoods and high-quality protein shakes), how I exercise (yoga, qigong, strength and resistance, beach running, and high-intensity interval training), my mindfulness practices (daily meditation, zen, breathwork, crystal singing bowls, kindness, and peace), my work in the world (emotion coaching, writing, teaching fitness, yoga, and qigong), and nourishing my loving connections to my wife, family, and community of friends and colleagues.

Top Sliding down the line at Currumbin Alley on the Gold Coast, Australia. Bottom Post-surf on my 60th birthday at Greenmount on the Gold Coast, Australia.

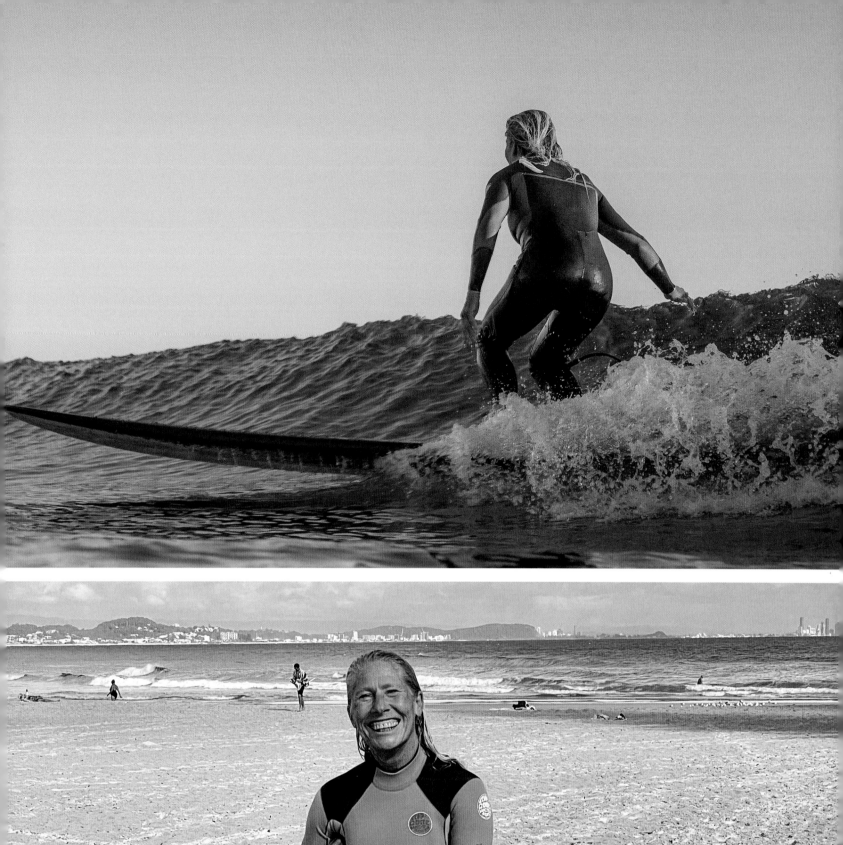
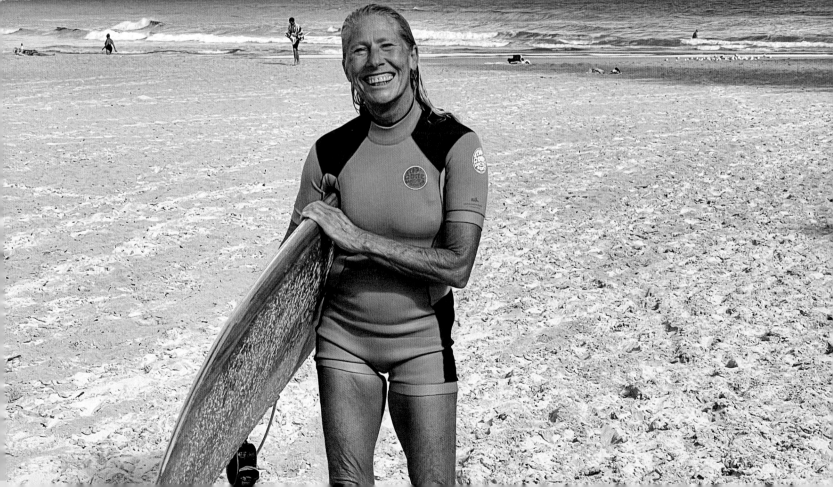

Aging is living.

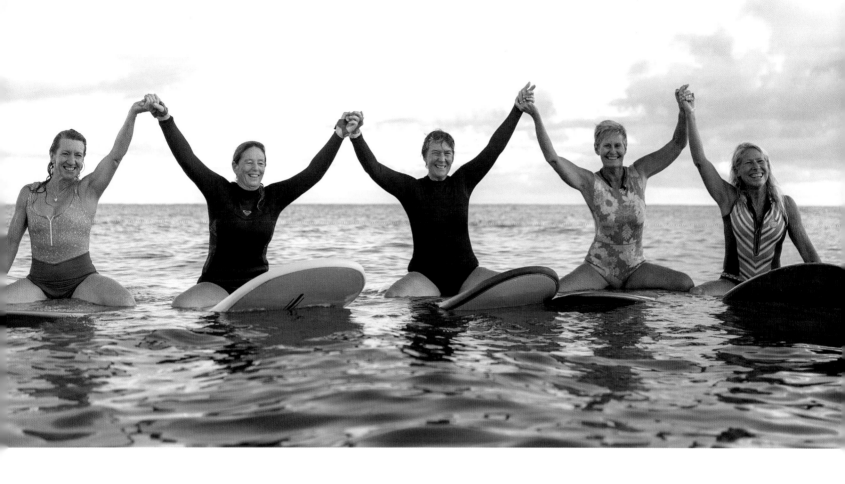

Alice MacKinnon

I'm physically stronger now than I have ever been in my life. I'm most certainly happier than I have ever been. In 2023, my wife Jen (also a surfer) and I, in collaboration with the Surf Witches Boardriders Club, released the documentary *Taking Off: Tales of Older Women Who Surf,* a love letter to older women that we hope will inspire us all to follow our passions and bring our dreams to life.

In the blink of an eye my hair has turned gray and I am sometimes the oldest woman in the lineup, especially on bigger days when some physical and mental resilience is called for. I like to maintain my shtick in and out of the water in these uncertain times, with climate collapse coming down the line at us. As a surfer, a child of the tides, and a daughter of Mother Earth, I feel my purpose is not only to engage in the play of surfing but also to tell stories of land and sea that invite humanity to care, connect, and be of service to all life, now and in the future.

Left Surfing at Rainbow Bay on the Gold Coast on my wedding day. | Top Liane, Brenda, Marg, Yvonne, and I celebrating friendship and life in the documentary *Taking Off: Tales of Older Women Who Surf.*

Sasha Jane Lowerson

"Living my truth and being honest with myself and the world at large was made easier with the nurturing help of Mother Ocean."

I am a surfboard shaper!

I am a womxn!

I am a surfer!

I am an Australian, and my name is Sasha Jane Lowerson, and this is my truth and my experience surfing and living as the first openly out transgender womxn to compete in a professional surf event, including World Surf League events.

Surfing is my safe place; my place of solitude, the first place I learned to love. The ocean shared its lessons with me as I grew and became the womxn I am today. Living my truth and being honest with myself and the world at large was made easier with the nurturing help of Mother Ocean.

My form of activism involves visibility, because "It is really hard to be what you can not see." Growing up, I saw no real positive representations for queer people, let alone transwomen. My goal in life is to be a positive representation for our current and future generations of womxn to follow.

A quick photo op on a rainy day at the Pass, Byron Bay.

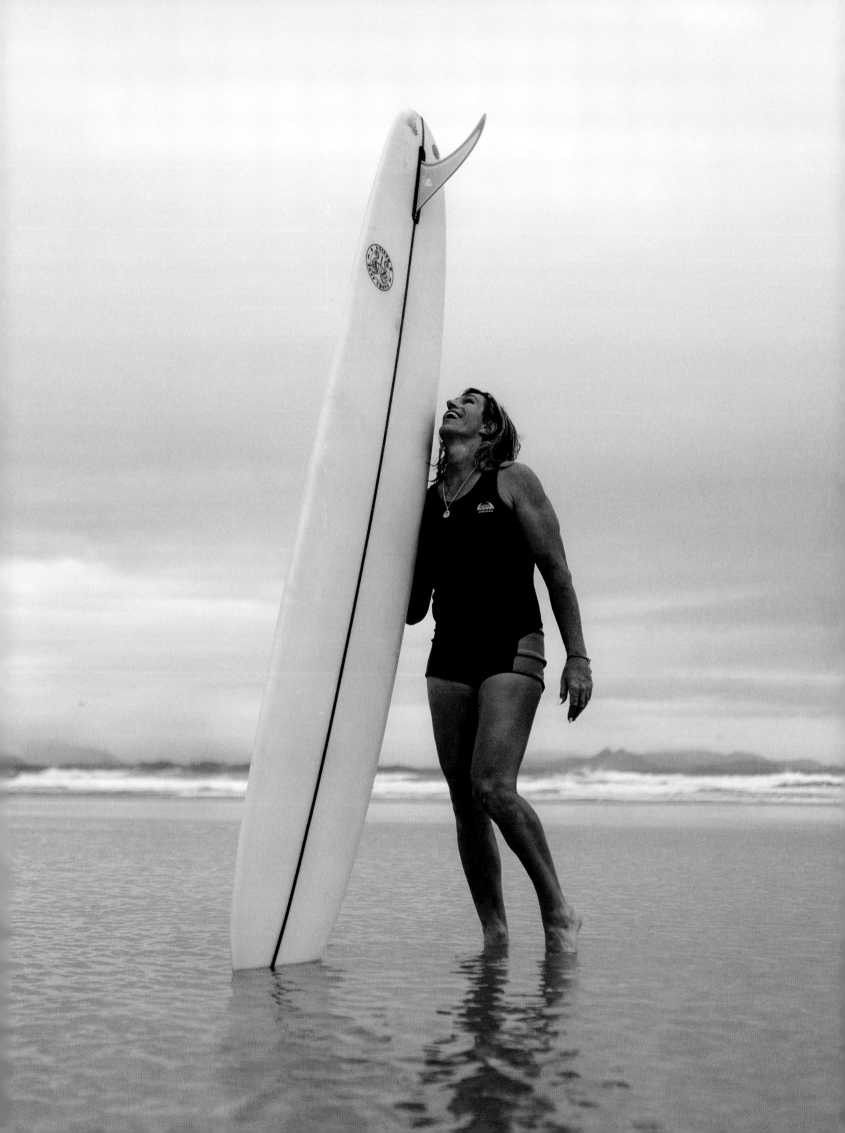

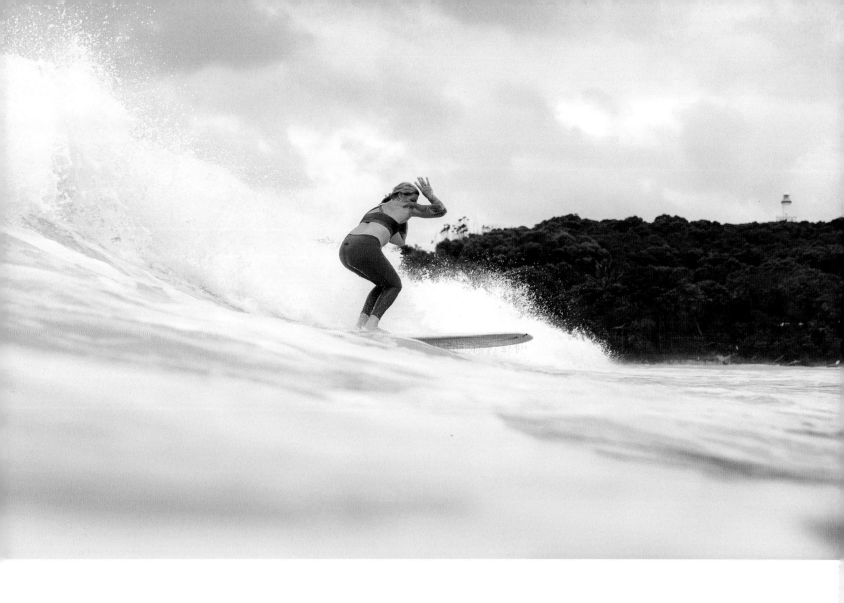

Sasha Jane Lowerson

The surf industry is improving, moving closer to gender equity, but we still have a way to go. Unfortunately, the big brands are still using the old marketing strategies of objectifying our bodies, mostly in negative ways. Projecting us as sexual objects for the male gaze. My way of combating this is to support womxn-owned brands. That way, we have the opportunity to take control of the industry and of our image.

Left Surf trip with Zealous swimwear in Bali. The surf had gotten a little bigger so I decided to take out my 6'0 step up.
Top Rainy days spent surfing the Pass in Byron Bay are always fun. | Next double page Indian Ocean golden hour: surfing late into the afternoon in Bali with the sunset only minutes away.

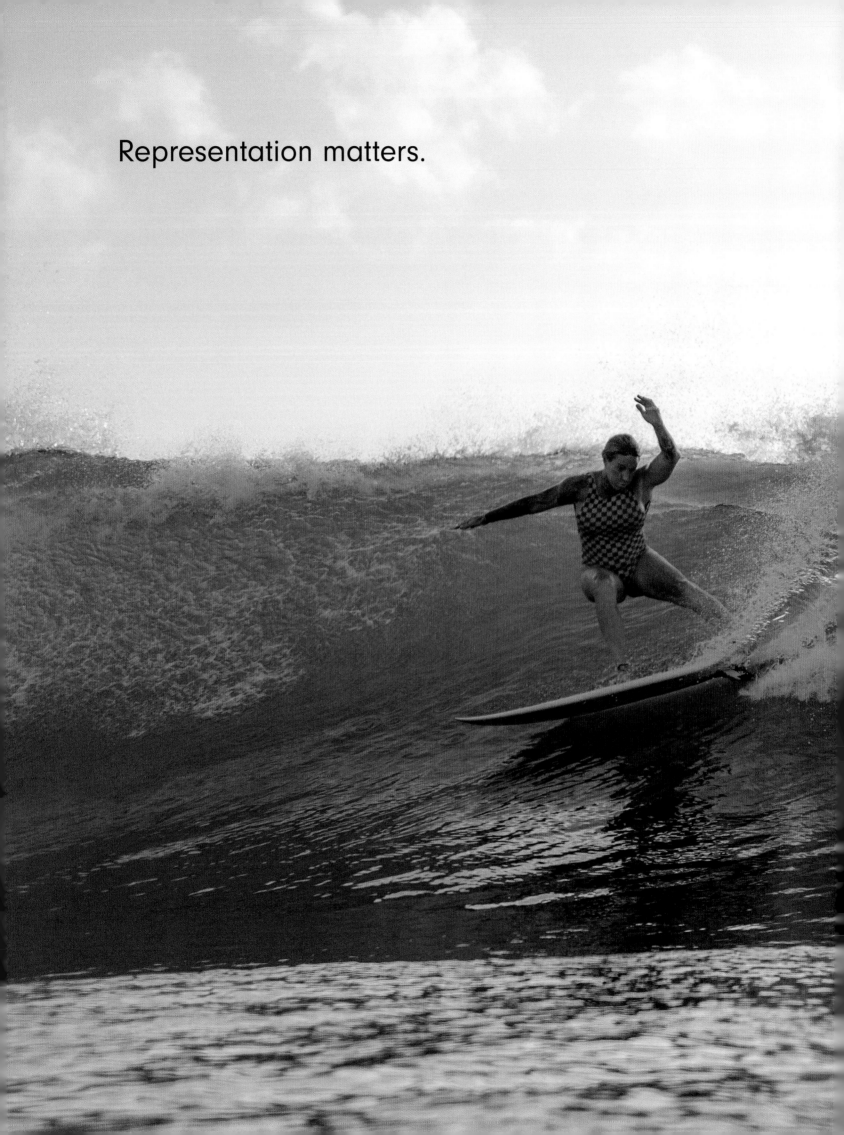

Representation matters.

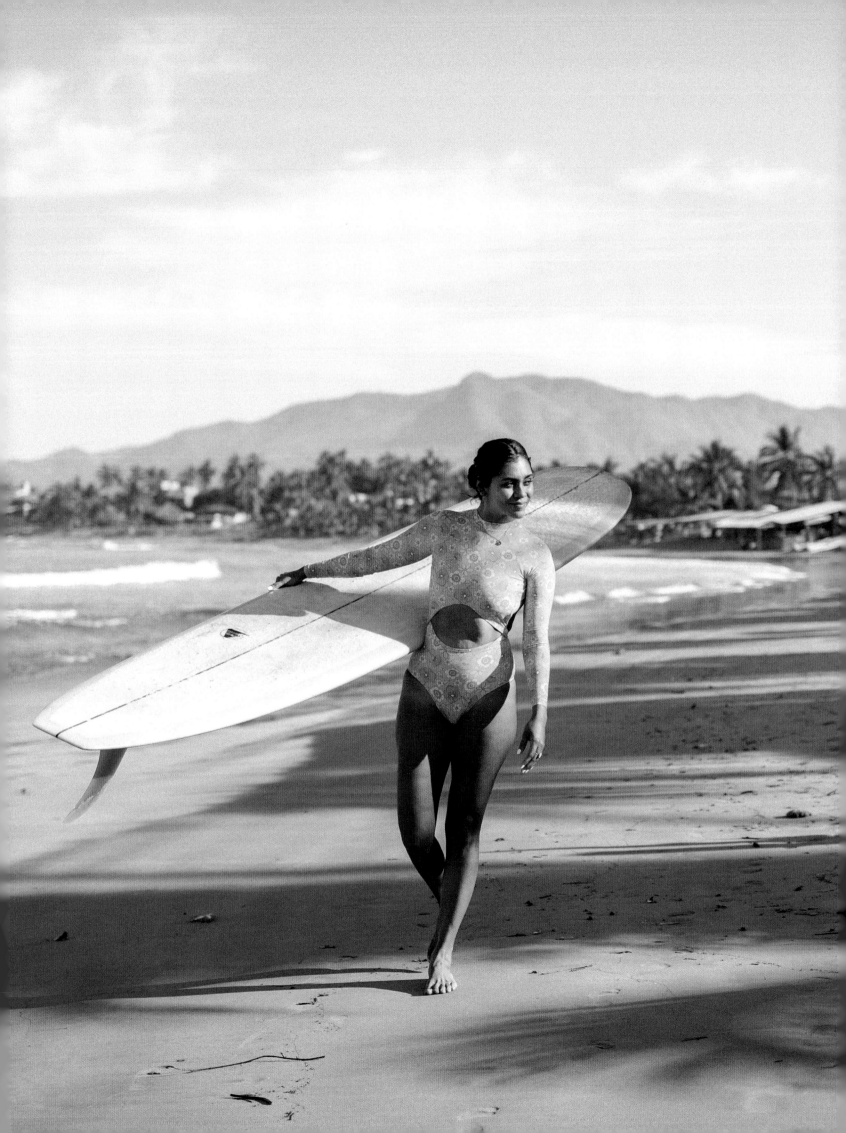

Patricia Valdovinos Ornelas

"Today I surf for myself, for my family, and for all the women who dream of learning something new and think it is impossible."

I grew up in a mountain village, an hour from the beach, and as a little girl I always dreamed of walking on the sea and dancing on it without sinking. My mother is from the town of La Saladita, five minutes from the beach. She used to take me and my two brothers to visit my grandparents, so that was my connection with the sea, but I never tried to get on a surfboard, even though I had cousins who were already surfing.

As the years went by and I grew up, I moved further and further away from the beach, but I was always curious to learn how to "float"—that's what I called it. After a while I tried to go in with my uncle a couple of times, but I only managed to stay on the shore. I remember it very well because I was having fun but felt nervous at the same time.

But it wasn't until I was 23 that I met Leonel. He was the right person to teach me to be the surfer I am today. His insistence that I learn his sport was so strong and came with so much love that I decided to go every day and started learning the basics. When I got pregnant I gave it up and thought I would never be in the salty water again. When my daughter Leah was a year and a half old, Leonel insisted again and I returned to the sea to finish what I had started. At that time we were living on the beach, thanks to a wonderful family who adopted us and opened the doors of their home to us. Thanks to them, we are here now, living a wonderful life, doing what we love, and—most importantly—teaching our daughter about another world. A world I didn't know. And doing a sport I never thought I would do, because I thought it was impossible.

I can tell you with certainty that surfing has changed my life, my mind, and my view of the world. Learning to surf has taught me many good things, and thanks to it, I can say that I have gone further than I ever thought I would.

Today I surf for myself, for my family, and for all the women who dream of learning something new and think it is impossible. I stay away from

We shine beautifully when we are confident in our potential. Playa La Saladita, Guerrero, Mexico.

competitions because when I tried them, it aroused feelings and insecurities that I didn't like. When I got to know this sport, I never intended to compete.

When I first started surfing, I only wore shorts and tops for running because of the insecurity in my body and mind. Bikinis were new to me, something I only wore to the pool, and I always made sure I wore a very conservative one. Where I grew up, people were not used to wearing swimwear. When I moved to the beach, everything in my world changed, both in my mind and in my manners.

In the beginning, when I was learning to surf and integrating into that world, my body insecurities became stronger. I saw girls with perfect bodies. I was coming out of a pregnancy where my body had changed completely. It was bigger and heavier. I started thinking about it and wanted to look like those girls—something I hadn't really struggled with or thought about before.

I've also experienced the insecurities that brands create in us, those bikini brands that we all dream of wearing: there's that body war again, that war within the mind itself. At first I thought it was important to be complimented on my physical appearance, and that's fine, but when someone compliments you on your personality, your mentality, and your essence, you realize that's what's really important.

"In the beginning, when I was learning to surf and integrating into that world, my body insecurities became stronger."

As I started surfing more and more, I felt more confident, stronger, and that was the moment I started to change the way I dressed in the water but also out of the water, free from thinking about what people would think of me.

I think the surfing world has started to change a bit. Now, it seems like there are more opportunities for all kinds of bodies and colours, which is good for me and makes me feel more accepted in this world. Today I can tell you that I love and accept myself partly because I feel very lucky to be part of this sport that has completely changed me and taught me my true value as a person and as a strong woman.

Always blossoming, enjoying and celebrating every step of this long journey. Surfing with joy and gratitude.

Right (top) I live in gratitude for being able to fulfil some of my dreams. (Bottom) Enjoying my favorite surf break with my daughter. Being able to share my passion for surfing with her is what I love the most. | Next double page (left) In Mexico, we celebrate Día de Muertos, not only in remembrance of those who have died, but with the true hope that they will return to be with us. (Right) Learning to surf has changed my life.

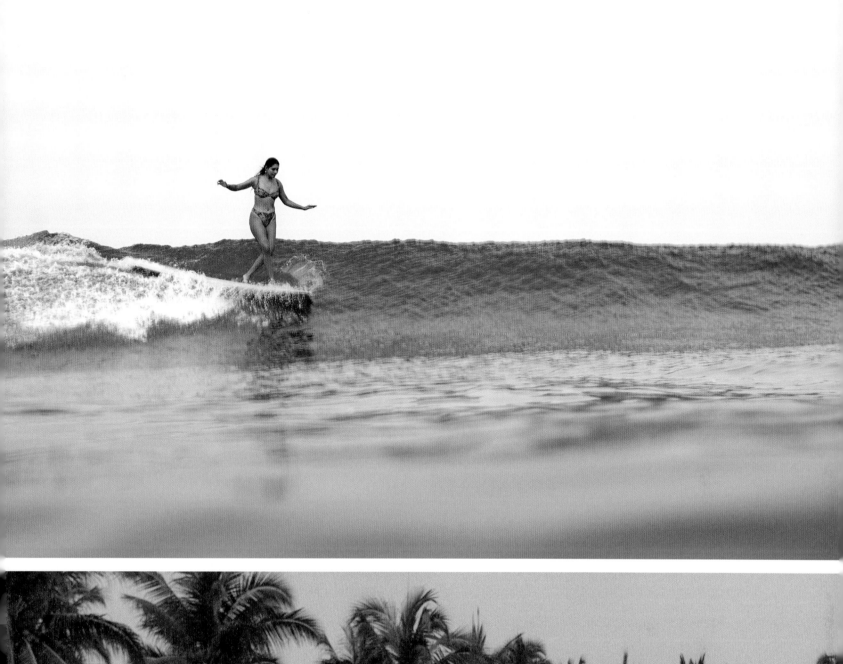

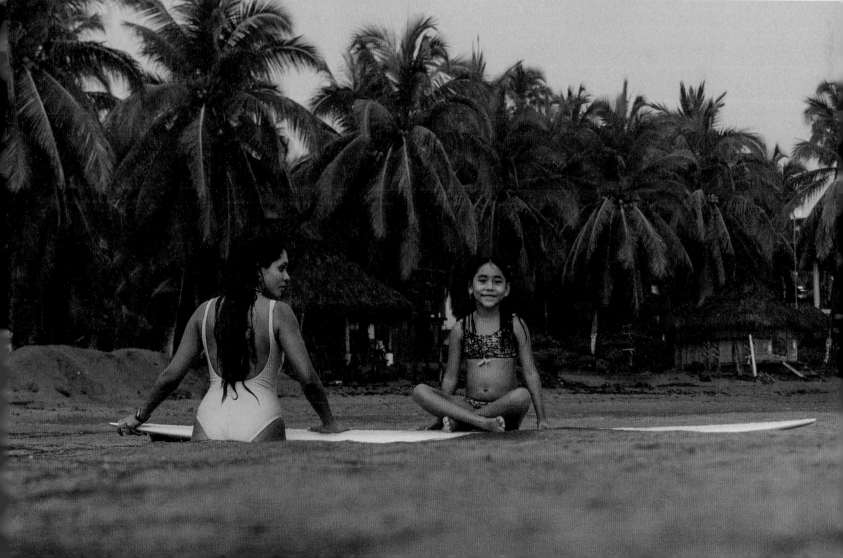

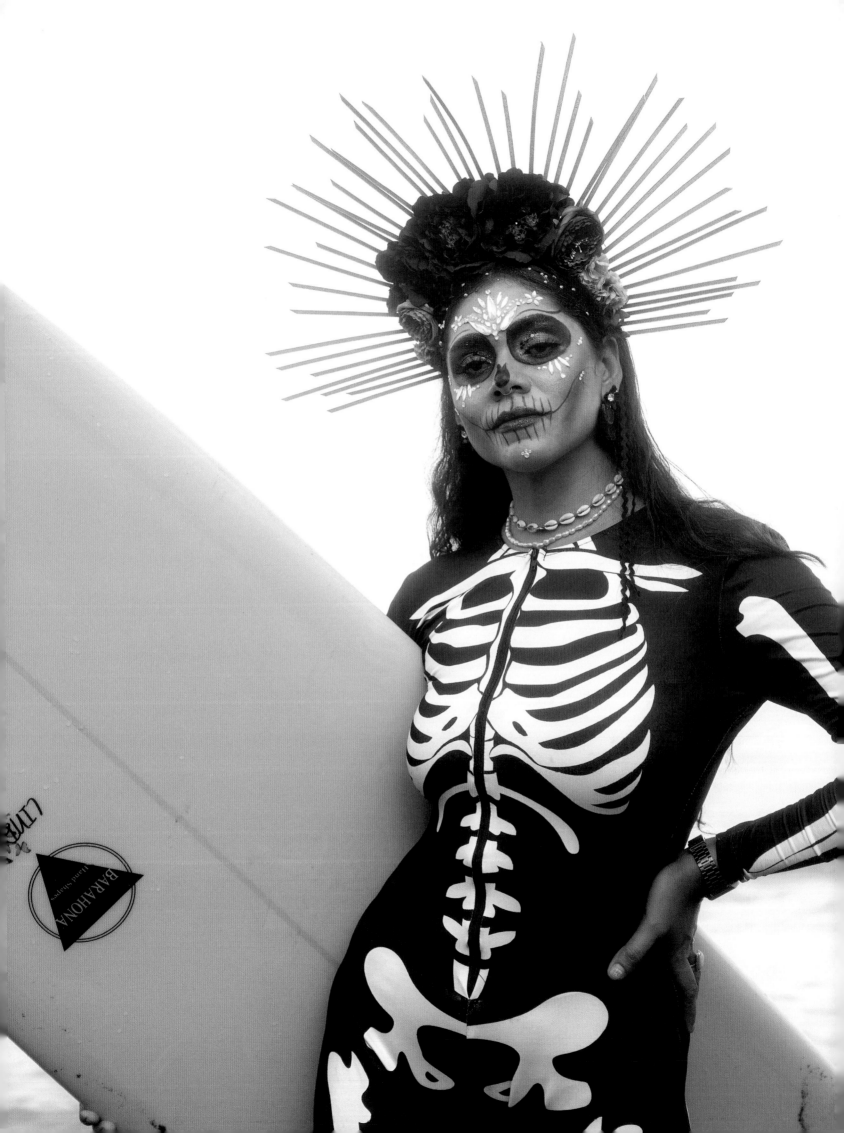

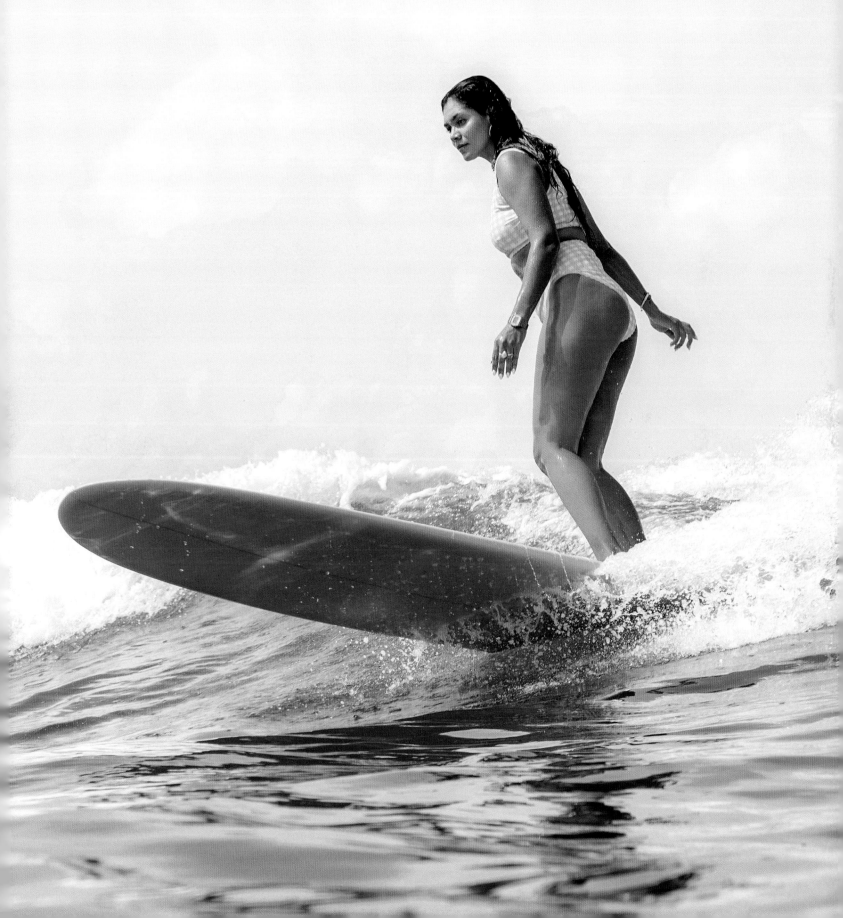

Society has a distorted
perception of beauty.

Marina Emerald

"Love yourself first, love your body, because that's who you will be spending the rest of your life with."

My name is Marina, which means "born in the sea" or "the one who loves the sea" in Spanish. I was born and raised in a coastal town by the Mediterranean coast in Spain, but in 2015, I moved to the Gold Coast, Australia, in search of waves and adventure. I wanted to become bilingual and explore this beautiful country.

I'm a surfer, freediver, and now an underwater maternity photographer. I've always been passionate about photography, and in 2016, I started shooting in the water. Since then, I've found a deep love for capturing moments in the ocean.

I consider myself a strong woman and I am always encouraging others to step in front of the camera, no matter what. From a young age, many of us judge ourselves harshly, maybe because we don't love ourselves enough. Over time, I realized that no one cares as much about how you look as you do. I don't have many photos of myself from my teens and twenties because I was self-conscious. When I was in my mid-thirties, I realized I didn't have many photos, and the ones I do have, I now love because I see myself as beautiful and youthful. I take any opportunity I have to share this with everyone and inspire them.

I love to see women surfing. The way women surf can be really stylish and elegant, no matter the body type, size of bikini, or if you have big or small boobs. The fact that we are out there is what matters. Back in the day, women were not even allowed to surf. We should be out there doing what we love without caring about how we look! We are out there to have fun, relax, enjoy the ocean, hang out with friends, or simply be alone. The ocean is therapy.

The last thing I want to worry about is if I look good or not. I want to be comfortable, feel good, and have the best time out there without judging anyone, including myself. I went through a stage where I was worried about what to wear, if it looked good, or what the trend was. But over time, I realized no one really cared but me. Even if they did, how long is that thought going to stay with someone? The answer is just that moment during the thought, then it's gone. People keep going with their lives, and you get stuck with irrelevant insecurities in your head. Love yourself first, love your body, because that's who you will be spending the rest of your life with.

Rainbow Bay, Snapper Rocks, Gold Coast, QLD, Australia.

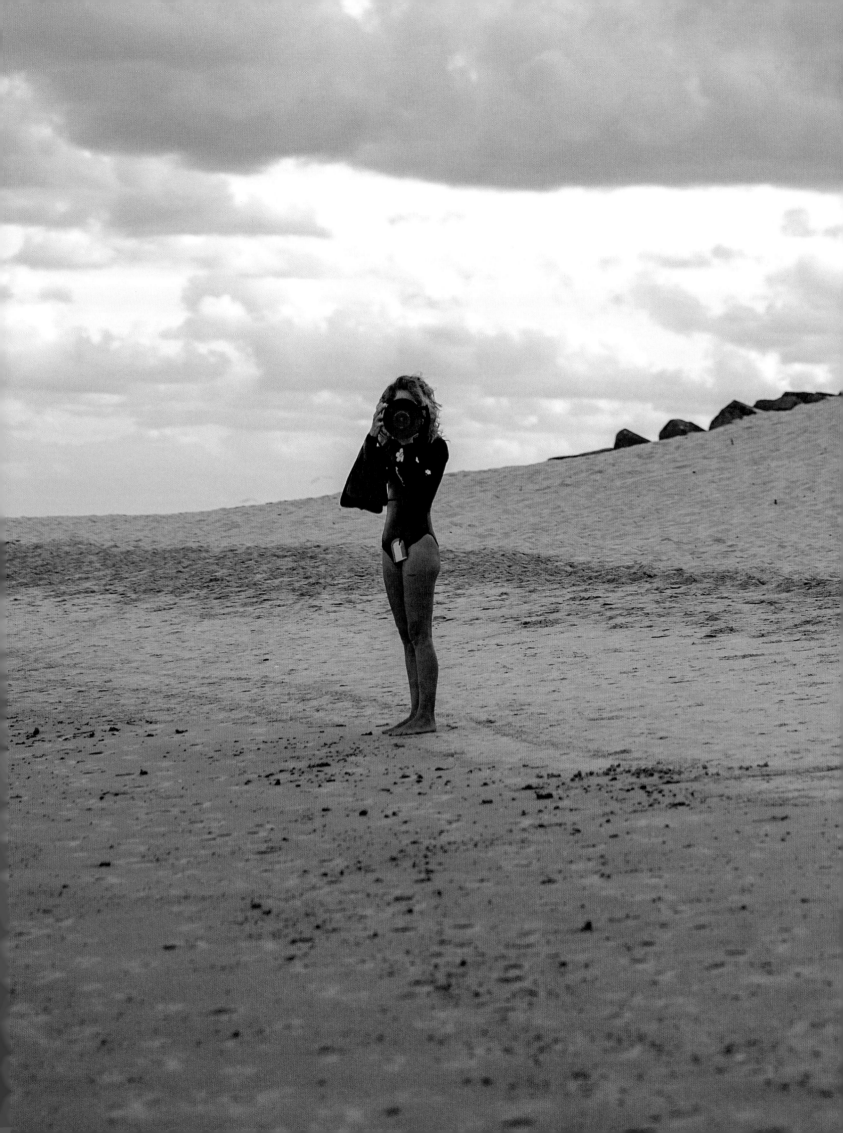

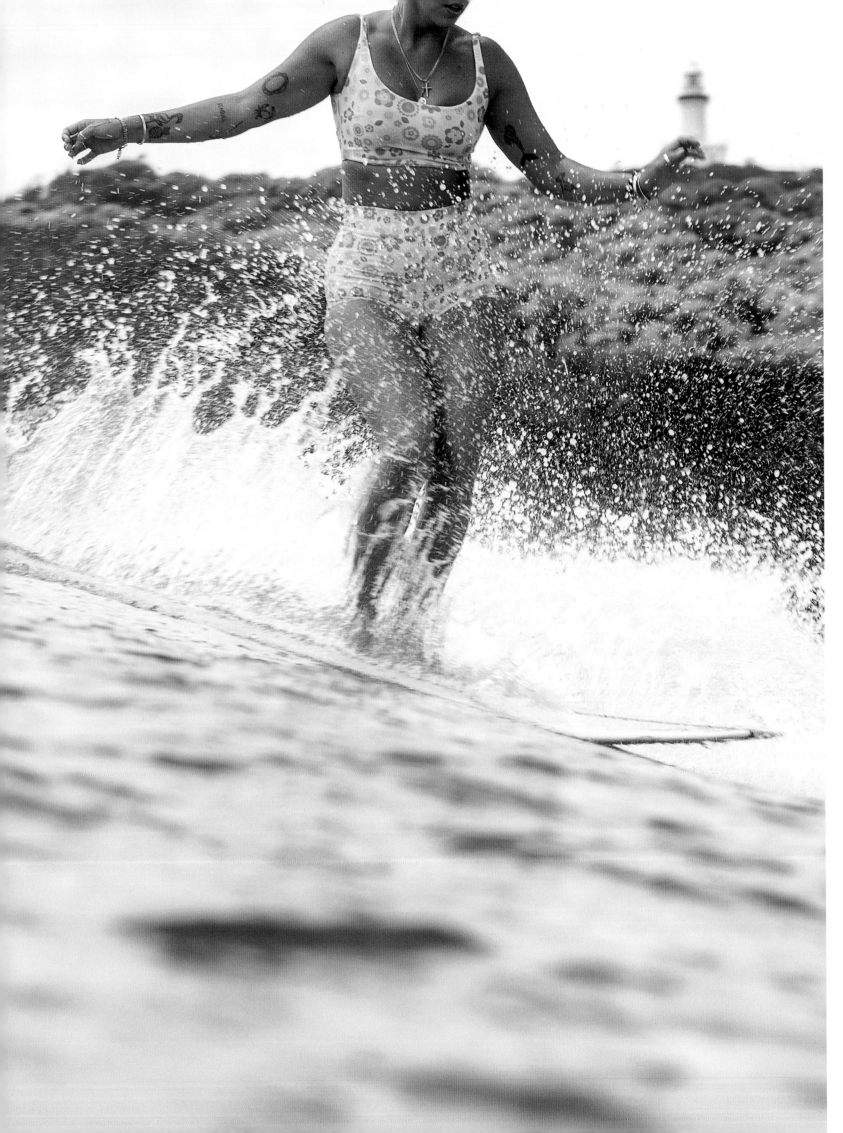

Marina Emerald

I've taken photos of Kirra and Anna for many years—surfing, freediving, on land, in the ocean—and I always encouraged them to get naked in front of the camera. As women, we all go through periods when we love our bodies and others when we don't feel as comfortable in them. But you need to embrace your healthy body because it is beautiful just the way it is. Your body is the one that takes you surfing, for a walk, for a swim in the ocean, wherever you want to be. We should praise it, love it, take care of it, and try not to be hard on ourselves.

I love nude photography because I find it incredibly empowering and beautiful. As women, we go through many body changes, especially during pregnancy, but I do believe the woman's body is art. Anna was my first underwater maternity model, and during that time she was around 36–38 weeks pregnant. She was already complaining about her weight and her legs, but the fact is she was stunning, beautiful, and surfing until she was full term.

Most of my maternity clients initially don't love their bodies, especially at the end of their term, and worry about how they'll look in photos. A lot of them come to me feeling uncomfortable, big, heavy, with cellulite here and there. I see them differently, and I capture them in a way that highlights their true beauty. When they receive their images, many of my clients cry tears of joy because they can't believe how amazing they look. I wish they could see themselves through my eyes.

"I love nude photography because I find it incredibly empowering and beautiful."

Here are some messages from clients when they received their photos: "I can't believe that woman is actually me. I never thought I could look so good. I'm in tears ... Thank you so much for making me feel so comfortable. This was the best experience I ever had, and I can't wait to do it again if I have another child." "OMG ... is that me?? You made me look so good!!! I can't believe it. I'm in awe ..." "OMG I am beyond obsessed with my photos. I cannot thank you enough! The photos are so stunning, they make me feel so beautiful. I can't stop crying. Even doing my nude shots, you made me feel extremely at ease in the water. I'm so happy to see myself this way now. Thank you so much!"

I love my job because of moments like these. My art helps my clients love themselves a little more because these photos change the way they see themselves.

The only thing you'll never regret is having photos of yourself. The way you look at them might change over time, but I can guarantee it will always change for the better.

Kirra Calleja at The Pass, Byron Bay, Australia.

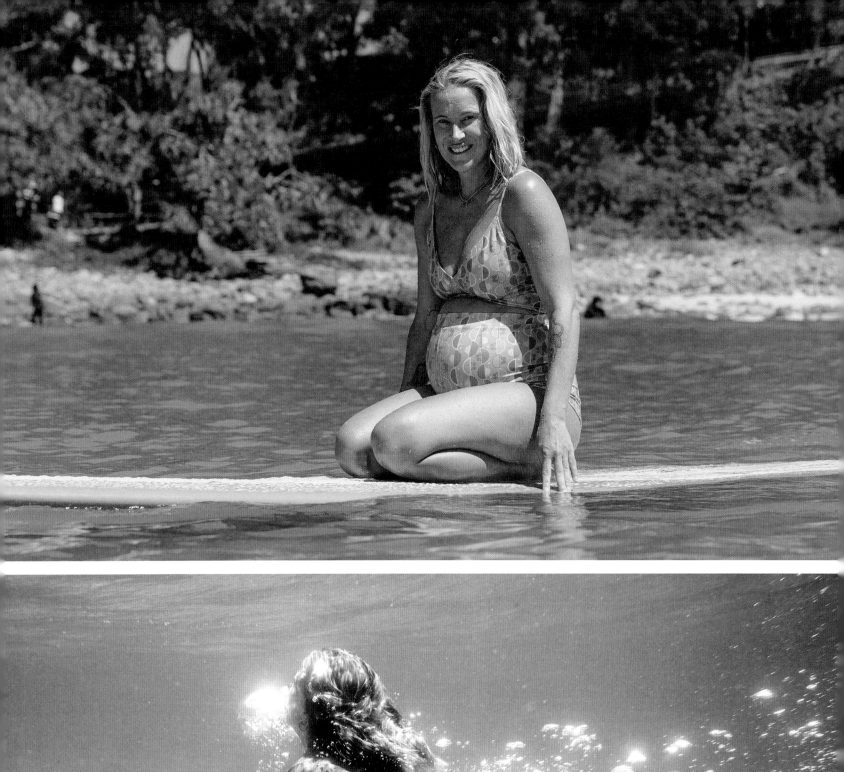
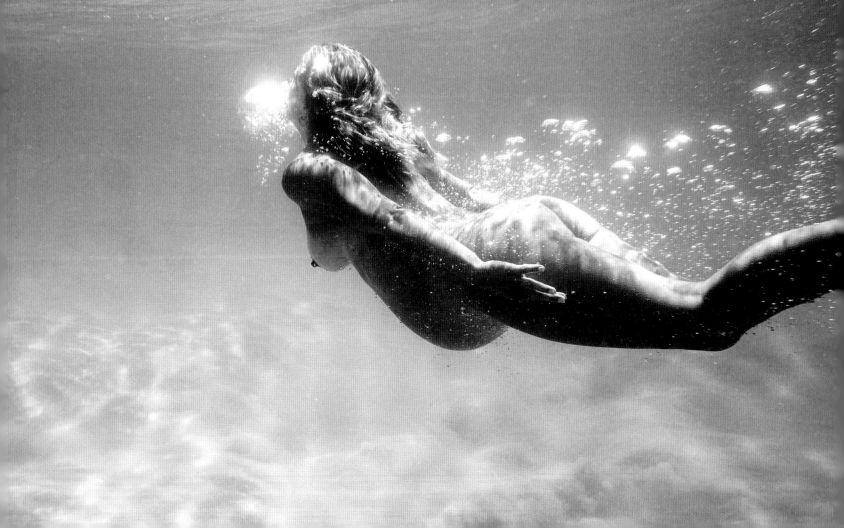

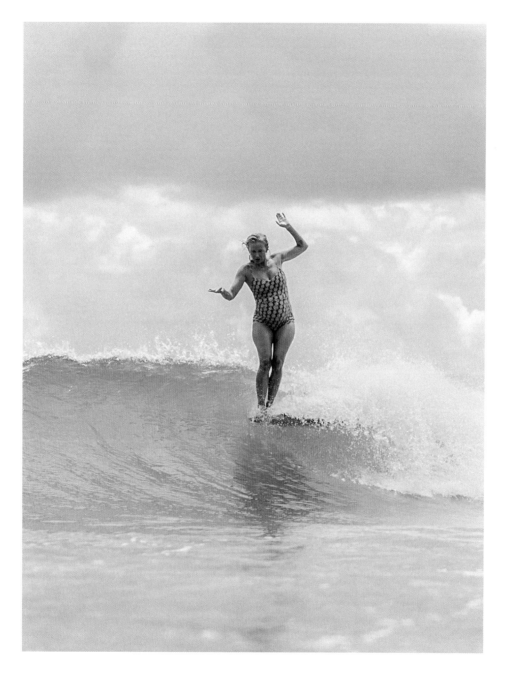

Anna surfing pregnant at Nationals, Noosa Heads, Sunshine Coast, QLD, Australia.

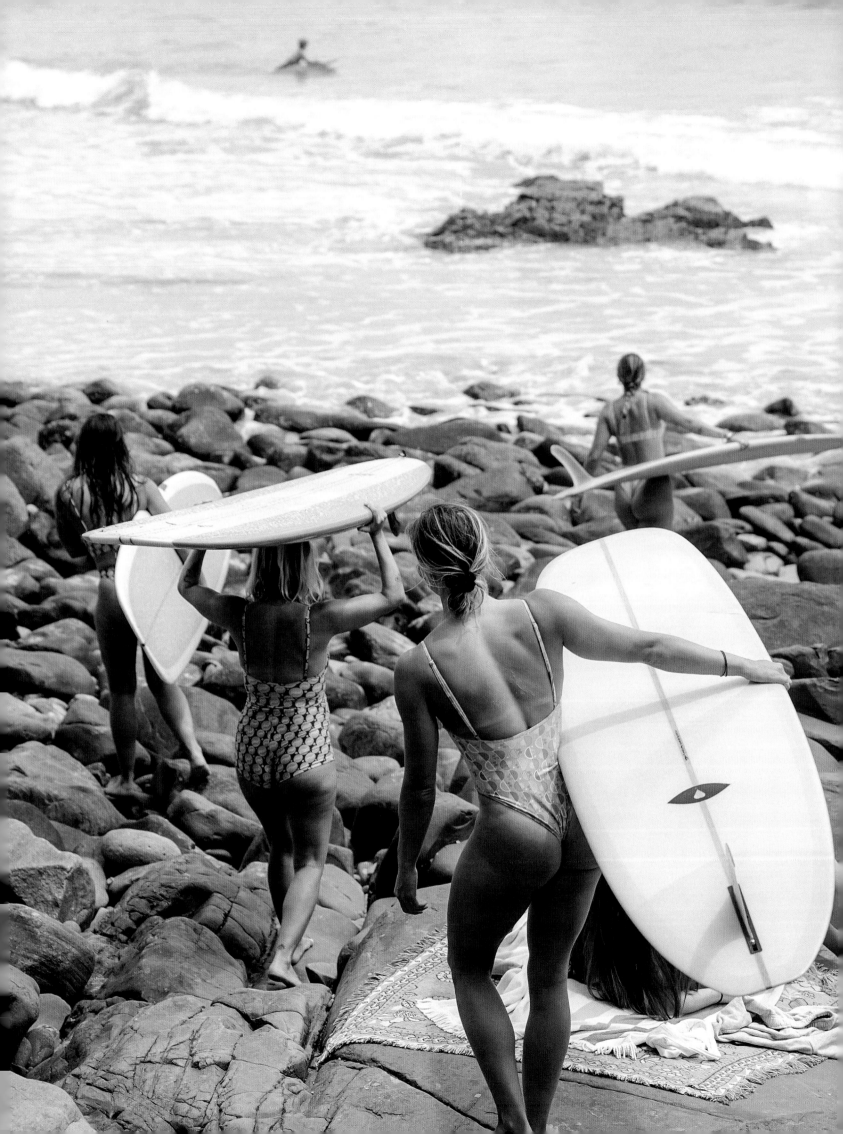

Women's bodies change.

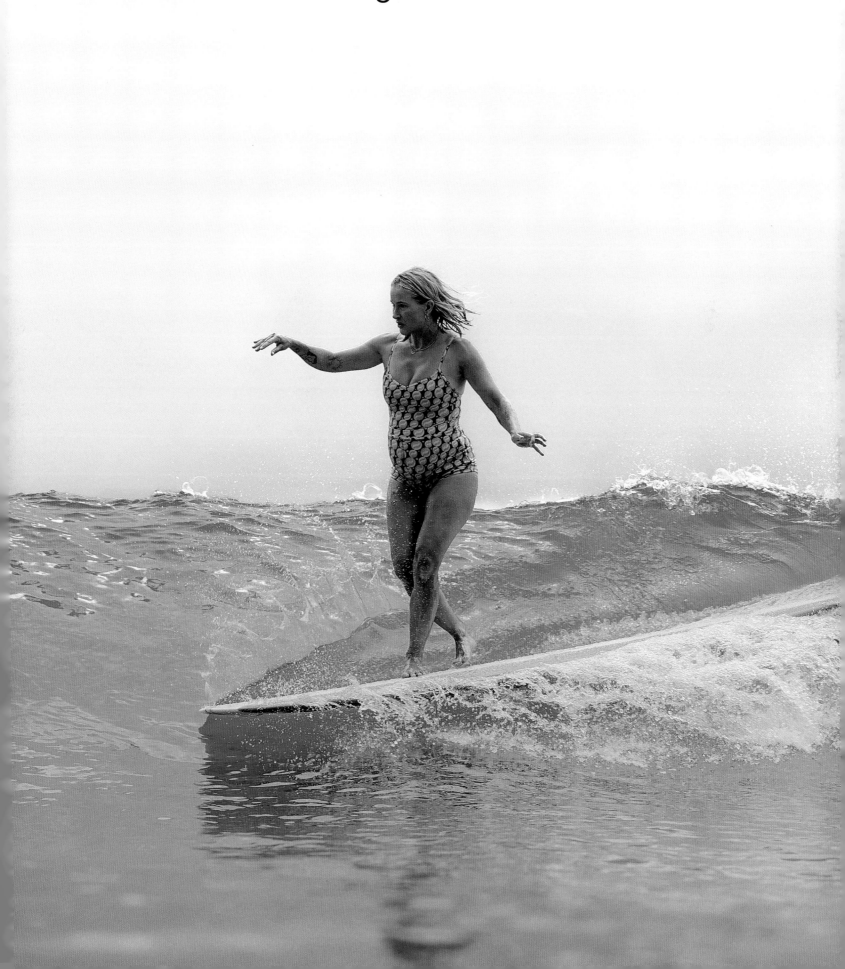

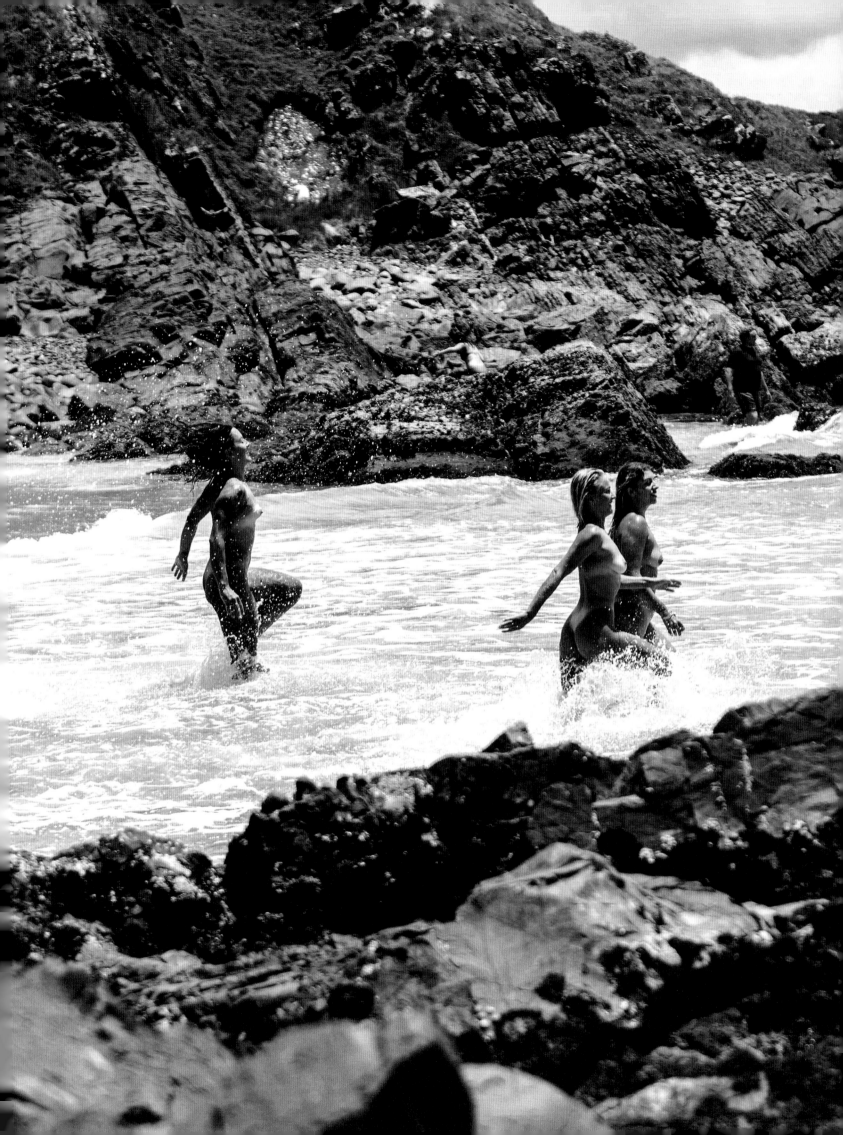

CONTRIBUTORS

A

ALICE MACKINNON
aliceionamackinnon.com
@aliceionamackinnon
Pages: 206 to 211

AMY ROSE HEWTON
amyrosehewton.com
@porkychopps
Pages: 54 to 61

ANAÏS PIERQUET
facingblankpages.com
@facingblankpages
Pages: 120 to 129

ASIA BRYNNE
openwaterproductions.net
@asiabrynne
Pages: 62 to 73

B

BITCHES 'N BARRELS
bitchesnbarrels.com
@bitchesandbarrels
Pages: 140 to 147

BRI ATISANOE
@bri_inspired
Pages: 18 to 27

C

CHELSEA ROSS
goddessretreats.com
@goddessretreats
Pages: 40 to 47

E

EMY DOSSETT
saltysee.com
@salty_see
Pages: 92 to 101

G

GABRIELA HAYDÉE
gabrielahaydee.com
@gabriela.haydee
Pages: 154 to 159

GIGI FORCADILLA
@gigi_forcadilla
Pages: 102 to 111

J

JESSA WILLIAMS
intrsxtnsurf.com
@Intrsxtn_Surf
@jae_bella
Pages: 182 to 189

JÚLIA MORENO
@juliashells
Pages: 176 to 181

K

KIRRA CALLEJA
@kirrashale
Pages: 28 to 39

L

LUCY SMALL
equalpayforequalplay.com.au
@saltwaterpilgrim
Pages: 48 to 53

M

MADDY MAY
@maddy____may
Pages: 190 to 195

MARGAUX ARRAMON-TUCOO
@margause
@queenclassicsurfestival
Pages: 112 to 119

MARINA EMERALD
marinaemerald.com
@marinaemerald
Pages: 224 to 232

MEHANA PILAGO
@mehanaokalaa
@mehanatattoo
@kaeohawaiistudio
@artafterdarkkona
@mehanadesignhouse
Pages: 148 to 153

MIKA TENNEKOON
@mika_tennekoon_art
@mikatennekoon
Pages: 130 to 139

MING HUI BROWN
@mingschwing
Pages: 166 to 175

N

NATSUMI TAOKA
@natsumi_taoka
Pages: 196 to 205

P

PATTI SHEAFF
@pattisheaff
Pages: 160 to 165

PATRICIA VALDOVINOS ORNELAS
@pattyyornelas
Pages: 218 to 223

R

RISA MARA MACHUCA
surfitout.com
@surfitoutmexico
Pages: 84 to 91

S

SASHA JANE LOWERSON
@sasha_jane_lowerson
Pages: 212 to 217

SUELEN NARAÍSA
suelennaraisa.com.br
@suelennaraisa
Pages: 74 to 83

T

TARA CRYSTAL
@pohoiki808
Pages: 8 to 17

PHOTO CREDITS

A

ALISON GOWLAND
@currumbinali
Page: 209 t

ALISSA WALDO
alissawaldo.com
@waldo.image
Page: 59

AMANDA BATTLE
oceansoflovephotography.
com.au
@oceansoflovephotography
Page: 50

AMBER JENKS
ajenksimagery.com
@ajenksimagery
Page: 167

AMY FITZGERALD
oceanspiredarts.com
@oceanspiredarts
Page: 10

ANA CATARINA
anacatarinaphoto.com
@anacatarinaphoto
Pages: 75 - 78 - 81

ANNA MARIE JANSSEN
annamariejanssen.com
@annamariejanssen
Page: 221 t

ANNE MENKE
annemenke.com
@annemenke2
Page: 90

ARTO SAARI
artosaari.com
@artofoto
Pages: 9 - 12 - 13 - 14

ASIA BRYNE
openwaterproductions.net
@asiabrynne
Pages: 5 - 18 - 21 - 23 - 25
26 - 65 to 71

B

BRENT BIELMANN
brentbielmann.com
@brentbielmann
Page: 16

BROOKE BERRY
brooklynhawaii.com
@brooklynhawaii
Page: 15

BRUCE OLINDER
bruceolinder.com
@bruceolinder
Pages: 163 t - 165

BRYANNA BRADLEY
bryannabradley.ca
@bryannabradleyphotography
Pages: 140 - 143 - 144

BUGSY HEATHCOTE
@bugsybazzatone
Page: 132 b

C

CHARLOTTE PIEPER
lottaandthewaves.com
@lotta_and_the_waves
Pages: 108 - 111 - 120

CHEMA GARRIDO
chemaphoto.com
@chema_photo
Page: 179

CHRIS BEZAMAT
chrisbezamat.com
@cbezphotos
Pages: 168 - 173

CHRISTA FUNK
cfunkphoto.com
@instaclamfunk
Page: 72

CHRISTIAN RASK
@raskal
Pages: 124 to 127

CHRISTIE GRAHAM
christiegraham.ca
@christiegrahamphotography
Page: 93

CLEMENTINE BOURKE
clementinebourke.com
@clementinebourke
Pages: 6 - 30 - 34 - 36 - 58
106 b - 110 - 213 - 215

D

DANE CREIGHTON
Page: 60

DANI HANSEN
danihansen.com
@dani__hansen
Page: 48

DAVID HARRY STEWART
for AGEIST Magazine
ageist.com
@weareageist
Pages: 160 - 164

DIMITRI FEDOROV
@fedorovdmitry
Page: 56

E

ELISE LAINE
eliselaine.com
@elise.laine
Pages: 222 - 223

EMY DOSSETT
saltysee.com
@salty_see
Pages: 4 - 84 - 87 - 88 t - 94
96 to 101

G

GABRIELA HAYDÉE
gabrielahaydee.com
@gabriela.haydee
Pages: 154 to 159

H

HEIKO BOTHE
heikobothe.mx
@heikobothe
Page: 218 - 221 b

HENRIQUE TRICCA
@henriquetricca
Page: 82

HUGO BIGONET
@hugobigonet
Pages: 112 - 115 to 119

I

IZZY HOBBS
izzyhobbs.com
@izsea_
Page: 38

J

JENN FARMER
jennfarmerphotography.com
@jenn_farmer_photography
Page: 91

JENNIFER JEFFERIES
jesseaphoto.com
Page: 209 b

JESSE JENNINGS
jesseaphoto.com
@jesseaphoto
Pages: 184 - 186

t - top
b - bottom

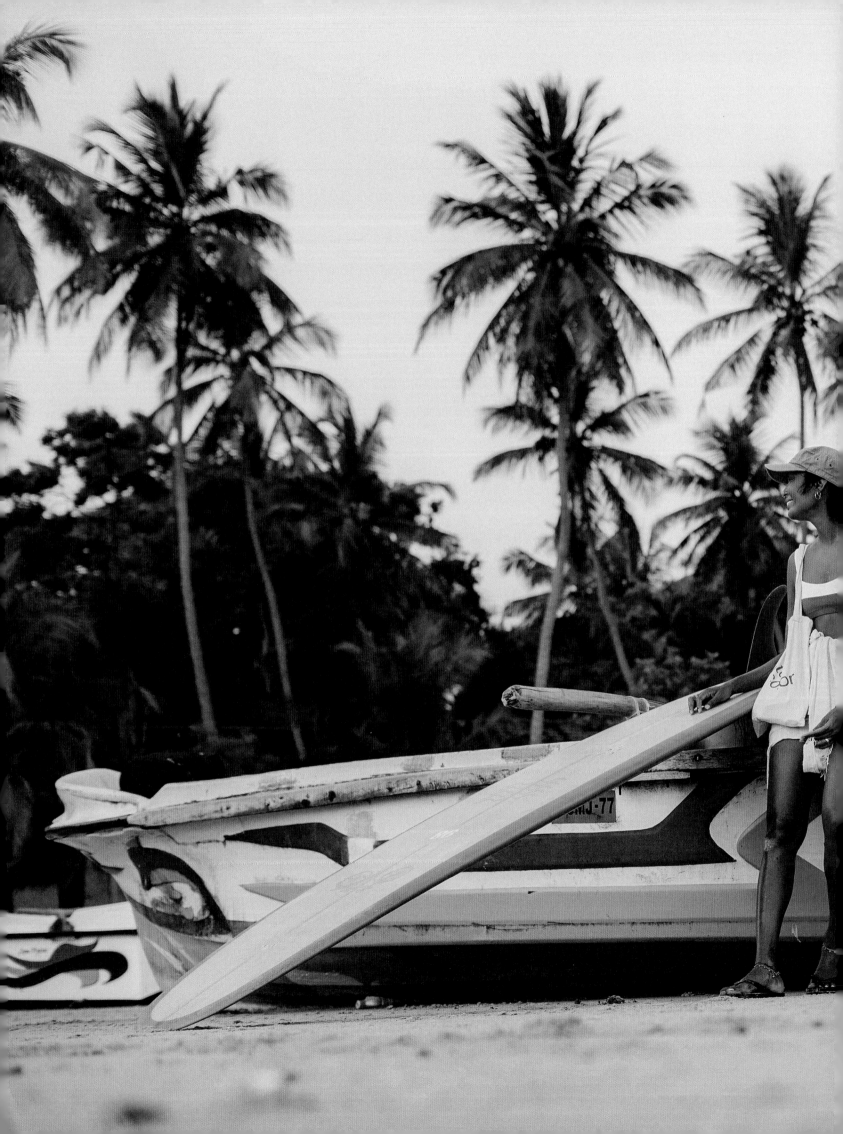

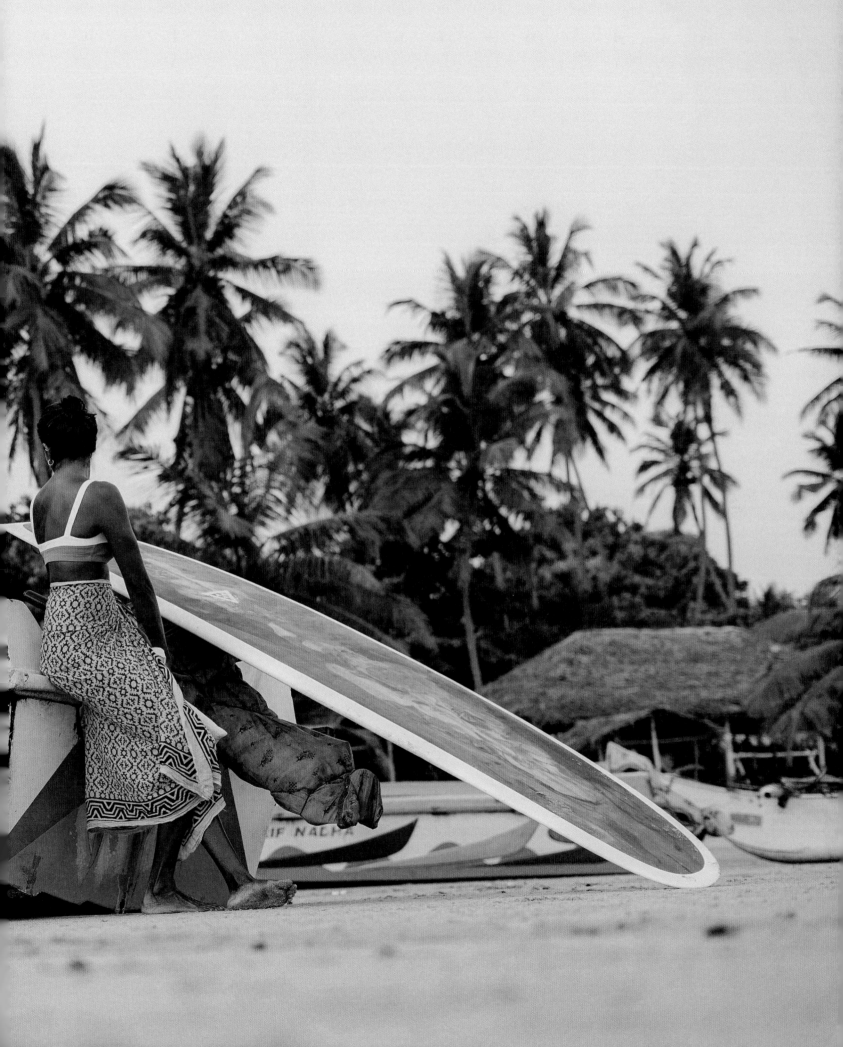

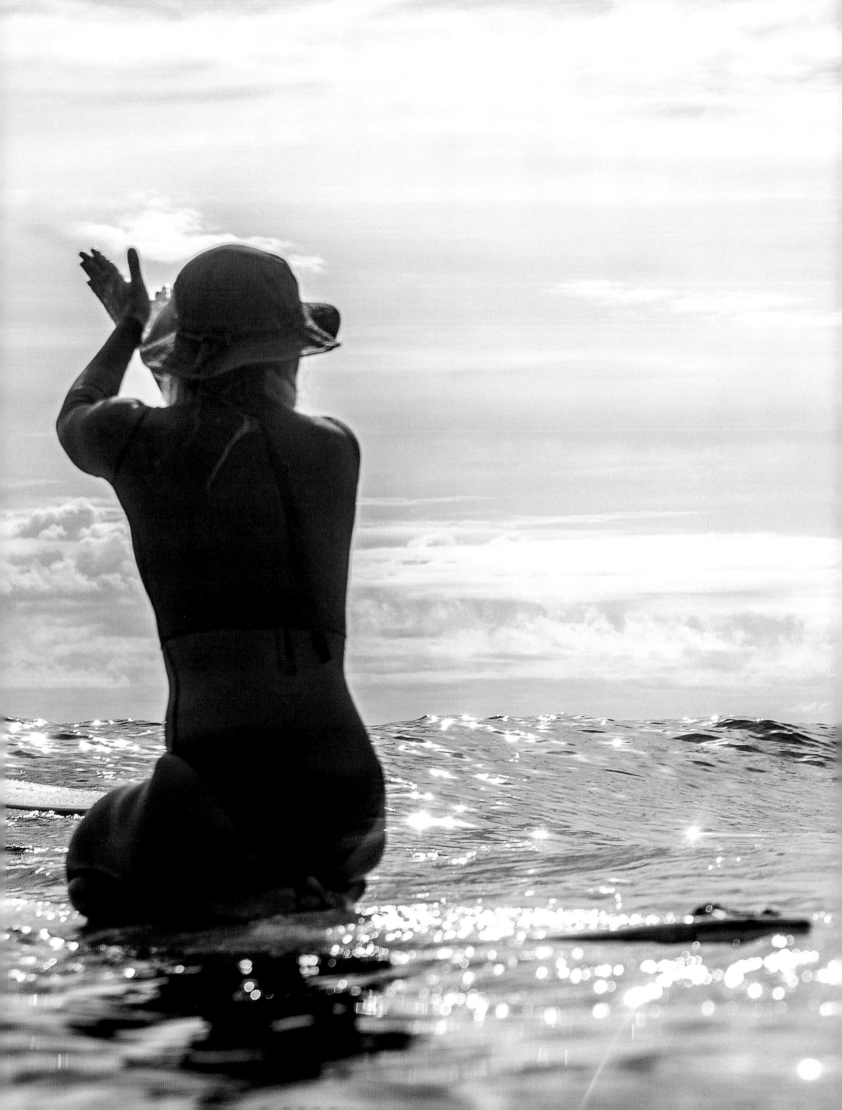

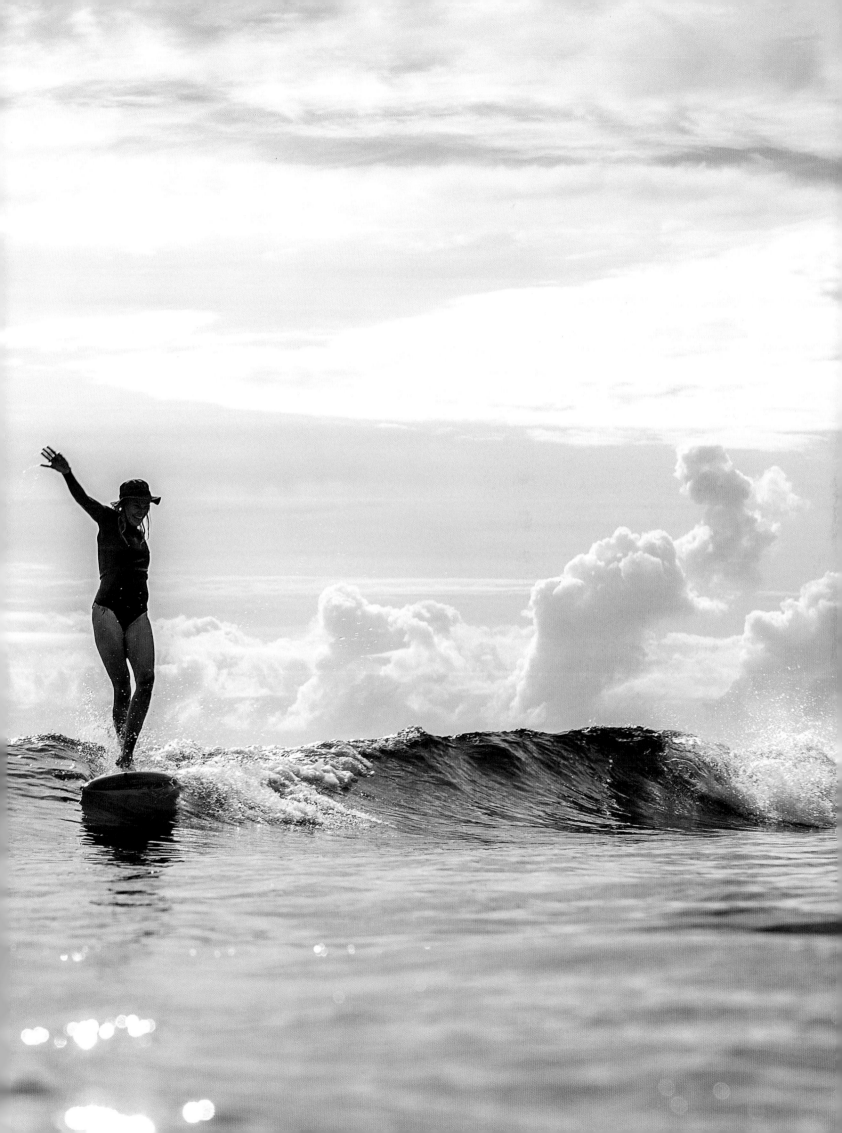

© Prestel Verlag, Munich · London · New York, 2025

A member of Penguin Random House Verlagsgruppe GmbH

Neumarkter Strasse 28 · 81673 Munich

produktsicherheit@penguinrandomhouse.de

Cover: Tara Crystal, photo by Arto Saari

Back cover: Photos by Jorge Moya (top left), Marina Emerald (top right), Amber Jenks (middle left), David Harry Stewart (middle right), Clementine Bourke (bottom left), Asia Brynne (bottom right).

Library of Congress Control Number is available; a CIP catalogue record for this book is available from the British Library.

Editorial direction: Julie Kiefer

Concept and coordination: Carolina Amell

Photo research: Carolina Amell

Design and layout: Carolina Amell

Copyediting: Martha Jay

Production management: Luisa Klose

Separations: Reproline Mediateam, Munich

Printing and binding: TBB, a.s., Banská Bystrica

Penguin Random House Verlagsgruppe FSC® N001967

Printed in Slovakia

ISBN 978-3-7913-9336-0

www.prestel.com